SISTERS

SISTERS

Relation and Rescue in Nineteenth-Century British Novels and Paintings

MICHAEL COHEN

Madison ● Teaneck
Fairleigh Dickinson University Press
London and Toronto: Associated University Presses

Associated University Presses
440 Forsgate Drive
Cranbury, NJ 08512

Associated University Presses
25 Sicilian Avenue
London WC1A 2QH, England

Associated University Presses
P.O. Box 338, Port Credit
Mississauga, Ontario
Canada L5G 4L8

Library of Congress Cataloging-in-Publication Data

Cohen, Michael, 1943–
 Sisters : relation and rescue in nineteenth-century British novels and paintings / Michael Cohen.
 p. cm.
 Includes bibliographical references and index.
 ISBN 0-8386-3555-5 (alk. paper)
 1. English fiction—History and criticism.
 2. Sisters—Great Britain—19th century—Historiography.
 3. Women and literature—Great Britain—History—19th century.
 4. Art and literature—Great Britain—19th century.
 5. Painting, Modern—19th century. 6. Sisters in literature.
 7. Rescues in literature. 8. Painting, British. 9. Sisters in art.
 10. Rescues in art. I. Title.
 PR868.S52C64 1995
 823'.809352042—dc20 94-14414
 CIP

PRINTED IN THE UNITED STATES OF AMERICA

To my sister Judyth

Contents

Preface

My STUDY IS ABOUT SISTERS IN NINETEENTH-century British paintings and novels. I look at how the depiction of sisters works and how it changes from the middle of the eighteenth century through the nineteenth, and I argue that a rescue of one sister by another is the subject of a surprising number of nineteenth-century works. These works all have sisters for their protagonists, and in them sisterhood is a synecdoche for all relationships among women.

I borrow ways of treating fictional characters from other writers in the field. That heroines of different books could be sisters to each other and that one author could revise and amend the construction of sisterhood that she found in another—these are enlivening ideas in Susan Morgan's *Sisters in Time: Imagining Gender in Nineteenth-Century British Fiction* and in Patricia Meyer Spacks's discussions of how Austen's sisters absorb and repudiate the simpler characterizations of Charlotte Lennox and Jane West. The notion of novels as conversations between authors is further developed in Jerome Meckier's *Hidden Rivalries in Victorian Fiction*. Susan Morgan also made me think about heroism in new ways. Morgan argues that the values of "feminine heroism" replaced those of "masculine heroism" in the work of both male and female writers in the nineteenth century, a thesis I find attractive, though somewhat too wishful. Of other writers discussing sisterhood and heroism, Dorothy Mermin and Helena Michie, both writing about Christina Rossetti's "Goblin Market," helped me form my thoughts. Helena Michie's *Sororophobia* confirmed some of the things I had been thinking about sisters and challenged others. I am grateful for her friendliness and help as well as for her ideas. My thanks also to Joseph Kestner for his encouragement at the same stage of my project. Along with Morgan's book, Kestner's *Mythology and Misogyny* was important to my

ideas about rescue and heroism as they could be used for female subjects; so was Adrienne Auslander Munich's book on the Andromeda myth. Spacks and Claudia Johnson both helped me think about Austen in ways I had suspected were right, but which seemed to defy the standard story of Austen the conservative.

Linda Nochlin, Nina Auerbach, Lynda Nead, and Susan Casteras all showed me ways to think about the sisterhood of Victorian prostitutes and respectable women, and Nochlin especially showed me the importance of the evidence that was not there. I am especially grateful to Susan Casteras for her suggestions for improving my book and her gracious assistance with the task of finding owners in order to obtain permission to reproduce their paintings. My thanks also goes, once again, to David DeLaura for his help and encouragement.

Richard Steiger read the whole of this book in an early draft and helped me see what I wanted to say. Many people read portions of it and offered criticisms or other sorts of help; my thanks to Katharine Cohen, James R. Aubrey, Victoria Beyer, Robert E. Bourdette, Jr., Sandra Donaldson, Calvin R. Dyer, David Earnest, William E. Grim, Ward Hellstrom, Donald Lawler, Jerry McGuire, John Maynard, JoAnna Stephens Mink, Adrienne Munich, Claudia Nelson, John Vance, Janet Doubler Ward, Marian Weston, Betty White, and Edith Wylder.

Parts of Chapter 5 appeared in *The Significance of Sibling Relationships*, edited by JoAnna Mink and Janet Doubler Ward (Popular Press, 1993) and in *College Literature* 20.2 (June 1993). Earlier versions of Chapters 8 and 10 were published in *Yearbook of Interdisciplinary Studies in the Fine Arts* 2 (1990), and *Victorian Literature and Culture* 21 (1993). I am grateful to the editors and publishers for permission to reprint these sections.

SISTERS

1

Defining Sisters: Augustus Egg's The Travelling Companions *and the Grammar of Sisterhood*

THE VISUAL LANGUAGE OF *THE TRAVELLING COMPANIONS*

WHEN I FIRST SAW AUGUSTUS EGG'S 1862 painting *The Travelling Companions* in the City Art Gallery in Birmingham, I thought it a beautiful and somewhat mysterious picture. At first glance it is a simple painting of two sisters in a railway carriage, two attractive people travelling through an attractive landscape. But the title, instead of pointing to the biological relationship of these particular sisters or twins, enlarges the significance both of their relation and their journey: they are not just travelling companions on this trip along a Mediterranean coast,[1] but travelling companions on the "journey of life." Egg's picture moves beyond the sisterhood of the two women to what sisterhood means. The painting provides a kind of grammar of sisterhood. Each of its features has something to tell about the relation, or, to put it more narrowly, *The Travelling Companions* has much to say about how sisterhood is conveyed in visual terms. Egg finds a visual language for the relation, a language whose elements represent characteristic features of sisterhood.

Symmetry and Asymmetry, Likeness and Unlikeness

From a distance the main impression created by *The Travelling Companions* is one of symmetrical composition and color largely silver: two dark, wide, clearly defined verticals above two heart-shaped masses of grey with white highlights, together reading as silver. Looked at closer, the picture resolves into an apparently simple scene. In a first-class railway carriage, two women identically dressed in voluminous, crinolined silk moiré or faille dresses and jackets sit opposite each other while their train passes above a picturesque, white-building, European town that hugs hillsides descending into a tranquil sea. The light falls from above and slightly to the left, judging by the shadows on the distant buildings and the highlights on the women's clothes, which form most of the reflecting surfaces in the compartment. It must be near midday. The woman on the right has pulled the curtain on her window slightly, since the light coming

13

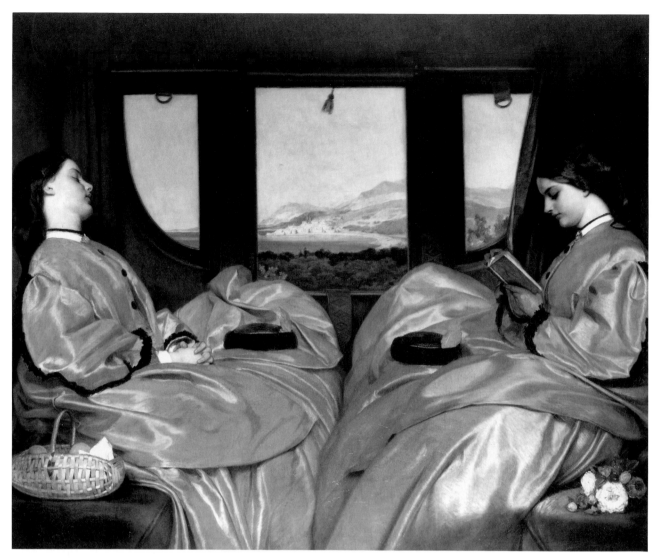

Augustus Leopold Egg, The Travelling Companions
(1862). Birmingham Museum and Art Gallery

from the opposite side disturbs her in her reading. Her companion sleeps undisturbed with open curtains; the light is slightly behind her. The windows, the faces of the two women, the masses of their dresses, and the placement of their identical hats all underline the symmetry. This symmetry of features and dress is what causes the observer to infer that the women are twin sisters.

The identical costume helps lead to the perception of the two women as sisters and twins, but, significantly, *no other feature* has been presented in duplicate for comparison. The hair color that seems to differ is probably an effect of the differing light: the brunette on the left might brighten into the chestnut on the right if the light fell from the other side. The woman

sleeping on the left presents a quarter view of her face turned up and away; the woman reading on the right tilts her head down toward her book and presents her profile. Other details that defeat symmetry are the sleeper's ungloved hands relaxed in her lap, the reader's gloved hands holding her book and preparing to turn a page, the hats, each with a single feather, yet not quite mirroring each other, and the balance of the fruit basket with the flower bouquet. The symmetrical-asymmetrical play of the painting's composition defines the notion of sisterhood itself. The most obvious feature of sisterhood, resemblance, is always tempered with difference. Likeness contains the idea of difference; even the very close likeness of what we call identical twins preserves differences for the

discerning eye. These twins look like mirror images, but they are distinguished in what they are doing and what they have with them. Like any sisters, including twin sisters, these have their differences of temperament, activity, and desire. Sisterhood is a relation characterized by difference within likeness.

Twinning and Equality

In these figures the likeness extends beyond mere family resemblance to twinning, an effect greatly assisted by identity of costume. Facing each other as they do, the women constitute a kind of human equation. Their likeness, conveyed as identity, suggests all sorts of equalities. The ages of these twins must be the same. If they are in the habit of dressing alike and travelling together, as the title indicates, their experience must be the same. They have the same status: both are middle-class women with the money and the leisure to travel through Europe in a first-class train carriage. Despite differences in taste and temperament, in other words, they are equal in appearance, age, experience, class, and economic status.

Not so obvious is another equality of status that goes along with their being sisters—equality of power, or more accurately, of powerlessness. Within the hierarchical family, sisterhood is a relation of unique equality.[2] Strictly speaking the artist has no way of representing all the terms of such a relation visually. But Egg manages to translate all sorts of intangible equalities in his twinning. His twins are significantly restrained in their huge dresses and contained in their boxlike carriage. The distant landscape seems a pleasure garden of freedom, but it also looks more like a picture on the wall of their compartment than a real place they can step into. And it is not approaching but going by. The sisters, alike and equal in so many other respects, are also alike in their indifference to its passage, though it may be resignation rather than indifference.

Twinning contains implications both sinister and comforting. The human equation is reversible: the twins are interchangeable. One may be replaced or displaced by the other. But the fact of likeness is also

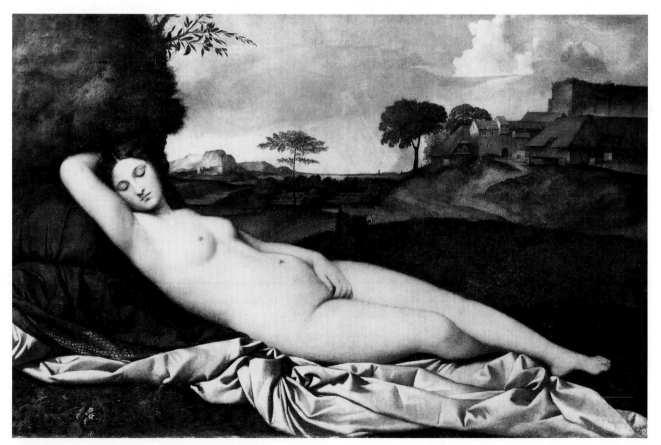

Giorgione, Sleeping Venus *(ca. 1500). Staatliche Kunstsammlungen, Dresden*

an assertion of solidarity. Unity of appearance suggests other unities not visible.

Rivalry: Sleeping and Reading in Art

The longer Egg's picture is studied, the more it reveals how subtly but thoroughly its symmetry is turned to variation. The effect of twinning or partial symmetry here resembles the subtle effects of rhyme in verse: once we get past delight at the likeness, we begin to see that it is only partial, and partial likeness draws attention to remaining *unlikeness*. In poetry, the knowing rhymer uses rhyme words that may contrast in meaning because the sound likeness helps to emphasize the semantic differences. In Egg's painting, the landscape within the symmetrical windows behind the figures varies from sea in the left window, sea meeting hillside village in the middle, to uplands in the right window.

What distinguishes the two women in the painting is their activity or lack of it: one reads and the other sleeps. The observer is offered a choice: do I prefer the sleeper or the reader? Am I more attracted by idleness or by industry?[3] For the observer, rivalry is suggested between the sisters, even though they are apparently unaware of a spectator's gaze. What gives the suggestion added force is a background of art historical associations in which both attitudes, sleeping and reading, are sexually charged.

For sleeping women in art, associations go back at least as far as the most famous unconscious sex-object of the Renaissance, Giorgione's *Sleeping Venus* from about 1500. Whether we see Giorgione's painting as inspiring prurient interest in a watcher, or perhaps depicting gratified desire (and still implying a watcher), it is an image that cannot be unsexed. In the century preceding *The Travelling Companions* Henry Fuseli painted one of England's sexiest sleepers in his 1781 *The Nightmare*, a pre-Freudian primer on the dream imagery of sex. Fuseli includes a randy little incubus and a horse that is both a pun on the picture's subject of a nightmare and an element of dream imagery associated with initiation to sex.[4] Finished earlier in 1781, Sir Joshua Reynolds's *The Death of Dido*, from which Fuseli's painting derives, could as easily convey sleep as death (and even, given the subject, indicate gratified sexual desire), so Reynolds must signal that Dido is dead by including other figures described by his source, Virgil. Reynolds's picture in its turn derives

from a 1528 fresco in Mantua by Giulio Romano, titled *Sleeping Psyche*. In Romano's fresco, Psyche is watched not only by a satyr, but by the unseen watcher, Cupid. In the story, Cupid is sent by his mother Venus to hurt Psyche because Psyche's beauty rivals that of the goddess. The beauty of the sleeping Psyche so rattles the watching Cupid that he wounds himself with his own arrow and falls in love with her.[5] English painters of the nineteenth century frequently used the Psyche subject or related literary subjects that enabled them to show a beautiful sleeping woman who would fall in love with her watcher (or vice versa) when she awoke. Thus there are many examples of Titanias, Sleeping Beauties, Madelines (from Keats's *The Eve of St. Agnes*), and Iphigenias (from Boccaccio's *Decameron* tale of Cymon and Iphigenia).[6]

The association of a reading woman with sex is more indirect. There is an iconographic tradition depicting Mary Magdalen as reading, that is, a woman who reads a sacred text as part of her repentance for sexual sins. An example is Rogier Van der Weyden's *The Magdalen Reading*, from about 1450. A reading woman in painting more often uses the activity to avoid acknowledging a presumably male gaze. Watchers may spend as long as they wish observing the charms of Jean-Honoré Fragonard's *A Young Girl Reading* (1776), and they will not be embarrassed by her being aware of their staring. Like the sleeping subject, the girl can be observed without acknowledging the observation. But is the girl genuinely unaware of being observed? X-ray examination shows that the girl's head was originally half-turned toward the viewer in an acknowledgment of being watched, though the artist's final thought was the noncommittal profile we have now. In fact reading is a very useful activity for *seeming* unaware of the rest of the world, but one is aware of watchers, especially persistent ones.[7] Thomas Rowlandson's reader is somewhat older and perhaps wiser—at least her book is bigger—and her gesture would seem to convey even more absorption in her book than is shown by Fragonard's reader. But the drawing is actually titled *A Young Lady Reading, Watched by a Young Man*, and the young lady can hardly be so absorbed in her book that she is unaware that she is in the lap of her main watcher.

Dante Gabriel Rossetti's 1855 watercolor *Paolo and Francesca* reminds us that reading led to adultery in the case of Paolo Malatesta and Francesca da Rimini. In Dante Alighieri's text, Francesca calls the book she

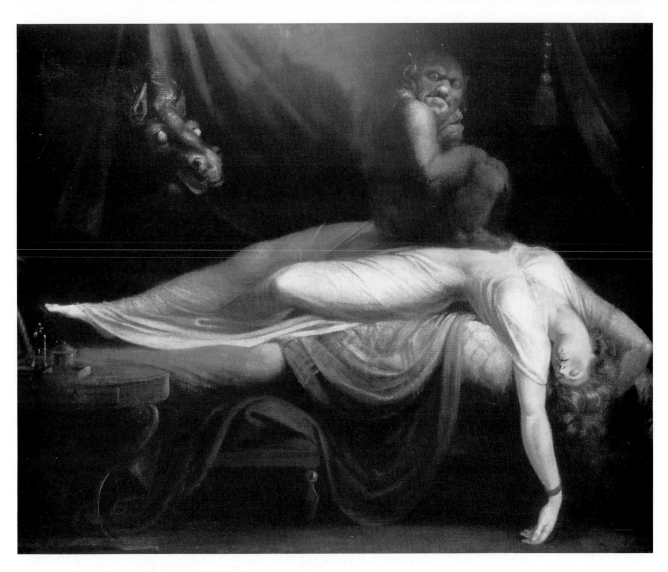

Henry Fuseli, The Nightmare (1781). Detroit Institute of Arts, Gift of Mr. and Mrs. Bert L. Smokler and Mr. and Mrs. Lawrence A. Fleischman

Sir Joshua Reynolds, The Death of Dido (1781). The Royal Collection © 1993 Her Majesty Queen Elizabeth II

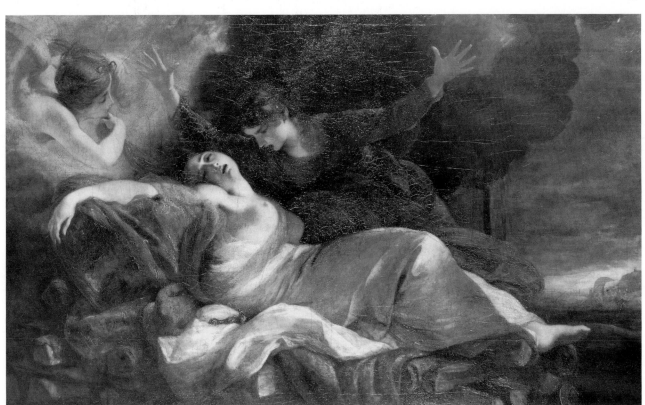

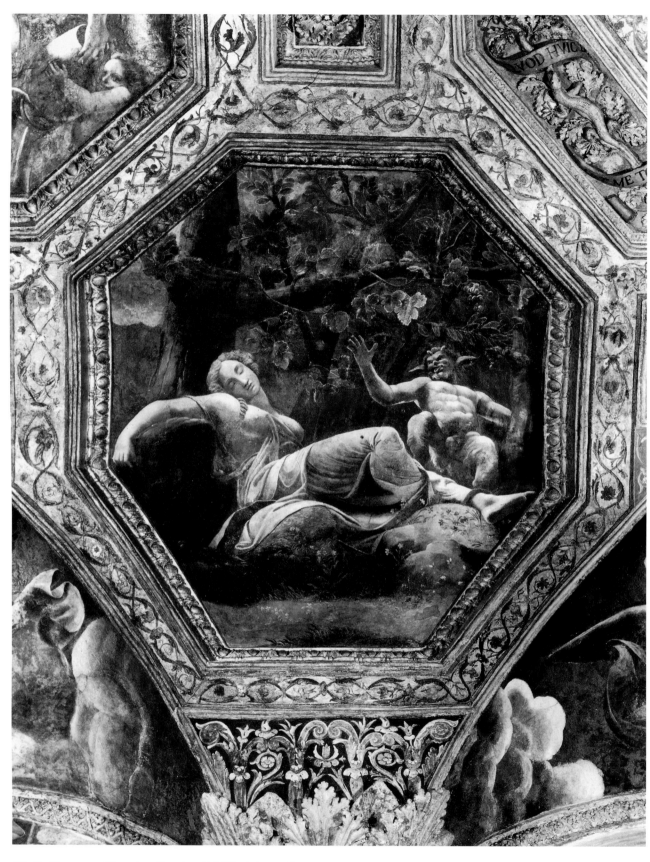

*Giulio Romano, Sleeping Psyche (1528). Museo Civico
di Palazzo Te, Mantua*

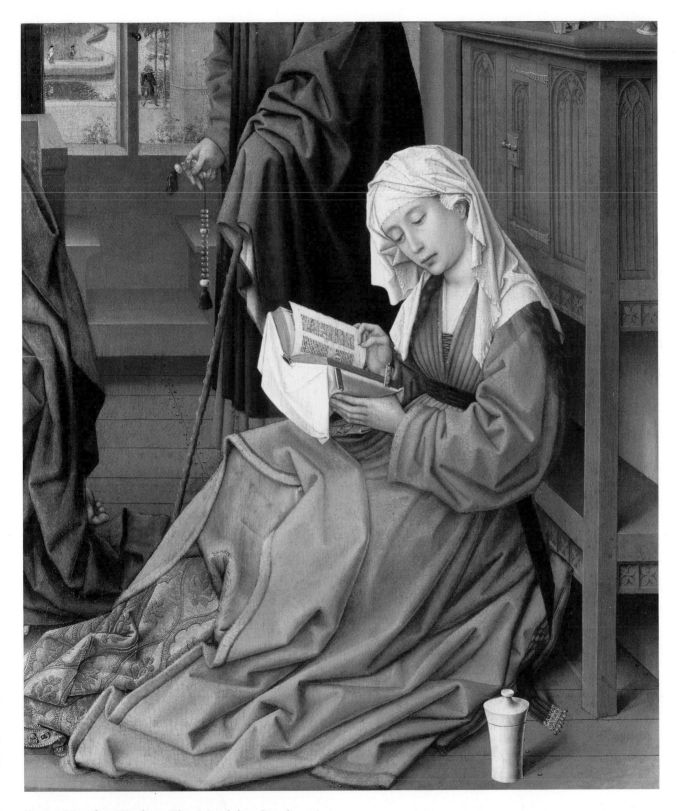

Rogier Van der Weyden, The Magdalen Reading (ca. 1450), National Gallery, London

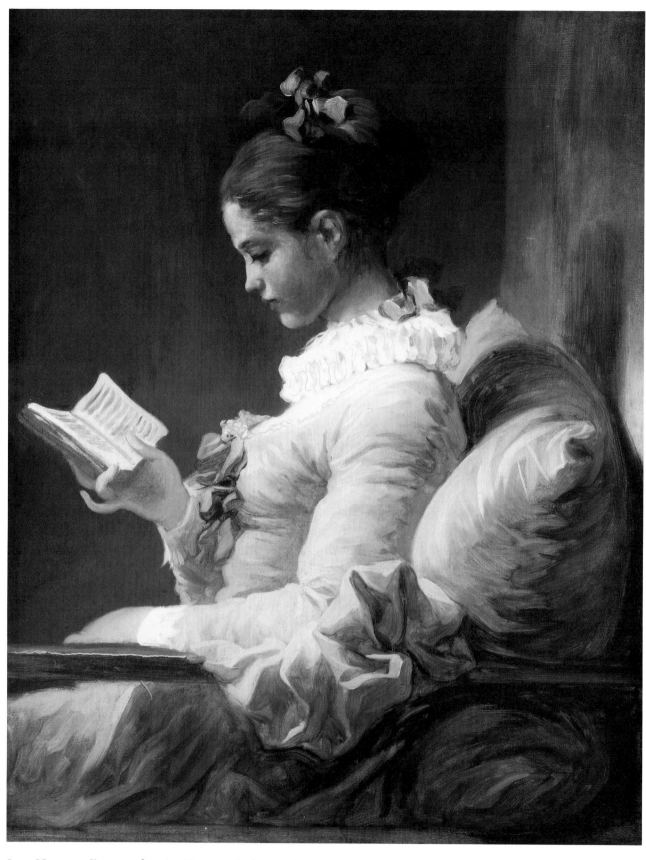

Jean-Honoré Fragonard, A Young Girl Reading
(1776), Gift of Mrs. Mellon Bruce in memory of her fa-
ther, Andrew W. Mellon, © 1993 National Gallery of
Art, Washington

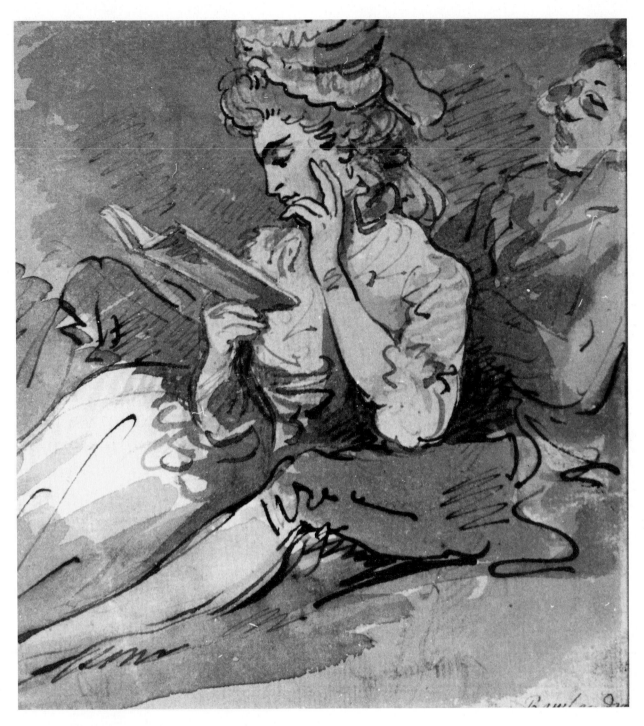

*Thomas Rowlandson, A Young Lady Reading,
Watched by a Young Man (1783–84), Collection of
Neil M. Fleishman, Photo courtesy of John Hayes*

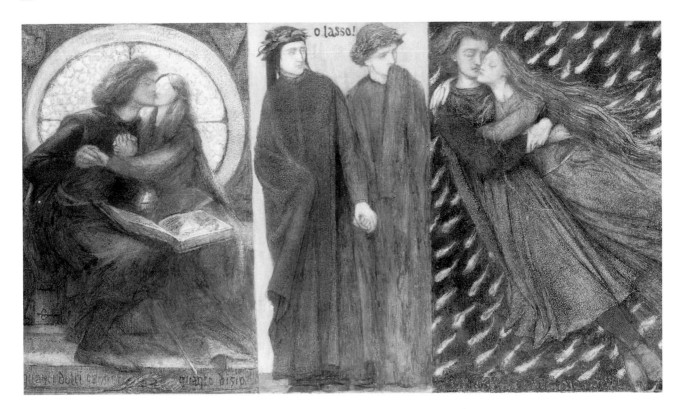

Dante Gabriel Rossetti, Paolo and Francesca *(1855),*
Tate Gallery, London

and Paolo were reading together (an account of the adultery of Lancelot and Guinevere) a pander. Dante's namesake Rossetti paints the whole little narrative, starting with the lovers reading, showing Dante's summoning of the lovers and concluding with the two spirits driven by the eternal, infernal wind painted as tongues of fire.

The erotic interest and the suggestion of rivalry I have been describing happen outside Egg's picture; the women within it remain demure and unengaged. The painting thus paradoxically manages to convey rivalry while also showing us a pair of women who take no interest in what goes on outside their little enclosed world and who seem to require nothing beyond themselves.

Containment, Self-Sufficiency, and the Mirror of Sisterhood

One of the painting's strongest impressions is that of completeness and self-containment. The two sisters seem absorbed in themselves, their separate pursuits, and each other; they ignore the spectacular landscape passing their windows. Susan Casteras asks whether the scenery might even be part of their sleeping or reading dreams: "is the scenery real or imagined by them?" She notes their containment as *self-created*, whatever the motive for its exclusions: "the pair has managed to create quite a snug 'portable parlor' to shield them from the dangers—and the beauty and the challenge—of the beckoning view."[8] The sisters are self-contained, indifferent not only to the landscape, but to our gaze.

Though they do not look at each other, the sisters face each other. Either woman, if she chooses to look up, will see first her own sister, her own reflection. The painting thus makes visual a metaphor about sisterhood: sisters are mirrors for each other. No woman sees in her sister an exact reflection of herself, even if her sister is a twin. But sisters look at living reflections of part of themselves when they see each other. Common parentage and common experience become visible as common features. Looking at Egg's painting lets us see sisterhood as a kind of relationship that can be exclusive, reflexive, self-regarding, and self-sufficient.

Sisters in History

The sisters of *The Travelling Companions* are located precisely in time and space. The landscape is identifiably European and the painting style identifiably English. And the picture is very self-consciously set in its place and time by costume. Dress is one of the painting's subjects that not only helps define the sisters' relationship but also locates them in class and space and time. The costumes here would enable a good historian to guess the picture's date within a year or two without referring to the external evidence of when it was painted. The twins' crinolined dresses and small round hats with their single feathers are like two locating lines in time; the fashions cross exactly in the early 1860s. Egg paints current fashion brilliantly, but he also reveals its amusing side: the little hats set against the enormous mass of dress fabric, the way the sisters' crinolines fill their compartment up to and above the level of the benches. *The Travelling Companions* marks the very peak of crinoline fashion, when crinolines are still worn only by women of the middle and upper classes.[9]

What has sisterhood to do with fashion? Sisterhood may seem a universal relation, but it is not exempt from the pressure of its time. Not only the way sisters dress but the way they choose to live or are able to live is governed by when and where they live. And moreover, sisterhood itself can be a fashion in art, as I discovered some time after my first encounter with Egg's picture.

At that first encounter what struck me was the way the painting seemed to describe sisterhood. Rather than telling a particular story—as one might well expect of a nineteenth-century painting in this realistic mode—*The Travelling Companions* conflates many sisters' stories. The sisters mirror each other, a mirroring that shows symmetry with difference. The sisters also mirror their world—deliberately, in those aspects of the picture that can all be generally labeled as "fashion:" clothes, hats, the design of the railway carriage, the depiction of a railway voyage at all, since a good deal of novelty still attached to this mode of travel scarcely thirty years after the first line opened in the north of England.[10] They mirror their world in inadvertent ways as well, in the choice of subject matter and the method of treatment that identifies the picture to all later eyes as mid-Victorian. Their pursuits of sleeping and reading can also hint at sexual rivalry or even moral divergence, but their quiet self-sufficiency and inward attitude belie the hint. As they reflect each other, they also reflect the condition of women in their time and place, in an enclosure that is both isolation and display.

THE CONTEXT OF UBIQUITOUS SISTERHOOD: SISTERS AS METAPHOR

When I first saw it I did not know that Egg's painting was part of a whole subgenre of art works dealing with sisters. In nineteenth-century English paintings and novels, sisters are almost everywhere. *Pride and Prejudice*, *The Heart of Midlothian*, *Little Dorrit*, *The Woman in White*, *Wives and Daughters*, and *Middlemarch*—arguably the best books of their authors—all concern sisters, and so do dozens of other novels published between 1800 and 1900. During the same period hundreds of paintings depict sisters. Neither the eighteenth nor the twentieth century shows any similar concentration of sisters in fiction and painting.

When I became aware of the extent of the subject in nineteenth-century arts, I wanted to know why there was such a concern with sisterhood in these arts during this particular century in England. I knew this question to be a more limited form of the question others were asking about the pervasiveness of women as subjects of painting and the novel. Susan Casteras considers the first part of the question, why "the central image in art" of the Victorian period was a woman, in *Images of Victorian Womanhood in English Art*, and finds the answer in a complex of reasons from visual appeal to recognition of or resistance to social change.[11]

Susan Morgan asks how it is that in an age and place where male hegemony is supposedly at its strongest, most nineteenth-century English novels are about women. Morgan argues in *Sisters in Time: Imagining Gender in Nineteenth-Century British Fiction* that the emergence of the woman as hero in nineteenth-century English novels is a shift to a feminine heroics and a part of the feminization of the novel, by which she means that certain qualities and beliefs traditionally labelled feminine are recognized to be more desirable than others that have been considered masculine.[12] For Morgan, this feminization affects male writers; in fact it begins in a significant way with Sir Walter Scott.

Certainly the nineteenth century in England is the century of women in the sense that for the first time women's issues are seriously talked about in public forums. The century begins with an improved climate for feminist ideas provided by the egalitarian spirit of revolutions on the continent and in the colonies. Through the century, property and divorce laws are reformed and women's franchise is seriously debated in Parliament. Women are not triumphant in their causes in nineteenth-century England, but the important causes are contested. For the union of women in this struggle in the "real" world, sisterhood is the usual metaphor. No steady progress from troubled to helpful relations between sisters can be mapped through the times. At the end of the century, though, many women of different backgrounds but like aspirations—nurses, suffragettes, the New Women of sport and work and politics—recognized the necessity of solidarity in the struggle for equality and called each other sisters.

METHOD OF THE BOOK

Applying Egg's Grammar of Sisterhood

I will use the "grammar of sisterhood" I have derived from Egg's picture to talk about sisterhood as it is depicted at various times immediately preceding and throughout the nineteenth century in Britain. Painters and novelists in this century recognized that literal sisterhood was a synecdoche for the relation of all women and that the depiction of sisterhood could effect change as well as reflect the *status quo*. The sister relation was used not only to examine and critique the situation of women in society but to attempt to model relations of everyone in society. Egg's twins, for example, are a way of depicting equality acceptably in a society that finds the idea difficult to embody in any other way—a society that may be said not to believe in equality. His women can have differences of interest and activity while their larger purposes—those of the metaphorical journey in which they are travelling companions—are shared. They can see their likeness when they look at each other, and the resemblance might extend beyond appearance to matters moral, social, and political. They have a self-sufficiency that denies their status is purely that of "relative creatures" whose whole being depends on men.[13]

Scope and Plan

In *Woman and the Demon* Nina Auerbach finds a "myth that was never quite formulated" that subversively turned the demonic woman in the Victorian demon/angel construction of woman into a figure of energy who would inherit the earth, triumphing over her sainted counterpart.[14] I have found in nineteenth-century British paintings and novels depicting sisters a persistent attempt to subvert another stereotypical construction of women: that which neatly divides all women into either whores or "respectable" women. This construction appears throughout the nineteenth century and is especially concentrated in the fiction of Dickens, whose families, if they contain a pair of sisters, seem to need for one sister to be sexually compromised while the other is as pure as Dickens's art can make her. But in many paintings and novels a female transformation of heroic myth opposes the "necessary whore" of this construction with an attempt to erase sexual difference between sisters. The agency of this erasure is a heroic rescue of one sister by the other. In both arts the subject of female rescue is resisted and contested.

In painting I found the evidence for the attempt at erasure of difference in pictures that make the sexually wayward woman and her respectable counterpart similar or identical in appearance, going part of the way toward suggesting their moral identity. The important female rescue picture does not get painted but is only approached by painters at mid-century, and we have to recover what the painting might have been by inference from the approaches to it. Part of the evidence is the otherwise puzzling ubiquity of twinned women in Victorian painting.

In novels the struggle to erase difference between women whose sexual experience differs starts early in the nineteenth century. I have begun my review of it by dipping back into the eighteenth century and the novels of Lennox, West, Edgeworth, and Burney that use sisterhood in plot-significant ways. Difference and likeness among sisters are first fully exploited by Austen and Ferrier; the heroic rescue of one sister by another after a sexual transgression occurs first in Scott's *The Heart of Midlothian*—although Scott ignores or plays down the ramifications of this rescue. In Dickens and Collins I found a retrograde movement in the trend elsewhere apparent toward erasure of women's sexual difference. The Dickens works I examine force into each family the prostitute/pure woman coupling;

Collins makes use of sensational displacements of the respectable woman by a counterpart stained in some way—if not by prostitution then by the taint of illegitimacy. In both these writers, sexual difference between women (in a literal or figurative sisterly relation) is highlighted rather than effaced. In the last books I treat, sisters novels of Meredith, Gaskell, and Eliot, there are rescues performed by sisters and the transformation of male characters into figurative sisters of the protagonists. In these authors the female rescues radically challenge gender distinctions while engaging related issues of class distinctions, health, and political reform. In Eliot there is also a characteristic qualification that gender stereotype reform, like political reform, is hedged with compromise and other limits.

Limitations

In the following chapters I look at paintings and novels made within the British Isles during the nineteenth century. I treat works in which literal sisters are the subjects, although this distinction is harder to apply to paintings than to novels, I have admitted some exceptions, and in any case the discussion rapidly opens out to figurative "sisterhood."

Limiting one's attention to a single subject in art is likely to distort vision. Like holding a candle up to a pier-glass "minutely and multitudinously scratched in all directions," the artificial center we have provided may make everything seem to circle it; though "the scratches are going everywhere impartially . . . your candle . . . produces the flattering illusion of a concentric arrangement" (*Middlemarch*, chapter XXVII). The effect is an emblem not only of egoism but also of narrow critical focus. I know that looking only at sisters can make sisters seem exaggeratedly important. And although I believe the subject is a sufficient condition for the artistic treatment of the important issues facing women in the nineteenth century, I do not argue that it is a necessary condition. There are many books and pictures featuring sisters during this period, but there are many more without sisters or in which sisters figure insignificantly. And comprehensiveness can hardly be argued for a book dealing with nineteenth-century novels that leaves out the Brontës, Thackeray, Trollope, and Hardy.

Of course the category of sister-works may be indefinitely enlarged. If any women contrasted or paralleled in looks or temperaments or fortunes can be termed sisters, then one may include Hetty Sorrel and Dinah Morris, Maggie Tulliver and Lucy Deane, Jane Eyre and Bertha Rochester, Lucy Snowe and Ginevra Fanshawe, Shirley Keeldar and Caroline Helstone, Becky Sharp and Amelia Sedley, Beatrix and Lady Castlewood, Eustacia Vye and Thomasin Yeobright, Arabella Donn and Sue Bridehead, and so on and so on. I have tried to avoid this indefinite enlargement by a loose restriction to works where the relationships begin with an actual sisterhood rather than a figurative one. The special relation of sisterhood always represents the larger one of womanhood, but not necessarily vice versa.

2

Demythologizing Reynolds:
Painting Modern-Life Sisters

Hundreds of nineteenth-century British paintings depict sisters. The subject crosses the categories of portraits, history, genre, and classical-subject painting. The images in these sisters pictures seem at times to reach the canvas unmediated by myth, sacred story, or modern fiction. Wilson Steer's *Girls Running: Walberswick Pier* (1895), for example, makes us believe it is merely a visual impression that owes nothing to a composing narrative. But few pictures are without debts to previous art in narrative or composition or single motives. Aside from those indebted to sacred iconography, most of the conventions for depicting sisters derive from classical or Renaissance models, paintings and statues of female communion such as the three Graces, the Muses, and the Fates, or of rivalry such as the Judgment of Paris and the Choice of Hercules. The English artist who had the most to teach later painters about adaptation of classical models was Sir Joshua Reynolds, and by looking at what happens to Reynolds's classical schemata in later painting we can see the derivation and the range of nineteenth-century sisters paintings.

Reynolds lays out the classical program in just four pictures of sisters: *Three Ladies Adorning a Term of Hymen* (1773), *The Ladies Waldegrave* (1781), *Garrick between Tragedy and Comedy* (1761), and *The Death of Dido* (1781). The first two of these pictures are portraits of sisters, young contemporaries of Reynolds. In the painting of Garrick, Reynolds uses mythological sisters, two of the nine daughters of Mnemosyne and Zeus. Thalia and Melpomene, the muses of Comedy and Tragedy, tug at Garrick in a composition derived from the Judgment of Hercules. In the last of these pictures the subject comes from Virgil's description of Dido's death and her discovery by her sister Anna. What looks at first like a fairly narrow range of reference to sisters in literature and mythology—the Graces, Fates, Muses, and the Carthaginian Queen and her sibling—turns out in fact to provide models for the whole nineteenth-century subgenre of sisters paintings.

It was not merely that nineteenth-century painters imitated Reynolds. They found in his painting ways to apply classical reference to what they were doing, and they also found the freedom to do it wittily. Perhaps most significantly, Reynolds showed them how painters could appropriate the past for their own uses. For Reynolds, classical and Renaissance works provided visual motives and compositional models. But more importantly, in his painting the classical behind the contemporary gave the cachet of history painting to what was considered before Reynolds the lower endeavor of portraiture. Reynolds exploited the prestige-making aspect of classical reference while still being playful with his allusions and even employing the mock-heroic. Nineteenth-century painters no longer had to justify their work and try to "elevate" it as Reynolds did. They did not have to invoke Michelangelo; they could invoke Reynolds for a pose or a grouping, and they had the freedom to *re-*

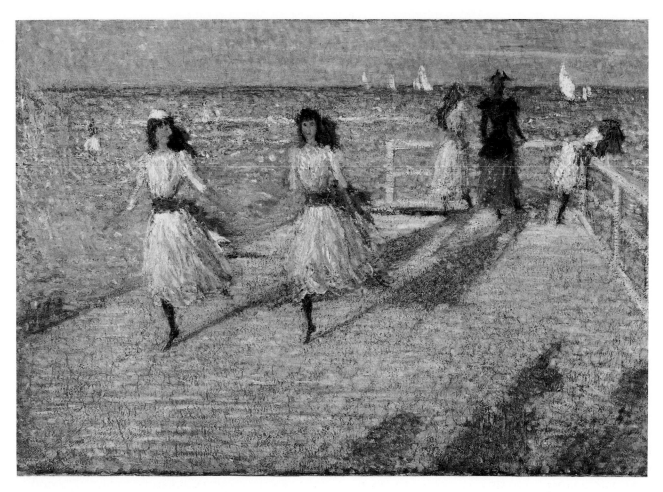

Philip Wilson Steer, Girls Running: Walberswick Pier
(1895), Tate Gallery, London

frain from allusion if they wished. And from Reynolds's sisters portraits they learned that classical allusion could be subtly used not only to create attractive poses but even to portray the relative power or powerlessness of the sitters. From Reynolds's example they could see how the ordinary assumptions of portraiture could be interrogated and the picture used to show a relationship among women rather than just two or three attractive faces.

Reynolds knew the use of classical motives and poses was a means of raising the art of painting to the prestige enjoyed in his era by poetry and history. Victorian painters use contemporary history as a means of bringing another kind of seriousness to their art. In each case what the painters appropriate to ennoble their art is what has their patrons' current sanction as serious and "real." For Reynolds's patrons it was the timeless "real" of the antique world and the Renaissance masters; for the Victorian painters' patrons it

was the material reality of streets, sitting rooms, and factories. The more diverse the sister subjects "demythologized" by artists in the century after he worked, the more impressive becomes Reynolds's accomplishment in suggesting the schemata with which they began.

DOMESTICATING THE GRACES AND THE FATES

Source-searching for one of Reynolds's sisters portraits, *Three Ladies Adorning a Term of Hymen,* has been going on since Reynolds's disgruntled rival Nathaniel Hone accused Reynolds of plagiarism in 1775.[1] Hone found sources for the various poses of the Montgomery sisters and for the whole composition of Reynolds's painting in works by Romanelli and Pietro da Cortona.[2] In our century Ernst Gombrich identi-

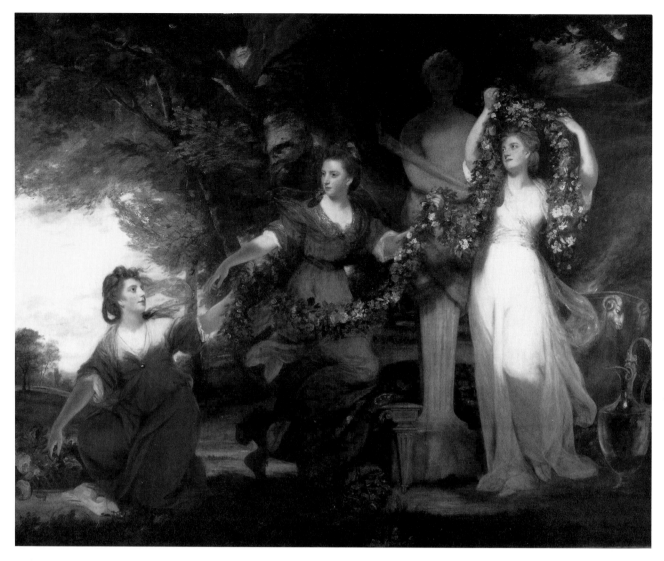

Sir Joshua Reynolds, Three Ladies Adorning a Term of
Hymen *(1773), Tate Gallery, London*

fied Poussin as the source for the Hymen rites and also
argued convincingly that Reynolds was joining several
different iconographic strains in this picture. By allud-
ing to Rubens's *Nature attired by the Three Graces,* he
made the picture more personally allusive (as well as
publicly complimentary), since it was natural before
the picture was painted, and inevitable afterwards,
that the sisters should be referred to as the "three Irish
Graces."[3]

As Gombrich hinted, the idea of the Graces may
help to take some of the possibly indecorous sugges-
tion from the activity in which the Montgomery sis-
ters are engaged, which is, after all, a fertility rite
with a carved figure whose most notable feature is usu-
ally an erect phallus. Here "offerings nicely plac'd /

But hide Priapus to the waist" as Dante Gabriel Ros-
setti describes another priapic rite in "Jenny" (lines
368–69). Reynolds's ability to contain and defuse the
potentially indecorous is not the least of his consider-
able powers in using the ancient to express the mod-
ern. But at the same time as he defuses, he wants a
squib of indecorousness left there, too.

Reynolds's allusion to the Fates in *The Ladies Wal-
degrave* has the same partly tamed potential for inde-
corousness. Horace Walpole commissioned this
picture of his nieces, the three Ladies Waldegrave,
and before it was finished he commented on it, refer-
ring to Reynolds's earlier triple portrait of the Mont-
gomery sisters: "I rather wished to have them [the
Ladies Waldegrave] drawn like the Graces adorning a

bust of the Duchess as the Magna Mater—but my ideas are not adopted." When the picture was completed, though, Walpole liked it, only later finding things to criticize. His first letter about the picture says in passing that the sisters "are embroidering and winding silk," but he never indicates, flippantly or otherwise, the subject that would reasonably be suggested by these activities: not the Graces but the Fates.[4]

Aside from the question of decorum, the Fates are, after all, a legitimate image to be conjured up in thinking about three sisters: like the Graces, these three are also the daughters of Zeus, though their mother was Themis, the Titan goddess of law, rather than Eurynome, the sea nymph who was the Graces' mother. But where the Graces represent joy and concord, the Fates are the ominous controllers of human destiny, one of whom (Clotho) spins the thread of life, another (Lachesis) measures its length, and the third (Atropos) cuts it. Reynolds appropriates the associations with boldness and humor. He domesticates his Fates: Lady Charlotte holds a skein of silk rather than spinning the thread, Lady Elizabeth winds the thread onto a card instead of measuring its length, and young Lady Anna, far from being "the blind *Fury* with th'abhorred shears" who, in Milton's phrase,

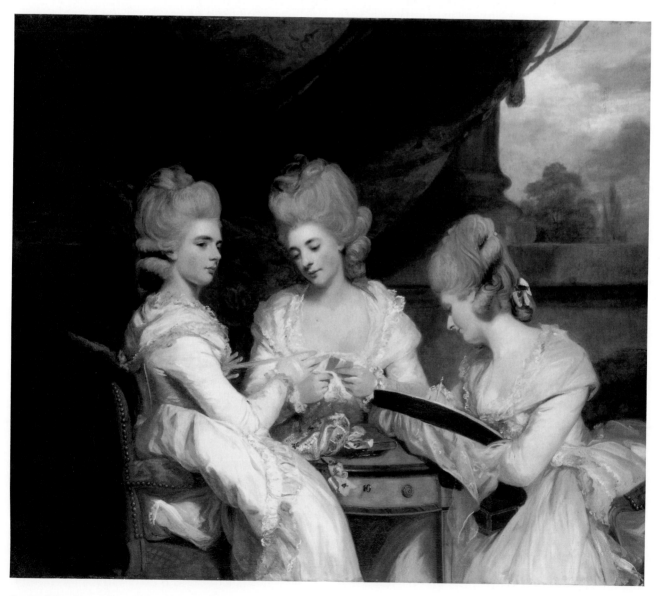

Sir Joshua Reynolds, The Ladies Waldegrave *(1781),*
National Gallery of Scotland, Edinburgh

"slits the thin-spun life" (*Lycidas*, lines 75–76), is the one who carefully weaves this strand into the netting on her frame, an embroidery tambour whose limits, like the shape of the table top or the circle of women surrounding it, can suggest the world or merely *their* little circle. It is for their world and their little circle that they seem to labor: the tulle into which the white silk thread is being worked might become the very sort of fichu the sisters each wear now—or it might become a wedding veil.

Where the Montgomery sisters perform a fertility rite in honor of just-celebrated marriages and one shortly to come, *The Ladies Waldegrave* shows us a view of young women at an earlier stage in their societal destiny (for they are fated even as they may manipulate the fate of others). The picture shows at once the constraints and the power of their situation. The sisters are confined within strict conventions of dress and of manners. The uniform they wear suggests the family constraint and the stereotyping effect of being unmarried daughters so close in age. They are expected to sit, be beautiful, and do their piece work. Yet the reference to the Fates shows their power. They are titled ladies of fortune and beauty who live in a time when choice is beginning to matter. They have some control over the men who will court them; they may at this moment have as much control over their own lives as they will ever exercise. The threads in their hands may serve to make only a small part of their world's web, but they do have those threads in their hands.

THE INFLUENCE OF REYNOLDS'S SISTER PORTRAITS

Millais, Sargent, and the Portrait Tradition

One picture influenced by *The Ladies Waldegrave* and in competition with it is Sir John Everett Millais's *Hearts Are Trumps* (1872). Millais's son tells us his father was piqued by a reviewer who "asserted that, successful as he was in certain branches of his art, he was quite incapable of making such a picture of three beautiful women together in the dress of the period as Sir Joshua Reynolds had produced in his famous portrait of 'The Ladies Waldegrave.'"[5] The result was *Hearts Are Trumps*. Here a spectator is implied in the gaze of the Armstrong sister on the right, Mary, and

in the fourth or "dummy" hand facing the viewer; this hand will be played for the absent fourth by the other whist players. Also made explicit are the stakes being played for—hearts—and a rivalry not at all obvious in the Waldegrave portrait. The circumstances, as well as the directness and singularity of the gaze, here point to *one* spectator of the game, to whom the sister on the right is showing her hand. The female spectator is constructed as a confidante and the sisters are excluded from the confidence by the nature of the game. A male spectator is constructed as the object of rivalry among the sisters. The mythological element is subtracted, or at least transformed, while there is a stricter definition of audience than in Reynolds.

Millais's *Autumn Leaves* as surely but less obviously derives from Reynolds's *Three Ladies Adorning a Term of Hymen*. In 1856 Millais painted his wife's two younger sisters in the garden of his house, Annat Lodge, in Perthshire; the two smaller girls were painted from local children his wife found to serve as models. Ruskin declared the picture "much the most poetical work the painter has yet conceived; and also, as far as I know, the first instance existing of a perfectly painted twilight."[6] The subject—piling leaves to be burned—Millais treats as an elegiac rather than a joyful celebratory rite: *Autumn Leaves* is not about marriage but about mourning, and there is at least a suggestion that the loss of a parent might be the cause of the mourning—that the season is a reaction to the human events (an expression of the pathetic fallacy) rather than vice versa. But the loss of innocence and the awareness of mortality are the real themes as in Gerard Manley Hopkins's "Spring and Fall: to a Young Child," to which the picture is frequently compared, for example by Timothy Hilton. According to Malcolm Warner, Millais's contemporaries did not always realize the seriousness of the themes of *Autumn Leaves*, but when they did the artist was grateful, writing to F. G. Stephens, for example, to thank him for his thoughtful review of the picture.[7]

The youngest child here holds an apple and stares at the dead leaves in dumb acknowledgment of nature's autumnal paradox of dying in fruition. The leaves have a transient beauty, many-colored though different colors from the flowers of spring, against the plain, possibly mourning dresses of the two older girls. The pile of leaves has a kind of monumental presence in the Millais picture and is placed in the foreground, where the term of Hymen is pushed back into the shadows in the Reynolds. The connection between

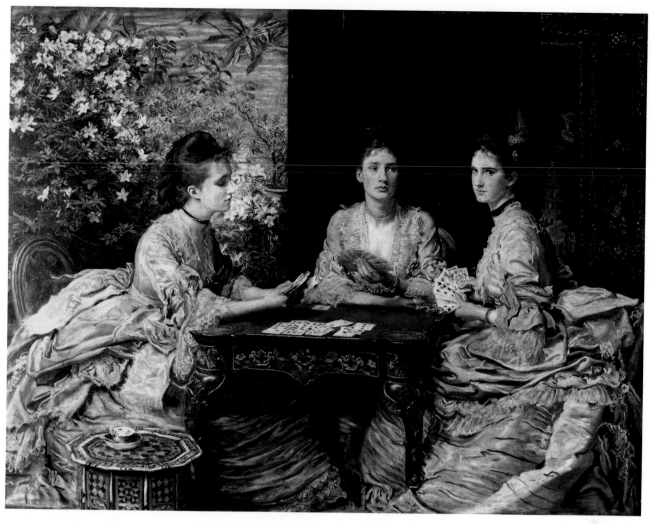

Sir John Everett Millais, Hearts Are Trumps *(1872),*
Tate Gallery, London

the pictures, in sum, is one of almost complete oppo-
sition of terms, though they both show us an "adorn-
ment" of sorts, by attractive sisters, full-length active
figures with highlighted faces in a landscape back-
ground. Mourning and elegy replace marriage and
joyful celebration, fruition replaces fertility—though
in fact the sisters are younger—and a very transitory
leaf "monument" to nature replaces the marble statue
to the cultural form of marriage.

The Millais paintings show us two pictorial deriva-
tives of Reynolds's influential pictures of the Mont-
gomery and Waldegrave sisters. But Reynolds's
paintings are in the background of many later British
portraits of sisters, whether more or less thematized.
They are behind Rowlandson's drawings and water-
colors of Georgiana and Henrietta Spencer, drawn
after their celebrated marriages, when they were the

Duchess of Devonshire and Lady Bessborough. Row-
landson depicts them singing together (1790—Yale
Center for British Art), listening to a singer and being
themselves the objects of much attention at Vauxhall
Gardens in 1784 (Victoria and Albert Museum), and,
in 1791, at a gaming table together at Devonshire
House. There is always the combination of play and
sexual charge that Reynolds captures in the Walde-
grave picture. The likeness of the two sisters is accen-
tuated by similar or identical costumes in these works
and by their common pursuits of fashionable pleasure
in venues where they can be seen to advantage. Row-
landson draws the two in white or light-colored cos-
tumes with hair powdered as in the Waldegrave
portrait, but loose rather than tightly wrapped as in
that picture.

After the turn of the century there is a time gap be-

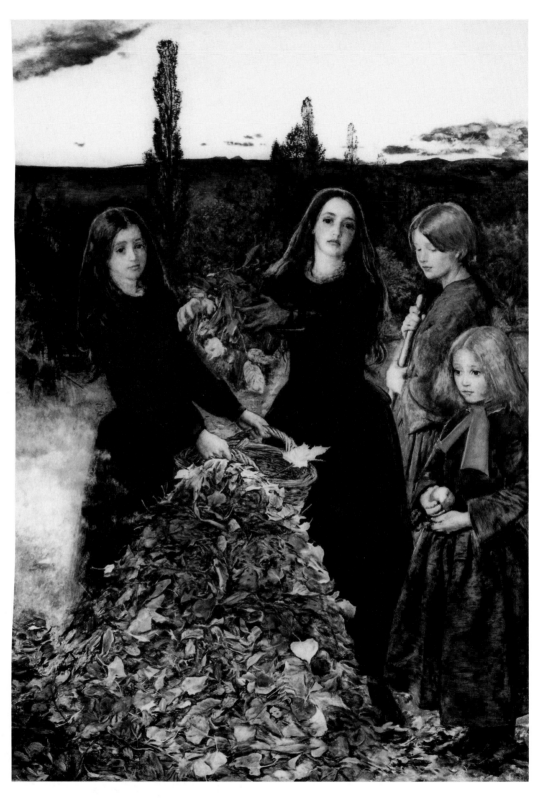

Sir John Everett Millais, Autumn Leaves (1856), Manchester City Art Galleries

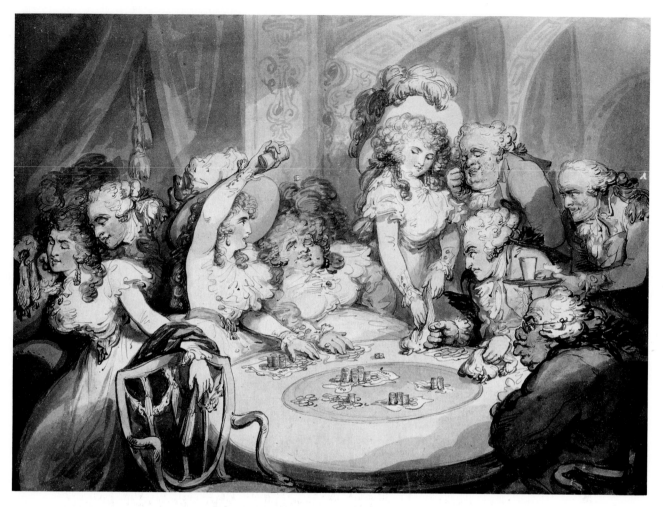

Thomas Rowlandson, A Gaming Table at Devonshire
House *(1791),* Metropolitan Museum of Art, New York

fore other artists take up the subject of sisters or sister-
hood again. Lawrence, though he occasionally paints
very young sisters—Emily and Harriet Lamb (1792—
Cowper Collection, Panshanger) or Emily and Laura
Calmady (1824—Metropolitan Museum, New
York)—does not paint sisters older than about twelve
years. Nor are sisters in the repertoire of Constable or
Turner. For the contemporaries of Wordsworth, the
sisterly portrait and sisters-as-genre painting lack the
drama John Martin wanted as well as the anecdotal
appeal and variety Wilkie sought in modern-life sub-
jects. Etty was busy with subjects "of a voluptuous
character," as the Redgraves put it,[8] largely nudes jus-
tified by classical and biblical stories. Of this genera-
tion only William Mulready has an example of the
"sisterhood" motif, and it is late in his career, in 1841
(see below).

The Reynolds pictures make it difficult to look at

any portrait of three sisters without seeing some re-
flection of the Waldegraves or the Montgomeries.
William Powell Frith shows the influence of both pic-
tures in his 1872 *The Fair Toxophilites,* where he inte-
grates the full-length view and the activity of the
Montgomery sisters with the romantic thematic sug-
gestions of the Waldegrave portrait, depicting his
three daughters in a painting that he first called *En-
glish Archers, 19th Century.*[9] Less thematized examples
also recall Reynolds. One is an 1883 royal portrait by
Sydney Prior Hall, *The Daughters of Edward VII and
Queen Alexandra.* The three daughters are dressed in
identical frocks, all with pearl necklaces and red
hair-ribbons, against the background of an oriental
parasol. The youngest daughter, Maud Charlotte
(fourteen years old), is in the center. The eldest, Lou-
ise Victoria (sixteen), is on the right; Victoria Alex-
andra (fifteen) is on the left. Another example from

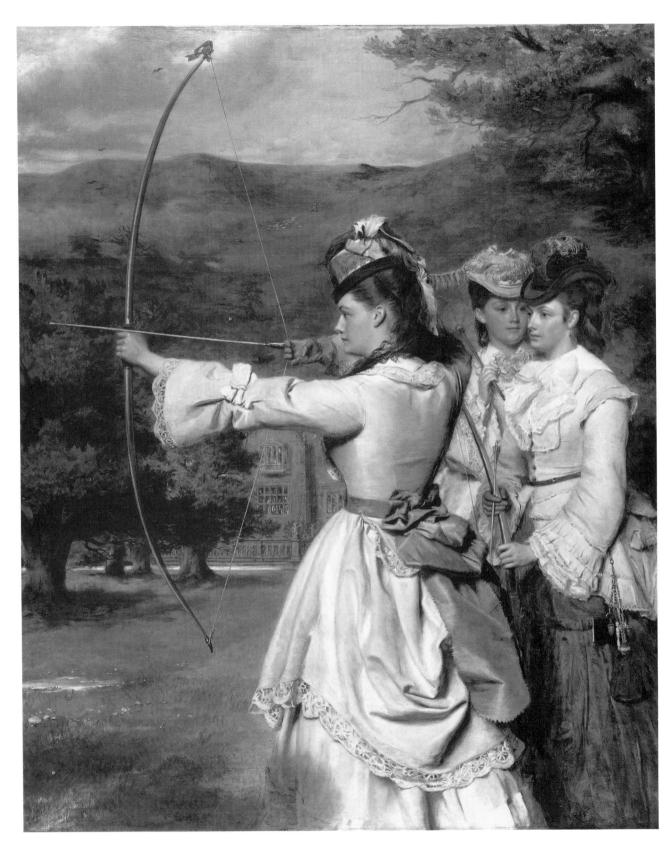

*William Powell Frith, The Fair Toxophilites (1872),
Royal Albert Memorial Museum, Exeter*

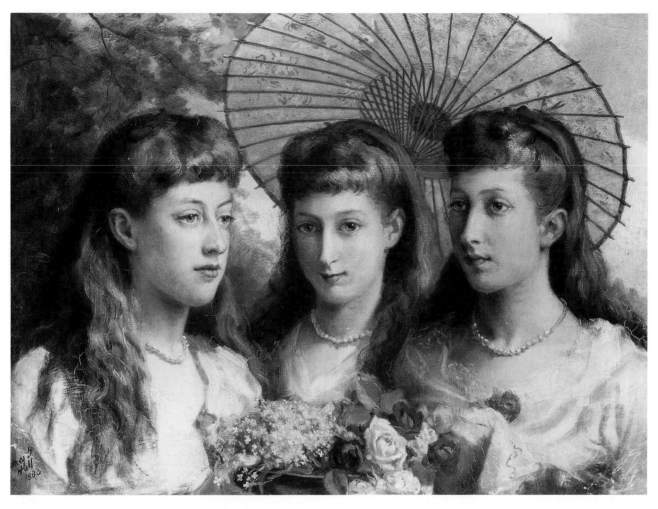

Sydney Prior Hall, The Daughters of Edward VII and Queen Alexandra *(1883), National Portrait Gallery, London*

just a year later is perhaps the most brilliantly "informal" of nineteenth-century portraits, John Singer Sargent's *The Misses Vickers.* Here, as in the Montgomery picture, the sisters are not twinned in dress, but carefully and formally arranged. Together in a large chair reading sit the blonde and the brunette, Florence and Mabel Vickers, dressed in white and dark dresses, while slightly apart and dressed in a combination of dark and light sits Clara, the sister whose coloring mediates between that of the others. Sargent's attention to the formal is offset by the informality of the teatime setting and the dramatic downward angle of the view of the seated sisters, as if a spectator has surprised them by opening a door and stepping in to stand above them. The gaze is as carefully studied as the other arrangements. Only the sister on the right meets the spectator's eye; the one in

the middle looks demurely downward at the book that had been an object of attention but now seems merely idly flipped. The third sister looks out of the picture to the right, inviting our speculation about her glance— does it indicate a state of mind detached from the immediate social situation, or is there another implied spectator?

Sargent is as fascinated as Millais with what Reynolds has done in the Montgomery and Waldegrave pictures, and the influence keeps showing up for another twenty years, into the new century. Examples are the 1899 *The Wyndham Sisters: Lady Elcho, Mrs. Adeane, and Mrs. Tennant,* a matronly trio modeled on *The Ladies Waldegrave,* and *The Acheson Sisters* (1902), a not-very-inspired imitation of the *Ladies Adorning a Term.*

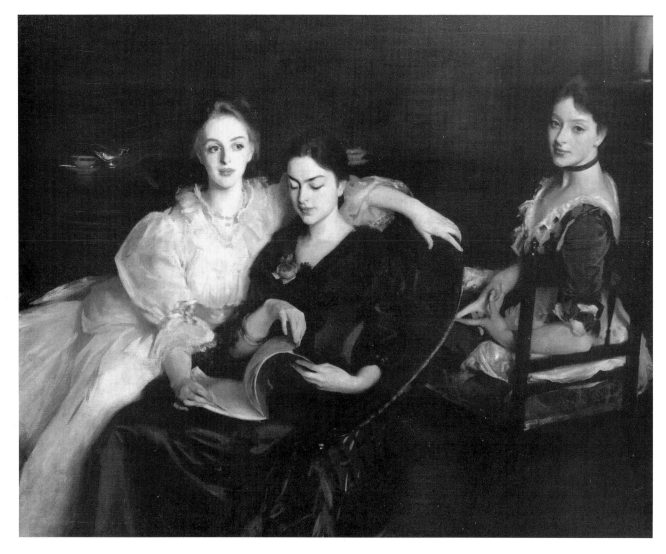

John Singer Sargent, The Misses Vickers *(1884), Sheffield City Art Galleries*

Sisters as Genre

In addition to the effect Reynolds's Montgomery and Waldegrave pictures had on the treatment of actual portraits, their influence may be seen in the way they help create a nineteenth-century invention: pictures of sisters treated for the first time as a separate genre.

Beginning in the 1840s, English artists begin to produce a number of pictures called merely *The Sisters.* The first may be Margaret Carpenter's 1839 painting now in the Victoria and Albert Museum; there are examples by Sir Charles Eastlake, Frank Stone, Charles Baxter, and others. There may be a whiff of theme in the pictures: Eastlake's 1841 exam-ple has the two women sketching together. Sometimes a slight or more distinct foreign flavor is added. These pictures are not painted *for* the sitters but for reproduction in the "Keepsake" magazines and books and for sale as genre pieces. Sir Charles Eastlake's 1841 picture of two women—a Mrs. Ker and her sister, Harriet Ludlow Clarke, sketching from a balcony overlooking a garden—was so popular that Eastlake made and sold four oil copies over the next eight years, in addition to a drawing of the subject for the Duke of Northumberland.[10] An 1844 copy was made for Prince Albert, who gave it to Victoria on her birthday that year. This version was engraved and published in the June, 1859 *Art Journal,* whose commentator remarked on the "Italianised" figures of the

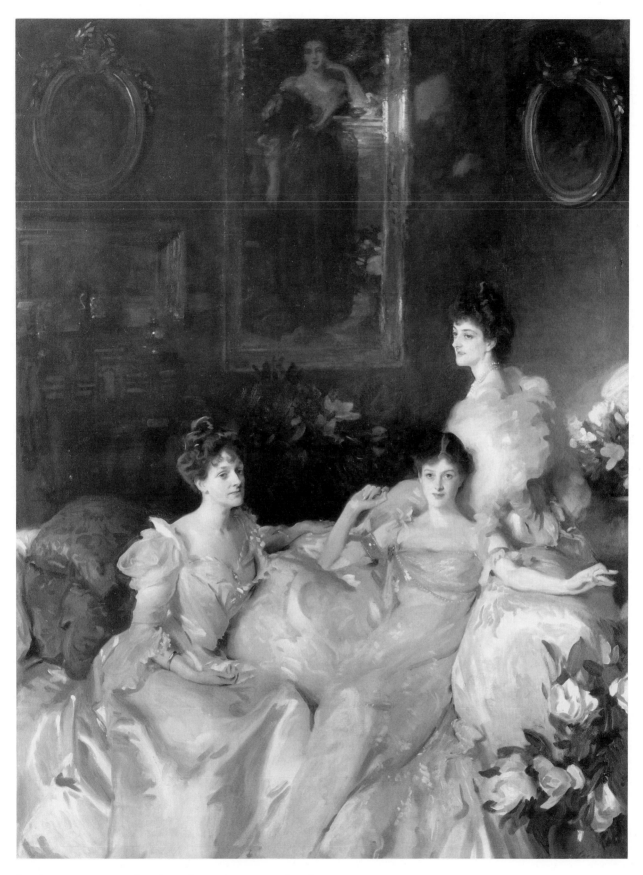

John Singer Sargent, The Wyndham Sisters: Lady El-
cho, Mrs. Adeane, and Mrs. Tennant *(1899), Metro-
politan Museum of Art, New York*

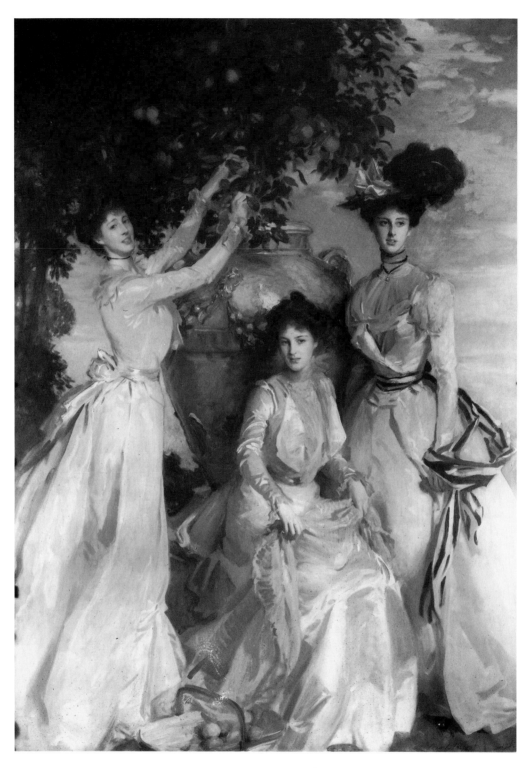

John Singer Sargent, The Acheson Sisters *(1902), Dev-
onshire Collection, Reproduced by permission of the
Chatsworth Settlement Trustees*

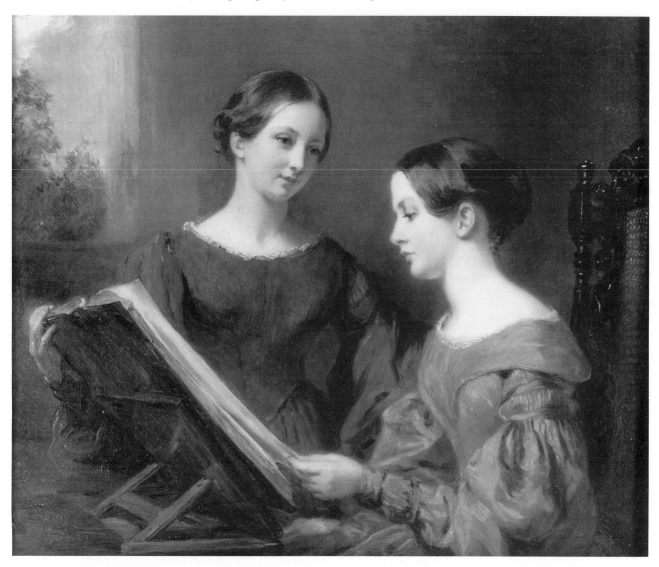

Margaret Carpenter, The Sisters *(1839), Courtesy of the Board of Trustees, Victoria and Albert Museum, London*

women. From the same period are Charles Baxter's tondo *The Sisters* (1845) in the Victoria and Albert Museum and an example by Frank Stone that shows a fair and a dark sister in a loose embrace in a garden scene. From a little later (1854) is John Phillip's *Gypsy Sisters of Seville,* where the sisters are posed almost exactly as in Stone's picture, but with the addition of foreign costume and the frank acknowledgment of a spectator's presence by their glances.

REYNOLDS AND RIVALS

Reynolds's playfulness in classical allusion is again evident in a painting that does much to inspire pic-

tures of female rivals during the next century, *Garrick between Tragedy and Comedy.* Horace Walpole gives us a contemporary reaction:

Reynolds has drawn a large picture of three figures to the knees, the thought taken by Garrick from the judgment of Hercules. It represents Garrick between Tragedy and Comedy. The former exhorts him to follow her exalted vocation, but comedy drags him away, and he seems to yield willingly, though endeavouring to excuse himself, and pleading that he is forced. Tragedy is a good antique figure, but wants more dignity in the expression of her face. Comedy is a beautiful and winning girl—but Garrick's face is distorted, and burlesque.[11]

Reynolds characteristically transforms his source: Garrick is not Hercules, and Hercules is not going to

Sir Charles Eastlake, The Sisters (1844), *The Royal
Collection* © 1993 Her Majesty Queen Elizabeth II

suffer in the comparison. Moreover Garrick makes
the wrong, at least the easier, choice here, if we ac-
cept Walpole's reading that he *has* chosen Comedy.
Hercules' choice was between Pleasure and Virtue,
and he chose Virtue. A moral opposition has turned
into an aesthetic preference. Such tension and slight
question about the appropriateness of the allusion,
from the point of view of strict decorum, are charac-
teristics of the way we have seen Reynolds use allusion
in the Montgomery and Waldegrave pictures. This
peculiar interrogation of the theme's applicability is a
Reynolds signature and has its effect on later painters.

Reynolds differentiates the contestants for Garrick
by coloring, height, seriousness, clothing, and style:
Tragedy is painted in the style of Reni and Comedy in
that of Correggio.[12] Garrick's preference shows partly

John Phillip, Gypsy Sisters of Seville (1854), Mersey-side County Art Galleries

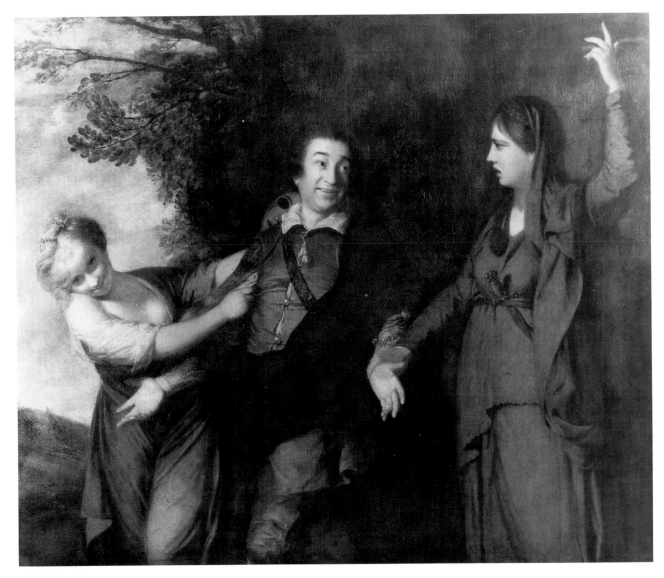

Sir Joshua Reynolds, Garrick between Tragedy and
Comedy *(1761), Private Collection*

from the inclination of his body toward Comedy but
also in his apologetic expression: "endeavouring to
excuse himself," Garrick smiles. Accustomed as we
are to the very modern practice of photographs with
smiling faces, we find with some surprise that a smile
in a portrait might be considered indecorous; this is
surely the meaning of Walpole's reaction that "Gar-
rick's face is distorted, and burlesque." Comedy is
the genre.

Garrick between Comedy and Tragedy contributes to
a long line of rivals pictures starting in Rowlandson's
time. Typically these are three-figure compositions in
which two women or girls contest for the affections of
a man or boy. Usually he has already indicated his

choice, and the reaction of the unchosen rival is jeal-
ous rage or pain. These pictures are not allegories: the
contest never concerns anything beyond love, though
vanity may be an issue. The rival women are not nec-
essarily sisters, though they can always be read as
such.

Rowlandson's 1803 watercolor *Jealousy: The Rivals*
shows a young woman at a keyboard instrument, fa-
vored by the attentions of two officers—one young
and handsome—while her sister frets in jealousy over
her sewing at a nearby table and brandishes her scis-
sors threateningly. In Philip Hermogenes Calderon's
Broken Vows (1856), the young man has apparently
changed his affections from the dark-haired beauty on

the near side of the ivy-covered wall to the fair-haired beauty to whom he is just glimpsed talking through the gate. In John Calcott Horsley's *Showing a Preference* (1860—Sir David Scott), both ladies are dark-haired, and the contested male is showing his preference for the hatless one (there seems little else to choose between them, as in most of these pictures). In the first painting of William Maw Egley's 1861 diptych, *Just As the Twig Is Bent*, a young boy playing at soldier with toy sword and rifle has the full attention of a blonde young girl while her dark-haired sister watches from her reading desk unhappily. In the second picture, *The Tree's Inclined*, the boy, grown up now and an army officer, shows his attentions (by fanning her with his hat) to the same, now grown sister, while the other sister, reflected in a convex mirror

above the pair's heads, sulkily watches from her seat at a piano. Haynes King's 1874 rivalry scene is a country cottage, where a young workman talks to one sister—who very uncoyly shows her pleasure by her broad smile and relaxed hands-behind-her-head slouch—while another watches from a corner of the room. The picture is called *Jealousy and Flirtation*.

The best pictures of this kind are those in which the artist interrogates the genre as Reynolds does. Augustus Egg has an early picture (1845) that was in Evelyn Waugh's collection, called *A Teasing Riddle* and showing two sisters, apparently twins, in identical dress, with a puzzled young villager outside a country cottage doorway. The young woman who is standing shushes her seated sister, who holds a book in one hand and looks up mischievously and expectantly at

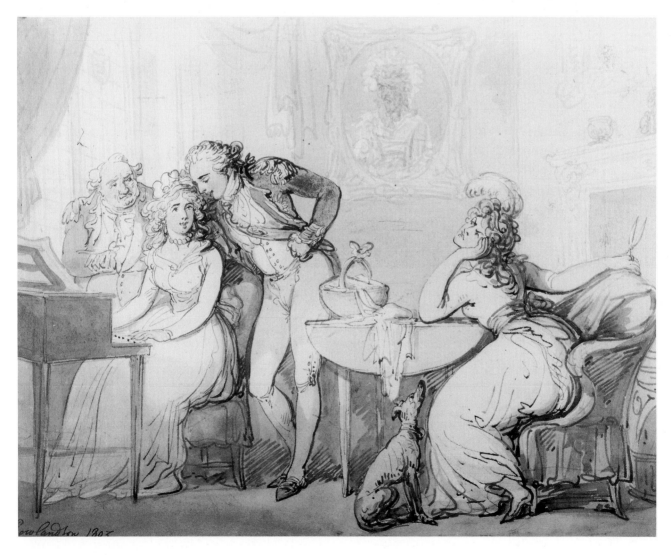

Thomas Rowlandson, Jealousy: The Rivals *(1803),*
Boston Public Library

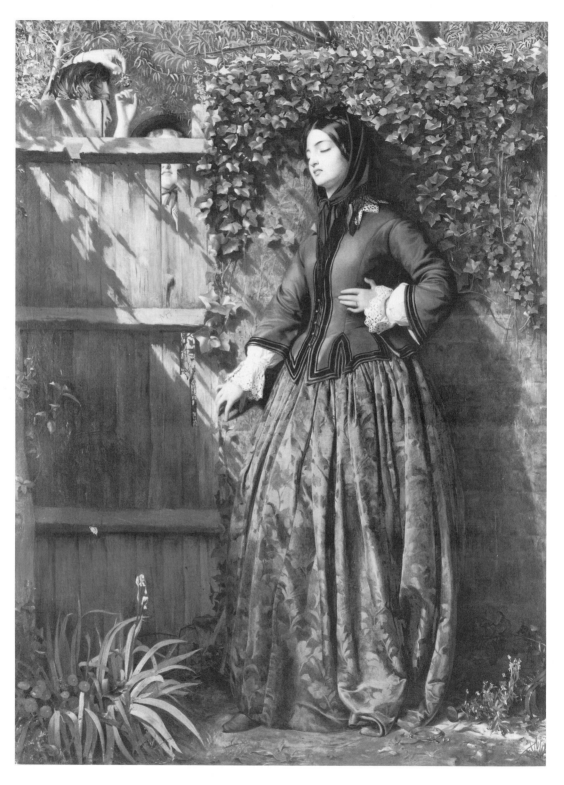

Philip Hermogenes Calderon, Broken Vows (1856),
Tate Gallery, London

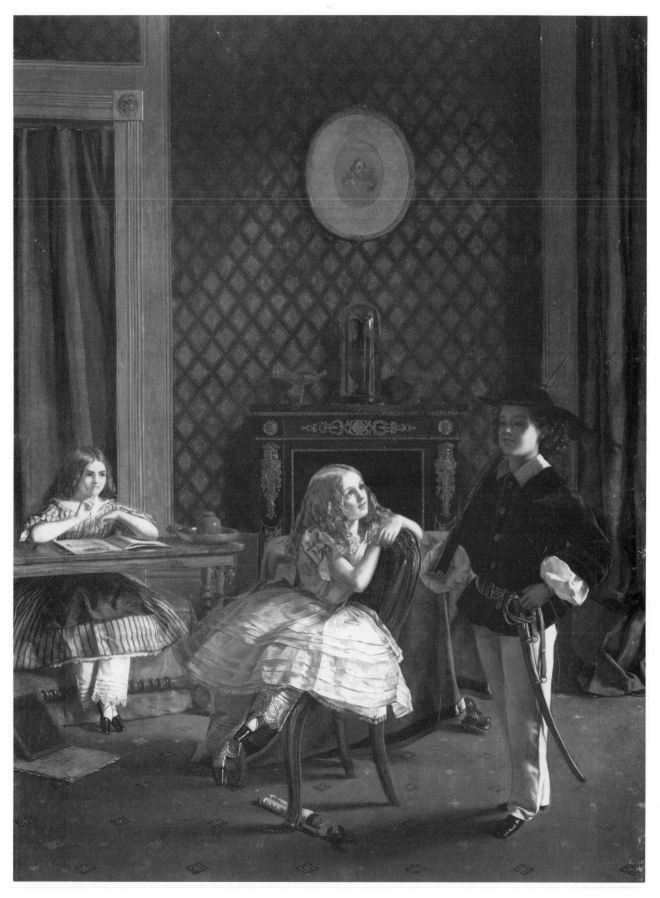

William Maw Egley, Just as the Twig Is Bent (1861),
Philadelphia Museum of Art, Katherine Levin Farrell
Fund

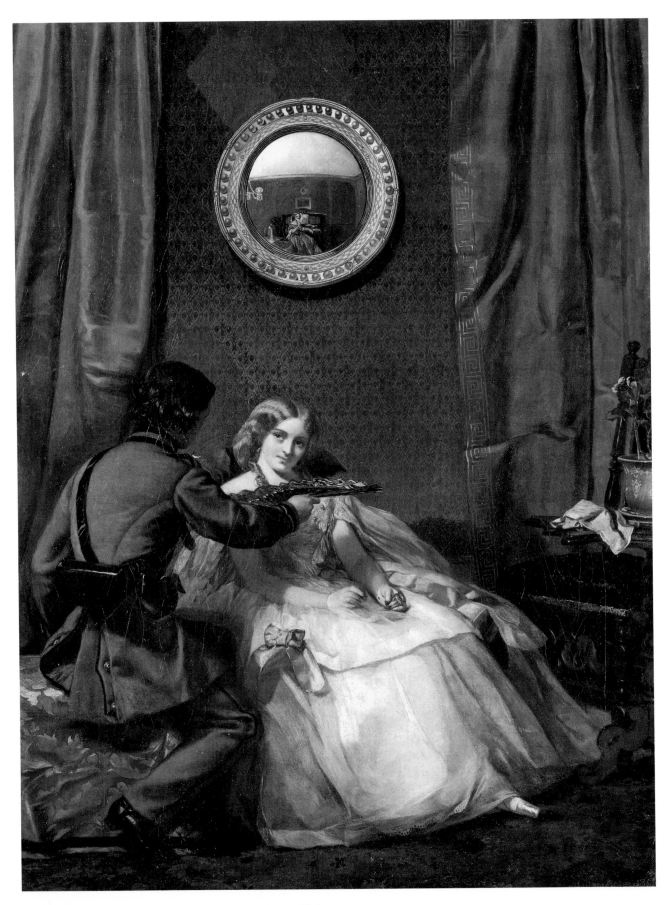

William Maw Egley, The Tree's Inclined (1861), Philadelphia Museum of Art, Katherine Levin Farrell Fund

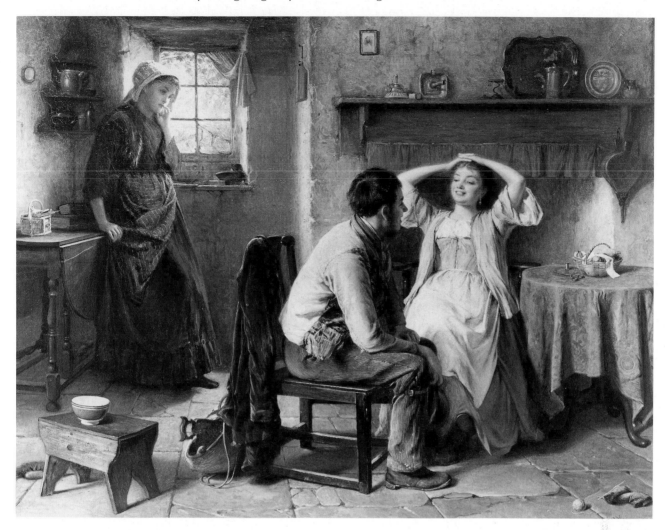

Haynes King, Jealousy and Flirtation *(1874), Courtesy of the Board of Trustees, Victoria and Albert Museum, London*

the seated man, who frowns with his hand on his brow. Ostensibly, he labors to guess the riddle, but the fact that the two identical sisters have colluded to puzzle him makes the riddle suddenly take in more than lines read from the book. Egg plays with the fact that romantic choice is always curious, choosing as we do from two or five or five thousand possible partners and discovering only after we have fallen in love the unique and clear superiority of our choice over several billions of the same sex on the planet. Egg pictorially makes a riddle of the romantic choice: not only are the sisters from whom the swain has chosen or must choose identical, but they may be teasing him at this moment about which is which. James Tissot also, when he comes to treat the rivals subject, characteristically complicates it. His enigmatic *In the Conserva-*

tory, sometimes known as *The Rivals* and painted about 1878, offers us three rivals for the attention of the young man. The girl toward whom he partially turns is dressed in the pink costume that appears so repeatedly in Tissot's *The Ball on Shipboard* (page 66). But the animated tea drinkers, with their identical faces and identical blue costumes, also contest for him. In Tissot's little world, the men may be cynically asking, "What is there to choose between young ladies in these sorts of circumstances? Are they not all alike anyway?" The women, as in Egg's picture, may be asking the more substantive question, "Who shall have him?"

Many of these pictures make use of the dark-light contrast Reynolds uses in *Garrick between Comedy and Tragedy,* but Reynolds can hardly be considered

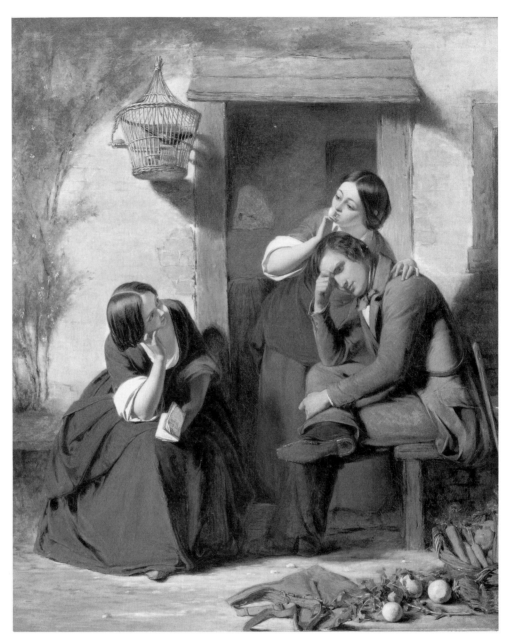

Augustus Leopold Egg, A Teasing Riddle *(1845), Location unknown, Photo courtesy of Sotheby's*

the only begetter of such rivals pictures: the literary tradition in English goes back at least as far as Shakespeare's differentiation in height, coloring, and temperament between Helena and Hermia, Rosalind and Celia. Mario Praz points out that the Victorians were repeating a perennially interesting theme in "the contrast of two opposite types of beauty—the sisters Minna and Brenda in *The Pirate,* Rebecca and Rowena in *Ivanhoe,* and so on—a theme already treated by Greuze in *The Two Friends* and *The Two Sisters* (or *The Comparison*); by Elizabeth Vigée-Lebrun in *The Two Sisters;* by William Owen in *The Sisters;* and frequently repeated later by painters about 1840 (for example, *Blonde and Brunette* by Dubufe, *Italy and Germany* by Overbeck, and so on)."[13] But the contrast in types was only part of what the artists who followed Reynolds's lead adopted from the Garrick picture.

THE TWO SISTERS AND
THE TWO ESTATES

Reynolds's last sister subject, *The Death of Dido* (page 17), illustrates the end of Book IV of the *Aeneid.* Dido, in her grief and despair at Aeneas's departure, has approached Anna, her sister, confidante, and go-between. She convinces Anna that she knows how to retain Aeneas's love or else how to "unbind" her own for him, having been advised by the Massylian priestess who guards the temple in the Hesperides. Dido instructs Anna:

> "Within the secret court, with silent care,
> Erect a lofty pile, expos'd in air:
> Hang on the topmost part the Trojan vest,
> Spoils, arms, and presents, of my faithless guest.

> Next, under these, the bridal bed be plac'd,
> Where I my ruin in his arms embrac'd:
> All relics of the wretch are doom'd to fire;
> For so the priestess and her charm require."
> Thus far she said, and farther speech forebears;
> A mortal paleness in her face appears:
> Yet the mistrustless Anna could not find
> The secret fun'ral in these rites design'd;
> Nor thought so dire a rage possess'd her mind.
> Unknowing of a train conceal'd so well,
> She fear'd no worse than when Sichaeus fell;
> Therefore obeys.
>
> (Dryden translation, 712–27)

Dido mounts the pyre and, after sending for her sister, falls upon Aeneas's sword. In the moment that Reynolds depicts, Anna discovers Dido just as Juno, pitying Dido's death agony,

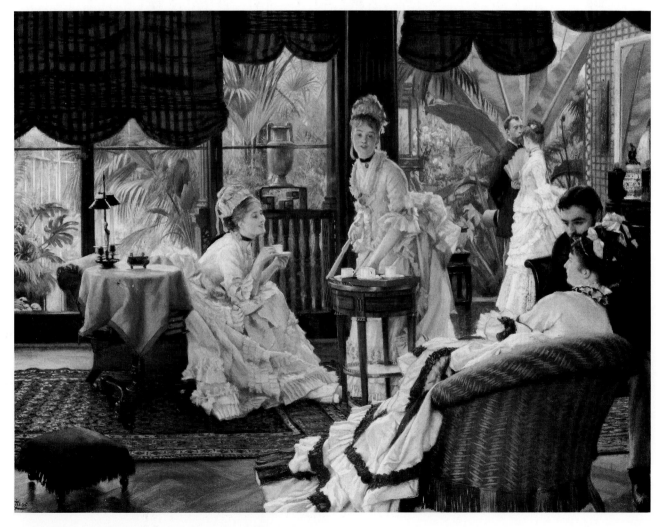

James Tissot, In the Conservatory *(ca. 1878), Private Collection, U.S.A., Photo courtesy of Richard Green Gallery*

Sent Iris down, to free her from the strife
Of lab'ring nature, and dissolve her life.
For since she died, not doom'd by Heav'n's decree,
Or her own crime, but human casualty,
And rage of love, that plung'd her in despair,
The Sisters had not cut the topmost hair,
Which Proserpine and they can only know;
Nor made her sacred to the shades below.
Downward the various goddess took her flight,
And drew a thousand colors from the light;
Then stood above the dying lover's head.

(995–1005)

Virgil reminds us about other sisters—the Fates, who reserve control about exactly when mortals will die. In Reynolds's picture, Iris is pulling a lock of Dido's hair toward her to cut it, an act that will release her to die.

Reynolds takes the pose of Dido from Giulio Romano's 1528 fresco, *Sleeping Psyche,* (page 18) in the Palazzo Te in Mantua. The influence of Reynolds's *Dido* is frequently seen throughout the subsequent century, primarily in the use of the main figure's pose for sleeping rather than dying women: illustrations of Titania asleep or Cymon watching Iphigenia sleeping.[14] Reynolds's Dido, more than Romano's Psyche, conveys suggestions of either voluptuous abandonment or gratified desire; Jean Hagstrum, in *Sex and Sensibility,* describes how Reynolds sexualizes Dido's pose:

Dido, already dead, lies stretched out. One nude foot appears sexually tensed. The eyes are not yet closed. The mouth, round like that of the Greek tragic mask (an emblem of sexual passion as well as of the theater and the muses), looks like frozen ecstasy. Above all, because the head tends to hang back, the breast is thrust out almost assertively. But anatomical reasons do not explain the insistent and pervasive rhythms of arrested sexuality, as though this were not a postmortem but a postcoital rigor. Reynolds has sexualized the model Romano gave him of a chastely clad sleeping Psyche, and in what Edgar Wind has called his "greatest attempt at the truly 'grand' style" he shows that he was not untouched by sex and sensibility.[15]

The influence exerted by Reynolds's picture came from the difference between the two sisters, a difference that could somehow be abstracted and translated to other dramatic situations or even transmuted into other differences. At one level of generalization, the difference is between a sexually wronged or sexually guilty party and her sister innocent of any such intrigues. Dido's role was always ambiguous: from one point of view she was the woman who had married

Aeneas in her own country's fashion, who was then wronged and deserted by the false Trojan; from another view she was the Carthaginian temptress who tried to impede the destiny of Rome. In the latter role she was sometimes likened to Cleopatra, and Aeneas to Antony. Reynolds kicks Romano's image of Psyche up to an even higher level of sexual provocation, and he suggests visually what Virgil's poem reminds us about Dido, that she is dying pierced by Aeneas's sword on the bed of their passion, surrounded by his clothes and images. In this scheme Anna is the innocent whose sexuality is conventional and unforegrounded. At a further level of generalization, the difference between the sisters is that one is fortunate and the other unfortunate. The sisters inhabit two separate worlds as far as destiny is concerned. Anna is unfated and lives in the "ordinary" world. Dido has been singled out by fate for blows that will echo in literature and art for millennia; hers is a world of passion and of great wrongs greatly resolved. They are women of two entirely different "estates" of passion and fate.

The Anna/Dido sisters subject in Victorian hands conveys differences that have to do with sexuality, class mores, and class differences. It measures the difference between the respectable and the "fallen" woman, between the married woman and the celibate nun, and between the governess or the servant and the lady.

One of the clearest debtors to Reynolds's *Dido* is Thomas Edward Roberts in his 1851 painting *The Discovery.* Here the emotional tone of the *Aeneid* subject has been quieted, and one sister discovers, not the other's suicide, but a sexual secret. The waking sister is married, as we can tell by the wedding ring on her finger. She is looking at her sleeping sister's locket, with, presumably, a miniature picture inside. In the window behind them, two butterflies hover over a single flower, conveying, in a beautifully painted little passage, that the sisters are rivals in love, as the married one has just discovered from the locket normally hidden in the younger woman's clothes. *The Discovery* is not an untypical Victorian picture in some ways, although the ordinary discovery scene is the more dramatic one between husband and wife. Midcentury examples are Millais's 1854 drawing *Retribution,* in which a wife and her children confront her offending husband and his mistress (who looks remarkably like the wife), and the first picture of Augustus Egg's 1858 triptych usually called *Past and Present,* in which the husband has just discovered his wife's adultery by

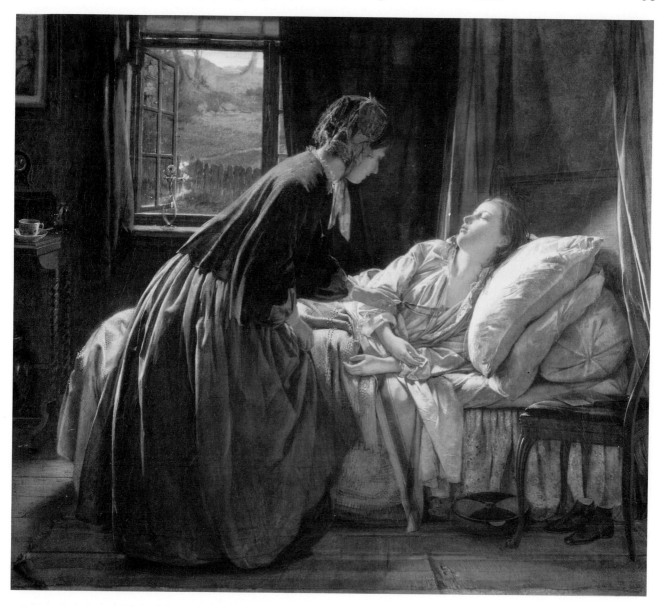

Thomas Edward Roberts, The Discovery *(1851), Private Collection, Photo courtesy of John Hadfield*

finding a letter she has been writing to her lover. But Edwards's picture is untypically quiet and subtle in its narrative, which is not dependent on an external text as the *Dido* is. Yet for anyone who recalls the composition of Reynolds's picture or what was made of it by Fuseli, more sexual tension is added to the reading. *The Discovery,* as I argue in the next chapter, is also one approach to a sisters subject Victorian painters attempted to paint throughout the period, a reconciliation scene between a respectable and a "fallen" woman whose sisterhood is literal as well as figurative.

The Anna/Dido subject is also transmuted into an-other situation concerning sisters whose sexual "estates" are different: a meeting between two sisters, one of whom has taken the veil. The secular sister visits the convent and we see the two women's like faces juxtaposed, one framed in severe black and white, the other in flattering and fashionable apparel. The secular sister may bring her children to underline the contrast in their estates; Sir Charles Eastlake painted such a picture in *The Visit to the Nun* (1844), which was engraved for *The Art Journal* in 1856.[16]

The most obvious differences in "estate" were those of class and money, and a number of paintings and

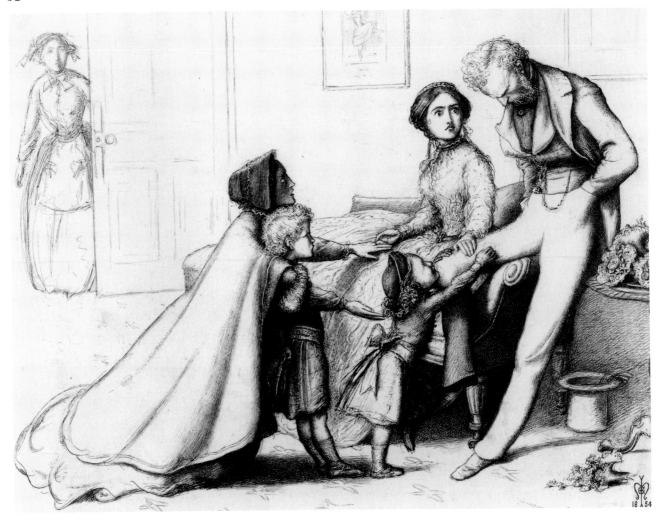

Sir John Everett Millais, Retribution (1854), *British Museum, London*

Punch graphics contrast the rich, careless, vain, and usually blonde society woman with the poor, exhausted (sometimes even dead of overwork), usually dark-haired servant, governess, or needlewoman who serves her. Examples include Richard Redgrave's 1847 *Fashion's Slaves;* John Leech's two 1849 *Punch* cartoons *Needle Money* and *Pin Money;* Rebecca Solomon's 1854 painting, *The Governess;* Augustus Egg's *A Young Woman at her Dressing Table,* from the late 1850s; and John Tenniel's *The Haunted Lady, or "The Ghost" in the Looking Glass,* an 1863 *Punch* cartoon.[17]

THE UBIQUITOUS TWINS

A peculiar nineteenth-century British pictorial development is the twinning of women with shared interests, whether they are in fact sisters or not. Reynolds is in the background here, too, not merely because of his much-imitated painting of the Waldegrave sisters in identical costumes, but because in both the Montgomery and the Waldegrave pictures he points out aspects of sisterhood—shared work, joy, and ceremony—that can be extrapolated to women in general. This curious twinning phenomenon is more widespread than would seem to be indicated by the pictures already mentioned—Egg's *The Travelling Companions* and *A Teasing Riddle,* Tissot's *In The Conservatory.*

William Mulready's 1841 *Train Up a Child* is an example that Graham Reynolds describes in *Victorian Painting:* "a small boy is being urged by his mother and nurse to give alms to two Lascar beggars. He is terrified by them and only with difficulty forces himself to

do the task. This is the discipline which is the subject of the title."[18] The odd feature that Reynolds does not mention, though he notes a "hallucinatory quality of the scene," is that the mother and nurse, if that is indeed what they are, have identical hairstyles and dresses and appear to be twins. Why? Are we to believe that the women are really twins—the mother and aunt of the boy? Or are they merely alike in their function here, which Mulready underlines by the exaggerated likeness? Sometimes the twinned women of nineteenth-century English paintings are sisters with a common purpose or situation; their depiction as twins thus pictorially thematizes their connections. As in *The Travelling Companions*, identity conveys equality of status and situation. In Emily Mary Os-

born's *For the Last Time* (1864), twin sisters in mourning pause outside a room that presumably contains their dead mother or father. Sometimes the twinning may be explainable as expediency: when William Holyoake's *In the Front Row at the Opera* has five women in the row of operagoers it depicts, but only two different female faces, we may conjecture that using two models instead of five was cheaper and easier. Millais repeats the face of his daughter Alice for two of the young girls in his 1859 painting *Apple Blossoms*; he used his wife Effie for all the faces in his illustration of *The Foolish Virgins* (for the Dalziel brothers' *The Parables of Our Lord*, 1864).

At other times a shared hardship may be such as to justify the twinning in pictures—it is as much as to

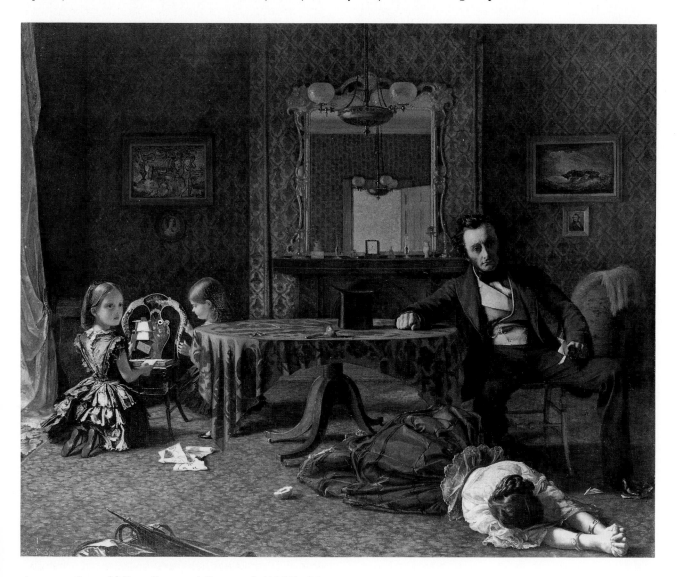

Augustus Leopold Egg, Past and Present I (1858), *Tate Gallery, London*

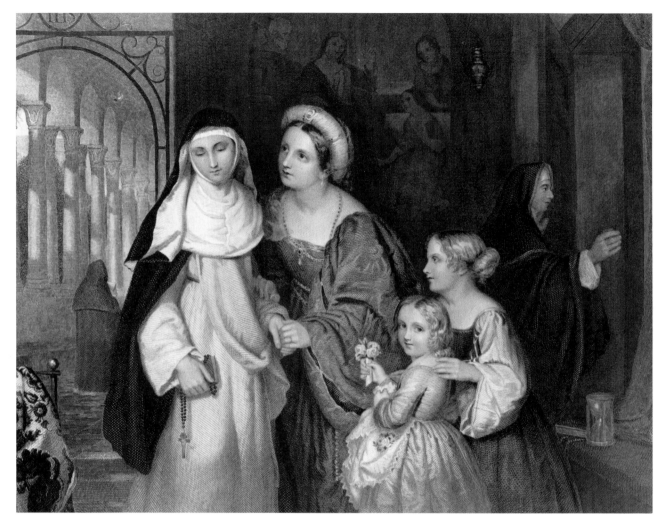

Sir Charles Eastlake, The Visit to the Nun *(1844), en-graving by S. Smith,* The Art Journal *(1856)*

say, "these things make sisters of us." Thus Edward Hopley paints an English family in danger during the 1857 Indian Mutiny, and the two women he depicts, one apparently the mother (she has an infant beneath her shawl) and another perhaps her sister, are made identical in facial features and apparent age in *An Incident in the Indian Mutiny* from 1857. And Frank Holl, in *The Song of the Shirt,* shows three young seamstresses, two of them nearly identical. Eventually the idea is used as an empowering one: sisters uniting to become stronger and near identity of appearance signalling unity of purpose. Thus Linley Sambourne's *Punch* cartoon of 1892 shows two lady cricketers, differing in hair color but alike in face and uniform, braving the cowering wicket-keeper who has the face of the reactionary Gladstone.

Twinned women and costumes are also to be found in Frederick Barwell's *Parting Words, Fenchurch Street Station* (1859), in James Hayllar's 1863 *Going to Court,* in Abraham Solomon's *Brighton Front,* in John Collier's *The Pharaoh's Handmaidens* (1883), in Marcus Stone's 1887 *Good Friends,* in Philip Wilson Steer's 1895 *Girls Running: Walberswick Pier,* (page 27) and, most egregiously, in James Tissot's 1874 *The Ball on Shipboard.* In this last picture there are no fewer than three pairs of women dressed identically, and one group of four women all wearing the same pink dress!

What is going to explain the "countless canvases that quite eerily twin the features, attire, and doppelgänger identity of the sitters," in Susan Casteras's words?[19] Tissot's commentators speculate about his own particular reasons for painting twins.[20] The practice is so widespread, however, that the personal idio-

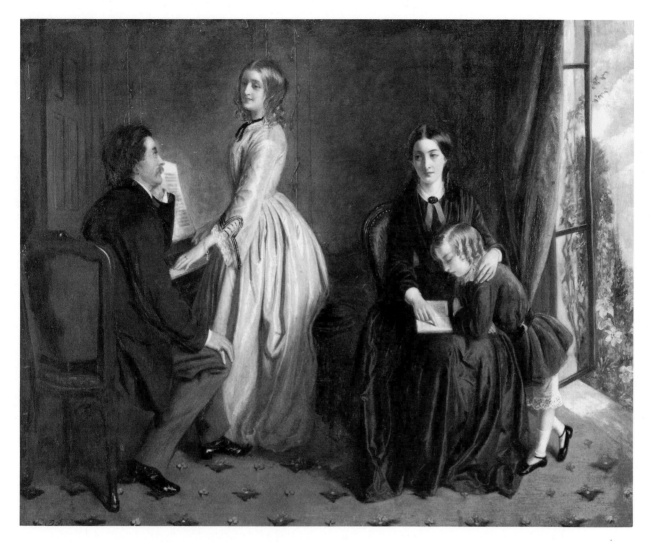

Rebecca Solomon, The Governess (1854), *Collection of Edmund J. and Suzanne McCormick*

syncrasies of one painter will not explain it.

Technology may have had some slight influence on the twinning phenomenon. Photography facilitated the making of multiple images, and twinning in painting probably owed something to the advent of photography, which coincided almost exactly with the accession of Victoria. Photographs enabled the artist to compose multiple images of the same woman, but (since that was possible before photography—not simultaneously but in several sittings of the same model) more importantly, it *suggested* twinning. The

incredibly popular *carte-de-visite* or calling card photographs, of which even Victoria had a photographer make her a set in 1861, before they were cut apart showed the painter a Warhol-like array of dittoed faces, and double or multiple exposures showed the same face in transformation. Muybridge's multiple image motion studies, made by several cameras, were made in the seventies and eighties. Before the end of the 1850s, photographers such as Disdéri in France and Rejlander in England had made multiple exposures with the same fidelity as single ones, according

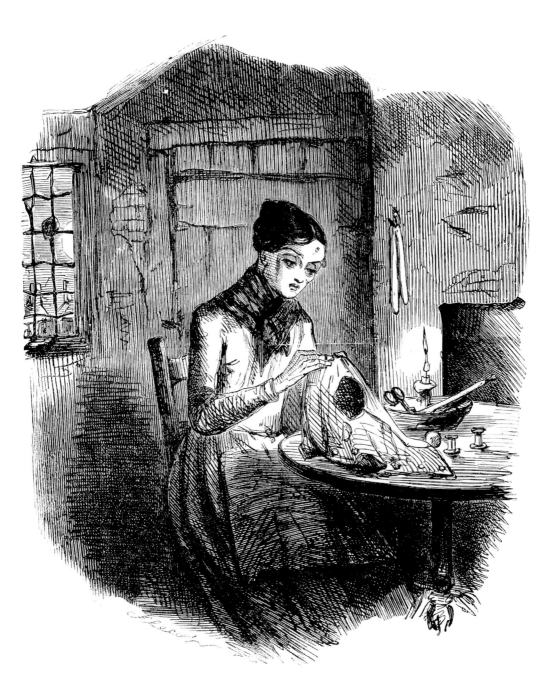

John Leech, Needle Money and Pin Money (1849),
Punch

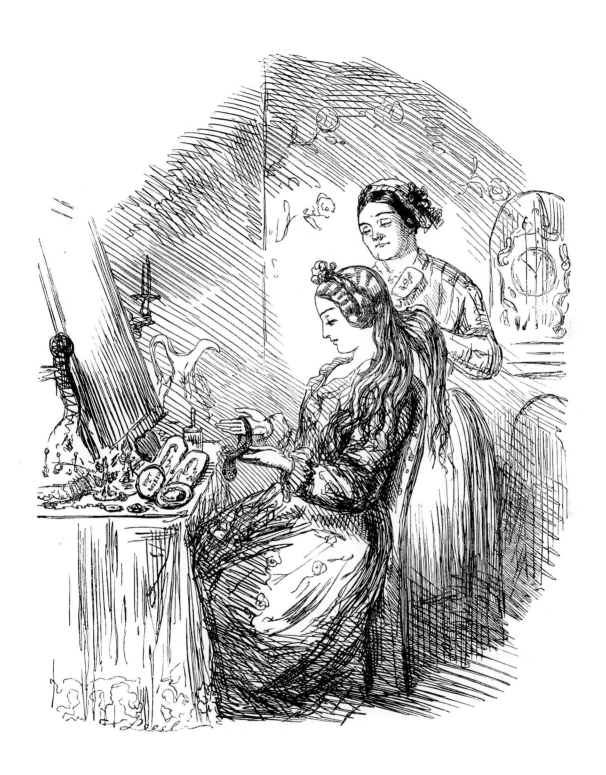

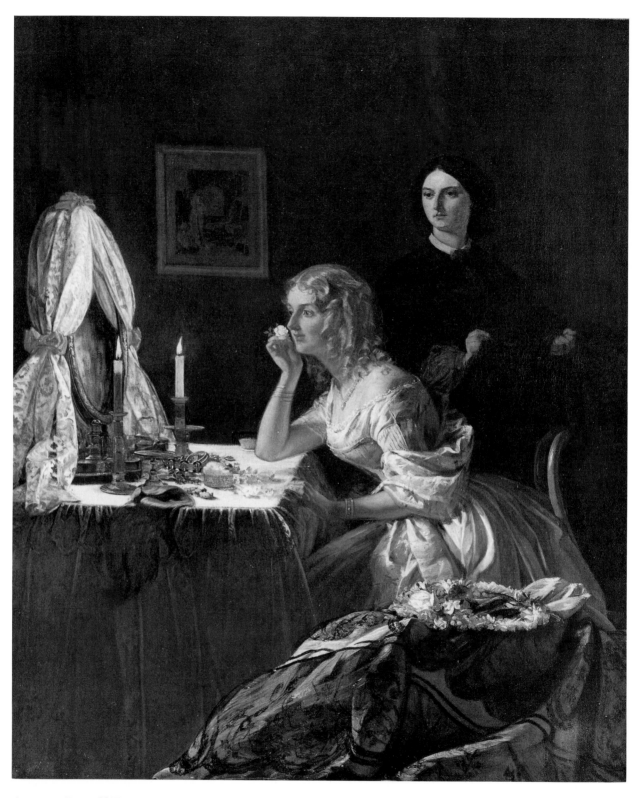

Augustus Leopold Egg, A Young Woman at Her Dress-
ing Table *(1858–60), Collection of Edmund J. and Suz-*
anne McCormick

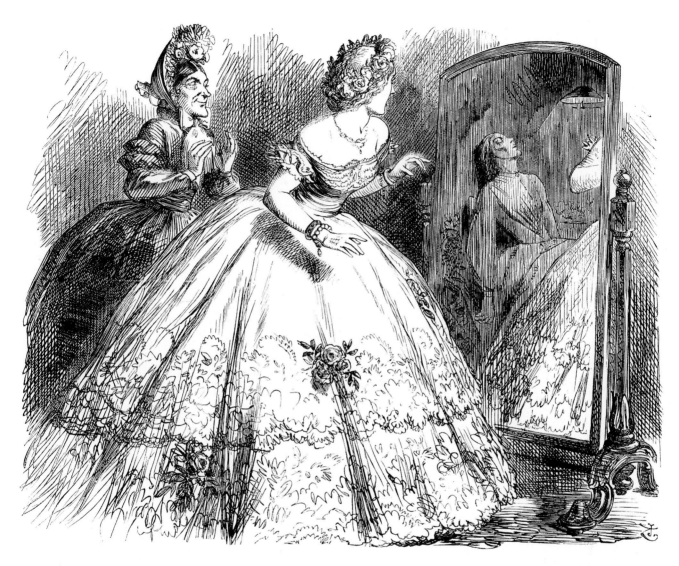

John Tenniel, The Haunted Lady, or "The Ghost" in
the Looking Glass *(1863),* Punch

to Beaumont Newhall.[21] Interestingly, Reynolds had
even anticipated the multiple image of the subject
who sisters or mirrors herself: the doll-like faces of
Miss Frances Isabella Gordon, repeated five times in
Reynolds's 1787 *Heads of Angels,* do not differ greatly
from, for example, the double-exposure images of
Mary Pickford in Moody's 1914 photograph.

A more comprehensive explanation of the ubiquity
of twinned women has to consider the pictorial con-
text of such pictures. Nineteenth-century English
paintings of pairs of women emphasize either the
women's differences or their likenesses. Even within
some of those that emphasize difference of estate, of
marital status, of sexual knowledge or experience, we
can see a tendency to mirror the features of the
women being contrasted. In this context there also
appear a number of pictures—for despite Casteras's
hyperbole they are countable—that depict identical

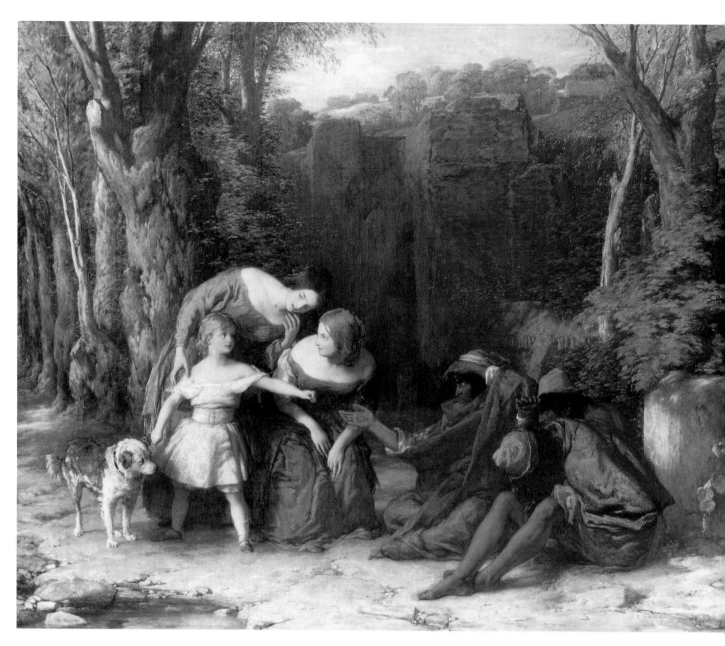

William Mulready, Train Up a Child (1841), *The
FORBES Magazine Collection*

William Holyoake, In the Front Row at the Opera (ca. 1880), Glasgow Museums: Art Gallery and Museum, Kelvingrove

Frank Holl, The Song of the Shirt, *Royal Albert Memorial Museum, Exeter*

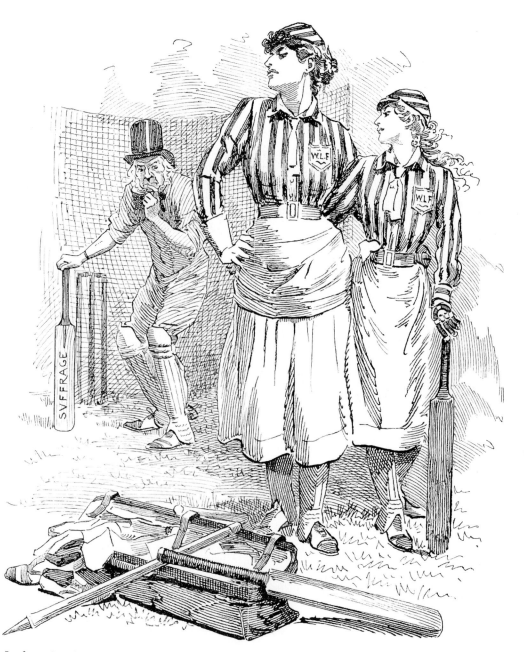

Linley Sambourne, The Political Lady-Cricketers
(1892), Punch

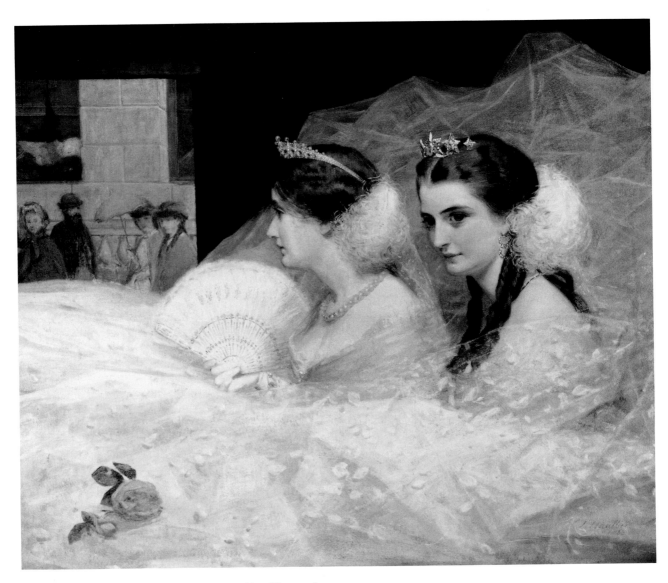

James Hayllar, Going to Court (1863), Christopher
Wood Gallery, London

*Marcus Stone, Good Friends (1887), Royal Academy of
Arts, London*

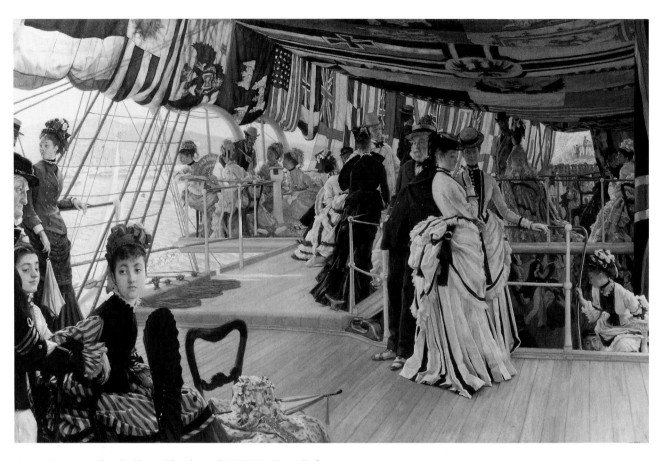

James Tissot, The Ball on Shipboard *(1874), Tate Gallery, London*

John Mayall, Carte-de-visite photo of Queen Victoria
(1861), Gernsheim Collection, Harry Ransom Humani-
ties Research Center, The University of Texas at Austin

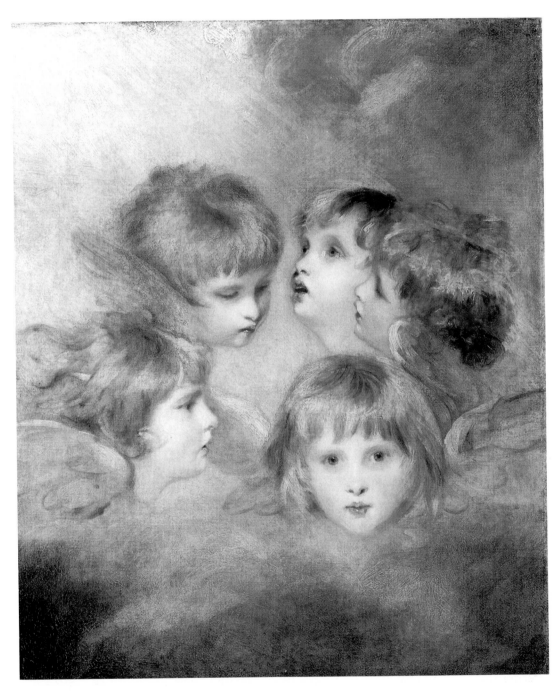

Sir Joshua Reynolds, Heads of Angels: Miss Frances Isa-
bella Gordon *(1787),* Tate Gallery, London

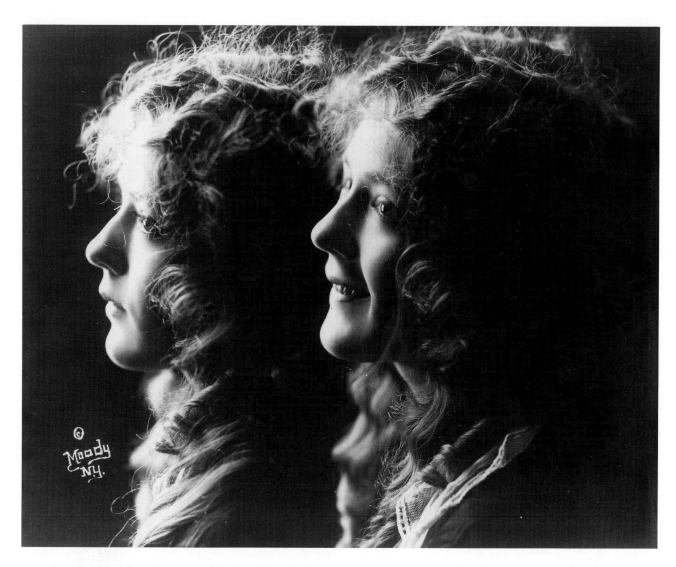

Moody, Photograph of Mary Pickford *(1914),* Library
of Congress

sisters. Such twinning may be interpreted in two very different ways. It is probably true that some of the twinning has sinister implications reflecting fears about the interchangeability of women and the ominous possibility that one may be displaced by another. The fear of one woman's being replaced by her sister may be inferred from the resistance to the almost yearly attempts to eliminate the prohibition of marriage with a deceased wife's sister and from the narratives that were invented to justify that resistance.[22] The law was not changed until 1907, even though there were emigrations to the United States to avoid its sanctions. I explore the fear of displacement and its legal contexts in Chapter Seven, on the sensational novels of Wilkie Collins.

But it is also true that the eradication of difference in twinning can convey a healthy equality. In this interpretation, pictures of twins, always women, are part of a larger pictorial effort toward equality and the erasure of differences among women, an effort that will be examined in the next chapter.[23]

3

Painted Women and Unpainted Pictures: Secularizing the Imagery of Sisterhood

WHEN PAINTERS ATTEMPT A NEW SUBJECT, THEY must either adapt old ways or make a radical departure from them. Either way the past conventions and methods of doing things are not disregarded. When nineteenth-century paintings featured sisters in modern life situations, displaying modern manners, painters had to invent new pictorial languages to treat them. Reynolds had been helpful in showing how the past could be used imaginatively and wittily to treat the sisters subject. Other important conventions for treating sisters came from sacred story. The attempt to find an imagery for sisterhood in nineteenth-century English painting leads to some unlikely alliances: for example, Old and New Testament iconography with subjects from the London streets.

FALLEN WOMEN AND UNFINISHED PICTURES

Linda Nochlin argues in her 1978 article, "Lost and *Found:* Once More the Fallen Woman," that paintings of prostitutes and other "fallen women" are the best place to look at "nineteenth-century attempts to invent a secular pictorial imagery."[1] Some of these attempts still have a good deal of religious iconography left. In Ford Madox Brown's 1857 *Take Your Son, Sir!*, the fallen woman's child, her mirror-halo and wall-paper field of stars "give her the air of a looming, outsize Madonna, asserting her power to God, perhaps, as well as man," according to Nina Auerbach. Helene Roberts calls the use of the madonna subject here "clever and brave."[2] Less obtrusive uses of religious imagery may be found in William Holman Hunt's 1853 *The Awakening Conscience* and Dante Gabriel Rossetti's *Found,* begun in 1854. Helene Roberts praises Hunt's suggestion of sacred story in *The Awakening Conscience:* "He had taken a fallen woman, the symbol for the Victorians of what was physically and morally monstrous, a creature unworthy to be represented in art, and elevated her into a religious, an almost saintly symbol—the woman taken in adultery, the Magdalene." And both Linda Nochlin and Nina Auerbach see behind Rossetti's *Found,* in Nochlin's words, a "sort of dark Annunciation, a perverse revision" of his 1850 painting of the Annunciation called *Ecce Ancilla Domini!*[3] All three of these "fallen woman" paintings were either unfinished or drastically repainted by their artists, testifying to the struggles involved in this secularizing enterprise.

WHORES AND WIVES AS SISTERS UNDER THE SKIN

The fallen woman subject was difficult to paint, but

Ford Madox Brown, "Take Your Son, Sir!" (1856–57),
Tate Gallery, London

William Holman Hunt, The Awakening Conscience
(1854), Tate Gallery, London

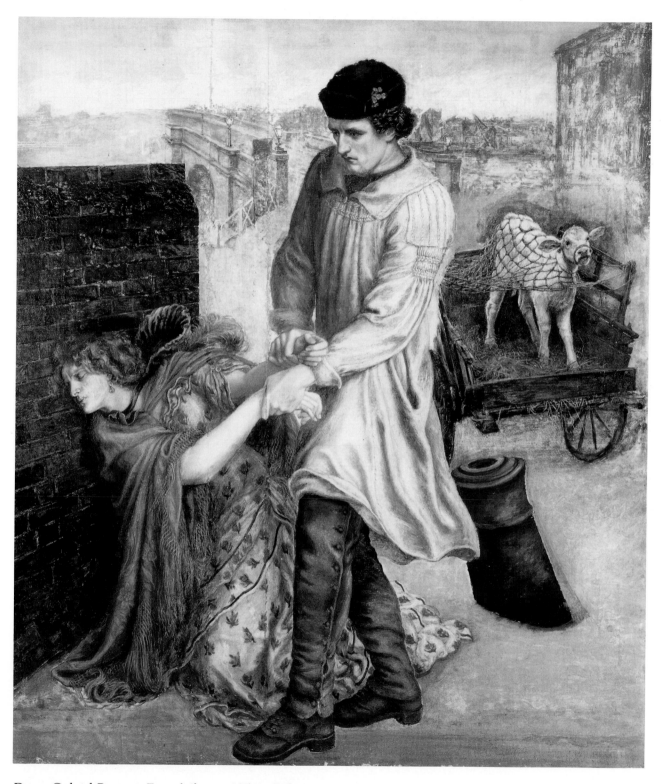

Dante Gabriel Rossetti, Found (begun 1854), Delaware Art Museum

it did get painted, with some struggle. It would have been even more difficult to paint a picture that asserted the literal as well as spiritual sisterhood of the fallen woman and her respectable sister. Yet the evidence is that painters wished to paint such a picture, attempted to paint such a picture, and, though they failed, painted something like it. Because of the struggle, what must be regarded as the most important sisters picture never got painted. It would have shown a fallen woman assisted by her respectable sister, who is her twin. We can make these assertions about a picture that does not exist because there are a series of *approaches* to this painting, in which we see that the characteristic features of sisters in art have extremely subversive implications for the fallen woman subject. These features, which I have called the grammar of sisterhood—likeness combined with difference, twinning and the use or suggestion of mirrors, topicality, containment and self-sufficiency, all tend to assert the equality of the subjects and graphically challenge the moral system that depends on their difference.

In each of the existing pictures that approach what I am calling the unpaintable subject of the identical sisters, whore and wife, there are compositional debts to a few sacred subjects. The most important of these subjects is the Visitation of the pregnant Virgin Mary to her cousin Elizabeth, who is herself pregnant with John the Baptist (Luke 1:35–56). Another sacred subject that furnishes a compositional model for sisters paintings is the *Noli Me Tangere!* picture that shows the newly risen Christ at the sepulchre with Mary Magdalene, to whom he says, "Touch me not; for I am not yet ascended to my Father" (John 20:17). In its Victorian, secularized use the two figures are frequently both women, *Noli Me Tangere!* becomes a warning from the fallen woman to her sister, and the reason for being untouchable shifts from exaltation to degradation. Contributing images come from New Testament pictures by Rossetti, Corbould, Dyce, and others of women pure and impure, in subjects such as the Annunciation, the Nativity, and those adulterous women whom Jesus meets in the New Testament: the Woman of Samaria at Jacob's Well (John 4:1–30) and the Woman Taken in Adultery (John 8:2–11).

The subject was unpaintable because it was too subversive; the sisterhood would have too obviously suggested identity, and the combination with sacred subjects would have made explicit what painters such as Brown only imperfectly suggested: the coalescence

of the Madonna and the Magdalene. Time and again the subject is approached—by writers as well as painters—and time and again the work turns into something safer and more conventional. Thinking adults knew perfectly well that the respectable woman and the whore did in fact have a "family" relationship in Victorian England; as Susan Casteras has put it, "In an age that was paradoxically obsessed with both virginity and sexual promiscuity, the two extremes were related, one almost at the cost of the other. . . . The stability and sanctity of the home and family itself rested to a considerable degree on the existence of prostitutes."[4] Rossetti's narrator in "Jenny," looking down at a sleeping prostitute, is led to think of his cousin Nell, and the likeness between the two:

> Just as another woman sleeps!
> Enough to throw one's thoughts in heaps
> Of doubt and horror,—what to say
> Or think,—this awful secret sway,
> The potter's power over the clay!
> Of the same lump (it has been said)
> For honour and dishonour made,
> Two sister vessels. Here is one.
>
> (177–84)

The narrator considers that Jenny's children may well be giving needed charity to Nell's, and he comes very close to putting the two women together in frame or line, but backs away:

> If but a woman's heart might see
> Such erring heart unerringly
> For once! But that can never be.
>
> (250–52)

Jenny is "like a rose shut in a book / In which pure women may not look" (253–54). And this exclusion is repeated in novels and in paintings. The "fallen woman," according to Nina Auerbach, has to be isolated from her respectable sister. "Characteristically, Victorian literature plays with her [the fallen woman's] professional alliance with virtuous wifehood only to snatch the two apart at the last minute. In painting, in what Linda Nochlin calls the 'secular pictorial imagery of the fallen woman,' she is associated with sweeping vistas of space and with impersonal urban masses, as in Egg's trilogy, never with snug domestic interiors" in which her respectable counterpart is enclosed.[5] The two have to be kept apart because their likeness has to be concealed; if they are brought close they will rush together and coalesce, eliminating

imagined differences and with them most of the neater separations between good and evil in middle-class sexual assumptions.

Pictures near in subject to this unpainted and unpaintable picture of the sister's rescue make it possible to be very specific about what it would have looked like. It would have been a picture of two women, one a respectable woman and the other a "kept" woman or a prostitute. Everything about the picture would have tended to *erase* any distinction between the two women. Therein lies the obstacle to its realization in a time that puts nearly unrelenting emphasis on the moral distance between two such women.[6]

FIVE NEAR MISSES

Five pictures, all dating from the decade 1850–60,

are of particular interest in examining the approaches to this unpaintable subject. All of them make a sexual contrast between two women, though it is not always so simple as that between wife and whore. Some of these pictures tend to blur moral distinctions and shift the blame for sexual transgression to society or to the male. These pictures always compare two women, however many others may be in the picture, and the range is from one woman's lack of awareness of the other's situation to sudden discovery to attempts to help (through restraint of a male figure who wants to cast the other out).

The potential danger of one woman's being unaware of her sister's fate is illustrated in Abraham Solomon's *Drowned! Drowned!* from 1860. The title comes from Gertrude's lament for Ophelia in *Hamlet* (4.7.183), but the scene might be an illustration for Thomas Hood's "The Bridge of Sighs," for long one of

Abraham Solomon, Drowned! Drowned! *(1860), engraving by J. and G. P. Nicholls,* The Art Journal *(1862)*

the standard stories about how the prostitute's life must end.[7] The fruitsellers around her "take her up tenderly" from the watermen who have brought the drowned woman up the embankment; she is "so young and so fair"—as in Hood's poem and as we can see, because a policeman shines his bullseye lantern across her face and shoulders. The left half of the picture depicts a scene not in Hood, a discovery scene in which a male reveller coming from a costume party happens to see the drowned girl's face in the lantern's light and recognizes her; we assume that he is the original debaucher of the girl. The picture's composition relates the two young women, the one who is with the male debaucher now and the one already ruined by him. The first woman is centered in the masquerade group to the left and the other is centered in the working-class group to the right. Neither is aware of the other, but they are linked by their fates. The man's compositional role is to keep them apart: he extends the bridge rail barrier, keeping the upper from the lower world.

Both women are carefully highlighted, the drowned woman by the direct light of the lantern and the other by the bridge light above and to her left. Solomon opposes unconscious, loose-tressed, fully lighted, and fair dishabille with darker, sidelighted, full dress and coif, showing us both faces, tilted away from each other, in three-quarter view. The faces are very much alike, despite a difference in coloring. The woman on the left may be completely unaware of the scene, or she may be deliberately ignoring it. In either case her danger of a like fate is shown by a like face.

Discovery scenes are a further stage in the dynamics of pairing respectable/fallen women. One such picture is Thomas Edward Roberts's 1851 *The Discovery* (page 51), briefly discussed in Chapter 2. A young wife, in the act of waking her sister, discovers in the locket around the younger woman's neck a picture or an inscription that reveals its giver to be her own husband. In addition to the debt to Reynolds's *The Death of Dido* (page 17), *The Discovery* also derives from the Visitation subject, as most of these pictures do in some measure. Roberts tells the story very quietly. He contrasts the women largely in incidentals: the wife, lit from the back, fully dressed in muted colors and with hair up, makes a dark foil for the lightness and suggestion of sexual passion in the younger sister, in dishabille and loose hair, whose white nightdress and fair skin reflect the full light. The contrast is very like

that in Solomon's picture. But the emphasis falls more on likeness rather than contrast. The two women are near in age and very like in appearance; the quarter profile of the wife and two-thirds profile of the sister might well be of the same face. The absent husband-lover is represented by tokens. The wedding ring and the locket, both at the picture's center where the wife's purposeful left hand contrasts with the relaxed, open hands of the younger sister, emblematize the man's contrasting relation to the two women: the ring is an open and sanctioned token, the locket, normally hidden, represents the illicit, but both have the same source. The opened flower in the window vase, perhaps another gift from the husband to the sister, is a tiny arena of competition for two nearly identical butterflies.

Another discovery is illustrated in John Everett Millais's 1854 drawing *Retribution* (page 52), which shows a middle-class dwelling and an errant husband, hanging his head at his discovery by his wife and children. As in Roberts's discovery scene, the wife's wedding ring is an important hand property, but this time the "other" woman also makes a discovery, of a licit union rather than an illicit one. Here too the women are remarkably near in age and like in features.

In the middle of the 1850s, when Rossetti was beginning his twenty-year unsuccessful struggle to finish *Found* (page 73), John Everett Millais fell in love with Effie Gray Ruskin, waited while her unconsummated marriage to John Ruskin was annulled, and then married her. A recurrent subject of Millais's paintings from this time on is rescue of one kind or another (these paintings are discussed in Chapter 4), but there are drawings from this period that, in Timothy Hilton's words, "dramatize the effects of passion in contemporary life" and show Millais's heightened interest in sex at the time,[8] though their subjects do not connect directly with his romance with Effie. But the very fact that they are drawings that never get made into paintings evidences some tension between their subjects and what Millais perceived as worthy, appropriate, or saleable in easel pictures.

Two final pictures, Richard Redgrave's *The Outcast* (1851) and Rebecca Solomon's *A Friend in Need* (1856), illustrate a woman's attempt to help her fallen sister. *The Outcast* naturally calls to mind Old Testament expulsion stories beginning with the Garden of Eden. Redgrave alludes to another expulsion by putting on the wall of his scene a picture of Abraham

Richard Redgrave, The Outcast *(1851), Royal Academy of Arts, London*

casting out Ishmael and Hagar (Genesis 21:9–14). But the painting's subject is not a precise fit with either allusion. The expulsion from Eden is not a real parallel to this casting out, which ignores one guilty party—the father of the child—and ejects the innocent child as well as the mother. The ejection from the Garden of Eden is an even less apt allusion here than it is in the first painting of Egg's *Past and Present* (page 53), where the Eden expulsion scene's presence on the wall at least forecasts what is in store for everyone in the picture. But the story of Abraham, Hagar, and Ishmael does not work much better as parallel to *The Outcast.* An expelled mother and child are the only real elements where the allusion connects with its referent. Abraham can hardly be seen as the stern patriarch turning out the sinner for morality's sake, since he fathered the child.

Sarah in Genesis is a kind of sister to her former maid Hagar, since their situations are so similar, but Sarah causes the expulsion of Hagar. Here the younger sister attempts to prevent the expulsion. The Sarah-Hagar allusion better reinforces a narrative that is the *converse* of the one Redgrave tells here. Such a narrative is Elizabeth Gaskell's "The Old Nurse's Story." Gaskell's ghost story uses the same situation as *The Outcast* except that the "innocent" sister, instead of trying to restrain the father, helps and urges him to cast out both her sister and the sister's illegitimate young daughter, whose spirit later returns to drive her aunt mad. (This sisterly ill-feeling is an aberration in Gaskell's work; I discuss the more frequent, healthy relations between sisters in two of her novels in Chapter 9.) Unlike the Gaskell and the Sarah-Hagar story,

Rebecca Solomon, A Friend in Need *(1856), engraving*
from The Illustrated London News *(1859)*

Redgrave's scene depicts an attempted rescue of one sister by another. The sisters' drama is highlighted in *The Outcast;* in fact the sister who resists the expulsion of the woman and baby is at the center of the picture. And the likeness of the two women is emphasized: their two faces, viewed from the same angles that Roberts had used for his sisters in *The Discovery,* might be those of twins.

Given the number of women interested in reclaiming their fallen "sisters," as evidenced by the Magdalen houses, the "Midnight Missions," Angela Burdett Coutts's home for fallen women known as Urania Cottage, and the activities to assist prostitutes by the Anglican sisterhoods newly reconstituted in the 1840s, it is surprising that there are not dozens of pictures of reclamation or rescue scenes of respectable

Nicolas Poussin, The Annunciation *(1657), Reproduced by courtesy of the Trustees, The National Gallery, London*

women and prostitutes. The scene was there to paint. But the paintings that do treat the subject do so only indirectly, as in *A Friend in Need* by Rebecca Solomon, Abraham Solomon's sister. *A Friend in Need* shows a fallen woman and her infant about to be ejected from the steps of a church where they have stopped to rest. A beadle has his arm outstretched to move the woman on, but he is restrained by the hand of a well-dressed woman. An equally well-dressed child, a girl of perhaps five years old, stands between this second woman and the seated mother with child on the steps. The attentiveness of the older child to the infant may allude to another sacred subject, namely, the "communion of the innocents" in paint-

*George Morland, "The Fair Penitent," Plate 6 from Lae-
titia (1789), engraving by John Raphael Smith, British
Museum, London*

ings that show another child or several children along with the infant Christ. The subject shows up in depictions—without any scriptural sanction—of the infant Christ and the slightly older St. John, with or without Elizabeth, or of the apocryphal Family of St. Anne subject, in which the Virgin Mary's half-sisters and

William Blake, Mary Magdalene at the Sepulchre *(ca. 1800), Yale Center for British Art*

William Blake, The Nativity *(ca. 1800), Philadelphia Museum of Art, Gift of Mrs. William T. Tonner*

their infant children are depicted with her and her baby.

THE SUBMISSION POSTURE

Looking at all of these pictures together makes their common features stand out and gives us a basis for further speculation about the unpainted picture they hint at. Generalizing from these pictures enables us to conjecture, for example, about the likely attitudes of the two women in the picture that was never painted.

One or both of the women in that unpainted picture would very likely have been in a sitting or kneeling position. The association of the "fallen" with this posture is partly natural but, as usual in the visual arts, owes much to convention and especially to the conventions of religious iconography. The Virgin

Mary takes this submissive attitude, with her hands open and spread outward, in Nicolas Poussin's 1657 *Annunciation,* a picture that could have directly influenced English artists as early as 1775, when the painting may have entered England, according to Anthony Blunt.[9] Earlier influence is possible through engravings. By 1789 George Morland uses the posture for a country girl who has sinned sexually and is now contrite, in his series *Laetitia.* The sixth plate, *The Fair Penitent,* shows Laetitia sitting or kneeling in this posture on the front porch of her family's house as they take her in after her adventures.

Around the same time as this posture is being used to characterize a *magdalen*—that is, a reformed prostitute, it is also becoming transferred within sacred subjects from Mary Virgin to Mary Magdalene. At the turn of the century Blake uses the posture for a Magdalene in a *Noli Me Tangere!* scene and also for both

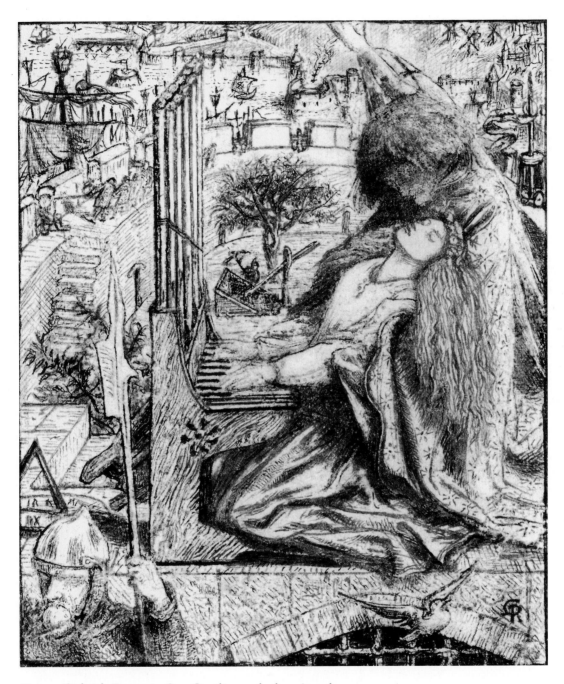

Dante Gabriel Rossetti, St. Cecilia and the Angel
(1856–57), Birmingham Museum and Art Gallery

the Virgin Mary and Elizabeth in a remarkable *Nativity:* with her naked son in her lap, Elizabeth sits opposite the swooning Mary, supported by Joseph, as the infant Jesus *leaps* from his mother's womb into Elizabeth's hands. Blake thus uniquely conflates the Visitation and Nativity subjects. Moreover he uses the submission posture found in Poussin's Virgin for a Magdalene and also as a way of "sistering" the cousins

Elizabeth and Mary through its mirroring of their birthing experiences. Dante Gabriel Rossetti, perhaps following Blake (who certainly influenced him profoundly), uses the submission posture in a number of both sacred and profane subjects. His *St. Cecilia* (1856–57) swoons backward from a kneeling position at her organ into an angel's arms. The figure in *Beata Beatrix* (about 1863), with eyes closed as in all Ros-

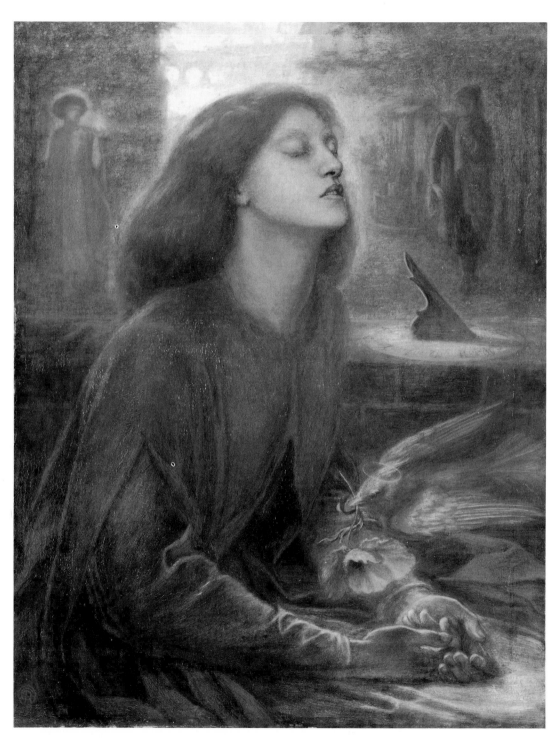

Dante Gabriel Rossetti, Beata Beatrix *(ca. 1863), Tate Gallery, London*

E. H. Corbould, "Go and Sin No More" (1842), en-graving by C. H. Jeens, The Art Journal *(1856)*

setti's versions of the submission posture, has her hands open together before her. Both these pictures postdate the beginning of *Found* (1854) and the sev-eral drawings of the woman's kneeling figure Rossetti made before and after he had started the painting (all are illustrated in Nochlin's article).

At mid-century this kneeling or sitting attitude was used by many English artists for the subject of fallen women. E. H. Corbould uses it for the figure of the woman taken in adultery in *Go and Sin No More*, a watercolor bought by Prince Albert in 1842 and en-graved for *The Art Journal* in 1856. Jesus points to the woman, who sits or kneels below him, an attitude in defiance of the text, where her "standing in the midst" is explicit (John 8:2–11), while it is *Jesus* who bends down (to write with his finger on the ground). Henry

Nelson O'Neil places his figure (with her baby sleep-ing beside her) against a country-churchyard grave marker in *Return of the Wanderer* (1855). In Rebecca Solomon's *A Friend in Need* the prostitute sits on a church step with her babe on her lap. And in Abra-ham Solomon's *Drowned! Drowned!*, the submission posture has the limpness of death as the fallen woman lies in the arms of her would-be rescuers.

An important variation is the use of the submission posture for the *other* figure, not the fallen woman: in Millais's *Retribution*, the wife rather than the kept woman assumes this posture, and in Redgrave's *The Outcast*, it is taken by the kneeling sister of the out-cast girl, vainly trying to restrain her father from ejecting his fallen daughter and her child out into the snowy night. We infer from the variation that

Dante Gabriel Rossetti, Illustration for Christina Rossetti's "Goblin Market" (1862), The Huntington Library, San Marino, California

the posture may be used in our unpainted picture as a means of distinguishing—marking—the fallen woman, *or* for both figures, as a means of erasing distinctions between them. The presence of children is another possible means for erasing differences, as in Rebecca Solomon's *A Friend in Need*, but it is also possible to imagine such a scene in which both women are pregnant.

SISTERING BY TWINNING

The principal means of erasing distinctions, though, is the twinning of the two women. Looking back at our five near misses we see that resemblance between the women is insisted on by the artists regardless of any possibility of family connection. In the Roberts and Redgrave pictures the women *are* sisters, and their resemblance is one of the means that con-

veys the relation. In the remaining pictures the women are not sisters, but their features in each case, where we would expect them to be differentiated, are likened. Here twinning conveys the women's essential identity. Moreover it is an effect not owing to any of the sacred compositions behind these pictures. Twinning successfully secularizes at least one motive in fallen woman imagery—the rescue. By being in every way like her sister, the respectable woman effects a rescue of her fallen sister because she cancels all the moral opprobrium that goes along with being fallen. Or so, at least, the twinning would have signified had anyone been able to paint it. The irony is that in this one corner of their culture, at least, the Victorians succeeded in developing a secular symbol powerful enough to replace a religious one, and they could not use it. The sister's rescue could have been a redemptive icon in which family cohesion and the perception of virtual identity substituted for a spiritual

revelation of oneness. The visual identity of the women in the painting would thus have pointed to moral identity and have been for the spectator more clinching than an assertion of the sisters' oneness in the sight of God, or of their being "sisters under the skin." But because the picture's erasure of difference would have conveyed this too powerfully subversive suggestion that there was no *moral* difference between the wife and the whore, it defied being painted and could scarcely be thought.

The approaches to the subject of the sister's rescue attest to a struggle just as the unfinished or repainted pictures of Brown, Rossetti, and Hunt do. Artists are more likely to isolate the prostitute or errant wife in paintings rather than juxtapose a fallen woman with a respectable one. Egg (in the last painting in *Past and Present*), Watts, Millais, and Stanhope, among others, show the fallen woman alone. Even when fallen and respectable women are put together, conventional restraints prevail: Richard Redgrave shows the younger sister's compassion rather than any real effort to help; Rebecca Solomon depicts a gesture rather than a rescue.

Paintings and illustrations of women, sisters or not, depict more closeness, physical intimacy, and touching than any other pictures of the period (including courting pictures, according to Susan Casteras, who has studied them comprehensively). An extreme instance is Dante Gabriel Rossetti's "*Golden head by golden head*", an illustration for the 1862 publication of his sister Christina Rossetti's poem "Goblin Market." The illustration shows the two sisters, Laura and Lizzie, asleep in each other's arms after Laura has eaten the goblin fruit but before she has felt its effects. Because the two golden-haired sisters resemble each other so closely, the scene showing them asleep could represent the time before Laura's goblin experience or after Lizzie's rescue of her sister—except for the circle of fruit-carrying goblin men in the upper left corner of the illustration. The circle might be a window or perhaps Laura's dream of the goblin men, though the poem mentions no such dream:

> Golden head by golden head,
> Like two pigeons in one nest
> Folded in each other's wings,
> They lay down in their curtained bed:
> Like two blossoms on one stem,
> Like two flakes of new fall'n snow,
> Like two wands of ivory
> Tipped with gold for awful kings.
> Moon and stars gazed in at them,

> Wind sang to them lullaby,
> Lumbering owls forbore to fly,
> Not a bat flapped to and fro
> Round their rest:
> Cheek to cheek and breast to breast
> Locked together in one nest.
>
> (184–98)

In the poem, after eating the goblin fruit Laura suffers from "baulked desire" (267); her hair turns grey and she dwindles, but she cannot hear the goblins' cry. Her sister Lizzie can, though, and wishes to help Laura, but she fears "to pay too dear" (311):

> She thought of Jeanie in her grave,
> Who should have been a bride;
> But who for joys brides hope to have
> Fell sick and died
>
> (312–15)

Lizzie offers to buy goblin fruit with a silver penny, but the goblin men want her to eat with them (380). When she will not, they assault her and attempt to make her eat, but she withstands their attack:

> Like a royal virgin town
> Topped with gilded dome and spire
> Close beleaguered by a fleet
> Mad to tug her standard down.
>
> (418–21)

Lizzie will not open her mouth to the pushing attempts to make her eat, but she laughs at all the fruit she's acquiring on the outside. The goblin men—now called "the evil people"—go away (437). Lizzie runs home to Laura:

> "Hug me, kiss me, suck my juices
> Squeezed from goblin fruits for you,
> Goblin pulp and goblin dew.
> Eat me, drink me, love me;
> Laura, make much of me:
> For your sake I have braved the glen
> And had to do with goblin merchant men."
>
> (468–74)

Laura assumes that Lizzie has "tasted" for her sake "the fruit forbidden" (479), but actually Lizzie has *risked* a sexual initiation rather than had one as Laura has. Lizzie has acquired sexual experience of a sort, but resisted assault, and her going thus far in the experience where her sister went farther makes her like enough to Laura to erase difference: Laura comes back to be like Lizzie the next morning:

> Laura awoke as from a dream,
> Laughed in the innocent old way,

Hugged Lizzie but not twice or thrice;
Her gleaming locks showed not one thread of grey
 (537–40)

The poem's conclusion tells how years later when
both of them are wives and mothers, Laura tells her
children:
 how her sister stood
 In deadly peril to do her good,
 And win the fiery antidote.
 (557–59)

With the poem as gloss, the brother's illustration
shows two moments in time, before and after the sis-
ter's rescue and the need for it. The sisters begin as
visually identical, "like two blossoms on one stem";
Laura's sexual transgression makes them differ, and
Lizzie's rescue erases the difference to make them
identical again.

Rossetti does not shrink from the lesbian sugges-
tions implicit in Christina Rossetti's poem. After all,
that text describes physical intimacy between two
women; moreover, physical intimacy between Laura
and Lizzie rescues Lizzie from the effects of a sexually
suggestive encounter between her and a number of
men, and the intimacy is imaged as a taste of the same
fruit. Dante Gabriel Rossetti scarcely veils the sugges-
tion: remove the loose gowns from his sleeping sisters
and you have Courbet's *Le sommeil* (1866).

And yet, despite such a limiting case, the sister's
rescue is usually presented as a refuge from sex, more
chaste than any of the male-female rescues of art.
Males rescue females in many nineteenth-century
pictures, but all except one of these paintings is a he-
roic rescue from romance or myth of the Ruggiero-
Angelica or Perseus-Andromeda type. Rossetti's
Found is the sole example in which the theme is
treated as a modern-life subject without mythological
trappings. The female rescue is generally free from the
sex motive that lends the male rescue one kind of ap-
peal and frequently leads to its treatment as soft por-
nography. The male rescue, whether it is by Perseus,

Gustave Courbet, Le sommeil *(1866),* Petit palais,
Photo Cliché photothèque des musées de la Ville de Paris,
© *SPADEM 1993*

Ruggiero, some unidentified knight, or a shepherd from the country, is always tainted by the suggestion that the rescued is being saved for the rescuer's use. The rescued women, in Nochlin's words, are "prisoners of sex,"[10] and they will not be liberated by choosing or finding gentler keepers. The male rescue cannot be de-sexed enough for the male to appear as Christlike and for the picture to profit by the allusion to the subject of the Woman Taken in Adultery. The sister's rescue, on the other hand, aspires to an ideal type to which others can only approximate, an attraction of likeness approaching identity, a rescue by and to oneself. Thus Dickens, for example, in his "Appeal to Fallen Women," printed for possible candidates for the Home for Homeless Women, Urania Cottage, which he managed for Angela Burdett Coutts, attempts to erase the male in the stance he takes toward the "fallen" in this situation: "And do not think that I write to you as if I felt myself very much above you, or wished to hurt your feelings by reminding you of the situation in which you are placed. GOD forbid! I mean nothing but kindness to you, and I write as if you were my sister."[11]

ARTISTS OF THE UNTHINKABLE

There is no monolithic view of women, respectable or not, to be located in art of the nineteenth century, because the views were constantly changing. The main form of discourse about women in the century, as recent studies have been insisting, "is not pronouncement but debate."[12] Painting was part of the debate and helped to create, not just reflect, views of women. As Lynda Nead says, "throughout the nineteenth century the differences between the 'respectable' and 'fallen' were defined and redefined."[13] As the view of the prostitute, for example, changed from wicked temptress or demon of society to victim, the role of the respectable woman changed from that of the angel in the house to that of the angel with a lamp, from aloof domestic model of chastity to active ministrant and model for reform. But however much the view of the two categories changed during the century, the categories remained, and remained different. Society changed its thinking, but there were still things that could not be thought. Painting, like other forms of artistic discourse and other forms of discourse in general, is one way in which a society thinks. When a particular sort of painting is not started or not finished or not circulated, one kind of thinking is not going on. And in the middle of the century, it seems that it was not possible for an artist to think that illicit sexual activity did not leave some visible sign of its distinctiveness. The problem facing artists was that painting the kind of picture we have been imagining was doubly difficult. The two women had to be visibly different, since a spectator could not intuit their difference, while everything else about the picture was asserting that the women were not different but identical. Mid-century artists found it necessary to translate the moral difference into visible, external difference, and they struggled in trying to do it. In the succeeding decades it would not only be possible to think that differences in sexuality among women might be invisible, but the apparent indistinguishability of the respectable and the fallen would be the basis for plots and situations—and reason for horror—in the novels of Meredith and Collins.

4

Looking-Glass Arts:
Connecting Paintings and Novels

IN AT LEAST ONE CASE, A NOVELIST HAD THE SAME difficulty as the painters in depicting respectable and "fallen" sisters together in a reconciliation or rescue story. The novelist is Olive Schreiner, and the work is *From Man to Man,* a book she had substantially completed before the end of 1883 but with which she struggled for the next thirty-five years, leaving it incomplete at the time of her death in 1919. Her struggle to complete the novel closely mirrors the struggle of painters to depict a similar subject.

AN UNFINISHED SISTERS NOVEL: OLIVE SCHREINER'S *FROM MAN TO MAN* (1883–1919)

From Man to Man is a story of two sisters from South Africa and of their converging experience. One is a respectable married woman and the other a prostitute, and putting them together in a narrative frame was as difficult for Schreiner as putting such sisters together in a painting was for artists earlier in the century. Rebekah, the older sister, is an example of the "new woman": she is interested in science, thinks for herself, and has strong convictions about women's sexual, economic, and intellectual independence from men. She has married an obsessive philanderer who cannot admit his philandering even when Rebekah confronts him with it and offers her own plans

for dealing with their scarred lives. Rebekah eventually falls in love with a like-minded man, Drummond, the husband of one of her husband's many lovers, a man who has spent most of his married life away from his wife (now Rebekah's neighbor) because the wife is as unlike him as Rebekah's husband is unlike her. Rebekah and Drummond search for Rebekah's sister Bertie. Bertie has attempted to live a respectable life after her seduction at sixteen by her tutor, but she is repeatedly sabotaged by the gossip that follows her. The only person whom she has told about her seduction is her cousin, on the occasion of his proposing to her. He not only breaks off with her but later tells his new wife the story, and the wife ensures that it is passed on to other gossips, most notably Mrs. Drummond.

Bertie is the kind of woman for whom independence is impossible; as her sister says, "if the life of personal relations fails Bertie, all will have failed her."[1] She goes from man to man and disappears into the underworld of London. Rebekah and Drummond begin their search for her. Here the story breaks off, and Schreiner never finished it.

For hints about the ending of *From Man to Man* we have to rely on Olive Schreiner's husband, Samuel Cron Cronwright, a man who understood little about what his wife was doing; Cronwright did not even comprehend the title his wife gave her unfinished novel, imagining that it came "from a sentence of John (later Lord) Morley's, which runs as follows, ex-

cept that I have forgotten the adjective: 'From man to man nothing matters but . . . charity.' The missing word connotes 'boundless,' 'all-embracing,' or some such large and generous attitude of mind" (ix).

Cronwright's obtuseness makes me suspect his account of the novel's proposed ending, which he says his wife had described to him. That part dealing with Bertie is especially full of Cronwright's doubtful recollections:

Drummond, persisting in his search for Bertie, found her in a house of ill fame at Simon's Town, stricken down by a loathsome and terrible disease [Cronwright cannot bring himself to write certain words: "prostitution," "syphilis," or even "a venereal disease"]. Rebekah took this dearly loved sister to her own house at Rondelbosch, where everything that love and medical science could do was lavished upon her. But alas, the rescue came too late; the ravages wrought in this tender but helpless woman were too far advanced. . . .

Some people were gathered round the dying woman's bed; I do not know all who were present, nor how it came that Mrs. Drummond was among them; but that evil woman was there. Baby-Bertie's simple nature had presumably never been troubled by the doubts, still less had it reached the conclusions, inevitable in the case of a cultured modern mind of the caliber of Rebekah's; Bertie had no doubt retained the primitive beliefs implanted early in her mind by her childlike "little mother." However that may be, as the end drew near, Rebekah leaned over her dying sister and asked her whether she would like them to pray. It is no great mental effort to remember the very words of the reply, because they seemed to me so terrific and because Olive chuckled over them. She used to style such a cut "the stroke oblique," and was always pleased, as in this instance, when she got it in at the right moment. "Let Mrs. Drummond pray," said Baby-Bertie; "she is a Christian." And so one of the two women Olive loved so passionately passed into the Silence. (461–62)

My naturally suspicious mind balks at almost every sentence of this. Mrs. Drummond's convenient presence, Rebekah's very unlikely question to her sister, Olive's chuckling over her "stroke oblique," and the remark that is supposed to come from the unmalicious Bertie but makes sense only if meant maliciously, since they are all Christians—all of these read Cronwright instead of Schreiner to me. I find myself wondering about even the basic plot line here: suppose Schreiner let Bertie live? And the continuation of Rebekah's story has a very Cronwright sort of conventionality about it:

Rebekah lived on. The sense of full comprehension and close fellowship between her and Drummond increased until they realized mutually the depth and the fitness of the undying love between them. But, as they were situated, a more intimate relationship was unwarrantable to such a woman as Rebekah; for her it was impossible to do anything which could degrade such a love; it therefore became inevitable that she must give up and leave the one man who she felt could be her life's close companion; and so they parted forever. (462–63)

The key phrase here is "such a woman as Rebekah," and the key question is whether Cronwright could have known so confidently what such a woman was like or what she would do. In any case, the very best we can say of Cronwright's account is that Schreiner could not write the very conventional ending he has outlined for us. But the *real* ending of the book, existing as it does only in our imaginations, since both Schreiner and Cronwright are now dust, the real ending of the book must, it seems to me, be a much more adventurous affair, and Schreiner's being unable to write it is much more understandable if it is. Did Bertie and Rebekah grow closer in their sense and sensibility? Could "such a woman as Rebekah" have slept with the husband whose wife had slept with her own husband? Some convergence of the sisters beyond the physical one of Bertie's return from London to South Africa appears much more likely than a tale of death for the whore and renunciation for the good wife, especially for the author who wrote of this book, "You will see, if you read my novel, that all other matters seem to me small compared to matters of sex, and prostitution is its most agonising central point" (xxvi).

THE SISTERS' RESCUE PLOT

Most novelists had less of a struggle depicting sisters than had Schreiner; at least they finished their novels. And these novels contain plots that have a clear relation to the painters' subjects, but with a difference. In painting, there is a struggling move toward rescue of the fallen sister and erasure of sexual difference. In novels about sisters an allied struggle takes place away from a rescue of a fallen sister by a male (who then gets one or the other sister as reward for his intervention) toward an unmediated heroic rescue of one sister by the other. The issue is almost always sex: the sister in trouble is fallen, prostituted, seduced, illegitimate, or otherwise compromised in a sexual way. The struggle is by no means a clear "progression" from novel to novel; sometimes the movement is retrograde, as in Dickens and Collins.

Moreover, the rescue frequently shares importance in a novel with other issues concerning the sisters and, through them, all women—issues of class, education, marriage law, inheritance, independence, and political reform. But the rescue plot is there in novel after novel.

The sisters' rescue plot derives directly from no ancient myth, but it might usefully be compared to the Andromeda myth so ubiquitous in English painting and literature during the Victorian era. In *Andromeda's Chains*, Adrienne Auslander Munich explores the pervasiveness of the myth and analyzes its political implications as a "prescription, a conservative remedy for the disease of the times." Thus, for example, in the simplest reading, Perseus's triumph over the monster from the sea reinforces notions of male superiority, and the bargain he has struck with Andromeda's parents, with Andromeda as prize, gives an official, classical imprimatur to the treatment of women as property. But Munich says the Andromeda myth can also "represent . . . conflicts in the dominant gender system:" the naked and chained Andromeda and the monstrous Medusa both signal male fears of dangerous female sexuality, and the sea monster's gender ambiguity can express uncertainties in Victorian gender typing.[2]

Rescue as Male Fantasy

Most of what has been written about the idea of rescue in the Victorian age presents it as a male fantasy. Munich, for example, looking at the Andromeda myth and its cognate, St. George and the dragon, decides that whether men are using these myths "to celebrate the rewards of a patriarchal system [or] to record their discomforts with it," it is *men* who usually invoke them. Munich admits the variation that some men, either overtly or symbolically, imagine themselves as Andromeda" (her example is Browning's *Pauline*), or, in the case of George Eliot's Daniel Deronda, can be portrayed as the object of rescue, but the rescuer in these allusions is always male.[3]

Joseph Kestner finds male aggressiveness and female passivity in rescue motives throughout classical-subject painting in Victorian England and concludes that such paintings are male vehicles expressing attitudes about male superiority and female inferiority. Kestner lists more than thirty artists who treated some aspect of the Perseus and Andromeda story during Victoria's reign.[4] Other variations of the rescue-by-the-sword included paintings of St. George and the dragon and Millais's 1878 *The Knight Errant*, also discussed by Munich. A less violent rescue subject was Keats's *The Eve of St. Agnes*, painted by William Holman Hunt (1848), Arthur Hughes (1856), and John Everett Millais (1863). More troubled and problematic was the attempt to portray the modern-life rescue of prostitutes. There were real-life subjects for such painting in the activities of people associated with the Magdalen houses; a more notorious private effort to reclaim fallen women was Gladstone's. But the subject resisted depiction, for reasons I have discussed in Chapter 3.

Sir John Everett Millais made a career out of rescue pictures. His rescuer was a young lover untying his beloved, who was accused of witchcraft during the Inquisition, in *The Escape of a Heretic, 1559* (1857), a father ransoming his two daughters in *The Ransom* of 1862, a young knight freeing a naked woman after having killed her (human) attacker in a painting already mentioned, *The Knight Errant* of 1870, an old knight with two children aboard his enormous horse in *Sir Isumbras at the Ford*, a young fireman bringing children out of the flames to an anxious mother in *The Rescue* (1855). In 1858 Millais painted the rescuer of the streets, *Gladstone*. Sometimes women and children in Millais's pictures await a rescue that may or may not come: in *Mariana* (1851), from Shakespeare by way of Tennyson, the false lover "cometh not" to the moated grange; in the 1852 *Ophelia* and *The Flood* (1870), young woman and infant stare upward as they float unaware of their peril. *The Martyr of the Solway* (1871) and *The Princes in the Tower* (1878) will definitely not be rescued. Just twice Millais paints a woman rescuing a man. In the notable year when his wife-to-be, Euphemia Gray Ruskin, left her husband, John Ruskin, Millais painted two historical pictures. In *The Proscribed Royalist 1651*, a Puritan woman helps a Cavalier who is hiding in an oak tree; and in *The Order of Release 1746*, a barefoot highland woman, modeled by Effie Gray, effects the release of her husband who has been imprisoned after the disastrous '45 rebellion. Elsewhere Millais depicts a female rescuer—*Portia* (1886)—without the male she brings back alive or the female object of a rescue—*Effie Deans* (1877)—without her female rescuer, her sister Jeanie.[5]

It is hardly surprising that in the decades of Robert Browning's rescue of Elizabeth Barrett (or vice versa), of Millais's rescue of Effie Gray (or vice versa), and of

Sir John Everett Millais, The Knight Errant *(1870),*
Tate Gallery, London

Sir John Everett Millais, The Ransom *(1862), J. Paul Getty Museum, Malibu, California*

Sir Joh Everett Millais, Sir Isumbras at the Ford *(1857),*
Merseyside County Art Galleries

Gladstone's rescue of fallen women in the streets of London (or vice versa?), that rescue should be so pervasive a topic in art and literature. But those permutations of the rescue plot in which the rescuer is a woman remain comparatively rare and tend to be limited to those works concerning sisters.

Feminizing the Rescue

Women writers as well as men adapt a story related to the Perseus and Andromeda myth. Here too there are two women, a male rescuer, and a villain. The rescued woman and the rescuer's sexual prize, one and the same in the Andromeda myth, are divided into two sisters in the new story. The rescuer releases one woman from sexual bondage and gets the other—the sister—as romantic reward. The monster is usually a false accuser or a seducer. Gradually the story changes until the sister is no longer the sexual prize but the rescuer of her endangered sister.

Shakespeare has a version of the sisters' rescue plot in *Much Ado about Nothing.* Hero and Beatrice are not actual sisters in this play, but they are, like Celia and Rosalind or Helena and Hermia, closer than the actual sisters—Bianca and Kate, Adriana and Luciana—that Shakespeare uses mostly for debates about a wife's proper place. Hero is falsely accused at the ceremony where she is to marry Claudio; he has been duped into believing Hero received a lover the night before she was to marry. After everyone has left

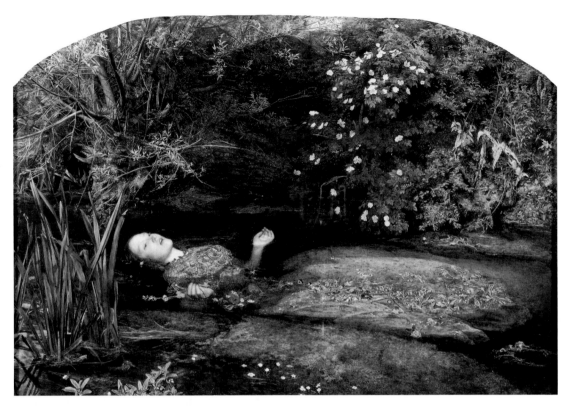

Sir John Everett Millais, Ophelia *(1852),* Tate Gallery,
London

the church, Benedick declares his love to Beatrice and asks what he can do to serve her. She replies without hesitation, "Kill Claudio." She presents it as a condition of her love for him, and he undertakes to challenge Claudio. Shakespeare's plot moves toward its resolution without an encounter between Benedick and Claudio. The sexual threat of defilement—actually a false apprehension—is defused when Claudio accepts betrothal to a *twin* of the accused woman.

Spenser's version of the rescue plot sets the two sisters against one another. Radigund, the Amazon queen, and Britomart, the heroic ancestor of Queen Elizabeth, are figurative sisters, strong, martial, and both rivals for Arthegall. But instead of one rescuing the other, the *Faerie Queene* has Britomart rescuing a man, Arthegall, from the subjection to "feminine" tasks to which Radigund put him when she conquered him. Here one woman rescues a male from another female and reinstates the "proper" relation—that is, the patriarchal one. Britomart "repeals" the "liberty of women" the Amazons had enjoyed and restores their subjection to men (*Faerie Queene* 5.7).[6]

Nineteenth-century paintings and novels attempt to give the rescue story a completely new turn on the

older variations. From these examples it can be seen that the rescue was always about gender and usually about sex. In the sister's rescue of a sister the attempt is to eliminate a sexual blot by asserting that there is no difference between a respectable woman like Rebekah and a woman who has been seduced like Bertie, any more than there would be between one man whose sexual experience was outside of marriage and another whose experience was within it. This plot works, in other words, to eliminate gender distinctions, where the Shakespeare and Spenser versions work to reinstate them. Because the nineteenth-century rescue works in this way to eliminate gender distinctions, it can have males for the objects of rescue, too, and the inclusion of men in "sisterhood" can indeed be found in the novels of Meredith, Gaskell, and Eliot that will be discussed in later chapters.

In the novel, suggestions of the rescue plot appear in novels of the 1790s by Wollstonecraft and Edgeworth. Jane Austen has two versions. In *Pride and Prejudice,* Darcy is told of Lydia Bennet's sexual plight by her sister Elizabeth. He says nothing, but proceeds to act in loosely guarded secrecy to rescue Lydia by turning her false marriage with Wickham into a real

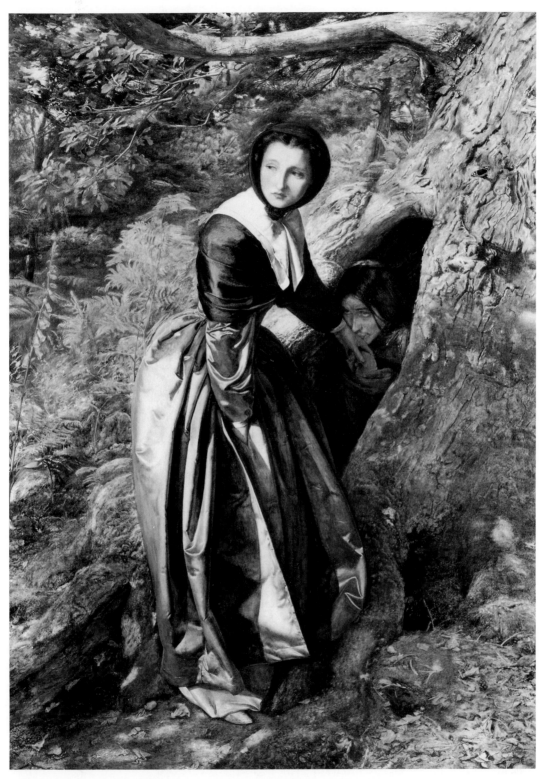

Sir John Everett Millais, The Proscribed Royalist, 1651
(1853), *Private Collection*

Sir John Everett Millais, The Order of Release, 1746
(1853), Tate Gallery, London

one. Elizabeth finds out what he has done, and the knowledge helps in her change of affection and her rapprochement with Darcy. In *Sense and Sensibility*, the encounter between the character who might be a rescuer, Brandon, and the villain, Willoughby, eerily repeats a previous encounter because of Marianne's resemblance to Brandon's first love, Eliza, whom Willoughby seduced and abandoned. Brandon's "rescue" of Marianne becomes little more than a symbolic act of fetching Marianne's mother when Marianne seems to be dying. In this version of the rescue, the love of the sister (Elinor) is not the reward for the male intervention—the reward is the love of the "rescued" woman herself.

The rescue is undertaken by the sister herself, without assistance from a male, in Scott's *The Heart of Midlothian*, when Jeanie Deans sets out for London to obtain a pardon for her sister Effie from the charge of murdering her illegitimate child. After that, all-

female versions of the story become more common. In poetry, Christina Rossetti treats the subject of a sister's rescue of her fallen sister in "Goblin Market." In novels, there are rescues or attempted rescues of sisters by sisters in *Little Dorrit, The Woman in White, No Name, Rhoda Fleming,* and *Wives and Daughters.* In *Little Dorrit, No Name,* and *The Woman in White,* one sister attempts the rescue of another who is "fallen" or caught in a sexual trap, though that trap is sometimes encoded as servitude, loss of "name" in a legal or economic rather than moral sense, or actual incarceration. In *Middlemarch* Dorothea Brooke's rescue is not of her sister Celia, though Celia in her own way makes heroic gestures toward Dorothea. Dorothea attempts the rescue of three people: her rival/"sister" Rosamond Vincy Lydgate, Rosamond's husband Tertius Lydgate, and Dorothea's own husband-to-be Will Ladislaw, who is another figurative "sister" of Dorothea. Figurative sisterhood extends, in Meredith,

Sir John Everett Millais, Portia (1886), Metropolitan
Museum of Art, New York

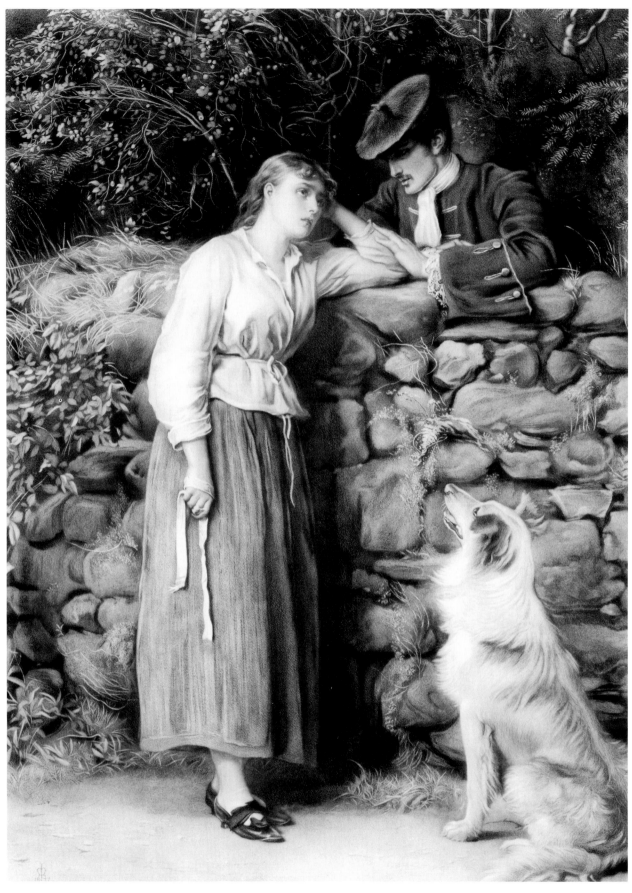

Sir John Everett Millais, Effie Deans (1877), mezzotint
by T. O. Barlow (1878), British Museum, London

Gaskell, and Eliot, to include males as well as females, but rescue in all these cases begins with literal or biological sisterhood.

KINDS OF REFLECTION

Sisters in novels, as in paintings, constitute a center for all the concerns of women in the nineteenth century: the reflections of sisters are synecdochic for those of all women. Sisters look at each other and see reminders of their own mortality; they see evidence that difference needs toleration, defense, and sometimes rescue; they see the possibility for mutual modification and remaking. On the darker side, they can look at each other and see themselves fairer, imagine that fairness is a reprieve from death, see their sisters as irreconcilably different, and imagine themselves appointed to scourge the difference.

Actual sisterhood in novels tends to put surrounding pairs or larger groups of women in a sisterly relation; sisters in novels are always accompanied by "sisters." This tendency can go so far as to include virtually every woman in the book, as it does in *Pride and Prejudice*. With a very few exceptions, the books in the following chapters contain actual sisters—women who share at least one parent. In the figurative sense, though, we can talk about sisterhood as a relation that spans books, starting with Roxana and Moll Flanders in Defoe, and Pamela and Clarissa in Richardson—each pair "sisters" of a sort though not in the same novel. Such an extension of sistering makes for conversations among novels, and it is possible to find passages, for example, where George Eliot is responding to Jane Austen and others where she is answering Elizabeth Gaskell.

These books can mirror each other and they can mirror painting. It is sometimes difficult to tell whether a novelist's description of a particular scene inspired or was inspired by a painting. Richard Altick describes hundreds of paintings derived from Romantic and Victorian novels—subjects from Scott and Dickens being the most frequent.[7] But many scenes in books and paintings may have a generic relation: In Felicia Skene's *Hidden Depths* (1866) the heroine discovers that her suitor was the first seducer of a dying prostitute she has befriended. Is this discovery Skene's invention to raise consciousness about prostitutes, or was it specifically inspired by Abraham Solomon's

Drowned! Drowned! (page 75)? Sir Edwin Landseer's *Taming the Shrew* (page 149), also called *The Pretty Horsebreaker* (c. 1861), almost certainly inspired a character in George Meredith's *Rhoda Fleming* (1865), as I will argue in Chapter 8.

Do these novels mirror reality? As we have seen in looking at paintings, the distinction between "life" and "art" is difficult when our records about the one consist partly of the other. Moreover we know that the relation is more complicated than a simple reflection: aesthetic works create ways of perceiving and categories for our perceptions, and every kind of discourse is part of the social construction of reality. But we can still generalize and say that what is going on in novels about sisters throughout the century, whether it helps make or merely reflects what is going on outside those novels, engages issues that are vital to women. I will argue interrelations between the novels discussed here and various historical events from the Porteous Riot of 1736 to the Crimean War, the Contagious Diseases Acts, the "horsebreaker" scandals of the 1850s, the work of Florence Nightingale, the Married Women's Property Act, and the reform bill of 1867. The necessity of wider access to education, the pernicious relation of class distinctions to gender distinctions, the inequity of double standards in sexual morality and in law concerning marriage and property, all of these are concerns of sisters in and out of novels, and so is a vision of women reliant on each other rather than dependent on men.

Within the course of the British novel about sisters there is a struggle toward and against change during the century. On the one hand there is a heroic and independent group of sisters compared by their authors to heroines in history, epic, and scripture: Jeanie Deans as Britomart, Molly Gibson as Una, Dorothea Brooke as St. Theresa, Rhoda Fleming as Rachel. These women attempt to preserve their sisters' lives, their autonomy, their human dignity. On the other hand a group of females threatens class distinctions, frequently in the same books where we find the heroism, and some indignant characters see society itself threatened by such women. In this group of class-crashers are Effie Deans, Fanny Dorrit, Dahlia Fleming, and most of Wilkie Collins's heroines, all threatening to displace "respectable" women of society—a plot situation with a hundred-year run from Austen's Lucy Steele in *Sense and Sensibility* to Bernard Shaw's Eliza Doolittle in *Pygmalion*. The rescue plots and the

displacement plots frequently move simultaneously.

Sisters novels create their own mythology of rescue and fear of displacement, and, like paintings, they also report on these matters in the world outside of art. Together the two arts make of sisters works the nineteenth century's most frequent metaphor for the lives of all women.

5

First Sisters in Ferrier, Austen, and Scott

THE PRESENCE OF PLOT-SIGNIFICANT SISTERS IN novels virtually always means the contestation of feminist issues in those texts. But plot-significant sisters are not there in the British novel from the beginning. Early nineteenth-century novelists are the inheritors of a tradition that makes only limited use of sisters. Fielding, Sterne, and Smollett take virtually no advantage of the opportunities offered by sisterhood for enriching plots, for multiplying formal relations of symmetry and opposition, or for showing the commonality of women's experience in ordinary social situations, such as courtship and marriage, as well as extraordinary social concerns, such as prostitution and sexual deviance. From the work of Charlotte Lennox in the 1760s to that of Susan Ferrier, Jane Austen, and Walter Scott in the teens of the new century, sisters begin to come into their own as plot movers and as representatives for all women's relation to each other. Novels during this fifty-year period establish the usefulness of the sisters subject, which is used by the major novelists of the nineteenth century. Critics have begun to attend to the pre-Austen sisters novels as important for their own sake and for what they point toward. Patricia Meyer Spacks looks at novels by Charlotte Lennox and by Jane West in her 1986 article "Sisters." She thinks that they deserve attention in our reading of Austen, who certainly read them, that their emphasis on "bad" characters must be looked at for what it says about the nature of female power (beauty and being loved = power), and that

sexual competition between sisters is inevitable in these books: "Sex provides the arena of conflict in a society which defines a woman's worth by her marriage."[1] Susan Morgan believes that novels by Burney, Edgeworth, and Ferrier are part of a new definition of the heroine that will ultimately allow for the substitution of a more humane "feminine heroic" for the masculine heroic code that had prevailed in British fiction until the nineteenth century.[2] Not enough examination has yet been made, however, of the synecdochic relation of sisters in these novels to the situation of all women. The appeal for solidarity among women always asks for symbolic "sisterhood," but literal sisterhood already depicts in small the relation of all women, and that depiction enables the concerns of all women to be expressed in novels whose scope may never seem to extend beyond the domestic scene.

LENNOX, GOLDSMITH, AND WEST

One of the first British novelists to use the sisterhood subject is Charlotte Lennox, whose *History of Harriot and Sophia* appeared serially in 1760–61 and was published as *Sophia* in 1762. Lennox limits her plot to the two women, opposing her sisters temperamentally and morally. She also makes them rivals for love. When hard times come to the widowed Mrs. Darnley and her two daughters, Harriot and Sophia,

Sophia goes into service, and her virtue wins the love of the rich Sir Charles Stanley, formerly one of Harriot's suitors. After being kept for a time by a lord, Harriot eventually emigrates to the colonies with the poor captain she has married—a method of getting rid of the "fallen" woman later to be used by Dickens in *David Copperfield* and Collins in *The New Magdalen*. Lennox's sisters have only limited interest for readers because they do not have any dimension beyond their antithesis, and they are incapable of affecting each other.

Goldsmith's Olivia and Sophia Primrose are differentiated but not opposed morally, though Olivia is more flirtatious and livelier than her sister Sophia. *The Vicar of Wakefield* (1766) makes use of the plot devices of rivalry and false rivalry between the sisters. There is also extended "sisterhood" in the sisters' relation to their eventual sister-in-law Arabella Wilmot, whom George Primrose marries after many harrowing plot turns. All three women are pursued, more or less literally, by Squire Thornhill at various times during the action, another feature that tends to "sister" them. But they are all such puppets in the rapid reversals of fortune and they are so little together that not much can be said about them as individual characters or as sisters.

The novels of Lennox, Goldsmith, and one by Jane West, *A Gossip's Story* (1797)—in which the two sisters are starkly opposed as to temperament and the sensible sister proved unerring—are hampered in introducing significant issues about women's relation to each other because the sisters are not independently realized as characters: in Lennox and West each sister constitutes only one half of a contrast, and in Goldsmith the plot moves so rapidly each sister scarcely knows what is happening to the other, so that their relation is only through reference to the title character—Olivia and Sophia are daughters of the vicar more than they are sisters to each other.

A development in the novel of the nineties brings with it sisters who do affect each other's lives, who are something more than opposed poles of a duality, whose characterization brings other women into their circle and makes figurative sisters of them, and who begin to function not merely in relation to one man but as a small society. The new development is the novel of education that makes up part of what Moira Ferguson calls feminist polemic.[3] These novels argue specifically for an enlightened approach to the education of women. Notable examples employing sisters are books by Maria Edgeworth and Fanny Burney. Susan Ferrier caps this development in the teens of the new century with a novel whose title is *Marriage* (1818) but whose real topic is education. And before the teens are over Jane Austen will have written her books, perhaps partly inspired by the novel of education but taking the subject of sisters through new virtuoso turns of social comedy. At the same time Scott will graft a true account of sisterly heroism onto a historical background at times in contest with his main story, and, despite himself, enable female rescue plots for the next century.

THE NOVEL OF EDUCATION AS FEMINIST POLEMIC

The plots of the novels of education tend to multiply sisters. Where there are sisters there are likely to be sisters-in-law or the relation created when one woman wishes her friend and her brother to marry, though one or the other has romantic interests elsewhere. Around sisters there tend to be formed figurative sisterhoods out of shared experience or romantic rivalry. "Extended" sisterhoods consisting of half-sisters, stepsisters, or sisters-in-law can also be a way of distancing women with moral or sexual differences. Sisters and "sisters" tend to be involved in romantic rivalries or in false rivalries where one sister imagines the attentions of a man are directed toward her sister when he is really wooing her. And in Maria Edgeworth's novels there is at least a hint of the rescue plot that will become an important feature of so many sisters plots from the teens of the new century on. Edgeworth writes stories in which a sisterly confidence binds two women and where there may be an anticipated further relationship of sisters-in-law. She also has plots in which one woman attempts or accomplishes what might be called an armchair rescue of another—on the analogy of the armchair detective who solves the crime from a distance. Edgeworth's plots, as Susan Morgan points out, place "the favored heroine, Belinda Portman in *Belinda*, Helen Stanley in *Helen*, at a distance from the center of the action. That center offers a traditional sexual ingénue caught in her traditional plot. The lead heroine stands to the side, as visitor, as observer, and finally as repairer of other people's lives."[4] This "lead heroine" attempts to rescue the ingénue by establishing a closer relation as her sister-in-law, but she usually fails.

In the first of such Edgeworth stories for example, the *Letters of Julia and Caroline* in *Letters for Literary Ladies* (1795), Caroline Percy is the adviser and confidante of Julia, who does not profess to think, but "only to feel,"[5] and who fears apathy more than anything else (5). The two, friends since infancy, are shortly to be even more closely related when Julia marries Caroline's brother. But instead she enters a loveless marriage with a Lord V—, and subsequent letters detail Julia's leaving her husband and Caroline's fears that she is morally disintegrating. In Letter V, Caroline writes that at recently seeing Julia she had observed "that from whatever cause the powers of your reason had been declining, and those of your imagination rapidly increasing," and "the boundaries of right and wrong seemed to be no longer marked in your mind" (57). Caroline attempts a rescue of Julia: "I no longer *advise*, I *command* you, quit your present abode; come to me; fly from danger and be safe" (60–61). But Julia disregards the advice and the command. She goes to France, apparently an encoding here for committing adultery, and when Caroline next sees her in England Julia is dying. Caroline takes her home, where Julia in her last words pleads with her own daughter, now apparently adopted by Caroline, to *be good and happy* (78).

This account would suggest that Edgeworth's main point here was an attack on Julia's exaggerated sensibility, her passion for feeling at the expense of thought, and her horror of apathy. Certainly that strain of end-of-century feminism, represented best by Mary Wollstonecraft's attacks on Rousseau in *A Vindication of the Rights of Woman* (1792), is important not only as background to Edgeworth but also to Fanny Burney and to Susan Ferrier. But I believe it may be exaggerated, for example by Margaret Kirkham, who identifies the condemnation of sensibility as the most important strain of what she calls "Enlightenment feminism."[6] Feminists in the Mary Astell-Catherine Macaulay-Mary Wollstonecraft tradition indeed begin from the argument that human nature—male *and* female—is rational and therefore should be governed by one rule of conduct. But "sensibility"—sensitivity to affect and feeling—made up *less* of an exclusive part of the gender construct for women at the end of the eighteenth century than at any time before or since, simply because the influence of people like Rousseau had made the *man of feeling* so fashionable.

In any case there is more to the *Letters for Literary*

Ladies than the *Letters of Julia and Caroline*. The book begins with the *Letter from a Gentleman to his Friend upon the Birth of a Daughter, with the Answer*. The first gentleman is a kind of straw man who knows his friend to be "a champion for the rights of woman" (2) who "insist[s] upon the equality of the sexes" (3), and he baits the new father by warning him from too much education for his new daughter. The discussion moves with startling rapidity to the question of power. The first correspondent leaps from the self-directed dangers of female power—"their power over themselves has regularly been found to diminish, in proportion as their power over others has been encreased" (10–11)—to the threat to national security female empowerment poses: "tell me whether you can hesitate to acknowledge, that the influence, the liberty, and the *power* of women have been constant concomitants of the moral and political decline of empires" (12). The answer argues that power rightly understood "is an evil in most cases" (53) and will be seen to be such by women taught properly. "If, my dear sir, it be your object to monopolize power for our sex, you cannot possibly better secure it from the wishes of the other, than by enlightening their minds, and enlarging their view of human affairs" (53). In this section Edgeworth gives variety to the play of ideas by having two men debate the issues that involve her heroines, but it is still a feminist debate, making a dialogue of the points made by Wollstonecraft and also by Catherine Macaulay.

The idealism expressed by the second male correspondent, for example, bears most resemblance to the tone of Macaulay rather than to that of Mary Wollstonecraft, and arguments from Macaulay's *Letters on Education* (1790) are frequently behind Edgeworth, Burney, and Ferrier in the works discussed here. Wollstonecraft was much influenced by Macaulay, as her moving eulogy to Macaulay in Chapter Five of the *Vindication* attests, and some of their arguments would of necessity be similar even had they been ignorant of each other's existence. But the two women are writing in historical circumstances that have given them hearing and that call out for particular arguments. The argument for women's rights from the basis of a common rational human nature, formulated so tellingly by Mary Astell in *A Serious Proposal to the Ladies* in 1694, just four years after Locke's *Essay Concerning Human Understanding*, seized *its* historical moment and made up a part of the feminist platform ever after. A century later when Wollstonecraft and Macaulay

were writing, the revolutionary spirit of the time called out for arguments based on liberty, and there were always minor circumstances, such as the temporary triumph of the Whigs, that could inspire constitutional debate points in a Whig polemicist such as Macaulay. For Astell, Macaulay, and Wollstonecraft the general arguments always began from common rational nature and from the moral conviction that virtue is genderless and requires the same instruction whether it is being nurtured in men or in women. Sometimes Macaulay's turn of phrase and sometimes Wollstonecraft's particular juxtaposition of ideas is identifiable behind a passage in Edgeworth, Burney, or Ferrier.

Edgeworth's feminist, new-father correspondent has asserted that power is an evil and that enlightenment can be relied on to make its attractiveness seen to be meretricious; Macaulay had written "I know of no learning, worth having, that does not tend to free the mind from error."[7] Then Edgeworth's writer argues that predispositions and tempers are not natural to one sex, but a consequence of education (54). A half dozen lines below her comment on learning and error Macaulay had written, "all those vices and imperfections which have been generally regarded as inseparable from the female character . . . are entirely the effects of situation and education." On the other hand, when Julia and Caroline are corresponding and Caroline attempts to talk Julia out of her conviction that "the sole object of a woman's life" is "to *please*" (12), her pleading sounds more like Wollstonecraft's ninth chapter: "Men are not aware of the misery they cause and the vicious weakness they cherish by only inciting women to render themselves pleasing."[8] But whether she is relying on Macaulay or on Wollstonecraft, Edgeworth most effectively uses feminist polemic when it is a dialogue between those whom it most concerns—the women. For this purpose the relation of the would-be sisters-in-law works most dramatically for her.

The moral supporter and confidante is an actual sister in Fanny Burney's *Camilla* (1796), another novel of education. Burney uses three sisters and a cousin to tell her complex and strangely lifeless story about the importance of moral education very early in life and the dangers attendant upon bad advice. Lavinia Tyrold is Camilla's beautiful sister, two years older; Eugenia is two years younger, intelligent, with features scarred by smallpox, and lame as a result of an accident that occurred at the time she caught the disease.

Eugenia is educated in the classics and rich because her indulgent uncle, Sir Hugh Tyrold, who feels himself responsible for her illness and her accident, spares nothing in the way of tutors and legacies. Eugenia provides subplot incidents throughout the book, but Lavinia is so like Camilla that she virtually drops out of the action. Burney needs a cousin more beautiful than Camilla or Lavinia, Indiana Lynmere, to oppose Camilla, to be a rival for the love of the man Camilla will eventually marry, and to be her foil in illustrating certain thematic principles concerning instruction. Indiana's complete self-absorption is a result of her neglected education. She eventually breaks an engagement to run off with a "wild and eccentric" Irishman named Macdersey.[9] Both Eugenia and Camilla are led into perilous situations by bad advice, but their moral foundation—based on parental instruction—is sound, and they come through.

Camilla moves rapidly and with sudden changes of fortune, very much like *The Vicar of Wakefield*, which it also resembles in the basic family situation—a vicar with several daughters and a hapless son—and some incidents—Eugenia is abducted, Dr. Tyrold is thrown into prison for debt. But the book also remorselessly presses home its themes of early moral education. The sisters and the cousin illustrate these themes for the most part, but a passage late in the book applies them to the men as well, and makes clear that moral indoctrination and instruction at a very early age is what instills "radical worth" and is more important than formal education later. Lavinia has married Henry Westwyn, the college friend of her dissipated cousin Clermont Lynmere, Indiana's brother. Lord O'Lerney is an Irish nobleman related to the Macdersey with whom Indiana has eloped, and he has pledged himself to help support his kinsman. Lavinia goes to her new home among the Westwyns:

> Like all characters of radical worth, she grew daily upon the esteem and affection of her new family, and found in her husband as marked a contrast with Clermont Lynmere, to annul all Hypothesis of Education, as Lord O'Lerney, cool, rational, and penetrating, opposed to Macdersey, wild, eccentric, and vehement, offered against all that is National. Brought up under the same tutor, the same masters, and at the same university, with equal care, equal expence, equal opportunities of every kind, Clermont turned out conceited, voluptuous, and shallow; Henry modest, full of feeling, and stored with intelligence. (909)

Early moral education creates "radical worth" in Burney's system, for men or women. Its effects surpass any imagined predispositions that come from eth-

nicity and cannot be made up by formal instruction later. Once those roots are established, further "education" does not touch them. It is a point reiterated by Astell, Macaulay, and Wollstonecraft that genuine moral education, even at the beginning, is not mere indoctrination. Pitying the condition of the young lady "taught the Principles and Duties of Religion, but not Acquainted with the Reasons and Grounds of them;" Astell writes that "her Piety may be tall and spreading, yet because it wants Foundation and Root, the first rude Temptation overthrows and blasts it."[10]

To be one of Camilla's sisters is to be morally safe, regardless of how much time one spends later in households like Sir Hugh's. The book asserts that just being a sister is enough. Burney scorns the Hypothesis of Education and the National Hypothesis, but does not address the Blood Hypothesis. What would happen if two sisters differed in this early radical training? Is it possible to imagine two sisters as different as the cousins Camilla and Indiana? To the question whether the child was predisposed from the womb for either good or evil, Astell, Macaulay, and Wollstonecraft say no, that the child is predisposed neither by the family into which it is born nor by its sex. But these ideas wait for narrative illustration until after the turn of the century and Susan Ferrier's *Marriage* (1818).

MARRIAGE AND EDUCATION

In *Marriage* (1818), Susan Ferrier puts twin sisters at the center of a novel. What results is an unsubtle moral tale but nonetheless a subtle narrative demonstration of how the binary of likeness and unlikeness can work, as the identical sisters recapitulate different parts of their mother's experience. Ferrier's narrative denies the "identity" of the sisters, or rather denies any importance to their genetic identity while it assigns everything of importance to their early education.

Lady Juliana, the pampered daughter of the Earl of Courtland, having refused a match with the fifty-three-year-old Duke of L— because she can't love him, marries the penniless Henry Douglas and ends up in his family's remote Highlands seat, Glenfern Castle. There she meets her husband's brother, Archibald Douglas, and his wife, Alicia Malcolm Douglas, a sensible, well-bred woman.

The contrast between Alicia and Lady Juliana sets up the first antithetical "sisters" pairing of the book. The two women have had very different upbringings and marriages. Rather than having been petted by her parents, Alicia was orphaned at two years of age and taken in by her aunt, Lady Audley, in London. When Alicia and Sir Edmund, Lady Audley's son, fell in love and he wished to marry her, she would not agree because of Lady Audley's disapproval. Alicia left to visit other relations in Scotland, and when, after two years, Edmund made clear he would not marry anyone else but her, in order to free him she accepted the proposal of Archibald Douglas, the oldest son of Mr. Douglas of Glenfern. She refused a love match for the sake of honor, but now lives with her husband in faithfulness and affection. These very different women will be the formative influences on the twin daughters of Lady Juliana.

Alicia Douglas tries to amuse and occupy Lady Juliana, but her "attempts to teach her to play at chess and read Shakespeare, were as unsuccessful as the endeavours of the good aunts to persuade her to study Fordyce's Sermons, and make baby linen."[11] Alicia takes Lady Juliana to her home at Lochmarlie Cottage, not far from Glenfern Castle. It is all that nature and art can make it, and even in its upkeep Alicia is busy improving the neighborhood children, whom she enlists to be gardeners. But even there Lady Juliana suffers from *ennui*, "the sad fruits of a fashionable education" (98). Where Alicia's tuition is vain in Lady Juliana's case, though, it will be wonderfully effective on her daughter Mary.

After the birth of her twin daughters, Lady Juliana refuses to nurse either child, and the Laird will hire only one nurse. Alicia offers to take the other girl. When Henry manages to get himself reinstated in the army and given an allowance by a general he knows, he and Juliana and one girl go to London. There Adelaide Julia is christened—significantly, at a ceremony scheduled to conflict with a soirée of one of her mother's rivals in the London social scene. Meanwhile her twin sister, Mary, has been quietly baptized in Scotland. For eighteen years the book allows the education of the twins to go on separately. Lady Juliana's other sister-in-law, Lady Lindore, leaves her husband to go off with a lover. Henry's expectations from his benefactor General Cameron are frustrated by Cameron's marriage, and when the Earl of Courtland dies he leaves nothing to Juliana. Penniless, Lady Juliana is received by her brother, who pays Henry's debts and secures him a regiment in India, to

which Juliana refuses to accompany him.

When she is eighteen, Mary becomes ill, and Alicia Douglas sends the girl to her mother, now in Bath, to get well. It will be her first meeting with her mother and with her sister, Adelaide, whom the narrator finds "as heartless and ambitious as she was beautiful and accomplished" (187). Ferrier, not content with contrasting the twin sisters, Adelaide and Mary, sets up yet another contrast with Lord Lindore's daughter, Lady Emily Lindore, whose character "had undergone exactly the same process in its formation as that of her cousin; yet in all things they differed" (187). Unfortunately, the introduction of Lady Emily tends to confuse all the points Ferrier has been making about the importance of education and the insignificance of one's genetic makeup. The generalization the narrator derives from Lady Emily's difference is, "It sometimes happens, that the very means used, with success, in the formation of one character, produce a totally opposite effect upon another" (187). The expected result, the narrator ironically implies, of "the sophistry of her governesses, and the solecisms of her aunt," would have been a character like that of Adelaide. But Lady Emily is neither heartless nor immoral like her cousin. At this point in the book we seem to have an optimistic theory of education developed—*Marriage* is far more concerned with education than with marriage—which asserts that there is no natural depravity, that Adelaide's spoiled character owes everything to her education and nothing to her birth. On the other hand, Lady Emily has been able partially to withstand the effects of the identical education, and what could have enabled it except some strength of character derived from birth?

The sisters finally meet, exactly halfway through the book. Adelaide, the spoiled, sophisticated twin, is controlled, where Mary is warm, emotional, and affectionate. Adelaide's "usual sweetness and placidity" (229) accompanies reserve and coolness. But more interesting than the temperamental differences ascribable to the distinct upbringings of the twins is Ferrier's differentiation of them even in physical ways. Adelaide is not only taller than Mary—not surprising considering the lamentable starving of Mary during her first few weeks, before Alicia Douglas took over her care—but even her eye color is different from her twin sister's! This careful differentiation seems to be intended to insulate the virtuous Mary from too much connection with her morally lax sister and to emphasize just what education can do.

One scene in the middle of the book is emblematic of the reunion of the cast-off child with her mother and sister:

Lady Juliana looked in upon her [Mary] as she passed to dinner. She was in a better humour, for she had received a new dress which was particularly becoming, as both her maid and her glass had attested.

Again Mary's heart bounded toward the being to whom she owed her birth; yet afraid to give utterance to her feelings, she could only regard her with silent admiration, till a moment's consideration converted that into a less pleasing feeling, as she observed for the first time, that her mother wore no mourning [Lady Juliana's father-in-law, Mary's grandfather, has recently died].

Lady Juliana saw her astonishment, and, little guessing the cause, was flattered by it. 'Your style of dress is very obsolete, my dear,' said she, as she contrasted the effect of her own figure and her daughter's in a large mirror; 'and there's no occasion for you to wear black here.' (230)

The "obsolete" style of dress is that her mother would have worn twenty years before in Scotland, when she was the age of her daughter now, before the twins were born. The narrator makes use of the peculiar way in which the twin daughters each recapitulate part of the mother's experience: Mary representing her mother's brief Scotland period, but making good use, unlike her mother, of Alicia Douglas's friendship and tutelage. Mary, for example, sincerely mourns the passing of the old laird her mother had found insufferable, and she finds affectionate friends instead of monstrous strangers in Henry's three aunts and five sisters. Adelaide's experience, restricted to the urban, the sophisticated, and the trivial part of Lady Juliana's existence, has made her so like her mother that they can represent each other, as in the passage above, which might as easily be a meeting of the twins as of Juliana and Mary.

The two most significant features of the story, as both formative and representative of the way sisters can be used in British fiction, are the differentiation of the sisters (twins, but so different in their young adulthood Ferrier even feels constrained to give Adelaide eyes colored differently from Mary's) and the apparent necessity to *construct* additional sisterly relations. Alicia Douglas, a sister-in-law, befriends and tries to educate Lady Juliana; failing that, she becomes a sister nurse-and-mother of Juliana's child, Mary. Lady Emily, who has grown up in the same household with Adelaide, the child of Juliana's brother Lord Courtland and his bolted wife, becomes—not the "sister" of her cousin Adelaide,

whose education she has shared, but the sister of Mary. Emily is attracted to Mary because the latter has a settled and educated virtue, which Emily has been unable to reach merely by reaction against the vapidity of her own education: "her notions of right and wrong were too crude to influence the general tenor of her life, or operate as restraints upon a naturally high spirit, and impetuous temper. . . . Lady Emily remained as insupportably natural and sincere, as she was beautiful and *piquante*" (187). Part of their mutual attraction is the ironic humor both women share and the fact that their liveliness, though as compassionate on Mary's side as it is satirical on Emily's, contrasts with the coldness and lack of feeling of their "sister" Adelaide.

Much is made of Adelaide's "indifference" (277). In one episode her intervention would persuade her mother to allow Mary to attend a masked ball, but she impassively refuses to help:

With a few words, Adelaide might have obtained the desired permission for her sister; but she chose to remain neuter, coldly declaring she never interfered in quarrels.

Mary beheld the splendid dresses and gay countenances of the party for the ball with feelings free from envy, though perhaps not wholly unmixed with regret. She gazed with the purest admiration on the extreme beauty of her sister, heightened as it was by the fantastic elegance of her dress, and contrasted with her own pale visage, and mourning habiliments.

"Indeed," thought she, as she turned from the mirror, with rather a mournful smile, "my aunt Nicky was in the right: I certainly am a poor *shilpit* [feeble] thing." (260–61)

In these passages one sister is the mirror of comparison for the other sister, and the fashionable mother and the fashionable sister are interchangeable in the glass, which shows the heroine, smaller and paler, in her dark garments, against the fairer, taller, and more elegantly fitted out other.

In mirroring a part of her mother's potential life, each twin makes it actual and extends it. Mary profits from the instruction of Alicia Douglas and the experience of coping with her eccentric great aunts, where Juliana was consumed by *ennui* and the desire to get out of Scotland. Though Juliana began by loving Henry Douglas, eventually she was only too happy to be separated from him. Tutored by Scots women, Mary sees their merit as well as the merit of the country and the men—eventually marrying a man with ties to Scotland. Adelaide marries a Duke twice her age, as Juliana came near doing, and the resulting

loveless marriage does not even give Adelaide the freedom that money and a title seemed to promise. Her husband, though not clever, is stubborn, and his old-fashioned ideas of propriety restrict Adelaide at every turn. When she elopes with her former admirer Lord Lindore, the man she jilted to marry the duke, she enacts a possibility from which her mother was apparently only saved by a torpor that extends to sex as well as to all her other behavior. For Adelaide, whose dispassionate if willful nature has been insisted on throughout the latter half of the book, the elopement is somewhat less believable than it is for Lindore, whose mother was a bolter.

As for Mary, her "grief and horror at her sister's misconduct, was proportioned to the nature of the offence":

She considered it not as how it might affect herself, or would be viewed by the world, but as a crime committed against the law of God; yet, while she the more deeply deplored it on that account, no bitter words of condemnation passed her lips. She thought with humility, of the superior advantages she had enjoyed, in having principles of religion early and deeply engrafted in her soul; and that, but for these, such as her sister's fate was, hers might have been. (433–34)

Difficult as it may be to disregard the sanctimonious tone of this passage, we have to admire the downright admission in Mary's last observation. The early nineteenth-century writers we are examining here have a straightforward approach that says two women of the same parents can differ in sexuality and defiance of convention to the extent that one is an Adelaide and one a Mary, one a Lydia Bennet and one an Elizabeth, or one an Effie Deans and the other a Jeanie—though Scott is so squeamish about this issue as to change his source and make the two women who show such a sexual difference only *half*-sisters. Victorian novelists are less likely to admit that such different women could have the same father *and* the same mother; frequently the connection between the unconventionally sexually active woman and the story's other important woman is attenuated to that of cousins (*Adam Bede*'s Hetty Sorrel and Dinah Morris) or that of niece and aunt (*Mary Barton* and her aunt Esther), or the blood relation is removed entirely.

Ferrier uses sisters to show us the development of moral difference, demystifying sexuality by making it a matter of education. In the first hundred years of British novelists' use of the sisters subject, only Aus-

ten is able to do more with the plot potentialities offered by the sisters' relationship.

Sisters and Difference

Differences of height and coloring have always been used by authors and painters to reflect temperamental variations among women. Shakespeare's use of the device demonstrated its efficacy in helping gender identification: it could even be employed in transvestite theater when the repertory company had two teenage boys of markedly different height. The taller became Helena, Portia, or Rosalind; the shorter, Hermia, Nerissa, or Celia. The only other difference was a wig color. The difference somehow made each boy actor more convincingly gendered as a woman character. In nineteenth-century novels, the differences of appearance tended to enact or to encode ethical or sexual difference or more subtle differences of temperament that could include or transcend ethical and sexual difference. In *Marriage*, a difference in appearance conveys one of ethical education—conscious morality versus amoral laxity or ignorance. Eventually, with the bolting of Adelaide from her marriage to Duke Altamont, the educational difference becomes ostensive as sexual difference. In *The Heart of Midlothian*, contemporaneous with *Marriage*, and in *Rhoda Fleming* decades later, the taller, fairer sister is sexually active while the darker sister is chaste, but it would be a mistake to generalize about the way these differences dispose themselves, because frequently the darker of a pair of sisters or women closely related in a plot—Rebecca and Rowena in *Ivanhoe*, for example—is the more sexually *attractive* or the one, like Mary here or Elizabeth in *Pride and Prejudice*, with whom almost all of the eligible men are in love and to whom two or more propose. Smaller can also mean more acceptably passive, in the manner of Little Dorrit and of Fanny Price in *Mansfield Park*. In books such as *Cranford*, *Wives and Daughters*, and *Middlemarch*, activity is once again presented as praiseworthy—as it had been for Elizabeth Bennet, for example, in *Pride and Prejudice*. Dorothea itches to improve the lot of those about her and that of the larger world—but her activity also implies a measure of discontent. The apparent passivity of Celia and of Rosamond, on the other hand, reveals a complacency that approaches ethical anaesthesia or conceals an active and discontented manipulation through gender.

Difference is always exploited in sister plots, and it is a force always striving to blow the plots apart and destroy the advantages to be gained from the sister relationship. In *Marriage* the plot manages to so distance the heroine from both sister and mother that the relation is effectively lessened to a kind of step-relation. In fact, the archetype behind this story is the tale of Cinderella. Lady Emily brings up the Cinderella comparison—in this case it is real mother and real sister both playing wicked stepsisters (328), and it is also Lady Emily who points out that Mary's relation with her sister and mother is characterized on their side by "prejudice, narrow-mindedness, envy, hatred, and malice" (318). These are strong words—more so, perhaps, as applied to the woman conceived and born with Mary than to the woman who conceived and bore them both. The book's point about the importance of education requires the close relationship of the two women so disparately educated, but it is significant that no novelist of any reputation twins women at the center of a story again in the century. Dickens's tentative use of twins in *Little Dorrit* comes near to destroying sympathy for the characters in his subplot. Any suggestion of a resemblance near twinning is enough to infuse a plot with danger, as is the case with the Eliza/Marianne resemblance in *Sense and Sensibility* and the Anne Catherick/Laura Fairlie near identity in *The Woman in White*.

FROM THE NOVEL OF EDUCATION TO THE COMEDY OF SISTERHOOD

Margaret Kirkham believes that Jane Austen uses her novels to develop the "Enlightenment feminism" of Mary Wollstonecraft and she argues "the resemblance between Wollstonecraft and Austen as feminist moralists" by citing Austen on the need for reason, by simplifying Austen's position into a clear choice for sense and against sensibility and by showing the antipathy of both Austen and Wollstonecraft to James Fordyce's sermons.[12] That Austen admires the achievement of Edgeworth and Burney and that she agrees with the basic tenets that had been stated by Mary Astell and iterated by Macaulay and Wollstonecraft seems clear not only from Kirkham's evidence but from reading any one of the novels. But what Kirkham makes of this evidence diminishes Austen's original feminism, a comic vision potentially more subversive than any eighteenth-century feminist

polemic. Kirkham, for example, calls Austen's "scepticism about Romanticism largely a product of her feminism,"[13] a breathtaking judgment that takes credit away from Austen and simply throws it away; she could hardly argue that Austenian ironies are really attributable to the prose of Mary Wollstonecraft.

Austen goes far beyond the novels of education to see what a sister who was not a foil or a rival might actually be like to live with, and by extending sisterhoods she makes visible and believable the almost infinitely drawn out, changeable, but no less real relation that exists among all the women in a given society. Moreover we find in two of her books the first hints of the female rescue plot that marks so many sisters books throughout the century.

Austen contains and resocializes the sexual difference of sisters. She constructs a plot in which two women with the same father, the same mother, and the same education, neither aristocrats nor lower-class women but the daughters of a gentleman, behave as differently sexually as Elizabeth and Lydia Bennet do in *Pride and Prejudice* without the destruction of the erring sister. She does not argue that education is what makes the difference, as Susan Ferrier's *Marriage* does, nor that different mothers are responsible (*The Heart of Midlothian, Wives and Daughters*), nor that their class explains their behavior (*Rhoda Fleming*). Elizabeth and Jane condemn the sexual difference of Lydia, but the book does not. Austen solves the "problem" of sisters before it is even discovered to be a problem. She allows her books to confront immediately sexual difference, difference in sensibility, difference in choosing a spouse (love at first sight versus careful vetting of the prospective bridegroom, for example) and declares yes, sisters are different, but the difference is not quite so simple as that one is wrong and the other right. Her books do not pronounce on these matters. Her characters do, of course; that is what we expect of them. But when Elizabeth says of Charlotte Lucas's approach to marriage, "It is not sound," and when you and I agree, reader, that it is not sound, all Elizabeth and we have affirmed is that it is not sound for Elizabeth or for us. The moral always turns out to be a limited assertion: rather than insisting that only prudent choices lead to happiness, *Pride and Prejudice* particularly affirms that the prudent are only happy when choosing prudently.

This is not to say that Austen is a moral relativist; nothing could be farther from the truth. She allows the world within her books to go on in ways that ignore moral distinctions, but she knows that Elizabeth is right and that Lydia is wrong. But Lydia does not know it. If Lydia were capable of moral thinking, her conscience would eventually get the better of her and she would rue her behavior. But she does not, and her immediate world, rather than turning away to make her miserable, rallies to give her practically everything she regards as happiness. Uprightness and compassion—right action on the part of Mr. Gardiner and especially of Darcy, do not show Lydia and Wickham that their actions have been wrong. Society readjusts to include the Wickhams.

Pride and Prejudice and *Sense and Sensibility* are books about being in the world with others, living very close to them, and living with them. These others are least significantly mothers and fathers, more significantly spouses-to-be, and most significantly, sisters. Austen's other books are not about precisely this experience. The necessity that Emma feels to construct a sister in Harriet Smith testifies that Emma does not live with others in quite the same way the Bennet and the Dashwood sisters do. Although sisters are important in *Northanger Abbey, Mansfield Park*, and *Persuasion*, these books and *Emma* are really about a young woman alone and able to choose whom she admits to the place of sister/mirror/contrast/mentor/confidante.

First Impressions: Pride and Prejudice *(1813)*

Pride and Prejudice insists that all its women are sisters. In its first two pages, before we know (perhaps before Austen knows) that Elizabeth's consciousness will be our privileged viewpoint on the world of Longbourn, Netherfield, Meryton, Hunsford, Rosings, and Pemberley, we range down from "some one or other of [the] daughters" of the "surrounding families" to Mrs. Bennet's "our girls" to the realization that there are no fewer than "five grown up daughters" in the Bennet household. What is no more obvious at this point than our eventual limited point of view through Elizabeth is that Austen has embraced the idea of using sisters so enthusiastically that she will not stop with the five daughters in the Bennet household but will construct relationships that imitate those of sisters among all the women in the book. Differences and likenesses among the actual five sisters of the Bennet family are complemented by comparisons and contrasts among sisters, such as Mrs. Bennet and Mrs. Philips; sisters-in-law, such as Mrs. Bennet and Mrs. Gardiner; and

pairs of women who are revealed to have common interests or common ends, even if they do not at first know it or would not admit it—"sisters" such as Mrs. Bennet and Lady Catherine, Georgina Darcy and Lydia Bennet, as well as Charlotte Lucas and Elizabeth Bennet. The reader progresses through the realization of the sistering of such characters half a beat ahead of the heroine. The effect of all this is a reconstitution of society around the women in a comedy that neutralizes or makes unwilling allies of the threatening "sisters"—finally only Miss Bingley and Lady Catherine—and asserts universal sisterhood.[14] But all of this begins with the actual or literal sisters in the Bennet household, of whom the most significantly linked are Elizabeth, Jane, and Lydia.

At last even the unlikeliest of pairs of women—Mrs. Bennet and Lady Catherine de Bourgh—are brought together in Elizabeth's and Darcy's consciousness and in ours. Elizabeth cringes for her mother's purposeful rudeness to Darcy (Chapter Nine) at the time of Jane's recovery from her illness and for her mother's lack of restraint at the Netherfield ball (Chapter Eighteen), when Mrs. Bennet crows of Jane's conquest of Bingley: "Elizabeth blushed and blushed again with shame and vexation."[15] Darcy does not blush at Rosings when Lady Catherine is rude to Elizabeth in consigning her to practice piano in the housekeeper's room, though he "looked a little ashamed of his aunt's ill breeding" (173). From that moment there is a convergence. Darcy conquers his aversion to Mrs. Bennet enough to propose to Elizabeth, but unfortunately he does not conquer his urge to state the aversion. Even more than his proposal, his letter of explanation after Elizabeth's refusal strongly condemns "that total want of propriety so frequently, so almost uniformly betrayed" by Mrs. Bennet (198). But this Elizabeth accepts as "mortifying, yet merited reproach" (209). Later Elizabeth goes head-to-head with Lady Catherine and bests her—a scene that does more for class iconoclasm in this century's novel than anything before Dickens. One of the dozens—perhaps hundreds—of symmetries in the book is that Mrs. Bennet's strenuous efforts to marry her oldest daughters go far toward foiling both Elizabeth *and* Jane's prospects, while Lady Catherine's full-dress state visit to quash the Darcy-Elizabeth romance revivifies it: "they were indebted for their present good understanding to the efforts of his aunt" (367). Darcy says, "Lady Catherine's unjustifiable endeavours to separate us were the means of removing all my

doubts" (381). Elizabeth has the last word on the officiousness of Lady Catherine, which parallels the officiousness of Mrs. Bennet: "Lady Catherine has been of infinite use, which ought to make her happy, for she loves to be of use" (381).

The actual sisters begin to be differentiated as soon as they have been likened. Three chapters are enough to do it at the same time as getting us well into the two main romances. The first chapter opens and closes with likeness: the sisters are alike in being the potential wives of which a single man in possession of a good fortune is in want, and they are alike in having as parents Mr. Bennet ("quick parts, sarcastic humour, reserve, and caprice") and his wife ("mean understanding, little information, and uncertain temper"—not quite a neatly balanced opposition). What we get of their differences is partly prejudice (Mr. Bennet's for Elizabeth, which the reader shares, and Mrs. Bennet's for Lydia, which the reader does not) and partly observation that will be confirmed by others: Jane is beautiful and Elizabeth is quick. In the second chapter we learn that Lydia is the youngest and tallest, Lizzy is the second, and the other daughters are named: Kitty and Mary. Mary is characterized as a would-be savante. Jane does not speak and is not mentioned at all. By the time we conclude Chapter Three, we not only have seen the interest shown in Jane by Mr. Bingley and the lack of interest shown in Elizabeth by Mr. Darcy, we have all the daughters arranged. We know that there are five, and a passage near the end goes down through the ranks:

> Mrs. Bennet had seen her eldest daughter much admired by the Netherfield party. Mr. Bingley had danced with her twice, and she had been distinguished by his sisters. Jane was as much gratified by this, as her mother could be, though in a quieter way. Elizabeth felt Jane's pleasure. Mary had heard herself mentioned to Miss Bingley as the most accomplished girl in the neighbourhood; and Catherine and Lydia had been fortunate enough to be never without partners, which was all that they had yet learnt to care for at a ball. (12)

A scene in Chapter Four between the two eldest sisters establishes the contrast between them while centering Elizabeth for the first time in the narrative, giving us overt access to her mental life that was only hinted at previously ("Elizabeth remained with no very cordial feelings toward him. . . . Elizabeth felt Jane's pleasure"—12). Chapter Four breaks neatly into thirds, contrasting Jane and Elizabeth, giving us a view of Bingley's sisters (starting with an authorial

confirmation of what Elizabeth has just been thinking about them), and contrasting Bingley and Darcy. These symmetries set up the correspondence Jane-Bingley, Elizabeth-Darcy when nothing except the perversity of their first encounter and the close, worthy sisterhood of the older Bennet girls points to the latter pairing: the reader is certainly not going to be content with Darcy's being forfeit to Miss Bingley.

A figurative sisterhood between Charlotte Lucas and Elizabeth is next developed. During the rest of the book, Elizabeth will be concerned with one or the other of her blood sisters or with Charlotte, even when she seems most occupied with her own concerns. While she is at home and Jane is too, she and Jane share an almost complete confidence. From the time of Elizabeth's visit to Pemberley until late in the book, Lydia is never far from her thoughts, though this sisterly relation lacks mutual confidences. And during Elizabeth's visit to Hunsford, Charlotte fills the place of Jane.

Charlotte is, of the Lucas children, "the eldest . . . a sensible, intelligent young woman, about twenty-seven . . . Elizabeth's intimate friend" (18). Charlotte feeds Mrs. Bennet's vanity by repeating Bingley's compliments on Jane, and she tweaks Elizabeth on Darcy: "Poor Eliza!—to be only just *tolerable*" (19)—at least a hint that Charlotte would have considered such a remark about herself a compliment. The two women contrast in beauty as well as age—Elizabeth, we learn later, is twenty. All of the eligible young men in the book except Bingley—Darcy, Mr. Collins, Wickham, Colonel Fitzwilliam—fall in love with Elizabeth or come as near to it as they are able, and she turns down two overt proposals, while Charlotte accepts the first one offered her, though it is from Collins on the rebound from Elizabeth. But Charlotte is introduced to us as sensible, intelligent, and Elizabeth's particular friend, so that when she gives advice in Chapter Six, we listen as carefully as Elizabeth. She advises that Jane should not conceal her partiality for Bingley and that if she married him after two weeks' acquaintance she would be just as likely to be happy as if she had known him for a year—but Elizabeth thinks both her observations are faulty. Events prove Charlotte right about Jane's reserve: according to Darcy's account, had Darcy or Bingley seen Jane's interest, the one friend would not and could not have persuaded the other to abandon her. The entire Elizabeth-Darcy romance, asserting that marriage partners need to assess each other at length and prove

their match in different venues and social tests, is set against Charlotte's second point. But the Jane-Bingley romance seems to argue for it.

At a gathering at her own house, Charlotte acts as matchmaker by pushing Elizabeth into performing at a moment when Darcy's attention is focussed fully upon her. Charlotte has not seen Darcy's pride (nor Elizabeth's, in being something more than tolerable in beauty) as an obstacle to a match. Her likeness to Elizabeth (and thus her intimacy with her) and her unlikeness (viewing Darcy differently) serve to make Charlotte push her friend and Darcy together. Yet her premise for so acting seems to be, as Elizabeth points out, "not sound" (23).

Darcy meanwhile recommends himself to the reader by beginning to fall in love with Elizabeth, a process Austen describes in a paragraph that begins with the symmetries of the situation: "occupied in observing Bingley's attentions to her sister, Elizabeth was far from suspecting that she was herself becoming an object of some interest in the eyes of his friend" (23). Elizabeth does not see herself and Darcy mirrored in the image of her sister and Bingley. She avoids "reflections" of herself in other women who could be mirror images all through the book, out of a necessity of character. It is part of the honesty (and humor) of her self-perception that she not see herself reflected when she looks at Jane: "But that is one great difference between us. Compliments always take *you* by surprise, and *me* never" (14). She cannot see herself reflected in Charlotte when the latter's sentiments reduce to "nothing is in question but the desire of being well married" (22). She cannot see herself reflected in her mother; despite her affection for her father, she sees what is wrong with that match. Even Mr. Bennet acknowledges it at last: "My child, let me not have the grief of seeing *you* unable to respect your partner in life" (376). Mirrors are a danger Elizabeth understands, and she quickly perceives and feels the folly of having fallen in love with the image of her own *understanding*. After reading Darcy's side of the Wickham story, Elizabeth chides herself:

I, who have prided myself on my discernment!—I, who have valued myself on my abilities! who have often disdained the generous candour of my sister, and gratified my vanity, in useless or blameable distrust.—How humiliating is this discovery!—Yet, how just a humiliation!—Had I been in love, I could not have been more wretchedly blind. But vanity, not love, has been my folly.—Pleased with the preference of one, and offended by the neglect of the other,

on the very beginning of our acquaintance, I have courted prepossession and ignorance, and driven reason away, where either were concerned. Till this moment, I never knew myself. (208)

If a sisterly mirror can be admonition, the Lydia/ Wickham marriage should be a young cautionary example for the reader and Elizabeth to put beside the older one of Elizabeth's parents. But Elizabeth is not an empty-headed girl like Lydia—or like her mother at the time of her marriage. None of Elizabeth's sisters is more like her mother than Lydia, and Wickham is as vicious as Mr. Bennet is aloof ("indolent" is Elizabeth's word—283). But it is precisely *as* cautionary example that Lydia's elopement and marriage do not come up to the nasty expectations of ruin and misery entertained for them by people in the book. Elizabeth's first reaction is, "she is lost for ever" (277), which looks like plain good sense rather than hyperbole. Later, with Elizabeth, even Jane alludes to "the horror of what might possibly happen" (292).

But because of Wickham's avarice and Darcy's assiduity, Lydia is not "ruined." When it is known that she will marry Wickham, only Elizabeth sees the irony of the family's joy, and she speaks of it to Jane:

"And they are really to be married!" cried Elizabeth, as soon as they were by themselves. "How strange this is! And for *this* we are to be thankful. That they should marry, small as is their chance of happiness, and wretched as is his character, we are forced to rejoice! Oh, Lydia!" (304)

We can imagine Elizabeth as reader of *Clarissa*, perceiving the irony of her own urging, along with Anna Howe's, that Clarissa marry Lovelace. But in that book the readers join Anna Howe to urge the marriage, hoping that Clarissa may be saved and failing to acknowledge that they are in a tragedy. In this book we readers know we are in a comedy, and we join in urging the marriage with the full sense of its irony (at least after the heroine has informed us of it).

Lydia is not ruined. Nor is she shamed. On her wedding day she arrives at the Bennets: "Lydia was Lydia still; untamed, unabashed, wild, noisy, and fearless" (315). It is Elizabeth who is abashed: "*She* blushed, and Jane blushed; but the cheeks of the two who caused their confusion, suffered no variation of color. . . . They seemed each of them to have the happiest memories in the world. Nothing of the past was recollected with pain. . . ." (316)

Nor is the couple even ostracized. Wickham's commission takes them to the north of England, but that is none of Darcy's or Mr. Gardiner's doing. Mr. Bennet is talked out of his brief refusal to admit Lydia and Wickham to Longbourn by Jane and Elizabeth herself. Wickham will never be welcome at Pemberley, but Lydia, to whom Elizabeth frequently sends money, visits when Darcy is away, and both Wickhams visit the Bingleys at length. It is comedy after all, and the worst that is visited upon the Wickhams is an "unsettled" manner of living (387) and affection that changes to mutual indifference. They are cautionary examples that look uncommonly subversive: sexual laxity gets rewarded. Patricia Meyer Spacks suggests this feature of Austen's work is forecast in *Sophia* and *A Gossip's Story* in the way "the actual outcome of sexual laxness seems oddly muted" and "The relative lack of punishment for sexual deviation in these novels underlines the emotional ambivalence manifest in them." Spacks continues:

The implicit double assessment of beauty, both important and meaningless; the plots which reveal the greater freedom of the weak or wicked even as the narrative voice insists on the penalties of misdoing: these aspects of the novels, like their curious treatment of sexual misconduct, convey more complicated attitudes than the texts ever acknowledge. One conspicuous difference between Austen and her predecessors involves the later writer's capacity to *use* the ambivalence which Lennox and West betray, but do not openly admit."[16]

More subversive is the way principles of will and action that the whole course of the book works to make repulsive for Elizabeth are celebrated and rewarded in others. In the discerning people, Darcy and Elizabeth, first impressions are shown to be erroneous and dangerous to one's happiness. If there is anything like love at first sight that happens to Elizabeth, it is in her brief infatuation with Wickham, which Elizabeth learns to regret. Few novels use so much time and space as *Pride and Prejudice* to get their eventual lovers of one mind after *unfavorable* first impressions. This slowness of maturation becomes a subject for ridicule by Elizabeth. After Darcy's second proposal and Elizabeth's acceptance, Jane wonders how long her sister has been in love with Darcy. "It has been coming on so gradually, that I hardly know when it began," Elizabeth answers, "But I believe I must date it from my first seeing his beautiful grounds at Pemberley" (373). The reader knows better than Jane how much actual truth there is in what Elizabeth intends—and Jane takes—for a joke. But finally we are left not with a moral or cautionary tale in which the multiplication of sisters teaches us over and over again this same tale

of how we should plan, choose our mates, and marry wisely. We are left with marriages that seem to occur as they must, with as little (Lydia-Wickham) or as much (Jane-Bingley) expectation for happiness as the world ever offers, and a marriage (Elizabeth-Darcy) that shows us *not* that prudent choices lead to happiness but that the prudent are happy choosing prudently. If there is moral judgment in the book, it has come before any plot events, in rating the *capacity* of each character for happiness.

Jane herself has no gradual growth of regard for Bingley, nor is there anything gradual about his for her. The two of them have characters wholly visible on the surface; there is nothing further to be learned than what they display. Their ingenuousness operates so well as foil for the more complex characters of Elizabeth and Darcy, the reader can forget just how charming they are and just how hard Elizabeth fights to make sure that love at first sight is rewarded in their case. Despite a good deal of firm talk about this mode of operating, the impulsive marriage decision seems to be the rule all around Elizabeth. When her friend Charlotte Lucas says Jane will have as good a chance of happiness marrying Bingley after a fortnight's acquaintance "as if she were to be studying his character for a twelve-month," Elizabeth laughs and says "You know it is not sound, and that you would never act in this way yourself" (23). She is very quickly proved wrong about the second half of her reaction, at least, and Charlotte's low expectations about marriage prepare us, if not Elizabeth, for her seeming content at Hunsford. Charlotte, alone at Hunsford in her room away from Collins, and Mr. Bennet, alone in his library at Longbourn, are the only characters who rue a marriage decision, but their partners are so comically unpleasant that sympathy for even Charlotte's decision is difficult.

Bingley, like Jane, also has the power of quickly falling in love, and he is rewarded for it, after delays caused by Darcy, who has not that power. Bingley's reward is the most charming of women in the book, after Elizabeth herself.

One of the most important obstacles to the considered, conscious, slow-forming, and informed romance of Elizabeth and Darcy is her defense and his disregard of the right of others to choose hastily (and well). The book's first title and its second are usually taken as warnings, but *First Impressions* would have been and *Pride and Prejudice* is a romance in which love at first sight is described with sympathy, defended with pas-

sion, and rewarded with happiness the readers cannot help feeling will be as genuine and long as that of Elizabeth and Darcy, without being complicated by deep, intricate character.

Second Attachments: Sense and Sensibility *(1811)*

I have said that Elizabeth does not see herself and Darcy mirrored in the image of her sister and Bingley and that her character keeps her from finding reflections of herself in other women who could be seen as mirrors for her. In *Sense and Sensibility* each sister watches the other and sees a contrast with her own image, but the contrast lessens as the book progresses. To this end, Elinor and Marianne Dashwood are kept together practically every moment, through romances, romantic crises, physical crises, and romantic resolutions. Their relentless proximity shows by contrast how much of the time Jane and Elizabeth are separated in *Pride and Prejudice,* and separated, moreover, during some of the most telling of the experiences of each: Jane's growing disappointment at Bingley's failure to call in London, Elizabeth's growing acquaintance with Darcy at Rosings, his proposal at Hunsford, and their reacquaintance at Pemberley. Elizabeth's significant sisterly relation during the book's action is not merely with Jane but also with her figurative sister Charlotte and even to some extent with Lydia. Elinor's sister is only Marianne, first and last.

Sense and Sensibility has less symmetry while managing to seem more contrived than *Pride and Prejudice.* The principals, contrasting sisters, are flanked by other contrasting sisters: the stupid Anne Steele and the cunning Lucy Steele, the aloof, indifferent Lady Middleton and her nosy, scatterbrained sister Mrs. Palmer. But contrasting relations turn out to be far less important than those working toward likeness or identity. Here the important pairs are Elinor and Marianne (along with their abstracted qualities of sense and sensibility—a false opposition to begin with), and each sister paired with her rival, the first "attachment" of the man each will eventually marry. The prior attachment in Brandon's case, the unfortunate Eliza whom he lost through no fault of his own, seems a first attachment much more complimentary to him than Lucy Steele's to Edward. The novel might almost be called *Second Attachments:* all the men have had them and so by the end has Marianne,

who learns they are acceptable and that her prejudice against them has been unfeeling as well as unthinking. Marianne's prejudice reflects, as Elinor says to Brandon, "on the character of her own father, who had himself two wives" (56).

Romance shifts attention toward the *likenesses* rather than the differences between the two sisters, between Elinor and Lucy Steele, and between Marianne and Eliza. In the last case the relationship is a resemblance that arrests Colonel Brandon at his first seeing Marianne and impels his love for her. This twinning between Marianne and Brandon's former, lost love is the starting impulse for a romance that will eventually end happily. Later in the century, twinnings will become more ominous and dangerous: In Dickens's *Little Dorrit*, Pet Meagles's twin is dead; in the novels of Wilkie Collins, twinnings will threaten displacements of one woman by another, displacements seeming to endanger the whole social order and involving money, class, and respectability.

Elinor and Marianne Dashwood are far from the antithetical sisters of Lennox, West, or Edgeworth. The opposition of sense and sensibility does not contain or epitomize the two because both are sensible and feeling. These two sisters are the closest thing to co-heroines that can be found in any of the novels. On the one hand we see through Elinor's consciousness; on the other Marianne is the main attraction—more men fall in love with her than with the "heroine." Where Elizabeth Bennet, Fanny Price, and Anne Elliot all attract more lovers and proposals than their sisters (and Emma more than her metaphoric sisters Jane Fairfax and Harriet Smith), in *Sense and Sensibility* Marianne is the romantic center without being the narrative center of consciousness. Elinor's romance with Edward Ferrars is not centered as the book's main concern; it is set up in the first three chapters and resolved in the last three. Elinor never doubts Edward or imagines that he really still loves Lucy Steele, and she can scarcely believe that he ever did. Marianne, on the other hand, is loved and actively wooed throughout the rest of the book by Willoughby and Brandon. And Willoughby's villainy is not permitted to cast doubts on Marianne's worth. It is scarcely allowed to impugn her judgment. Instead, Willoughby is carefully rehabilitated in order to demonstrate to Elinor and to us that Marianne did not invent the seriousness of a romance that amounted to a tacit engagement.

These sisters are each other's mirrors in a way also unique to Austen novels. The mirroring of one sister serves to modify the other's behavior, and Marianne's behavior is not always the one being corrected.[17] The changes are most significantly represented in the alteration of attitudes of the two women toward two men, both Marianne's lovers.

Elinor changes her mind about Willoughby, and the change is one sign of the whole expansion of sensibility that Marianne effects upon her sister. Elinor's assent that Willoughby is not completely worthless is called forth at the dramatic moment when her sister has just passed the crisis in her fever. We are likely to think that Willoughby's extraordinary visit to Cleveland occurs because Marianne needs to hear, or wishes to hear, that she had not completely invented Willoughby's love for her: when she finally is told, her reaction is "I have now heard exactly what I wished to hear" (350). But Willoughby's recital first and most significantly convinces *Elinor* that Willoughby, because he cared for Marianne, was not thoroughly wicked.

Willoughby's role as the man of feeling is exploded even before his mercenary engagement is revealed, when we watch him operate in company, cutting the frantic Marianne and trying to save himself from the reproaches of his fiancée—although she, too, apparently, is so cold as to be angered without being hurt or throwing him over.

Marianne's change from scorn for Brandon to love for him at the end of the book looks at first like her complete capitulation to sense at the expense of sensibility, but Brandon is eventually revealed to be the only genuinely *romantic* male character in the book, and thus eminently suitable for Marianne. When he first appears on the scene we might well expect that his most suitable match is with Mrs. Dashwood, who is "hardly forty" (10), and bears a "strikingly great" resemblance to Marianne (6) and therefore to Eliza also. Elinor uses the words "sense" and "sensible" relentlessly about Brandon when she, her sister, and Willoughby first discuss him. Marianne, looking at Willoughby, decides without much examination that Brandon has "neither genius, taste, nor spirit" and that "his understanding has no brilliancy, his feelings no ardour, and his voice no expression" (51). But Brandon's sensibility is gradually exposed. He falls in love instantly with Marianne because she uncannily twins his lost love, and he perseveres in his suit though everyone thinks it doomed. His former love, Eliza, was a ward of Brandon's father (at one point he

calls her his "unfortunate sister"—207), with whom Brandon fell in love and whom he was prevented from marrying. He has been willing to sacrifice his reputation to take care of Eliza's daughter, and he has challenged and fought the daughter's seducer Willoughby. He is willing to make every sacrifice to aid Marianne's recovery, knowing that she is likely to thank him but feel nothing more than polite gratitude toward him. Colonel Brandon is a man governed by passionate loyalties and completely uncalculating about what those loyalties make him appear—because of mistaken rumor or true knowledge of the facts—to the world. Elinor comes to know Brandon's sensibilities before her sister, and as a measure of her assimilation to her sister, she comes to appreciate them as well.

The last surprise in *Sense and Sensibility*—after Elinor's grudging recognition of some worth in Willoughby and Marianne's change from aversion to Brandon into love for him as her husband—is the removal of the obstacle to Elinor's and Edward's union. Since Edward's "first attachment," Lucy Steele, is calculating and heartless, her abdication to Edward's rich brother is less of a surprise to the reader than it is made to seem to Elinor and Edward:

Lucy's marriage, the unceasing and reasonable wonder among them all, formed of course one of the earliest discussions of the lovers; and Elinor's particular knowledge of each party made it appear to her, in every view, as one of the most extraordinary and unaccountable circumstances she had ever heard. How they could be thrown together, and by what attraction Robert could be drawn on to marry a girl of whose beauty she had herself heard him speak without any admiration—a girl, too, already engaged to his brother, and on whose account that brother had been thrown off by his family—it was beyond her comprehension to make out. To her own heart it was a delightful affair, to her imagination it was even a ridiculous one; but to her reason, her judgment, it was completely a puzzle. (364)

In fact the pair are a complementary match, a marriage made in hell that couples the obtuse and affectless Robert with the ignorant Lucy, whose "want of information" (127), selfish disregard for everyone's feelings, and bad grammar have tortured Elinor all through the middle of the book. To Elinor's "reason, her judgment, it was completely a puzzle"—the weighting of the sentence here signals a change in Elinor's views. Though her reason is puzzled—a fact mentioned last—the puzzlement does not prevent her heart's being delighted and her imagination amused. The sentence could describe the comic muse looking at human affairs. Here it describes an Elinor trans-

formed, no longer the woman to whom her mother had once said, "Oh! Elinor, how incomprehensible are your feelings! You had rather take evil upon credit than good" (78). Elinor has become more closely assimilated to the mirror of her sister.

Little Rivalry, Few Confidences, Fewer Rescues

Lucy Steele is only a temporary metaphorical sister of Elinor; actual sisters are not significant rivals in Austen's books. Rivalries, if they affect the heroine and one of her sisters, are either ludicrous or discontinuous in time—or both. The rivalry between Elizabeth Bennet and Lydia for the love of Wickham is never very serious on Elizabeth's part and discontinuous in time. *Persuasion* contains another discontinuous rivalry: Anne Elliot was once proposed to by Charles Musgrove, who later married her younger sister Mary. When rivalries affect sisters who are not at the center of action they are similarly discontinuous in time, or only apparent rivalries, such as that of the two Musgrove sisters for Captain Wentworth, who never has more than a mild interest and that only for Louisa. The one notable, real, and vicious rivalry, in *Mansfield Park*, does not involve the heroine. Julia and Maria Bertram struggle for Henry Crawford's affection, which he reserves for the engaged and then married Maria. Like Goneril and Regan struggling over Edmund and the brighter gloss that sordid matter gives to Cordelia, so the ménage in *Mansfield Park* also operates only as foil to the heroine of the book. Fanny Price is barely implicated in the rivalry, even though she attracts Henry Crawford's unwanted proposal at one point.

Not rivals, the sisters of *Pride and Prejudice* and *Sense and Sensibility* might be expected to be confidantes, and they do share some confidences. Elizabeth and Jane share innocent ones while Lydia and Kitty share guilty ones. Elinor and Marianne grow to be confidantes, which also speaks for change in Elinor, since Marianne never held back. Indeed, Elinor is so imprudent as to tax her sister at a time when she knows everything of Willoughby's neglect of Marianne but Marianne knows nothing of Elinor's sorrow, Edward's secret engagement to Lucy Steele:

"You have no confidence in me, Marianne."
"Nay, Elinor, this reproach from *you*! you who have confidence in no one!"
"Me!" returned Elinor in some confusion; "indeed Marianne, I have nothing to tell."

"Nor I," answered Marianne with energy; "our situations then are alike. We have neither of us anything to tell; you, because you do not communicate, and I, because I conceal nothing."

Elinor, distressed by this charge of reserve in herself, which she was not at liberty to do away, knew not how, under such circumstances, to press for greater openness in Marianne. (169–70)

Elinor is eventually able to share with her sister the most significant kind of confidence we find in these two books. Privileged, frequently dangerous information is given in each of them by a lover of one of the sisters to the heroine. Information about the welfare or happiness of a sister is imparted to the heroine, who then must use it as she thinks best. Confidence is a kind of empowerment, but it does not come in these books from one sister to another. Empowering information comes from men, and it is only a very limited kind of empowerment. Elizabeth is told by Darcy that Wickham is a seducer and a fortune-hunter, news that is both personally embarrassing, given her own favorable judgment of Wickham, and constraining: Elizabeth does not feel she can break Darcy's confidence by warning her father and mother about Wickham's possible attentions to Lydia. Elizabeth is also told that Jane's unhappiness is owing to Darcy, who persuaded Bingley to break with her. This Elizabeth also keeps to herself, though her vigorous defense of her sister causes Darcy to reconsider his advice and later to change it. Elizabeth personally effects no averting of danger, no rescue of either of her sisters. All happens through Darcy.

In *Sense and Sensibility* the case is not much different, though Elinor's confidences both come from Marianne's suitors rather than her own and though she passes both confidences on to her sister, one immediately and one later. Brandon tells her that Willoughby was the seducer of the younger Eliza, but he delays this confidence until Willoughby has jilted Marianne. Elinor immediately tells Marianne. The effect, never overtly acknowledged in the book, is to close off certain ways of rationalizing Willoughby's conduct that Marianne has been practicing and to precipitate her near-fatal illness, for which Marianne eventually blames her own exaggerated sensibility. After Marianne's recovery, Elinor tells her the second confidence, given her by Willoughby during his late-night visit to Cleveland. His confessions of love for Marianne, passed on by Elinor, confirm Marianne's conviction that she was not deceiving herself about

Willoughby, and the confirmation is now one that not only Marianne but Elinor herself can appreciate.

In summary, Austen's books refuse to take sides on sexual or temperamental difference, show that sisters affect each other and that the process is socialization more than education, virtually exclude sexual rivalry from the literal (that is, blood) sisterly relationship, and privilege the sister centered in the reader's view as repository of her sisters' secrets revealed by the lover of one or the other sister. The retaining or sharing of dangerous knowledge is the quintessential sisterly act in these two books and the closest thing to a rescue one sister can attempt.[18] In these books the construction of the feminine, which means the construction of the sister, includes the possibilities of confidante and of apparent rival, but not the possibility of one woman's active championing of another. Such an active rescue of a sister by a sister appears in Sir Walter Scott's *The Heart of Midlothian*, a year after Austen's death.

THE POSSIBILITY OF A RESCUE: *THE HEART OF MIDLOTHIAN* (1818)

All of the female rescues and attempted rescues in Victorian novels are in part enabled by Walter Scott's novel recognizing the heroic possibilities of sisterhood, *The Heart of Midlothian*. But despite a historical source fairly unequivocal about it, Scott's narrative fights the idea of female empowerment every step of the way, and the story turns out to be a woman's triumph in spite of what he has done to defuse and isolate the characters of Jeanie and Effie Deans. Jeanie's rescue of Effie potentially signals a revolutionary change in attitudes toward women, but considered in this light, Scott's treatment of history is everywhere a question in *The Heart of Midlothian*. He ties his story of female rescue to a mob scene that was a Scottish manifestation of a new revolutionary spirit, and he puts the head of the mob in the costume of a woman. But this revolutionary is in fact a man, George Staunton, and moreover, as the seducer of two of the book's three strong female characters, he is even more reactionary than the father of the Deans sisters, who is a caricature of the dour patriarch. Finally, Scott adapts a salacious bit of Georgian history when he brings into his story the king's mistress, Henrietta Howard, Lady Suffolk, as the companion of Queen Caroline when Jeanie Dean makes her appeal for a royal par-

don. By doing so he opposes the queen's agency in granting Effie's pardon against the fact that the queen is empowered partly through her use of Suffolk in an arrangement that makes the queen a bawd and the favor granted a bit of upper-class condescending recognition that the lower classes—and even the Scots—perhaps should not *always* be hanged for a little fornication.

Scott's subject is the different forms of truth and their working in the sisters' relation at the heart of the book. His thesis seems romantic enough: truth is a form of power. Contention begins in the source story itself, because it narrates a struggle between the truth Jeanie tells at the trial—a negative truth that is really silence and that condemns her sister—and the truth that empowers her when she tells it to the Duke of Argyle—the whole story of the two sisters. Scott's imagination, strongly scenic, constructs about half a dozen key scenes in which truth is alternately seen as restriction and as empowerment.[19] He first sets out the opposition of an imperilling and a rescuing truth that gives Jeanie dangerous but also redemptive power over her sister. Then he complicates the matter with other kinds of truth—historical "truth" from his reading of the Queen Caroline/Lady Suffolk connection and a fictive or mythic "truth" that comes from doubling key characters in the book, especially from paralleling Effie with Madge Wildfire.

The action begins during "a cottage evening scene," as Effie Deans is about to confess to her sister, Jeanie, her growing intimacy with George Staunton.[20] She is interrupted by her father, David Deans, who hears the girls talking of a dance and enters the house in a rage. Deans, a stern dissenter, threatens to disinherit them for even talking about dancing. This scene establishes the negative truth of a failed confidence, and the story hangs on just this lack of confidence between the sisters. Had Effie confessed her assignations with Staunton, these might not have led to greater intimacy and to Effie's pregnancy. Because Effie has moved out of the house to work in town, she can conceal her condition from Jeanie and her father. Had Effie later revealed her pregnancy to Jeanie, such a confession, testified to by Jeanie, would have freed Effie from the charge of having murdered her child, because the notorious Scottish child-murder statute under which Effie is tried *assumes* the guilt of a woman who has told no one about her pregnancy and whose child is not in evidence.

The book's second key scene, between the heroine

and the "wronger" of the heroine's sister, is a kind of prototype for such scenes that appear in one form or another in many nineteenth-century novels. Effie's lover, George Staunton, summons Jeanie to a meeting at "Muschat's Cairn" in the hills outside Edinburgh, giving her hope that she "might even yet be the rescue of" Effie (144). He tries to make her swear to perjure herself—to give an oath to break an oath—to save her sister at Effie's trial; then he threatens and begs her, meanwhile confessing his responsibility for fathering Effie's child, whom he is convinced was murdered by the unscrupulous Meg Murdockson, with whom he arranged Effie's lying-in. He tells her, "Nothing is so natural as that Effie should have mentioned her condition to you" (155), and he argues that "even the retainers of the law, who course life as greyhounds do hares, will rejoice at the escape of a creature so young—so beautiful; that they will not suspect your tale; that, if they did suspect it, they would consider you as deserving, not only of forgiveness, but of praise for your natural affection" (156). He offers some truth in his confession, but then he insists she tell a lie that everyone wishes for. Jeanie, against his persuasiveness and the appeals of her affection, refuses to give false evidence.

Characteristically in rescue plots, the male seducer makes a confession and the sister stands her ground against her own fears and possibly against his attempts to intimidate her. The confession may come from the rescuer rather than the seducer. Something like this scene happens in both *Sense and Sensibility* and *Pride and Prejudice*. In the first book, Willoughby makes a visit to Cleveland and confesses to Elinor how he has led Marianne on. Elinor, convinced by this recital that Willoughby is not completely wicked and did care for her sister, awaits her time and then relays a selected portion of what he said to the convalescent Marianne, whose response is, "I have now heard exactly what I wished to hear" (*Sense and Sensibility*, 350). Elsewhere in that book Brandon tells Elinor about Willoughby's sins against Eliza. In *Pride and Prejudice* the scene is Darcy's first proposal to Elizabeth, where he admits what he has done to impede the romance of Bingley and Jane. In later books the sister becomes a real agent in these scenes, which occur in *Rhoda Fleming*, *Wives and Daughters*, and in a greatly transmuted form, in *Middlemarch*. In each of these books the scene is a key indication of gender attitudes and the relative empowerment of the heroine. In *The Heart of Midlothian* Jeanie's unwillingness to

act against her conscience, even under Staunton's threat of death, lets her control the interview with him even in her terror. Eventually, her grasp of the truth will enable her to change the course of the action, directly or through the agency of other women.

A short but important scene occurs between Jeanie and David Deans, who has religious scruples about any testimony before an English—and therefore establishmentarian—court. David conquers these scruples so far as to tell Jeanie she must be guided by her own conscience. But she misunderstands, imagining that he is trying to justify perjury to save her sister (199). His message is, "testify if your conscience says so," but she hears, "perjure yourself." This false impression increases her pain without weakening her resolve to tell the truth. Deans's longtime patriarchal instruction to tell the truth takes precedence over the momentary adjuration to lie that she mistakenly hears.

In the prison, "The two sisters walked together to the side of the pallet bed, and sate down side by side, took hold of each other's hands, and looked each other in the face, but without speaking a word" (203). This scene and the trial scene are introduced with a quote from *Measure for Measure*; Jeanie's first, refused opportunity to rescue her sister is presented as a prostitution. As Claudio asks his sister Isabella to pretend her yielding to Angelo would be a virtue (3.2.136), so Effie at first wants her sister to sacrifice another kind of "honesty." She wants Jeanie to lie for her. Jeanie is close to agreeing, but then Effie, "better minded," says, "At my best, I was never half sae gude as ye were, and what for suld you begin to mak yoursell waur to save me, now that I am no worth saving? God knows, that in my sober mind I wadna wuss ony living creature to do a wrang thing to save my life" (208). Effie concludes that the truth is more valuable than her miserable life—but this "truth" is hardly complete. It is a silence about her pregnancy that the warped statute takes as proof of guilt for murder. Not only is the inference invalid and the assumption morally wrong, but it is also untrue in the particular case: Effie did not kill her child.

For Effie as well as Jeanie, the indoctrination of the father's word triumphs. Later, in the courtroom, the patriarchal word is reinforced at the swearing-in when Jeanie "educated in deep and devout reverence for the name and attributes of the Deity, was, by the solemnity of a direct appeal to His person and justice, awed, but at the same time elevated above all considerations save those which she could, with a clear conscience, call HIM to witness" (229). And finally, if these admonitions were not enough, another patriarchal figure in the person of the judge makes a special point of warning her that she owes the truth to her country and to her God. The truth triumphs over any ties of blood, Jeanie testifies that her sister told her nothing of her condition, and Effie is sentenced to death. But Effie has the last word:

"God forgive ye, my lords," she said, "and dinna be angry wi' me for wishing it—we a' need forgiveness. As for myself, I canna blame ye, for ye act up to your lights; and if I havena killed my poor infant, ye may witness a' that hae seen it this day, that I hae been the means of killing my grey-headed father. I deserve the warst frae man, and frae God too. But God is mair mercifu' to us than we are to each other." (239)

There is more in Effie's speech than the conventional Christian sentiment of "Father, forgive them, for they know not what they do." She speaks as if knowing more than they can. She condemns through her whole story the law contravening the most vital protection of English legal tradition—the presumption of innocence—and removing the burden of proof from the prosecution along with any necessity of *corpus delicti*. But Effie says more than Scott could have said with any other voice. "Ye act up to your lights," she says, and so they do, in enforcing a lethal statute that *cannot* be invoked against a man. Guiltless of her baby's death as she says, Effie is condemned on account of the father. But Effie denies that her God is made in the image of the stern father. She condemns the apotheosis of the father in religious, legal, and familial systems while she reaffirms her oppression: she thinks she has committed the ultimate crime in killing the father and she thinks she deserves death for having done it.

At this point the possibility of a rescue changes from the way George Staunton had presented it to Jeanie, as Effie had pleaded to Jeanie to effect it, and as Jeanie imagined that her father had suggested she accomplish it. Even before the trial Jeanie has started to feel "that, by some means or other, she would be called upon and directed to work out her sister's deliverance" (180). Up to this point truth for Jeanie has been silence, and it has upheld a male hierarchical system and, within it, an egregiously unjust law aimed at women alone. She could only have avoided condemning her sister by a lie that would also be acquiescing to the construction of sisterhood that Staunton

invokes: everyone, he suggests, will believe that Jeanie was Effie's confidante. But after Effie's sentencing, Jeanie's truth changes and becomes *positive*. She sees the chance to carry her story to a sympathetic listener whom she will convince by the plainness—that is, the truth—of it. Jeanie's truth turns from silence that can kill her sister to speech that can save her.

As Jeanie goes toward the south, the arena becomes more public, and other truths begin to contend in Scott's narrative. One of these is historical "truth"—not so much the extent to which Scott's use of figures such as Queen Caroline and Lady Suffolk corresponds with what can be known of their relationship and actions but rather the reading Scott gives to history as it impinges on his source story of Helen Walker. Yet another "truth" is what may be called mythic truth—the use of folk characters such as Madge Wildfire, characters who have no basis in the source story of Helen Walker or the public history of the period, in order to parallel and contrast with the principals. I have to conclude that Scott has used his reading of historical truth and his invention of mythic truth to work *against* the personal truth that empowers Jeanie. This friction occurs in a number of places but most notably in the interview with Queen Caroline and in the lynching/drowning of Meg Murdockson and her daughter Madge Wildfire.

Jeanie's successful interview with Queen Caroline, at first blush, looks as if Scott intends to show us an exclusively female rescue. He starts with the story of Helen Walker of Dalquhairn, who procured a pardon for a sister by application to the Duke of Argyle, and he changes it in a way that seems to make it *entirely* a woman's affair. The Duke is merely an intermediary in Scott's version who secures an audience with the queen. One woman petitions for the rescue and another grants it. He even doubles the audience of women who hear Jeanie's petition, so that instead of Queen Caroline alone, Jeanie meets the queen and her ally/rival, the king's mistress Lady Suffolk, the two women linked by a kind of sisterhood reflecting that of Jeanie and Effie, the pure and the sullied. But in this doubling, and in what he does with Effie's rustic double Madge Wildfire, Scott reveals his reactionary approach to his material. His tale is of a woman rescuing from punishment another woman who is both a sexual sinner and a sister. Practically every narrative strategy he chooses tends toward cushioning or gainsaying the subversive impact of this story.

He begins by burying the story of Effie and Jeanie in

enclosing narrative within narrative—an evening's conversation among travelers (26), recorded in the manuscript of Peter Pattieson, related at third hand by Jedediah Cleishbotham. The apparent interest of the sisters' story lies in its link to "more important" events: the Wilson execution and the Porteous mob. In the fifth chapter, fifty pages into the book, we begin to hear about Effie. From that point the sisters' story takes over, despite Scott's wishes to go back to his absurd character of George Staunton, the son of a gentleman, corrupted by his nurse (the "wretched hag" Margaret Murdockson, not the least of whose sins is having a pretty daughter for Staunton to seduce), who becomes a smuggler and highwayman. Scott changes his source to make Jeanie and Effie Deans *half*-sisters—a not-so-subtle narrative move copied by some Victorian novelists and having the effect of emphasizing other differences between sisters and therefore helping to explain sexual difference. The change also means that a mother can be blamed: there are mothers who produce pure offspring and mothers who produce impure offspring—not, inconveniently and inexplicably, one mother who produces both.

Presumptive child-murder was only briefly a capital offense in Scotland, but fornication was punishable by death in British novels for a much longer time. Although we are accustomed to thinking this retributive pattern a Victorian one, it is clearly operating, despite the restraints of the source story, in *The Heart of Midlothian*. If Effie is spared according to the story Scott begins with, others die in the story he eventually writes. The Helen Walker story says nothing about the sisters' mother, but Scott's story kills her. The living mother would simply have ignored her husband's, or anyone else's, scruples about lying to save her child—hence no imprisonment and no story. But others also die. Madge Wildfire serves as surrogate for Effie as a sacrifice to retributive "justice:" she has also been seduced by Staunton and is a "sister under the skin," a fellow magdalen who is in fact named Magdalen. But her popular name, from the Ophelia-like songs she sings in her madness, is Wildfire, a name that points to the rawness of a feared sexual energy, as does the madness itself; Madge's difference is externalized, on the outside for everyone to see and eventually to attack. They do attack, in the second lynching in the book.[21] Meanwhile Effie's perhaps-equivalent wildness is carefully enclosed in prison or convent throughout most of the book. Only

during Effie's and George's return to England is it not so sequestered. The story as received by Scott, with Helen Walker's sister living out a quiet life in Scotland, is not allowed here: Scott first locks Effie up and then shows her as impersonating a "respectable" woman—as living a lie about her identity—in London. In a letter to Jeanie, Effie describes her life in London as "a miserable impostor, indebted for the marks of regard I receive to a tissue of deceit and lies, which the slightest accident may unravel" (454). Scott anticipates a concern George Meredith and Wilkie Collins will dramatize later in the century: the fear that a "low" woman—and the lowness may be a matter of class or of a sexual "fall" or both—will, through boldness and deceit, penetrate the ranks of respectable society and manage to convince us that she is one of us.

Madge's death is not only included but witnessed by Jeanie, shortly following Madge's mother's death. Together the two deaths constitute the equivalent of Effie's in the sense that Jeanie can see through them what would have happened to her sister and why. When Meg Murdockson is hanged at Carlisle at the very moment Jeanie's carriage is passing, Jeanie sees "a female culprit in the act of undergoing the fatal punishment from which her beloved sister had been so recently rescued" (390), and, though the hanging apparently takes place for robbery, Meg is actually guilty of the very crime of child-murder for which Effie was condemned. When the mob lays hold of Madge to give her a ducking, ostensibly for witchcraft, the clear implication, as always with that accusation, is that the defiance of social norms that constitutes the mob's notion of witchcraft has a sexual component: "Shame the country should be harried wi' Scotch witches and Scotch bitches this gate," says one of the mob, "but I say hang and drown" (391).

Yet Madge's death is apparently not enough: the social outrage of Staunton and Effie's sexual transgression is finally atoned with the blood of one of the actual partners. Staunton dies, killed in fact by his illicit love, by the love child for whose presumed death Effie herself almost died, and who has been living like a wild animal in Scotland. Then the child, like Madge Wildfire a living representation of dangerous sexuality, is absorbed into an Indian tribe in America, and "it may therefore be presumed that he lived and died after the manner of that savage people, with whom his previous habits had well fitted him to associate" (506).

Staunton's functional relation to Madge Wildfire is signalled early in the book when he appears at the prison (the Edinburgh Tolbooth, called The Heart of Midlothian) dressed in Madge's clothes. As Madge Wildfire he attempts to rescue Effie from the prison, but she will not budge. Staunton's cross-dressing ineffectually disguises an ineffectual first, male attempt at rescue while it identifies Staunton with both of his female victims. Jeanie's sisters thus include Effie and her various surrogates: Madge, Meg, and Staunton. The ineffectual male rescue has the effect of making the female one more difficult; because of the Porteous riot, at least half-motivated in Scott by Staunton's desire to free Effie, the Queen is the less inclined to grant a Scot's request for pardon.

For Georg Lukács, Jeanie's "simple heroism" is that of a woman caught in a great historical movement; she is not herself "an exceptional human being" or "an outstanding talent."[22] But this view exaggerates connections between Jeanie's rescue and anything revolutionary. Jeanie, far from being caught up in a powerful expression of the popular will, is impeded in her own purposes by the Porteous mob and its aftermath. Scott has used the Porteous incident to complicate rather than to assist the female rescue; he avoids the suggestion that female empowerment has found its historical moment.

Michael Foucault notes in *Discipline and Punish* that a frequent manifestation of the new revolutionary century that began in Europe before 1789 was the crowd that shifted suddenly from the popular witnesses (and therefore approvers) of official acts of punishment to the reverse—a mob viewing the accused as a hero and the executioner as a villain to be punished with summary violence:

. . . the people, drawn to the spectacle intended to terrorize it, could express its rejection of the punitive power and sometimes revolt. Preventing an execution that was regarded as unjust, snatching a condemned man from the hands of the executioner, obtaining his pardon by force, possibly pursuing and assaulting the executioners, in any case abusing the judges and causing an uproar against the sentence—all this formed part of the popular practices that invested, traversed, and often overturned the ritual of the public execution. This often happened, of course, in the case of those condemned for rioting. . . . But apart from these cases, when the process of agitation had been triggered off previously and for reasons that did not concern some measure of penal justice, one finds many examples when the agitation was provoked directly by a verdict and an execution.[23]

Foucault's description might have been written with

the Porteous mob in mind, from the execution of Wilson to the vengeance exacted on Porteous himself. But only in the second decade of the nineteenth century could this 1730s bunch have been so described: Scott's mob is purposeful, but disciplined—polite to Reuben Butler even as it shanghais him, bloody without being unruly, vengeful without being promiscuously violent. The implication is that revolution can have limits—a comforting sentiment, and a way, perhaps, of consciously denying to himself the very thing Scott forecasts by combining these various story elements. Nothing impelled his connection of a female rescue with revolution aside from the image of prison-breaking itself—admittedly a powerful image since the Tolbooth (which had seen both the Porteous riots and the imprisonment of Helen Walker's sister), like the Bastille and later the Marshalsea in Dickens's *Little Dorrit*, stood for an old order and no longer stands. But only the Bastille came down through revolutionary force. The revolution Jeanie effects is much quieter—an aesthetic revolution in which it becomes possible for heroic sisterhood to replace heroic brotherhood within the bounds of the novel.[24]

Scott's handling of the historical intervention of Queen Caroline is also curious and problematic. Queen Caroline and King George II's mistress, Henrietta Howard, Countess of Suffolk, can be read as a kind of parallel of the principals, the two Deans sisters, in a pairing that has the effect, not of underlining and reinforcing the exclusively female nature of the rescue, but of diluting it, and the dilution is increased by the characterization of the queen herself and her relation to the king. Caroline is presented in one breath as masculine: "With all the winning address of an elegant, and, according to the times, an accomplished woman, Queen Caroline possessed the masculine soul of the other sex."[25] With the next breath she has all the submissive and self-deprecating features of the worst stereotype of wifely virtue: "whatever she did herself that was either wise or popular she always desired that the king should have the full credit as well as the advantage of the measure, conscious that, by adding to his respectability, she was most likely to maintain her own" (360). The word *respectability* here is just teetering on the edge of the denotation of "worthy of respect," ready to slide down into its more modern, pejorative meaning of "conventional; acceptable to the middle classes." Scott does not quite know where to have the queen; he wants to cancel her real empowerment (she defers to the king

in everything), make it unfemale ("the masculine soul of the other sex"), or sully it (the Suffolk connection, already long over by 1736, when the novel is supposed to be taking place). The queen's power works partly by controlled but illicit sexuality in Scott's version:

It was not the least instance of the Queen's address that she had contrived that one of her principal attendants, Lady Suffolk, should unite in her own person the two apparently inconsistent characters of her husband's mistress and her own very obsequious and complaisant confidante. By this dexterous management the Queen secured her power against the danger which might most have threatened it—the thwarting influence of an ambitious rival; and if she submitted to the mortification of being obliged to connive at her husband's infidelity, she was at least guarded against what she might think its most dangerous effects, and was besides at liberty now and then to bestow a few civil insults upon "her good Howard," whom, however, in general, she treated with great decorum. (361)

What *is* the decorum, one wonders. Does the protocol officer have a category for mistresses? Where does she sit at state dinners? Suffolk and Caroline domesticate a prostitution arrangement in the Scott version of Hanoverian history, with its disingenuous acknowledgment of Horace Walpole's memoirs (Scott's note to the above passage reads simply, "See Horace Walpole's Reminiscences"). The two women might merely have had some things in common, aside from the affection of George, and might even have liked each other. As it is, one is made an "obsequious and complaisant confidante" and the other a royal pimp who "submitted to the mortification of being obliged to connive at her husband's infidelity." I do not think I exaggerate the unpleasant implications of this for the Deans sisters' story, nor yet can I entertain the idea that Scott was fully aware of them. His Queen Caroline is at one moment an empowered woman dispensing power to women in despite of men's lust, and at another moment she is only a bawd whose power is an imitation of male power and who, to get it, services male lusts at the expense of another woman.

Judith Wilt's opinion is that the pardon scene in *The Heart of Midlothian* "reveals an astonishingly complex and truthful picture of patriarchy visibly and invisibly at work subtly corrupting, rather than celebrating, sisterhood and Queenship."[26] Moreover she has uncovered a very interesting reaction to Scott by Harriet Martineau, who wrote in an 1833 *Tait's* magazine essay that "he has advocated the rights of woman with a force all the greater for his being unaware of the import and tendency of what he was saying."[27] It

is as if, while the author looked away, the narrator addressed us directly with an apology for not destroying Effie Deans and said "What can I do when sexual sin is so connived at in high places, and these high sisters pardon their low petitioners? But Jeanie will see, on her way home, how the common folk treat such offenders." For the last mob image in *The Heart of Midlothian* is not that of the controlled violence of the Porteous mob, but rather the savage glee of the Murdockson lynch mob that attends the execution of the mother and then drowns the daughter for the witchcraft they are certain is the crime of both women, "Scotch witches and Scotch bitches."

Throughout the novel Scott empowers his heroines with one hand while he takes power away with the other. He links female rescue (and literal liberation) with revolutionary events, but he muffles the significance of this linkage by depicting the Porteous mob as tame and disciplined, an orderly posse whose actions impede rather than assist the heroine. Attacking the presumptive child-murder law reveals a misogynistic bias in the whole scheme of English law, but the challenge is contained by shifting the focus to an anti-Scot bias in that law. Scott weighs the relation between the sisters, stressing the importance of confidence between them by having its absence the main evidence of a murder trial, but then he alters his source to dilute their relation to half sisters. All the book's circumstances render Effie a victim, but the victim is punished by banishment, an inauthentic life, a murderous love-child, and the hanging and drowning of Effie's surrogates. Empowering Queen Caroline legitimizes Jeanie's empowerment, but then Caroline's power is sullied by the suggestion it comes from pandering.

Regardless of these qualifications, Scott's novel manages to define new possibilities for heroic action for women. For Susan Morgan, it is nothing less than a new definition of heroism itself, and a true one that reveals the older masculine conception to be a time-bound, artificial construct that substituted martial values for human values.[28] The moral may be that one does not have to be singlemindedly committed to revolution to make change. "As the story of Jeanie and Effie suggests," writes Morgan, "the progressive human community, as imaged in many nineteenth-century novels, may well be a sisterhood."[29] But an uncontested vision of that community, that sisterhood, cannot be found in Scott, nor yet in Dickens, to whom we turn next as the first great Victorian novelist to make sisters an important, if troubled, topic in his books.

6

Sisters in the Perturbed Families of Dickens

IN DICKENS, SISTERHOOD TENDS TO BE A FLAWED part of a flawed family relationship. Within the family, pairs of sisters reproduce society's categories of pure and impure women. Attempted female rescues retain or exaggerate the categorical differences rather than erasing them. If a rescue should attempt to erase differences, as when Miss Wade provides a refuge for Harriet Coram in *Little Dorrit*, the erasure is read as a lesbian seduction, damnable but scarcely nameable. The depiction of sisters in Dickens *could* be seen as constituting a radical critique of middle-class family life because it asserts that within the family every pair of sisters reproduces society's categories of whore and wife—the implication being that the family furnishes the model and is the reason why society contains the whore as well as the respectable woman.[1] Whether or not we take this view of Dickens as subversive, we find that he always heightens contrast in juxtaposing sisters, and sometimes the contrasting categories can be interchanged: "respectable" and "fallen" can be translated into other differences of estate frequently seen in visual arts: rich and poor, mistress and servant.

PLAYING THE WHORE FOR A SISTER IN *THE BATTLE OF LIFE* (1846)

Even in a supposedly innocent Christmas book story such as his 1846 *The Battle of Life*, Dickens

makes one of his loving sisters appear to be a fallen woman. Marion Jeddler, engaged to marry Alfred Heathfield, knows that her older sister Grace really loves him and he her. Instead of merely backing away from the engagement, Marion feels she must take stronger action, and so she disappears, making it seem as if she has eloped with a family friend named Warden. As she later explains to her sister, now happily married to Alfred:

"I had tried to seem indifferent to him . . . but that was hard, and you were always his true advocate. I had tried to tell you of my resolution, but you would never hear me; you would never understand me. The time was drawing near for his return. I felt that I must act, before the daily intercourse between us was renewed. I knew that one great pang, undergone at that time, would save a lengthened agony to all of us. I knew that if I went away then, that end must follow which *has* followed, and which has made us both so happy, Grace! I wrote to good aunt Martha, for a refuge in her house: I did not then tell her all, but something of my story, and she freely promised it. While I was contesting that step with myself, and with my love of you, and home, Mr. Warden, brought here by an accident, became, for some time, our companion."[2]

Marion feels the necessity to convince the others of her complete abnegation of claims to Alfred. She tells Grace, "I wished that you should feel me wholly lost to Alfred—hopeless to him—dead" (402). And so she runs off with Warden, allowing everyone to think for six years that she has stayed with him, married or not. In fact she "confided in his honour" (402) and

accepted his protection as far as her aunt Martha's.

Marion casts herself as fallen woman in order to rescue her sister and her own lover, who is really unknowingly her sister's lover. The difference in sexuality between the sisters here is only that Marion is more knowing of the true desires of both Grace and Alfred than either of them are of their own. Marion's fallen state is a pose; she is actually denying herself sex to save her sister. She sees her role not as fallen woman but as secular nun:

> "My love, my sister!" said Marion, "recall your thoughts a moment; listen to me. Do not look so strangely on me. There are countries, dearest, where those who would abjure a misplaced passion, or would strive against some cherished feeling of their hearts and conquer it, retire into a hopeless solitude, and close the world against themselves and worldly loves and hopes for ever. When women do so, they assume that name which is so dear to you and me, and call each other Sisters. But, there may be sisters, Grace, who, in the broad world out of doors, and underneath its free sky, and in its crowded places, and among its busy life, and trying to assist and cheer it and do some good,—learn the same lesson; and who, with hearts still fresh and young, and open to all happiness and means of happiness, can say the battle is long past, the victory long won. And such a one am I! You understand me now?" (403)

As Marion presents it in these two speeches, a necessary counterpart to one sister's normal and respectable sexuality is either the other's disappearance—with its apparent illicit sexuality—or her abjuration of sexuality. The real villain here, a draconian engagement code that makes changing one's mind or affections unthinkable, is never indicted. Instead the people blame themselves. If Marion simply tells the others she is not in love with Alfred, she will not be understood or will be seen as unforgivably fickle. If she tells Grace and Alfred they are in love with each other, they will not believe it, will deny it, and will make it untrue. Marion has to be dead or an immoral betrayer to escape from her engagement, which also engages Alfred and Grace.

Here Dickens reverses the usual female rescue: instead of one sister saving the other after a sexual fall by denying difference between them, here one sister fakes a sexual fall herself in order to effect the rescue; that is, she invents sexual difference. Dickens's plots resist the equating of sisters; the books almost always prefer the contrast of one sister who prostitutes herself (or only seems to, as here) and another who is respectable. Esther Summerson's "godmother" never forgives her erring sister Lady Dedlock—the very

reading of the story of the woman taken in adultery (the subject of E. H. Corbould's *Go and Sin No More* reproduced on page 85 and painted a few years before Dickens began *Bleak House*) precipitates her fatal stroke. Equality is an unstable relation for him.

SISTERS AS UNTOUCHABLES IN *DOMBEY AND SON* (1848)

Plot-significant blood sisters are uncommon in Dickens's books. He is more likely to construct a figurative sisterly relationship than to use a literal one. Sisters are much more likely to be defined in relation to a brother than to another sister, and the books work to divide women and prevent the confidences of sisterhood. I want briefly to look at a book that departs from my self-imposed concentration on literal or blood sisters, *Dombey and Son*. In this novel Dickens works out the metaphor of "sisters under the skin," pairing women in different classes or situations and showing their basic likeness. In these pairings, at least one of the women is "fallen," and the other confronts her during the book in scenes Dickens presents as tableaux. These are static relations, as the book depicts them; the upright and the fallen are essential categories of society, and the only relations between women in separate categories are patterned and conventional. They can contemplate each other with horror or with compassion—especially compassion together with religious forgiveness. They can also seem to mirror each other, and in such scenes Dickens gets as close as he ever does to erasing the difference between his prostituted and respectable "sisters."

Pairs of women are not related in literal sisterhoods in this book but rather in figurative sisterhoods where one or both parties have been prostituted. *Dombey and Son* asserts the sisterhood of Alice Marwood and Edith Dombey, of Harriet Carker and Alice Marwood, of Florence and Edith Dombey, and of Florence and Alice Marwood. And the scenes asserting these relationships may be best understood using schemata of pictorial encounters: there are mirroring scenes in which one woman sees herself reflected in the other (or another watcher comments on the likeness), reconciliation scenes—it is too late for rescues, and "Noli me tangere!" scenes in which one woman warns another from touching her.

The "sisterhood" of Alice Marwood and Edith Skewton Granger Dombey is made clear in illustra-

Hablôt K. Browne, A Chance Meeting *(1847), illus-
tration for* Dombey and Son, *The Huntington Library,
San Marino, California*

tions as well as text. In Chapter Forty, the two women
and their two mothers meet out on the Downs, and
Hablôt Browne's illustration, *A Chance Meeting,* ren-
ders the two younger women identical except for
Edith's clothes and a neater coif, while Alice's long
hair, as dark as Edith's, streams free and unbonneted.
Alice's mother "to Edith's thinking was like a dis-
torted shadow" of her own mother,[3] and the likeness
of the two younger women is noted in both their
thoughts:

And yet, however far removed she was in dress, in dig-
nity, in beauty, Edith could not but compare the younger
woman with herself, still. It may have been that she saw
upon her face some traces which she knew were lingering
in her own soul, if not yet written on that index; but, as the
woman came on, returning her gaze, fixing her shining eyes
upon her, undoubtedly presenting something of her own air
and stature, and appearing to reciprocate her own
thoughts, she felt a chill creep over her, as if the day were
darkening, and the wind were colder. (550–53)

* * *

"You're a handsome woman," muttered her shadow,

looking after her; "but good looks won't save us. And you're
a proud woman; but pride won't save us. We had need to
know each other when we meet again!" (554)

This mirroring scene is complemented by other sym-
metries. Edith and Alice each have long scenes in
which they berate their mothers for making them
what they are. In Chapter Twenty-Seven, under the
running heads "Mother and Daughter" and "Put Up to
Auction," Edith accuses her mother of making her an
"artful, designing, mercenary" woman (381) who has
been "hawked and vended" all over England (382). In
Chapter Thirty-Four, titled "Another Mother and
Daughter," Alice turns her mother's accusation of un-
dutifulness back on the old woman, accusing her of
Alice's moral ruin (468–69), and at the end of the
chapter, just in case we have forgotten the earlier in-
stallment, we are reminded of the other mother and
daughter:

Were this miserable mother, and this miserable daughter,
only the reduction to their lowest grade, of certain social
vices sometimes prevailing higher up? In this round world
of many circles within circles, do we make a weary journey

Hablôt K. Browne, The Rejected Alms *(1847), illustration for* Dombey and Son, *The Huntington Library, San Marino, California*

from the high grade to the low, to find at last that they lie close together, that the two extremes touch, and that our journey's end is but our starting-place? Allowing for great difference of stuff and texture, was the pattern of this woof repeated among gentle blood at all?

Say, Edith Dombey! And Cleopatra, best of mothers, let us have your testimony! (477)

As Andrew Lang writes in the introduction to the Gadshill edition, "Edith and Alice are twins, in different classes" (1:viii). Late in the book, as Alice lies dying, we hear from her mother that she and Edith are in fact cousins: Mrs. Dombey's father and her father were "as like . . . as you could see two brothers," says the old woman to Harriet Carker, "and if you could have seen my gal . . . side by side with the other's daughter, you'd have seen, for all the difference of dress and life, that they were like each other" (784). Carker is another connection between them—the seducer of Alice and the would-be seducer of Edith.

Harriet Carker encounters Alice Marwood as "her fallen sister" at Alice's first introduction in the book. Alice comes by the Carkers's cottage one stormy day, "a solitary woman of some thirty years of age; tall; well-formed; handsome; miserably dressed" (462). Harriet recognizes immediately in Alice's "dauntless and depraved indifference to more than weather" that she is a fallen woman, and "that, coupled with her misery and loneliness, touched the heart of her fellow-woman. She thought of all that was perverted and debased within her" and "did not turn away with a delicate indignation—too many of her own compassionate and tender sex too often do—but pitied her" (462).

Harriet has four scenes with Alice, beginning and ending with reconciliations. In this first scene Harriet befriends her "fallen sister" Alice—gives her food and money and binds up her wounds. In the last of their meetings Harriet holds Alice's hand and reads from

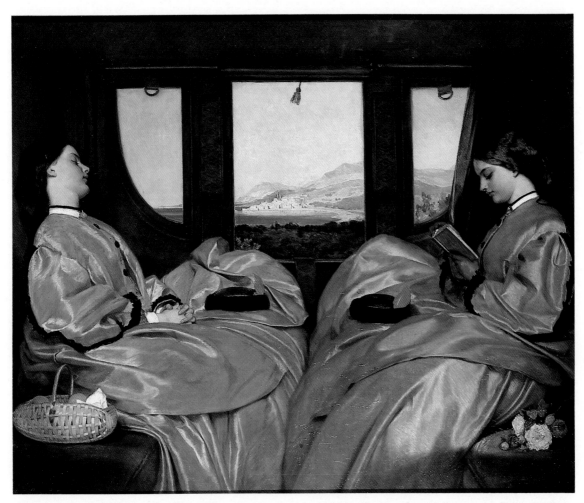

Augustus Leopold Egg, The Travelling Companions *(1862), Birmingham Museum and Art Gallery*

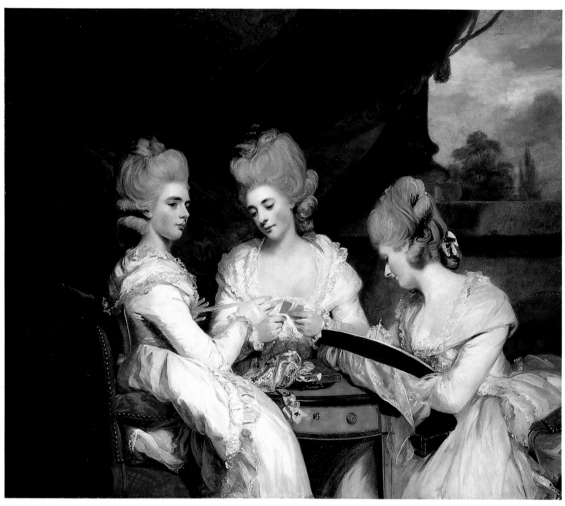

Sir Joshua Reynolds, The Ladies Waldegrave *(1781), National Gallery of Scotland, Edinburgh*

Sir John Everett Millais, Hearts Are Trumps (1872), Tate Gallery, London

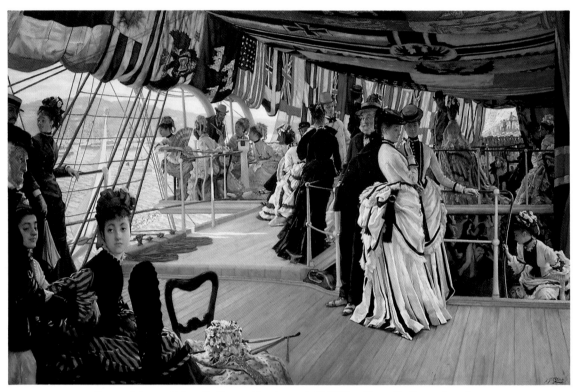

James Tissot, The Ball on Shipboard (1874), Tate Gallery, London

the Bible as Alice nears death (785). The two reconciliations bracket two variations of the "Noli me tangere!" encounter. In the first such variation, illustrated by Browne as *The Rejected Alms*, Alice has returned from London to the suburban cottage where, earlier in the day, Harriet Carker took her in. She throws the money Harriet gave her into the dirt, rejecting her charity and cursing her (474). Neither Harriet nor her brother John knows at this point in the story that their brother James seduced and abandoned Alice and that this is the cause of her hatred. But in a later scene, not illustrated, Alice returns to tell Harriet precisely that and to confess that her wish for revenge has sent Dombey to France after Carker and Edith (716–19). Where Alice rejects Harriet's aid, her money, and her very touch in the previous scene, now she seeks Harriet's help in preventing bloodshed. And once it is clear to Harriet that Alice has set Dombey on, Harriet shrinks from contact with Alice as Alice had earlier rejected her: "Remove your hand!" said Harriet, recoiling. "Go away! Your touch is dreadful to me!" (718). The two women are reunited as Alice is dying, in a final reconciliation scene whose most notable features are the unpenitent ravings of her mother and the scripture-reading of Harriet to the dying prostitute: "Harriet . . . read the eternal book for all the weary . . . the blessed history, in which the blind, lame, palsied beggar, the criminal, the woman stained with shame, the shunned of all our daily clay, has each a portion" (785).

Florence, though she wishes to think of Edith as her mother, is placed in a sister's relation to her by a number of formal and thematic elements in the book. One mirroring scene before Edith's wedding underlines the resemblance between the two women:

"Edith, my dear," said Mrs. Skewton, "positively, I—stand a little more in the light, my sweetest Florence, for a moment."
Florence blushingly complied.
"You don't remember, dearest Edith," said her mother, "what you were when you were about the same age as our exceedingly precious Florence, or a few years younger?"
"I have long forgotten, mother."
"For positively, my dear," said Mrs. Skewton, "I do think that I see a decided resemblance to what you were then, in our extremely fascinating young friend. And it shows," said Mrs. Skewton, in a lower voice, which conveyed her opinion that Florence was in a very unfinished state, "what cultivation will do."
"It does, indeed," was Edith's stern reply. (410–11)

Edith's stern and ironic reply reminds us that "cultiva-

tion" in her case has meant habituation to selling herself. Florence's formal sisterhood with both Alice and Edith lies in the fact that she was and is ground for "cultivation" though, unlike the other two, she lacks a mother to make her a whore. And if she resembles Edith she must resemble Alice as well (we already know she does, from an earlier scene in Chapter Six, discussed below). Edith's and Florence's two last scenes together are perhaps the clearest representations of the "Noli me tangere!" and reconciliation schemes and the movement from one to the other. When Edith is about to leave Dombey's house to meet Carker, Florence finds her on the stairs, in a scene illustrated by Browne, *Florence and Edith on the Staircase*. "Don't come near me!" Edith cries:

"Don't speak to me! "Don't look at me!—Florence!" shrinking back, as Florence moved a step towards her, "don't touch me!"
As Florence stood transfixed before the haggard face and staring eyes, she noted, as in a dream, that Edith spread her hands over them, and shuddering through all her form, and crouching down against the wall, crawled by her like some lower animal, sprang up, and fled away. (632)

Their last scene is both "Noli me tangere!"—reversed this time—and reconciliation. It begins with Florence, surprised when she has been brought suddenly into Edith's presence by Cousin Feenix, "shrinking back as [Edith] rose up, and putting out her hands to keep her off" (823), but it ends with "embraces and caresses" (828).

Least obvious, because they are never in each other's presence during the book, is the sisterhood asserted between Florence and Alice Marwood. But Florence's resemblance to both Edith and to Alice is pointedly noticed several times. The most curious of these occasions is that in which Florence falls into the hands of the "Good Mrs. Brown," who is really Alice Marwood's mother (70–83). The scene is actually a mirroring scene, a displacement of Florence by her "twin," Alice, even though Alice is far away and older.

Florence is separated from her companions and is found by the old woman who calls herself "Good Mrs. Brown." She is stripped of her frock and petticoats, bonnet and shoes, and dressed in rags that probably belonged to Alice. She very nearly has her hair cut off as well: "'If I hadn't once had a gal of my own—beyond seas now—that was proud of her hair,' said Mrs. Brown, 'I'd have had every lock of it'" (75). Class hatred—or envy—limited only by Florence's resem-

Hablôt K. Browne, Florence and Edith on the Stair-
case (1847), *illustration for* Dombey and Son, *The
Huntington Library, San Marino, California*

blance to her own less fortunate child, nearly causes
Alice's mother to make at least a symbolic sacrifice of
Florence, who is "relieved to find that it was only her
hair and not her head which Mrs. Brown coveted"
(75). The resemblance to Alice that saves Florence
may also have motivated her abduction in the first
place. The stripping and hair-cutting, done for imme-
diate money, also have implications of class resent-

ment. The assault on Florence is class-levelling and a
violation that equates Florence with Alice. Dickens
uses hair-cutting to express class outrage and levelling
again in *Little Dorrit* when Pancks cuts Casby's hair
and hat brim in Bleeding Heart Yard.

Dressed as a beggar, Florence is set loose by the old
woman to find her way—not home, but into the com-
mercial, dangerous City. She is "terrified by . . . the

prospect of encountering her angry father in such an altered state" (76), as if the change in clothes represented a moral fall even as it seems to show a class descent. For, of course, Florence is taken for a person not worth notice until she is rescued by Walter Gay.

In these pictures or tableaux of "sisters," we miss any mutual influence of one sister upon another, shared confidences, or satisfaction in the equality of situation that leads to understanding. We will not find them more abundant, however, when Dickens treats real sisters.

LITTLE DORRIT'S (1857) SOCIETY OF SISTERS: SERVANTS, SELF-TORMENTORS, AND STRUMPETS

Little Dorrit (1857) is a book filled with real and phantom sisters, literal and figurative sisters, and sisterhood seen as two sets of oppositions or contrasts: the pure versus the prostituted and the mistress versus the servant. It contains two sets of twins (only one set of identical sisters), but its main mode of presentation, as is usual in Dickens, is not identity or likeness but separation and contrast.

Both twinnings are curious and their functions not equally clear. The Meagles's daughter Minnie, who is called Pet (she is a pet daughter and later, for the Gowans, another sort of pet as they toy with her more maliciously), had a twin sister who died, according to Mr. Meagles, when she was just about of an age to begin to walk. Meagles goes on to explain the fantasy he and his wife have evolved about this, since they are romantics—though Meagles insists on terming their romanticism "practicality":

"Yes, and being practical people, a result has gradually sprung up in the minds of Mrs. Meagles and myself which perhaps you may—or perhaps you may not—understand. Pet and her baby sister were so exactly alike, and so completely one, that in our thoughts we have never been able to separate them since. It would be of no use to tell us that our dead child was a mere infant. We have changed that child according to the changes in the child spared to us, and always with us. As Pet has grown, that child has grown; as Pet has become more sensible and womanly, her sister has become more sensible and womanly, by just the same degrees. It would be as hard to convince me that if I was to pass into the other world to-morrow, I should not, through the mercy of God, be received there by a daughter just like Pet, as to persuade me that Pet herself is not a reality at my side."[4]

The death of Minnie's twin leaves a place for Harriet Beadle as Minnie's sister—a place that none of the characters in the book except Miss Wade perceives, although the reader does. Nothing is made of the phantom twin, although she is mentioned once more, in the middle of the novel. Arthur Clennam imagines he is in love with Minnie Meagles, and when he loses her to Henry Gowan, her father comforts Arthur, reminding him of his fancy in being unable to separate Minnie from her dead twin sister, and says, "I feel tonight, my dear fellow, as if you had loved my dead child very tenderly, and had lost her when she was like what Pet is now" (330).

The twinning of Jeremiah and Ephraim Flintwinch, unlike that of Minnie and her sister, has no plot-significant result. It serves to befuddle Mrs. Flintwinch and make her husband's pretense in bullying and quieting her—the pretense that she is dreaming—more plausible momentarily. But no comedy or darker play of errors is ever played with these twins, whose identity is set up so early in the book, as if for a later device.

The sisters of *Little Dorrit* are pairs of women in both literal and figurative sisterhoods. Between pairs of the principal women there exist relations that include lesbianism, between Miss Wade and Harriet; an ideal of sisterhood (help offered and received between equals, confidences, shared emotional circumstances) that is never quite realized between Amy and Fanny or, briefly, Amy and Flora; and inferior relations tainted by one or both of the sisters' involvement in servitude or prostitution. These relations exist without prostitution's ever being overtly mentioned in the novel and with the additional complication that the book cannot seem to decide whether servitude is good or bad for the female characters: though the plot in the second half of the novel moves to get characters out of servitude and durance, a countermovement centers on Little Dorrit herself: she has to lose her paternal inheritance to be eligible for happiness by marrying Arthur Clennam; then she has to sweetly invite him to burn her avuncular inheritance to preserve that eligibility. Throughout, the ideal represented by Little Dorrit is one of humble service, of "timid earnestness" (737), and the relation between Arthur and her is never more clearly shown than in their both rejecting her Christian name for the last name—by which a servant would be called—and the diminutive:[5]

"As you just now gave yourself the name they give you at my mother's, and as that is the name by which I always think of you, let me call you Little Dorrit." (160)

"Little Dorrit. Never any other name." (It was she who whispered it). (796)

Amy is a servant and Fanny is a prostitute. Fanny Dorrit's airs and her horror of humiliation at her sister's "lowness" have their ironies all through the book, but never more so than when Fanny is doing business with Mrs. Merdle. On the way to the Merdle's Harley Streeet house Fanny reminds her sister of her birth in the Marshalsea debtors' prison: "I was not born where you were, you know, Amy, and perhaps that makes a difference" (232). The difference the reader perceives is partly Fanny's imprisoning idea of eternally proving her worth and status versus Amy's lack of prisonhouse taint. But the more important difference is that between Amy's self-devaluation and Fanny's selling of herself. For sell herself Fanny does, first to Mrs. Merdle for a couple of dresses, and finally to Edmund Sparkler, not so much for the Merdle money as for the pleasure of humiliating Mrs. Merdle.

We meet Mrs. Merdle at the first transaction. Both Fanny and Mrs. Merdle seem to be excessively proud of the bit of business they have done and anxious that Amy should hear about it. Mrs. Merdle, afraid that her son might propose to Fanny, has attempted to bribe her with a cheap bracelet. Fanny, by a haughty rejection, has negotiated the offer into several dresses from Mrs. Merdle's dressmaker (237).

Fanny's marriage is frequently described in terms of negotiation, transaction, or, as Mr. Dorrit says when congratulating her, "aggrandisement" of the family name, which proves her a dutiful and principled child (578). Fanny tells Amy that despite their money, the Dorrits "labor, socially speaking, under disadvantages" (571). She wants "a more defined and distinct position" in order to oppose Mrs. Merdle and to triumph over her. "I would make it," says Fanny, "the business of my life" (573). And her triumph, once it comes, is described in a ludicrous image that picks up on earlier descriptions of Mrs. Merdle's broad bosom. Fanny's entry into Mrs. Merdle's house is a social displacement, but the description slips into the sexual:

Mrs. Sparkler, installed in the room of state—the innermost sanctuary of down, silk, chintz, and fine linen—felt that so far her triumph was good, and her way made, step by step. On the day before her marriage, she had bestowed on Mrs. Merdle's maid with an air of gracious indifference,

in Mrs. Merdle's presence, a trifling little keepsake (bracelet, bonnet, and two dresses, all new) about four times as valuable as the present formerly made by Mrs. Merdle to her. She was now established in Mrs. Merdle's own rooms, to which some extra touches had been given to render them more worthy of her occupation. In her mind's eye, as she lounged there, surrounded by every luxurious accessory that wealth could obtain or invention devise, she saw the fair bosom that beat in unison with the exultation of her thoughts, competing with the bosom that had been famous so long, outshining it, and deposing it. Happy? Fanny must have been happy. No more wishing one's self dead now. (592)

These examples of Fanny's prostitution confirm an ironic pattern in the novel, a pattern partly created by the description of the two sisters from the beginning. Fanny has always been in finery, however come by, and Amy has been plain or even shabby. It is Amy we see walking the London streets all night, talking with prostitutes, befriending the people of the street, and it is Amy, like Moll Flanders, who was born in a prison.

Fanny and Amy make a study in contrasts. The only point of resemblance between the sisters is their integrity: each is the same woman whether rich or poor. This is not to say that cash is not important, in its way, for both sisters, but each one remains the same personality in each of her two "estates." Fanny poor is just as disturbed with Amy for being seen with Old Nandy, a workhouse inmate, as Fanny rich is concerned that Amy acquire some of Mrs. General's "varnish." Amy on the other hand has the same wish to be helpful when poor or rich. Poor, and helping Old Nandy, she is puzzled by her father's displeasure, since he befriended the old man himself. Rich, she regrets that layers of servants prevent the closeness to her father she enjoyed previously as well as her attentions to him as nurse and servant.

Amy's servant status points to another opposition between the sisters. Fanny plays mistress to Amy's servant. In this, Fanny is not alone: "It was the family custom to lay it down as family law, that she was a plain domestic little creature, without the great and sage experiences of the rest. This family fiction was the family assertion of itself against her services. Not to make too much of them" (227). The Dorrit family fiction plays on the word *domestic*: they pretend she is a domestic sort when in fact she is a domestic servant, both in and out of the Dorrit household. The wish to serve and the "timid earnestness" define Amy's nature.

Amy has made herself into a servant during her father's time in the Marshalsea debtors' prison, supporting him and her sister Fanny but also ministering to their smallest needs as if she were a maidservant. Long after the father's release and the elevation of the family into wealth and society (usually given an ironic capital S in *Little Dorrit*), the relation between Fanny and Amy is still much the same. In the following scene at Fanny's dressing table, Fanny has just asked ungraciously for forgiveness after calling her sister a mole and a bat. The passage needs to be compared to an exactly contemporary painting by Dickens's friend Augustus Egg, *A Young Woman at Her Dressing Table with Her Maid* (page 58). There the blonde, ringletted beauty at the mirror might be taken for Fanny and the dark-haired maid in the shadows for her sister Amy:

Poor Little Dorrit, not seeing her way to the offering of any soothing words that would escape repudiation, deemed it best to remain quiet. At first, Fanny took this ill, too; protesting to her looking-glass, that of all the trying sisters a girl could have, she did think the most trying sister was a flat sister. That she knew she was at times a wretched temper; that she knew she made herself hateful; that when she made herself hateful, nothing would do her half the good of being told so; but that, being afflicted with a flat sister, she never *was* told so, and the consequence resulted that she was absolutely tempted and goaded into making herself disagreeable. Besides (she angrily told her looking-glass), she didn't want to be forgiven. It was not a right example, that she should be constantly stooping to be forgiven by a younger sister. And this was the Art of it—that she was always being placed in the position of being forgiven, whether she liked it or not. Finally she burst into violent weeping, and, when her sister came and sat down at her side to comfort her, said "Amy, you're an Angel! (570–71)

Fanny talks to her looking-glass as if it were another right-minded and agreeing Fanny. This is a *vanity* scene, and the reflection Fanny finds in her vanity is an ideal sister because identical to herself. Her sister's image is also there, but disagreeable in its difference, and Fanny attempts to turn the real sister into a mere image—a flat sister—even as she turns the sisterly relation into that of woman and maid—not without the compliance of Little Dorrit.

Although the Meagles twins and Fanny and Amy are the only literal sisters in *Little Dorrit*, there are other pairs of women who are virtual sisters or who should be sisters in all but blood. Two of these pairs share one "sister:" Harriet Beadle. She should be Minnie Meagles's adopted younger sister in the Meagles household. She is a kind of sister to Miss Wade (whose first name is never mentioned, even as Harriet's is changed, Minnie's is changed, and Amy's is virtually removed): they share parents in the sense of not knowing their parents. Moreover, Miss Wade recognizes "a kindred spirit" (as Dickens's 1868 running head for their Chapter Two meeting puts it) in Harriet, a similarly passionate, restive character who will always be unhappy with her situation.

When Minnie Meagles was fourteen or fifteen, her parents took a child from the Foundling Hospital in London to be her maid. The foundling girls were normally placed out in domestic service at eleven or twelve, so Harriet must be several years younger than Minnie. It does not occur to the Meagleses that Harriet Beadle should be adopted as a daughter rather than taken in as a servant, nor would it be likely to have occurred to any of the officials at the Foundling Hospital.[6] Mrs. Meagles is full of sympathy in looking at the charity children, though characteristically, she sees them from the mother's point of view: "when I saw all those children ranged tier above tier, and appealing from the father none of them has ever known on earth, to the great Father of us all in Heaven, I thought, does any wretched mother ever come here, and look among those young faces, wondering which is the poor child she brought into this forlorn world, never through all its life to know her love, her kiss, her face, her voice, even her name!" (17).

The Meagleses take in Harriet, prepared to make allowances if her temper is "a little defective" (18), and her name becomes transformed to Tattycoram. "Why, she was called in the Institution, Harriet Beadle—an arbitrary name, of course," says Mr. Meagles, "Now, Harriet we changed into Hattey, and then into Tatty" (18) out of the best of motives. Similarly, Harriet's last name goes because of its unpleasant suggestions:

As to Beadle, that I needn't say was wholly out of the question. If there is anything that is not to be tolerated on any terms, anything that is a type of jack-in-office insolence and absurdity, anything that represents in coats, waistcoats, and big sticks our English holding on by nonsense after every one has found it out, it is a beadle. . . . Whenever I see a beadle in full fig, coming down a street on a Sunday at the head of a charity school, I am obliged to turn and run away, or I should hit him. (18)

The passage should be read alongside Rebecca Solomon's 1856 painting *A Friend in Need* (page 78), with its officious beadle being restrained by a compas-

sionate "respectable" woman offering help to a woman of the streets.

So Harriet Beadle turns into Tattycoram—the last part because the Foundling Hospital's founder was named Thomas Coram. And the Meagleses have no idea that their condescension could be taken ill. But Harriet, when she allows herself, does feel it, though she cannot articulate the problem except to say she is ill-used, to point out that she is younger than Minnie yet must look after her as if she were older, and to assert what she knows to be untrue: that there is conscious ill-will on the part of Minnie and her parents. Miss Wade, who encourages her to leave the Meagleses and join her, *can* articulate Harriet's complaints. Though the whole portrait of Miss Wade as a "self-tormentor" tends to cancel the force of what she says about Harriet's situation, her description of that situation sounds very much the way a modern reader would see it:[7]

> Here is your patron, your master. He is willing to take you back, my dear, if you are sensible of the favour and choose to go. You can be, again, a foil to his pretty daughter, a slave to her pleasant wilfulness, and a toy in the house showing the goodness of the family. You can have your droll name again, playfully pointing you out and setting you apart, as it is right that you should be pointed out and set apart. (Your birth, you know; you must not forget your birth.) You can again be shown to this gentleman's daughter, Harriet, and kept before her, as a living reminder of her own superiority and her gracious condescension. (319)

When Dickens twins Minnie Meagles and kills off the twin sister, he creates a gap for a new sister. That the sister should be Harriet is suggested by some of the book's juxtapositions, as well as by Meagles's history of the twins and the "replacement" of the dead twin with Harriet (17–19). For example, Clennam looks at a picture of Minnie and her sister Lillie, trying to decide which is which, and Tattycoram appears in a neighboring frame: "The picture happened to be near a looking-glass. As Arthur looked at it again, he saw, by the reflection of the mirror, Tattycoram stop in passing outside the door, listen to what was going on, and pass away with an angry and contemptuous frown upon her face, that changed its beauty into ugliness" (189). But instead of sistering Harriet with Minnie, the book brings in for a sister the only person who can articulate how the Meagleses might have treated Harriet. Miss Wade is "a handsome young Englishwoman" (22), proud, reserved, and willfully solitary, with a

mystery about her. Miss Wade's and Harriet's resemblance is noted when they first meet. Miss Wade has dark hair like Harriet's, and she watches the younger woman's fit of temper "as one afflicted with a diseased part might curiously watch the dissection and exposition of an analogous case" (26). Miss Wade writes to Harriet to tell her the girl may go to her if she ever feels badly used (191), and Harriet later accepts the invitation, running away from the Meagles's house. Miss Wade describes it to Meagles and Arthur, when they come to retrieve Harriet, as Harriet's "taking refuge with me" (319).[8]

When Miss Wade makes the speech about Harriet's being a toy in Meagles's house, it confirms the younger woman in her refusal to accept his plea for her return. Meagles sees the speech as perverting "his motives and actions" (320). He repeats his plea and suggests that Miss Wade is motivated by a lesbian attachment to Harriet: "If it should happen that you are a woman, who, from whatever cause, has a perverted delight in making a sister-woman as wretched as she is (I am old enough to have heard of such), I warn her against you, and I warn you against yourself" (323). The language is oblique for a novel whose satiric targets include the "Circumlocution Office."

Miss Wade believes her concern for Harriet is based on the sisterhood of their anonymous birth and their refusal to accept a servile status: "What your broken plaything is as to birth, I am," she tells Meagles. "She has no name, I have no name. Her wrong is my wrong" (323–24). She reminds Arthur of the difference between her own birth and that of Minnie Meagles: "I hope the wife of your dear friend, Mr. Gowan, may be happy in the contrast of her extraction to this girl's and mine, and in the high good fortune that awaits her" (324). Since Arthur has just discovered in the previous chapter that the Gowans consider Minnie's "extraction" low indeed, some of the ironies of Miss Wade's remark are immediately apparent. Others must wait on our knowledge that she and Minnie Meagles are "sisters under the skin," Henry Gowan having been a former lover of Miss Wade's. Miss Wade confides this to Clennam in their last meeting at Calais, along with a written history of herself. In that account, she confesses her inability to receive anyone's kindness as other than insufferable, intentional reminders of her dependence. Her history contains ambiguous evidence of her lesbianism and a somewhat less ambiguous relation of an actual affair with Gowan. Miss Wade ends her account, which

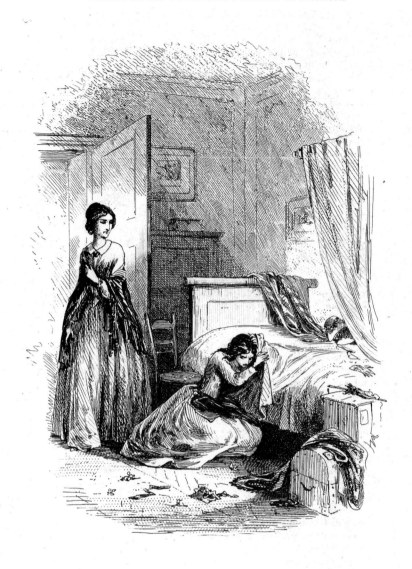

Hablôt K. Browne, Under the Microscope *(1855), il-
lustration for* Little Dorrit, *The Huntington Library, San
Marino, California*

takes up all of the chapter headed "The History of a
Self-Tormentor," by writing of her relation with Har-
riet, in whom she says she found "much of the rising
against swollen patronage and selfishness, calling
themselves kindness, protection, benevolence, and
other fine names, which I have described as inherent
in my nature" (651).

Miss Wade's intention, she writes, is to "try to re-
lease the girl from her bondage" (651). By using this
language, along with calling her house a "refuge" for
Harriet (319) and labelling her removal of the girl
from her old life as a *rescue* (642), Miss Wade makes
her taking up of Harriet recall the rescue of prostitutes

and "fallen" women by social activists in mid-century
England. Clearly for Miss Wade, the servile status of
a dependent woman in a household such as the Meag-
les's, or such as she spent her early years in, is a fate
comparable to sale of oneself. Miss Wade begins her
rescue of Harriet at their first meeting in I.II, a meet-
ing illustrated by Hablôt Browne's first engraving for
the book, *Under the Microscope.* The iconography,
like the language, points to rescue, as Harriet is
shown in the typical submission posture I discussed in
Chapter 3. Otherwise the illustration might be of two
dark-haired sisters of slightly different ages.

The book's other characters cannot appreciate Miss

Wade's feelings, and Harriet's return to the Meagleses is a plot turn that appears to condemn Miss Wade's attitudes. Harriet reports on her experiences with Miss Wade:

Oh! I have been so wretched . . . always so unhappy, and so repentant! I was afraid of her from the first time I saw her. I knew she had got a power over me through understanding what was bad in me so well. It was a madness in me, and she could raise it whenever she liked. I used to think, when I got into that state, that people were all against me because of my first beginning; and the kinder they were to me, the worse fault I found in them. I made it out that they triumphed above me, and that they wanted to make me envy them. . . . I have had Miss Wade before me all this time, as if it was my own self grown ripe—turning everything the wrong way, and twisting all good into evil. I have had her before me all this time, finding no pleasure in anything but in keeping me as miserable, suspicious, and tormenting as herself. (787)

Harriet cannot separate what might make sense in Miss Wade's views from the synergistic misery of the two of them living together. What she reacts against, what is bad about the relation with Miss Wade, is that Harriet has been just as dependent there as at the Meagleses'. Miss Wade detests dependence for all the right reasons, but her own nature acts to impose it as well: Harriet says in Calais, "she taunts me because she has made me her dependant. And I know I am so; and I know she is overjoyed when she can bring it to my mind" (643). This hypocrisy in Miss Wade does not make her condemnation of servitude and dependence the less telling. But her hypocrisy and paranoid conviction that she has been patronized, condescended to, and continually insulted by kindnesses do make her criticisms easier to dismiss. Meagles cannot see servitude as other than a natural state for certain classes, and therefore Harriet's servitude is natural. Her return proves him "right," though what would count as refutation is not clear since he cannot think in an alternative way.

What goes along with the implied judgment in Miss Wade's characterization (opposing the way society orders the classes makes a twisted, miserable neurotic out of a handsome young woman) is an endorsement of the provident rightness of servitude, especially when it is acquiesced to or even embraced by the servant. In *Little Dorrit* the acquiescence is gender-specific; it is presented as peculiarly feminine. The book ends happily because Harriet Beadle goes back to becoming Tattycoram, and Amy Dorrit Clennam will be forever her husband's domestic Little

Dorrit. The only obstacles to Amy's happiness at the end of the book are the fortune that her father lost by entrusting it to Merdle ("O my dearest and best," she says in her rapturous confession to Arthur that she has no money, "are you quite sure you will not share my fortune with me now?"—792) and the smaller fortune bequeathed to her by Arthur's father. She prevails on him to burn the codicil for the latter without ever telling him what it is. What stands in the way of Amy Dorrit's happiness is her independence. The whole book is about dependence, bondage, and imprisonment. There is some breaking out: Affery declares she is defying Mrs. Clennam and Flintwinch in II.XXX. Affery's servitude has included obedience to her mistress to the extent of following her orders to marry, and obedience to her husband to the extent of allowing him to assign much of her real experience to "dreams." The "incendiary" Pancks breaks outs when he publicly cuts the hair of the obnoxious rent-sweater Casby and cuts his hat brim off, too, in the process (780). But as is made clear earlier in the book (525), it is Casby's throat that is the more reasonable revolutionary target—or perhaps his heart, since the wonderfully contained "outrage" takes place in Bleeding Heart Yard. The real containment is in the book's ideal, represented by Little Dorrit, the domestic servant without the Christian name, whose "timid earnestness" (754) contrasts so completely with the discredited ideal of independence in Miss Wade.

The other "sisters" who must be considered in *Little Dorrit* are the two women whose bond is not shared parents but a shared child in Arthur Clennam: Mrs. Clennam and Arthur's birth mother. Like the other women of *Little Dorrit* (except Flora Casby Finching and Fanny Dorrit Sparkler), these two are denied Christian names. Miss Wade is never given a Christian name, Harriet's is changed, along with her last name, and Amy's Christian name is essentially removed in favor of her last name and a diminutive. Mrs. Clennam, like Miss Wade, is simply never given a Christian name, and Arthur's birth mother has no name at all.

Mrs. Clennam's story is another history of a self-tormentor, introduced by the blackmailer Blandois as "the history of a house" (750), but taken over and told by Mrs. Clennam herself as an unrepentant confession. Blandois gets her to admit that she is not Arthur's mother, and from there she takes the story over, asking, by way of explanation for telling it herself,

"Have I suffered nothing in this room, no deprivation, no imprisonment, that I should condescend at last to contemplate myself in such a glass as *that*. Can you see him?" (753).

She describes her youth of "wholesome repression, punishment, and fear" (753), and the assurance she had that Arthur's father was raised the same way. But after her marriage to him she discovers that Arthur's father has had a child by a woman with whom he secretly exchanged marriage vows, and she determines to be the punisher of this sin, calling herself, repeatedly, the "servant and minister" of God (754). "*Scourge* and minister" is the phrase we expect, but servant is ironically apt given the book's obsession with the role. Certainly there is nothing of the servile or the timid in Mrs. Clennam as she confronts Arthur's mother, who falls at her feet, and, in a cruel parody of a forgiveness and reconciliation scene, has her child (Arthur) extorted from her. Hablôt Browne's first illustration for the book, *Under the Microscope*, might serve in every respect for this scene as well, with the standing figure as the righteous Mrs. Clennam rather than the severe Miss Wade, and the other figure the fallen mistress of Arthur's father rather than the miserable Harriet Beadle.

Arthur's mother goes mad as a result of what she has renounced. Mrs. Clennam has no further relations with her husband, who eventually leaves the country and stays away until his death. Mrs. Clennam suffers from a hysterical paralysis for many years until it is relieved by this confession. Thus the relation between the two women is another tormented "rescue," in which Mrs. Clennam imagines herself saving the boy from beggary, the mother from the shame of exposure, and the father from public censure. The twist comes in that the rescuer is motivated by vindictiveness rather than compassion, and the rescue amounts to a curse, depriving Arthur's mother of both her lover *and* her child.

In the closest thing to a tender sisterly conference between women on an equal footing in *Little Dorrit*, Flora Finching and Amy meet at the pie shop across from the prison in a comic scene near the end of the

book. They are, after all, "sisters under the skin" as lovers of Arthur, and in this touching scene it is revealed that Flora has haunted the pie shop "hours after hours to keep him company over the way without his knowing it" (794) in the same way as Amy used to haunt Arthur's lodgings. Flora is so featherheadedly prolix that we flinch whenever she is reintroduced and about to speak in the book, but we soon realize that aside from Amy she is practically the only female character who is presented sympathetically. Amy understands the intended generous congratulations behind Flora's outpourings of words in this scene without necessarily following the actual train of thought, and the two women warm to each other while Flinching's aunt eats her kidney pie, occasionally shouting, "Bring him for'ard, and I'll chuck him out o' winder!"

"Sisterly" relations tend to misfire all over *Little Dorrit*. In Minnie and Harriet there is the potential of partially restoring the lost twinship—a sisterhood that would be healing and completing, but which class bigotries never allow to be considered. Fanny and Amy have a sisterhood that always breaks into differences: lady and servant, prostitute and respectable woman. With Harriet and Miss Wade we have a sisterhood that should be a complete equality, as Miss Wade puts it (both are parentless and thus without name or status), but one that is censured as a lesbian attachment and that includes Miss Wade's imposition of dependence on Harriet. Mrs. Clennam and Arthur's mother are the last "sisters." One sees herself as servant/scourge of God, and the other is a fallen, nameless woman. One offers a perverted rescue, actually a condemnation that annihilates the other and alienates Arthur and his father from both women forever. In this book sisterhood tends to be a battleground. Dickens does not block the possibility of a rescue, but he everywhere blocks equality in relations between women—one important condition with which sisterhood begins and the one that rescues in art attempt to recover.

7

Looking-Glass Women: Rescue and Displacement in Collins

SEVERAL OF WILKIE COLLINS'S BOOKS CONTAIN rescue plots in which one woman attempts to save her sister. These rescues are initially successful: In *The Woman in White* Marian Halcombe retrieves her half sister Laura Fairlie from the asylum where she is being held and where the keepers believe Laura to be another half sister, Anne Catherick, whom she resembles very closely. In *No Name* Magdalen Vanstone retrieves the family name after the revelation that she and her sister are illegitimate and thus nameless. But the rescues are incomplete or ineffective until they have been championed by males. Laura Fairlie's fortune and her identity are at risk until Walter Hartright manages to defeat the law *and* the lawless. Magdalen is stymied by her husband's legal manipulations until her passive sister saves the Vanstone fortune by marrying the heir. Magdalen herself is saved from a suicidal decline by Captain Kirke of the *Deliverance*, who finds her and marries her despite her checkered past.

These rescues occur in plots containing displacement struggles between two women in contest for the same identity. In *The Woman in White*, the three female protagonists in this struggle are all half sisters; in *No Name*, Magdalen Vanstone fights toward recognition of her own name and her sister's name. In *The New Magdalen*, the ex-prostitute or "magdalen" Mercy Merrick assumes the identity of the respectable Grace Roseberry whom she believes dead. In two out of the three books here, sisterhood is the family rela-

tion within which Collins plays out the drama of displacement. These displacement struggles in Collins's novels feature a woman compromised in some way—by illegitimacy or prostitution or sexual adventures just short of it—attempting to take the place of a respectable woman.

The displacement plots in these books have a specific historical, social, and legal context. Collins sees the problem of the mid-century Englishwoman as one of *identity*. As Richard Barickman, Susan MacDonald, and Myra Stark put it, the "plight of the disinherited Magdalen Vanstone (legally illegitimate like Anne Catherick) becomes a means of implying that most Victorian women have no firm identity, 'no name,' as they remain under paternal authority or pass from a father's authority to a husband's (exchanging, of course, one man's name for another's)."[1] This deprivation of identity occurs to women operating within the bounds of sexual propriety; for the sexually deviant woman the problem is erasure of identity by ostracism. Since law and society are responsible for these wrongs, the illegal and the antisocial can easily become a counterforce that has our sympathy, and that is exactly what happens in each of the novels treated here. They feature an almost Manichaean struggle and counterstruggle. Collins, according to Barickman, MacDonald, and Stark, "can so fuse the outlaw and the heroine as to deeply trouble his middle-class reading public."[2] During long stretches of *No Name* and *The New Magdalen* a heroine acting illegally or

fraudulently has our unqualified sympathy. All of this subversion leads Collins scholars to talk about a "counterworld" in his fiction, "asocial and amoral, unbound by the restraints of the socialized superego,"[3] a fictional world that is "blatantly amoral and relativistic, mired in contingency."[4]

Yet it would be a mistake to see Collins as the subverter of middle-class moral values and the reformer of wrong-headed attitudes about women. Collins capitalizes on such attitudes as much as he advocates their reform. His plots reflect the legal problems of women but his sensationalism also exploits public fears, extending and helping to construct new myths about women.

The way popular arts can participate in constructing such myths is described at length by Lynda Nead in *Myths of Sexuality: Representations of Women in Victorian Britain*. Nead traces the construction of sexual myths in mid-century England, primarily in visual art, but also in novels, sociological writing, and medical discourse. These myths served, according to Nead, to regulate sexuality as a part of class hegemony. Her interest is especially in "the ways in which visual culture contributed to the processes of bourgeois hegemony."[5] She argues that in the 1850s, there was a "moral panic" in England; the regulation of sexuality became a charged public issue because "sexual and moral behavior were perceived as the touchstones of social order," and social order was being threatened.[6] The threats were external (the Crimean War with its consequent scandals concerning improper management and the incompetence of the officer corps; the Indian Mutiny, which resulted in uneasiness about the whole Empire) as well as internal (economic troubles; Chartism; Owenite socialism). This moral panic was translated into an exaggerated fear of the moral, social, and medical threat of prostitution.[7] This fear was answered in various ways: one was the passing of the Contagious Diseases Acts. Another was the construction of a myth of the prostitute as a kind of self-destroying evil. According to this myth the prostitute's tortured conscience triggered a physical decline in which ill-health was frequently compounded by alcoholism. The prostitute lost her looks and became poorer as she was unable to practice her trade. Her life was invariably short, cut off by syphilis, drinking, other health problems, or the quicker release of suicide. Society found it convenient to believe in prostitution as a self-destroying evil, and so this myth flourished in popular

representations such as Thomas Hood's "Bridge of Sighs," William Bell Scott's "Rosabell," and paintings such as George Frederic Watts's *Found Drowned* and Abraham Solomon's *Drowned! Drowned!* (page 75). Literary and pictorial sources contributing to the construction of this view of the prostitute are discussed in works already cited by Nead, Linda Nochlin, Nina Auerbach, and Susan Casteras.

But even as this myth was being seized upon by sociological and medical writers, artists, poets, and novelists, a countermyth was being constructed, one that awakened new fears about prostitution. In his 1857 *Prostitution Considered in Its Moral, Social, and Sanitary Aspects*, William Acton suggested that "prostitution was a transitory state through which many women passed" and that *most* prostitutes "return sooner or later to a more or less regular course of life."[8] Henry Mayhew quoted one of the women he interviewed, a woman kept by her client in "superior style," who answers Mayhew's question about what will become of her by saying, "What an absurd question. I could marry tomorrow if I liked."[9] From such beginnings a new myth arose, not calculated to soothe fears, but to arouse them: prostitutes will not conveniently destroy themselves; they are more likely to compete with respectable women for husbands and they cannot be distinguished from their respectable rivals. Thus we have two views of the prostitute. In one, the whore self-destructs; in the other, she displaces the respectable woman in a Victorian anticipation of *The Invasion of the Body Snatchers*. Nead and Auerbach present ample evidence that these disparate views of the prostitute's existence and prospects were backed up by discourse in almost all areas where discourse is produced. Most of it did not call itself fiction.

Collins's sensational novels of the sixties and early seventies depend upon and exacerbate fears that respectable women do not have a distinguishing cachet that prevents their impersonation by women in some objectionable social or moral state. These are fears that the usual shibboleths (language, possessions, relations) may not work, that the poor and the fallen are not necessarily marked by signs that will prevent their displacing their betters. In *No Name* Magdalen Vanstone is willing to sell herself to get her family name and fortune back; in *The New Magdalen* a prostitute steps into a new, ready-made identity, displacing the supposedly dead woman whose name and position she usurps, and the displacement takes her immediately into the upper reaches of society. But the

displacement is not always coded directly in sexual terms. Collins is working in a social climate where any crossing of class lines is regarded with terror; actual prostitution need not be an issue. In *The Woman in White* (1860), Collins presents the displacement from the point of view of the displaced woman, who has her identity usurped not by a sexual adventuress, but by a poor, unfortunate, illegitimate, half-crazed woman whom she has the ill luck to resemble because of her father's philandering.

The Woman in White and *No Name* have as their context the turmoil of the late fifties described in Lynda Nead's book. *The New Magdalen* is written in a social and historical context that involved prostitutes and respectable women in a struggle that lasted throughout much of Collins's writing career but only began after the publication of *No Name*. The specific context is the proposal, passage (1864, 1866, 1869), suspension (1883) and repeal (1886) of the Contagious Diseases Acts. These acts were passed in response to the fear of public disease resulting from prostitution, especially near military encampments. They made women subject to examination on mere suspicion of prostitution. The acts *institutionalized* the fears they were meant to quell. They effectively erased legal distinctions between respectable women and prostitutes, and in the process they obliterated class distinctions as well. Writing for Josephine Butler's Ladies' National Association for the Repeal of the Contagious Diseases Acts in a letter published in the London *Daily News* on the last day of 1869, Harriet Martineau thus describes the way the acts worked:

Unlike all other laws for the repression of contagious diseases, to which both men and women are liable, these . . . apply to women only, men being wholly exempt from their penalties. The law is ostensibly framed for a certain class of women, but in order to reach these, all the women residing within the districts where it is in force are brought under the provisions of the Acts. Any woman can be dragged into court, and required to prove that she is not a common prostitute. The magistrate can condemn her, if a policeman swears only that he "has good cause to believe" her to be one. The accused has to rebut, not positive evidence, but the state of mind of her accuser.[10]

The objections of Martineau and others (the letter was signed by Josephine Butler, Florence Nightingale, and 125 other women) were partly legal and partly moral. They argued that the acts removed the ancient guarantee of presumption of innocence, since women suspected by a single policeman were required to prove their "innocence"—in both senses of the word. They argued, somewhat surprisingly, that the acts involved a "momentous change in the legal safeguards hitherto enjoyed by women in common with men."[11] The argument was surprising because in areas such as property and personal freedom men had always enjoyed a discriminate advantage over women. But the argument was shrewd because it appealed to theoretical principles of English justice and thus enabled the Ladies' National Association to take high legal ground. Moreover, the LNA was perhaps identifying a real trend: the changes that were taking place in divorce and property laws did gradually begin to make real statutes conform to a theoretical equality under the law. The LNA also objected to the moral implications of the acts, by which "the State recognizes and provides convenience for the practice of a vice which it thereby declares to be necessary and venial."[12]

The winning of the campaign by the opponents of the Contagious Diseases Acts meant a wider recognition of some facts of moral and legal life than had been possible before: Martineau stressed the need to treat women the same as men legally and the need to treat men the same as women morally. Collins's work pushed toward such awareness at the same time as it got a push from the topicality of the issues.

THE WOMAN IN WHITE (1860)

"The central idea" of *The Woman in White*, according to Collins himself, is a conspiracy "to rob a woman of identity by confounding her with another woman, sufficiently like her in personal appearance to answer the wicked purpose."[13] In fact the resemblance between the two women is not an actual twinning. Anne Catherick is about a year older than Laura Fairlie. According to Laura's mother, Anne is "although . . . not half so pretty . . . the living likeness, in her hair, her complexion, the colour of her eyes, and the shape of her face," of Laura.[14] The difference between Anne and Laura is seen by Laura's mother as one of prettiness, but by Hartright and Percival Glyde as a matter of health versus sickliness. "The delicate beauty of Miss Fairlie's complexion," writes Walter Hartright, "the transparent clearness of her eyes, the smooth purity of her skin, the tender bloom of colour on her lips, were all missing from the worn, weary face [of Anne Catherick] that was now turned towards mine. . . . If ever sorrow and suffering set their pro-

faning marks on the youth and beauty of Miss Fairlie's face, then, and then only, Anne Catherick and she would be the twin-sisters of chance resemblance, the living reflexions of one another" (1:143–44)). Laura's husband, Glyde, describes Anne by saying "She's a sickly likeness of my wife" (1:505). The difference in appearance encodes reference to class or to other differences. Laura Fairlie's mother was married to her father, while Anne Catherick's mother was not married to the man who fathered her child—the same man who fathered Laura. Clearness of eye and purity of skin point to clearness of one's pedigree and thus to inherited moral purity. Proper nutrition and consequent health were probably real markers in distinguishing those of Laura Fairlie's class; certainly ill health is part of the standard sociological descriptions of the poor in surveys at mid-century by Godwin, Chadwick, and others.[15] But these markers cannot be counted on if "sorrow and suffering" affect both classes.

The book's subject of interest is not the actual resemblance between the women but the fact that one can be accepted as the other regardless of the differences. The psychology of the displacement has much more to do with the expectations and convictions of those around the woman in question than with her appearance. When the supposedly dead Laura Glyde is brought in to be examined by her uncle Frederick Fairlie, he is clearly convinced that the woman before him is Anne Catherick. The evidence of his senses does not budge the firmness of his convictions, and the same is true for the servants Marian Halcombe hopes will recognize her sister, their mistress:

The scene that followed, though it only lasted for a few minutes, was too painful to be described—Miss Halcombe herself shrank from referring to it. Let it be enough to say that Mr. Fairlie declared, in the most positive terms, that he did not recognise the woman who had been brought into his room; that he saw nothing in her face and manner to make him doubt for a moment that his niece lay buried in Limmeridge churchyard; and that he would call on the law to protect him if before the day was over she was not removed from the house.

Taking the very worst view of Mr. Fairlie's selfishness, indolence, and habitual want of feeling, it was manifestly impossible to suppose that he was capable of such infamy as secretly recognising and openly disowning his brother's child. Miss Halcombe humanely and sensibly allowed all due force to the influence of prejudice and alarm in preventing him from fairly exercising his perceptions; and accounted for what had happened, in that way. But when she next put the servants to the test, and found that they too

were, in every case, uncertain, to say the least of it, whether the lady presented to them was their young mistress, or Anne Catherick, of whose resemblance to her they had all heard, the sad conclusion was inevitable, that the change produced in Lady Glyde's face and manner by her imprisonment in the Asylum, was far more serious than Miss Halcombe had at first supposed. The vile deception which had asserted her death, defied exposure even in the house where she was born, and among the people with whom she had lived. (2:79–80)

Walter himself admits that by this time "sorrow and suffering . . . *had* set their profaning marks on the youth and beauty" of Laura's face and made the resemblance between her and Anne Catherick "real and living" (2:87).

The presentation of Laura's appearance and character predicts from the beginning that she will be the one needing rescue, and her stronger sister Marian will provide it. Laura Fairlie is "a fair, delicate girl" (1:73) with pale brown hair, trusting, gentle, with "kind, candid blue eyes" (1:74), but with a manner that suggests, as Walter Hartright writes over and over again, five times in four sentences, "something wanting" (1:75). Marian, on the other hand, the daughter of Philip Fairlie's wife by her first husband, is tall, dark, with "thick, coal-black hair, growing unusually low on her forehead" (1:47), frank and forward, and, to Walter Hartright at least, unattractive because of features (swarthiness, a firm mouth and jaw) and a manner he reads as masculine: "Her expression—bright, frank, and intelligent—appeared, while she was silent, to be altogether wanting in those feminine attractions of gentleness and pliability, without which the beauty of the handsomest woman alive is beauty incomplete" (1:47). Marian has large hands, an open manner, presence of mind, and a general scorn for her own sex that she thinks women in general share (1:48).

Her energy and assertiveness enable Marian to rescue the passive Laura bodily from the asylum where she is being kept as Anne Catherick. Then Walter Hartright rescues Laura's fortune and identity by confronting Fosco and forcing a confession from him. But Walter marries the passive Laura. The rescued sister rather than the rescuing one is the reward for the male who intervenes in one version of the rescue story—the *Sense and Sensibility* model. Walter's preference for Laura is not unexpected after the clear description we have had of Walter's repulsion at Marian's capable manner. Laura appeals to him because of her weak-

ness. She thus describes herself shortly after her escape from the asylum:

> "I am so useless—I am such a burden on both of you," she answered, with a weary, hopeless sigh. "You work and get money, Walter; and Marian helps you. Why is there nothing I can do? You will end in liking Marian better than you like me—you will, because I am so helpless? Oh, don't, don't, don't treat me like a child!" (2:155)

Walter's response is to treat her like a child and not to like Marian any the better for being of help to him. Marian's help comes in the form of becoming the domestic servant of the other two. There is never any possibility that Laura will roll up her sleeves and help Marian, nor that Walter would be anything but horrified if she were to try. Walter's whole quest, after all, is to recover her name and class for Laura. He insists it has nothing to do with money but everything to do with her reception once again in the house where she was born (2:104). In the process it is as if the two contrasting sisters (already characterized for us by Marian as one rich and the other—herself—poor) were turned into members of different classes, as if in looking at the fair Laura and the dark Marian we were looking once again at Egg's *Young Woman at Her Dressing Table* (page 58) or Solomon's *The Governess* (page 55).

The Woman in White forces a romantic solution onto a legal problem. Marian, Laura, and Walter are met with nothing but resistance when they try to go to law to recover Laura's identity. The lawyer they consult tells them that "Questions of identity, where instances of personal resemblance are concerned, are, in themselves, the hardest of all questions to settle" (2:101). Walter falls back upon his only recourse—he must make Glyde or Fosco confess. The book's resolution affirms the moral maxim that Glyde and Fosco have sneered at ("crimes cause their own detection"), but only with the hero's help does the detection come about. Walter cannot force Glyde to reveal the truth, and eventually Glyde burns to death in a vain attempt to destroy the forged church records that would reveal his own bastardy. His dark secret, hinted at through half the book, thus connects him with Anne Catherick. He was not her father, as some local gossip had hinted, but his birth, like hers, had a seeming legitimacy that was spurious. Fosco *is* made to confess his own crimes. To bring this about, though, Collins must contrive a secret society and the coincidence that Walter's old tutor and Fosco are both members in it.

The female rescue has to be completed by a male, the societal/legal problem can be circumvented by male heroism, and the displacement threat can be overcome by male ingenuity and perseverance. Finally *The Woman in White* is what it announces itself to be at the beginning, "the story of what a Woman's patience can endure, and what a Man's resolution can achieve" (7). This resolution poses no challenge to convention, and the book was a rousing popular and critical success. Collins's next novel, *No Name*, was neither of those things, getting adverse reviews and fewer sales than expected by Mudie, who bought most of the first printing for his library.[16] *No Name* appears to challenge convention, but the challenges are more apparent than real.

NO NAME (1862)

The rescues in *No Name*, complex and more overtly sexual than in *The Woman in White*, start before the book's action and cast all the Vanstone women as rescuers. Two men also have this role—neither one a weak Vanstone male—Captain Kirke and George Bartram. The first rescue is Mrs. Vanstone's of her husband. Andrew Vanstone had married a woman from the American South when he was twenty-one (179). He separated from her when he found out about her "misconduct" before they were married (180). He meets Mrs. Vanstone—Miss Blake—in England, and she, to "rescue" him (186), agrees to live with him as his wife. When he hears his wife has died at New Orleans, he marries Mrs. Vanstone, but is not immediately aware that he needs to make a new will—circumstances prevent it, and he dies. Norah and Magdalen, once their mother is dead as well, are orphans and illegitimate as well. "As children born out of wedlock, Mr. Vanstone's daughters . . . had no more claim to a share in his property than the daughters of one of his laborers in the village" (197). "Mr. Vanstone's daughters are Nobody's Children" (199), says the lawyer, Pendril. Norah—twenty-six, dark-haired, "gentle and feminine" (12), which suggests, in the Dickens/Collins gender-adjective code, virtuous, predictable, and meek—reconciles herself to her loss and settles down as a governess. Magdalen, eighteen, chafes at the fact that "legally speaking, she and her sister had No Name" (259), and she determines on a rescue of name and fortune for herself and her sister.

Collins makes it clear what Magdalen is up against,

and the legal problem is only part of it. Her father's heir, Noel Vanstone, who might be expected to feel a sense of obligation toward members of his family, instead candidly asserts his grasping materialism: "I have lived too long in the Continental atmosphere to trouble myself about moral points of view," he says, "I have got the money, and I should be a born idiot if I parted with it. There is my point of view!" (412). As for the sympathy the Vanstone girls can expect from society as a whole, their former governess Miss Garth writes to Magdalen, "I have lived long enough in this world to know that the sense of Propriety, in nine Englishwomen out of ten, makes no allowances and feels no pity" (448). Magdalen's answer to society is to answer pretense with pretense. She pretends to be someone else—or rather pretends to be *someone*—a woman who is legitimate and eligible. She sets out to make "Nobody's Child Somebody's Wife" (2:276). Aping respectability is the ultimate radical act a woman can commit against society in *No Name* as well as in *The New Magdalen*.[17]

Collins has a variety of devices for conveying in his books the horror of the displacement of the respectable by the less-than-respectable. In *The Woman in White* Walter Hartright narrates a scene he himself did not witness (quoted above), when Frederick Fairlie denies his niece's identity. By having Walter tell us of Marian telling him, Collins manipulates the report so that we can watch the scene at the same time as we see the reaction of Marian, the actual witness. The scene is "too painful to be described—Miss Halcombe herself shrank from referring to it" (2:79). In *The New Magdalen*, the woman who is being displaced, Grace Roseberry, is brought face to face in a long dramatic scene with the ex-prostitute Mercy Merrick, the woman who is displacing her and usurping her identity. In *No Name*, the "victims" of Magdalen's impersonation, Noel Vanstone and Mrs. Lecount his housekeeper, are themselves villainous, so that their indignation will not awaken any particular sympathy or make us appreciate how Magdalen's act shakes the foundations of society. Who should speak for social stability here? Collins lights upon the clever expedient of using the swindler Wragge to do it. Even Wragge, who lives upon antisocial behavior, defends his calling by saying that he merely *forces* the redistribution of wealth his Christian society professes to be necessary and charitable (304). Wragge has a peculiar interest in the status quo, so it is understandable that he should be uncomfortable at the prospect of a tal-

ented girl like Magdalen's upsetting distinctions in society. His "horror" is disingenuous, of course, and his articulation of middle-class views is funny, coming from such a source—but no less accurate. "Hundreds of girls take fancies for disguising themselves; and hundreds of instances of it are related year after year in the public journals," writes Wragge (367). He is not talking about cross-dressing: "But my ex-pupil is not to be confounded for one moment with the average adventuress of the newspapers. She is capable of going a long way beyond the limit of dressing herself like a man, and imitating a man's voice and manner" (367–68). Wragge says this is "an experiment in deception, new enough and dangerous enough to lead, one way or the other, to very serious results. This is my conviction, founded on a large experience in the art of imposing on my fellow-creatures" (368).

When Noel Vanstone dies and Magdalen's respectable identity construction dissolves, we next see her playing the role of a housemaid in a vain attempt to find and cancel Vanstone's will, and from there she slips into London's underworld until her rescue by Kirke. *No Name*'s treatment of female rescue, of legal and social antigyny, and of displacement fears is finally no less problematic than *The Woman in White*'s. Magdalen sets out to rescue name and fortune for her sister and herself; she fails in everything except "legitimately" acquiring the Vanstone name for herself, and this she must prostitute herself to do. The real rescues are accomplished by the passive sister and two men, Captain Kirke and George Bartram. Kirke finds Magdalen dying in a London flophouse and rescues her from death and spinsterhood (she is twenty at the end of the book's action). George Bartram is Noel Vanstone's heir who meets Norah when they are both searching for Magdalen. Norah rescues her prostituted sister, who fell in order to rescue *her*, and Norah's rescue seems to demonstrate the perverted ambition of Magdalen's attempt:

Norah, whose courage under undeserved calamity had been the courage of resignation—Norah, who had patiently accepted her hard lot; who from first to last had meditated no vengeance and stooped to no deceit—Norah had reached the end which all her sister's ingenuity, all her sister's resolution, and all her sister's daring had failed to achieve. Openly and honorably, with love on one side and love on the other, Norah had married the man who possessed the Combe-Raven money—and Magdalen's own scheme to recover it had opened the way to the event which had brought husband and wife together. (2:468)

No Name turns out to be almost as conventional as

The Woman in White. But Mrs. Oliphant did not like Magdalen's getting off almost scot-free "at the cheap cost of a fever, as pure, as high-minded, and as spotless as the most dazzling white of heroines."[18] The criticism seems hardly fair, since the girl truly is a magdalen, and a penitent one, at the end. Collins may have anticipated such critics when he has Magdalen ask at the end of her book whether she deserves her happiness and has her answer in part: "Oh, I know how the poor narrow people who have never felt and never suffered would answer me if I asked them what I ask you. If *they* knew my story, they would forget all the provocation, and only remember the offense; they would fasten on my sin, and pass all my suffering by" (2:489–90).

THE NEW MAGDALEN (1873)

The New Magdalen might also be construed as an answer to the unforgiving sentiments of Oliphant's review. Although this book does not contain literal sisters, it collapses the sisters rescue plot and further develops Collins's sensational device of two women sharing one identity, and so I have included it here. This time the impersonator is actually a prostitute. The book starts in France, at war with Germany, in 1870. Mercy Merrick is a nurse who, as a prostitute, was saved from suicide by a London Refuge and the preaching there of Julian Gray. Her prostitution is defined solely in terms of necessity: "have you ever read," she asks Grace Roseberry, the woman whom she will soon impersonate in respectable society, "of your unhappy fellow-creatures (the starving outcasts of the population) whom Want has driven into Sin?" (203). In a French town about to come under German attack Mercy meets Grace Roseberry, on her way to London with a letter from her dead father to Lady Janet Roy, asking for protection and a job for his daughter. When Grace is hit and seemingly killed by a German shell, Mercy determines to rescue herself from her past by taking Grace's identity and place. Mercy's own loyalty and nobility of character gain the love and trust of Lady Janet, and in a few months Mercy is essentially Lady Janet's adopted daughter. Then the real Grace Roseberry shows up (having only been wounded by the shell), now in the protection of Julian Gray. Mercy is already predisposed toward Gray, and he falls in love with her at first sight. These plot developments Collins sketches in thirty

pages; the entire remainder of the book covers only a few hours and deals with the confrontation of the respectable woman and the poseuse.

Before she discovers Grace Roseberry is still alive Mercy Merrick dares to think "I am no worse than another woman!" (265). Collins takes this assertion and constructs one particular fantasy of its realization within society—a way it might come to be and its consequences. At the same time he opposes it with another view: that the valorizing of the whore devalues the honest woman. Perhaps it was Mrs. Oliphant's view—certainly it is Rosa Dartle's in *David Copperfield* and Lady Dedlock's sister's in *Bleak House*. When Grace makes her claim to be the *real* Grace Roseberry, she is treated as the impostor. The fallen woman and her respectable counterpart cannot coexist; one has to be forced out. Mercy's presence threatens Grace's whole ground of being and does away with every scrap of her authority, even her ability to get others to listen. The real Grace Roseberry is treated like a criminal or a madwoman, even by the most reasonable and compassionate people in the book.

In Collins's world there is no possibility of fallen woman and respectable woman being seen as equals, let alone as the identical sisters of so many contemporary paintings. Between Mercy Merrick and Grace Roseberry there is no equality because the respectable woman has an identity and the fallen woman lacks one—her identity has been erased by ostracism, as the Vanstone sisters' identity is erased by illegitimacy. Mercy and Grace (the names contain several ironies—Mercy seeks mercy in others and has grace; Grace lacks both grace and mercy) stand before Lady Janet, both asking for recognition, but only one can be recognized. The two cannot be brought together and reconciled in this fiction; they cannot occupy the same place at the same time; they are like matter and antimatter that would destroy each other if brought together. And Collins makes this opposition more telling by making Mercy Merrick the more imposing of the two: "If a stranger had been told that those two had played their parts in a romance of real life . . . he would inevitably . . . have picked out Grace as the counterfeit and Mercy as the true woman" (411).

Julian Gray proposes, attracted by the nobility of Mercy's character, shown by the fact that, with his influence, her conscience forces her to own her deceptions, even when she is triumphant in them. Mercy's remorse is caused partly by the dishonesty and fraudu-

lence of her impersonation and partly by her conviction that she has cheated Lady Janet out of her love (456). But the strength of the condemnation of her action seems out of proportion to its actual moral weight (considering that Mercy believed Grace to be actually dead and without relatives who could be hurt by the impersonation). Collins shows that the real fear about prostitution is clearly that it will cause a disturbance in the social order and the displacement of respectability. If fallen women could be safely kept in the missions where Julian Gray preaches, the middle class could be content and complacent, but those women cannot be told from other, respectable ones. The fallen woman's presence in middle-class society does not just cheapen respectability; it threatens to *displace* the respectable woman.

The novel is not completely consistent in its position. On the one hand Mercy's act of displacement is treated as the greatest of moral lapses. The plot itself shows the helpless degradation that the respectable Grace Roseberry suffers: at one point she is about to be hauled off by the police, having been successively deprived of her name and identity, her respectability, her free agency, her ability to convince others that she is even sane, and, finally, her liberty. Mercy Merrick's displacement of Grace Roseberry is a profound social threat in *The New Magdalen* and also a sin for which Mercy can atone only with help provided by the pious Julian Gray. On the other hand Grace Roseberry is made repulsive in order to provide a foil for Mercy's nobility of character. While Grace is constructed as prudish, ill-natured, bad-tempered, and venal (she is willing to sell her silence to Lady Janet—490), both Lady Janet and Julian insist that the earth holds no nobler woman than Mercy Merrick (579).

The New Magdalen enacts both myths of the prostitute, since Mercy begins as the guilt-ridden, suicidal victim of poverty and conscience, but she becomes the socially mobile woman who can step instantly into a place in respectable society. *No Name* had used the same two myths in reverse order, with Magdalen, under Captain Wragge's tutelage, able to move in a moment into respectable wifehood but degenerating

after she sells herself for the Vanstone fortune into a poor, wrecked, and destitute sufferer. But when Mercy Merrick attempts to rescue herself by adopting the persona of the dead Grace Roseberry, she finds her way blocked; in order to enter society she must displace another woman. Ultimately, she cannot effect her own rescue, and Julian Gray has to marry her to provide her with an identity.

Collins has his own reformer's points to make about the possibility and the Christian duty of reclaiming prostitutes. But the dramatic moment in these books—lengthening out into almost the whole of the last one—is the scene in which the "real" respectable woman is not recognized, and the author can play with the possibilities of a social world where distinctions suddenly operate for the underclass and against the privileged. His books are mid-Victorian horror novels that exploit the fears of society that center on sexuality.

The New Magdalen has as a main theme the reassimilation of the prostitute into society. With the defeat of the Contagious Diseases Acts, there was no longer inscription or registration of prostitutes, thus removing a stigma that could not but aggravate problems of reassimilation. At the same time the distance between the prostitute and other women was no longer terrifyingly erased, as it had been by the Acts. Collins had done his part in the sixties and seventies toward showing the terrors of displacement, while he got the benefit of having his stories enlivened by those terrors.

Collins is far more sympathetic than Dickens to some concerns of women—most notably the question of identity. He goes no farther than Dickens in one regard: neither has much confidence in the agency of women in bringing about their own salvation. The specific vehicle for the attempted rescue in Collins is usually a sisterhood—two pairs of half sisters in *The Woman in White*, full sisters in *No Name*, and only a figurative sisterhood—denied in fact by Grace Roseberry—in *The New Magdalen*. Again and again in these books the sister's rescue fails unless it is assisted or replaced by a male effort.

8

Sisters, Sexual Difference, and the Underclass in Meredith's Rhoda Fleming

SISTERS AND SEXUAL FALLS ARE LINKED IN DICKens and Collins, as they are throughout Victorian fiction. In Victorian culture, Helena Michie writes, sexual difference between women is often expressed by "the capacious trope of sisterhood" and "fallen sisters . . . are frequently recoupable through their sisters' efforts in a way forbidden to other Victorian fallen women."[1] Michie illustrates this recoverability from the fallen state with Christina Rossetti's "Goblin Market" (1862). In that poem, Laura's sexual fall is represented in an elaborate allegory where the exchange of symbolic coin (the golden curls and locks of Laura's hair) and the eating of forbidden fruit stand for illicit sexual relations with the "goblin men." Lizzie then saves her "fallen" sister, Laura, from the decline that follows from her commerce with the goblin men. Her rescue is also allegorized: Lizzie pays for the goblin fruit with real money but will not eat it herself, though the goblin men try to force it upon her. As Dorothy Mermin puts it, "her story has to do not with temptation resisted—neither the goblins nor their fruit attract her, and what she is resisting is attempted rape—but with danger braved and overcome, an heroic deed accomplished."[2] Michie reminds us, however, that even within these texts, where sisterhood is a privileged place in which moral rehabilitation can occur as it cannot in society at large, there can still be "hostility, competition, and sexual rivalry" between sisters. In fact she argues that as a whole "relations

among sisters in Victorian texts are vexed, competitive, problematic, and theatrical."[3] The reminder of competition and opposition is especially apt for stories of Dickens and Collins. In both these writers a strong inequality characterizes relations between sisters. In Dickens, one sister's fall seems almost a precondition for a sisterly pairing; in Collins, sisters are involved in displacement struggles—for their very identities—with their sisters or other women. In Meredith, there is also hostility between sisters, but it occurs in a context where equality is clearly the ideal relation among sisters. In *Rhoda Fleming* (1865), Meredith examines this equality, asks for perhaps the first time how a *man* might fit into a "sisterly" relation, and looks at what specifically *opposes* the equality of sisterliness.

Sisterhood in the texts Michie examines is a site for expression of difference in sexual experience, exercise of a saving impulse, and release of hostility between women resulting from the internalization of oppression. Sisterhood can also be the site where other societal conflicts—those of class, for example—are contested. When hierarchical systems of gender and class both get attention in a text, it is inevitable that there should be transactions between the systems. In Meredith's *Rhoda Fleming*, sisterhood helps to show how the class system and the double standard of sexual morality work together. The class system perpetuates distinctions of rank, ignoring worth, and the sexual code makes distinctions on the basis of gender,

ignoring morality. Through the literal sisterhood of Dahlia with Rhoda Fleming and the "anti-sisterhood" of Mrs. Lovell with both women, *Rhoda Fleming* links class and sexual attitudes in a critique of both. The attempted rescue of one real sister by another is complicated by and negotiated through the other "sisterly" relations created by class. In the process of creating the "anti-sister," Mrs. Lovell, Meredith makes use of a celebrated painting by Landseer and the reputation of the woman depicted in it, Catherine Walters.

DAHLIA AND RHODA

Meredith gives the two sisters, Dahlia and Rhoda Fleming, daughters of a Kentish farmer, a traditional fair-and-dark contrast with each other—"a kindred contrast, like fire and smoke," but he also sets up the possibility for another kind of contrast between their class and their aspirations when he says "In stature, in bearing, and in expression, they were . . . strikingly above their class."[4] Both sisters ape the pronunciation of the rector and his lady: "The characteristic of girls having a disposition to rise, is to be cravingly mimetic" (4). They dream of knights who are the heroes of storybooks, and they dream of London (5).

Seemingly alike in social aspirations above their class, the sisters are distinguished in looks and in temperament: Dahlia has the mild disposition, while her father says of Rhoda that she is "Too much of a thinker. . . . She's got a temper of her own, too" (27). Dahlia's is altogether the more conventional temperament and beauty: "Dahlia's . . . nose was, after a little dip from the forehead, one soft line to its extremity, and [her] chin seemed shaped to a cup. Rhoda's outlines were harder. There was a suspicion of a heavenward turn to her nose, and of squareness to her chin" (34). Rhoda's temperament resembles her father's (and his stern approach to religion resembles David Deans's). Meredith conceals the temperamental resemblance at first, even giving us a red herring in the form of an episode early in the book when Rhoda and her father are at odds. Dahlia has befriended Mary Burt, "the daughter of a Wrexby cottager, who had left her home and but lately returned to it, with a spotted name. . . . To her surprise, her father became violently enraged, and uttered a stern prohibition, speaking a word that stained her cheeks. Rhoda was by her side, and she wilfully, without asking leave, went straight over to Mary, and stood with

her under the shadow of the Adam and Eve [two stone-pines compared by Dahlia and Rhoda "to Adam and Eve turning away from the blaze of Paradise"—8], until the farmer sent a message to say that he was about to enter the house. Her punishment for the act of sinfulness was a week of severe silence" (9). The sisters do not understand their father's behavior. "By degrees they came to reflect, and not in a mild spirit, that the kindest of men can be cruel, and will forget their Christianity toward offending and repentant women" (10). This episode scarcely prepares us for Rhoda's similar intolerance later.

Dahlia is squeezed between the squirearchy and the lower levels of the aristocracy in the form of one of Meredith's neat oppositions, the country and the city cousins Algernon and Edward Blancove. Meredith makes clear that the danger comes from the higher class here, since Edward Blancove, heir to his city banker father's baronetcy, is the evil genius of Algernon, son of Squire Blancove of Wrexby. Edward seduces Dahlia, taking her abroad with a promise of marriage, instructing her in dancing, in languages and literature, but then reneging on his promise.

Rhoda wishes to rescue her sister, and in this book such a rescue includes a male, Robert Eccles, as agent. The old farmer, William Fleming, speaking out of his pain and unforgiving Puritan outrage, condemns Dahlia in front of Robert, the hired hand who loves Rhoda (Chapter XIII, "the Farmer Speaks"). It is the first time he has spoken out about his shame. "My first girl's gone to harlotry in London," he says (123), bequeathing all he has to Rhoda in the hope that someone—he means Robert—will not be ashamed of her on her sister's account and will quickly marry her, quieting his fear for the safety of Rhoda's chastity, too. The farmer goes to bed, leaving Robert and Rhoda in mutual mortification (Chapter XIV, "Between Rhoda and Robert"). Robert declares his love for Rhoda. Rhoda in her turn demands that Robert share her own absolute conviction of Dahlia's innocence (126), but he cannot.[5] She asserts her identification with her sister:

"I'm not likely to marry a man who supposes he has anything to pardon."
"I don't suppose it," cried Robert.
"You heard what father said."
"I heard what he said, but I don't think the same. What has Dahlia to do with you?"
He was proceeding to rectify this unlucky sentence. All her covert hostility burst out on it.

"My sister?—what has my sister to do with me?—you mean!—you mean!—you can only mean that we are to be separated and thought of as two people; and we are one, and will be till we die. I feel my sister's hand in mine, though she's away and lost. She is my darling for ever and ever. We're one!" (128)

Though she says she has no love for him, at his promise to find Dahlia she relents a little: "Oh! my dear, my own sister! I wish you were safe. Get her here to me and I'll do what I can, if you're not hard on her" (131).

Meredith paints a sharp contrast to the lower-class scene in farmer Fleming's cottage: meanwhile at Fairly Park, seat of Lord Elling, Edward, the baronet's son, is also thinking about Dahlia. Over the fine wines and delicate food, Edward muses at dinner: "He knew that there was something to be smoothed over; something written in the book of facts which had to be smeared out, and he seemed to do it, while he drank the bubbling wine and heard himself talk. Not one man at that table, as he reflected, would consider the bond which held him in any serious degree binding. A lady is one thing, and a girl of the class Dahlia had sprung from altogether another" (147).

Although Robert goes to Fairly and begins to harass both Algernon and Edward as he tries to find out Dahlia's whereabouts, the book does not turn into a struggle between the men. Meredith keeps attention on his issues of sex and of class. There is a long scene in the middle of the book, for example, during which Stephen Bilton, the huntsman at Fairly, drinks at the Pilot Inn and defends the fox hunt as quintessentially "English." "Foxes are gentlemen," he says, "I like the old fox, and I don't like to see him murdered and exterminated, but die the death of a gentleman, at the hands of gentlemen" (177). Stephen's absurd anthropomorphizing of the fox gives a satiric perspective to Meredith's criticism of the gentry. We might be willing to let the gentlemen shed each other's blood according to their code. But neither the fox nor the lower classes have embraced the code and willed to die or be otherwise ruined at the hands of gentlemen.

THE THIRD "SISTER"

The book sets up another, quasi-sisterly, relationship between the two Fleming sisters and Edward's beautiful and mysterious cousin Mrs. Lovell. Mrs. Lovell "tames" Robert; he gives his word he will not bother Edward (who is never again troubled about a murderous assault he has committed upon Robert) in exchange for her promise to give him Dahlia's address (200). She pacifies Robert when she finds him walking in Fairly Park. She is on horseback. He does not know it, but all the men who have been riding with her eavesdrop on the scene between him and Mrs. Lovell. As the riding party returns to Fairly Park, Edward, who has been one of the eavesdroppers, remarks that women can stop violence because they know how to incite it:

"*Similia similibus*, etc.," said Edward. "They can, apparently, cure what they originate."
"Ah, the poor sex!" Mrs. Lovell sighed. "When we bring the millennium to you, I believe you will still have a word against Eve."
The whole parade back to the stables was marked by pretty speeches.
"By Jove! but he ought to have gone down on his knees, like a horse when you've tamed him," said Lord Suckling, the young guardsman.
"I would mark a distinction between a horse and a brave man, Lord Suckling," said the lady; and such was Mrs. Lovell's dignity when an allusion to Robert was forced on her, and her wit and ease were so admirable, that none of those who rode with her thought of sitting in judgement on her conduct. Women can make for themselves new spheres, new laws, if they will assume their right to be eccentric as an unquestionable thing, and always reserve a season for showing forth like the conventional women of society. (207)

Lord Suckling's reference to the tamed horse down on its knees is part of Meredith's skillful adaptation of Mrs. Lovell's character from a contemporary *cause célèbre*. As he did twenty years later with Lady Caroline Norton in *Diana and the Crossways*, Meredith uses a scandalous figure who would have been recognized by the public in his fiction; here he uses a figure epitomizing fear of classbreaking to underline his questioning of class. In 1861 Edwin Landseer had exhibited a painting now variously known as *The Shrew Tamed*, *Taming the Shrew*, and *The Pretty Horsebreaker*.[6] The woman depicted reclining against the just-tamed horse in the painting, Catherine Walters, also known as "Skittles," was a well-known London courtesan and a skillful horsewoman often to be seen riding in Rotten Row (or just "the Row"), a sandy path beside the Serpentine in Hyde Park. Much is made of Mrs. Lovell's skill with horses in *Rhoda Fleming*. She shows her recognition of good manage of horses—and demonstrates her own skill—in the

Sir Edwin Landseer, Taming the Shrew, *also called* The Pretty Horsebreaker *(ca. 1861), engraved by James Stephenson (1864),* The Royal Collection *© 1993 Her Majesty Queen Elizabeth II*

scene at Fairly when she stops Robert from riding at Algernon (178–80). She is clearly in her element later in the book when Sir William Blancove encounters her in the Row.

The great flap made about Catherine Walters was over the ease with which a *demimondaine* seemed to be accepted in respectable society. According to Lynda Nead, Landseer's painting was itself an emblem of that acceptance, successfully crashing hitherto "pure" circles of high art at the Royal Academy exhibition,[7] where Meredith saw the painting in May of 1861. He did not much like the picture and said of it, "it is sufficiently bad."[8] He and his audience would have heard more of the "Skittles" matter through the reaction to the Academy exhibition in the newspapers and the James Stephenson engraving published in 1864, the year before *Rhoda Fleming*'s publication. Meredith's Mrs. Lovell is not a courtesan; the hint of the *demimonde* she carries is not from an overt sexual scandal. But she has a reputation of being a mankiller—literal-

ly. She has apparently reformed: she prevents Algernon Blancove and Lord Suckling from challenging each other (216–18), but Edward tells Algernon that she attempted to incite him to a duel (53–54), and her husband's death in the *third* of the duels he fought for his wife's honor, as well as another death in India, led her to leave that country "to save her complexion" (46). Her blushing is presumably meant by this coy phrase, since she blushes frequently and easily throughout the book.

Meredith's presentation of Mrs. Lovell is somewhat ambiguous; she is always well-mannered and attractive, but she has an edge of unscrupulousness. She is very charming, even when she refuses, out of mercenary motives, to marry Major Percy Waring in favor of the rich banker Sir William Blancove. Mrs. Lovell suggests that when she gives Dahlia's address to Robert, belatedly, after he's already gotten it from someone else, that she's keeping faith, when clearly she has already broken her earlier promise to supply him with the address. But it is in her connection with the

two sisters that she is most threatening.

Mrs. Lovell is intimately connected with Dahlia and Rhoda, a kind of anti-sister in her various roles. She resembles Dahlia slightly and is her rival in Edward's affections:

Mrs. Margaret Lovell's portrait hung in Edward's room. It was a photograph exquisitely coloured, and was on the left of a dark Judith, dark with a serenity of sternness. On the right hung another coloured photograph of a young lady, also fair; and it was a point of taste to choose between them. Do you like the hollowed lily's cheeks, or the plump rose. . . . your blonde with limpid blue eyes, or . . . sunny hazel?" (48)

Mrs. Lovell winks at the seduction of Dahlia; that is, she is willing to forgive Edward readily for seducing Dahlia, though she thinks his marrying the girl would be a far greater sin: "' . . . he may have been imprudent—' Mrs. Lovell thus blushingly hinted at the lesser sin of his deceiving and ruining the girl" (76). Later she tries to "help" Dahlia by arranging a marriage with the villainous Sedgett. She is, to put it another way, both ineffectual and damaging in her rivalry with Dahlia and in her acting "for" Rhoda.

Mrs. Lovell is very successful with her "sisters" in society; Meredith contrasts this conventional success with the friction between Rhoda and Dahlia in their attempts to preserve their affection and equal relation in the face of Dahlia's unconventional behavior. Mrs. Lovell is adept at "showing forth like the conventional women of society" (207), and they accept her without question as a "sister." "You are aware," says the narrator, "that men's faith in a woman whom her sisters discountenance, and partially repudiate, is uneasy, however deeply they may be charmed. On the other hand, she may be guilty of prodigious oddities without much disturbing their reverence, while she is in the feminine circle" (208). Mrs. Lovell's being a mankiller is not a bar to her acceptance in society; she knows how to manipulate the women of her class. Dahlia has no such possibilities open to her for concealing her seduction and being conventionally acceptable.

"MY SISTER? . . . WE'RE ONE!"

Despite Rhoda's protestations that her sister and she are one (128), it is Rhoda who relentlessly demands the marriage with Sedgett, and after the revelation of Sedgett's bigamy, wishes the marriage with the now-penitent Edward. Rhoda asserts her oneness with her sister early in the book, but she has only her class's conventional weapons to preserve her equality with her sister in the face of Dahlia's seduction. She denies it as long as she can; then she wants a husband to recoup Dahlia's lost honor. She wants to bring Dahlia to her level of respectability, but Meredith's strategy is to educate Rhoda in her nearness to her sister's case.

The dynamics of the Dahlia/Rhoda sisterhood in Meredith's book separate the sisters and then begin to bring them together again. All the movement takes place *within* Rhoda. Her estrangement from Dahlia comes about through her assimilation to the father's attitudes. When Dahlia asks not to see her sister until the marriage with Sedgett has taken place, for example, the narrator says that Rhoda becomes "mentally stern toward her sister, and as much to uphold her in the cleansing step she was about to take, as in the desire to have the dear lost head upon her bosom," she insists upon meeting Dahlia (380). Later she guards her sister against any rescue from the marriage with Sedgett. When Edward tries to enter the house where Dahlia waits, Rhoda confronts him eye to eye, "in a way so rarely distinguishing girls of her class" (386). The conversation reflects the way class distinctions and gender distinctions can be confounded—that is, a girl of the "right" class can speak to Edward "like a man":

"When I determine, I allow of no obstacles, not even of wrong-headed girls. First, let me ask, is your father in London?"
Rhoda threw a masculine meaning into her eyes.
"Do not come before him, I advise you."
"If," said Edward, with almost womanly softness, "you could know what I have passed through. . . ." (387–88)

The chapter is titled "Edward Meets His Match," but since Robert intervenes just as Edward seizes Rhoda's arm and tells her he will allow nothing to stand between him and Dahlia, the title is ambiguous: we do not know if Edward's "match" is Rhoda or Robert. But the passage shows Meredith confronting the arbitrariness of gender markers: Rhoda can have a "masculine meaning" in her eyes; Edward is capable of "almost womanly softness."

Rhoda retains her hardness even after the forced marriage, which Dahlia compares to being buried alive (439): "Rhoda had not surrendered the stern belief that she had done well by forcing Dahlia's hand to the marriage, though it had resulted evilly. In re-

flecting on it, she still had a feeling of the harsh joy peculiar to those who have exercised command with a conscious righteousness upon wilful, sinful, and erring spirits, and have thwarted the wrongdoer" (445). But she admits to herself, under Dahlia's repeated accusation, that she has deceived her sister (433).

The symmetry of Meredith's resolution means that the devices Rhoda has used to compel Dahlia turn to compulsion for her. Meredith constructs events so as to erase the difference between the sisters and remind Rhoda that she and her sister *are* one, as she has earlier insisted. Uncle Anthony embezzled from the bank; Rhoda cajoled a thousand pounds of the money from him in order to pay Sedgett for marrying Dahlia. When it appears that Anthony will go to jail if he cannot repay the money, Algernon Blancove offers to repay it *if* Rhoda will marry him: a forced marriage for a forced marriage. In her conversation with Robert the night before she must decide, Rhoda begins to see the symmetry:

"Oh! Dahlia, Dahlia!" Rhoda moaned, under a rush of new sensations, unfilial, akin to those which her sister had distressed her by speaking shamelessly out.
"Ah! poor soul!" added Robert.
"My darling must be brave: she must have great courage. Dahlia cannot be a coward. I begin to see."
Rhoda threw up her face, and sat awhile as one who was reading old matters by a fresh light.
"I can't think," she said, with a start. "Have I been dreadfully cruel? Was I unsisterly? I have such a horror of some things—disgrace. And men are so hard on women; and father—I felt for him. And I hated that base man. It's *his* cousin and *his* name! I could almost fancy this trial is brought round to me for punishment." (452–53)

Both sisters are being sold to unwanted husbands, and each has an eager and ineffectual lover on the sidelines. At this point Mrs. Lovell reenters the action like a comedy matchmaker in reverse, with a letter to Dahlia telling her cryptically that she is not really married to Sedgett (473). Mrs. Lovell flirts with Algernon until he gives up his pretensions to Rhoda, and she does what she can to further Edward's suit with Dahlia (495).

Meredith shows Rhoda's growth toward real sympathy with Dahlia when Edward arrives at Fleming's cottage, "to abase himself before the old man and the family he had injured" (483). Meredith's dissection of the feelings involved here is that Edward now loves Dahlia as much as a selfish nature can love: "It was not the highest form of love, but the love was his

highest development" (483). The scene—the seducer's confession and the seduced woman's sister hearing it—resembles one in *Sense and Sensibility* when Willoughby comes to Cleveland and makes his confession to Elinor the night Marianne's fever reaches its crisis. As Rhoda listens to Edward confessing to the men in the room below, a change of heart toward Edward takes place in her:

Thrice, after calling to Dahlia and getting no response, she listened again, and awe took her soul at last, for, abhorred as he was by her, his power was felt: she comprehended something of that earnestness which made the offender speak of his wrongful deeds, and his shame, and his remorse, before his fellow-men, straight out and calmly, like one who has been plunged up to the middle in the fires of the abyss, and is thereafter insensible to meaner pains. The voice ended. She was then aware that it had put a charm upon her ears. The other voices following it sounded dull.
"Has he—can he have confessed in words all his wicked baseness?" she thought, and in her soul the magnitude of his crime threw a gleam of splendour on his courage, even at the bare thought that he might have done this. Feeling that Dahlia was saved, and thenceforth at liberty to despise him and torture him, Rhoda the more readily acknowledged that it might be a true love for her sister animating him. From the height of a possible vengeance it was perceptible. (484)

Rhoda wills vengeance, spite, and torture. But Rhoda sees Edward's attraction and comes close enough to her sister to understand Dahlia's capitulation to his power.

To the reader's satisfaction, if not necessarily to Rhoda's, Dahlia rejects Edward. It takes him some time to get the message:

Edward had three interviews with Dahlia; he wrote to her as many times. There was but one answer for him; and when he ceased to charge her with unforgivingness, he came to the strange conclusion that beyond our calling of a woman a Saint for rhetorical purposes, and esteeming her as one for pictorial, it is indeed possible, as he had slightly discerned in this woman's presence, both to think her saintly and to have the sentiments inspired by the over-earthly in her person. Her voice, her simple words of writing, her gentle resolve, all issuing of a capacity to suffer evil, and pardon it, conveyed that character to a mind not soft for receiving such impressions. (494)

Part of the satisfaction comes from having Edward at the receiving end of a game of "Get the Gentleman"—he is not, as "gentleman," accountable for his actions in any other way.

Rhoda, who marries Robert and has Dahlia to

nurse her "growing swarm" (499), has never quite the oneness with her "darling" that she asserts early in the book. On the night of Edward's arrival and of Dahlia's attempted suicide, Rhoda becomes an advocate for Edward. Even though Dahlia may not know this, she does know Rhoda will always lack a necessary sympathy with a "fallen" sister. Between Dahlia and Robert, "there was deeper community on one subject than she let Rhoda share. Almost her last words to him, spoken calmly, but with the quaver of breath resembling sobs, were: 'Help poor girls'" (499).

"THE DEMOCRATIC VIRUS SECRET IN EVERY WOMAN": CLASSLESS AND GENDERLESS SISTERHOOD

Dahlia discovers that class is a refuge for the seducer and none for the seduced. This would be true whatever his class or hers. Dahlia's "salvation," once she has fallen, is seen by Edward Blancove in the same terms as it is seen by Rhoda: marriage. Infected with her father's class prejudice and fierce Puritanism despite her assertion of oneness with her sister, Rhoda sees marriage as Dahlia's only salvation. Edward presents the case to his own father as a matter of justice, telling him "in language special and exact as that of a Chancery barrister unfolding his case to the presiding judge, that he had deceived and wronged an underbred girl of the humbler classes; and that, after a term of absence from her, he had discovered her to be a part of his existence," and planned to marry her (373). But both know that Edward's marrying of the girl, whatever it is de jure, is bizarre for a member of his class de facto.

Those who befriend Dahlia at the end of the book are presented as somehow outside of class: Robert, the "Saxon yeoman," and Mrs. Lovell, the woman in between, who says she is always sincere (495) but who has long ago discovered she can lie by telling the truth—"perfect candour can do more for us than a dark disguise" (46). The curious place of these two is defined by their relation to other characters. Robert and Percy Waring are friends across the classes. When they were both in the army, Percy even "wanted to purchase a commission for him; but the humbler man had the sturdy scruples of his rank regarding money, and his romantic illusions being dispersed by an experience of the absolute class-distinctions in the service, Robert, that he might prevent his friend from violating them, made use of his aunt's legacy to obtain release" (235). In other words the only good gentle-

man—Percy—is one who does not understand what it is to be one. Meredith apparently sees no inconsistencies in pointing this out even as he patronizes Robert: "the humbler man had the sturdy scruples of his rank." Robert is caught in the middle; Meredith cannot decide where to put him, but his placement of Robert has to do with the way Robert treats Dahlia: "The young man who can look on them we call fallen women with a noble eye, is to my mind he that is most nobly begotten of the race, and likeliest to be the sire of a noble line. Robert was less than he; but Dahlia's aspect helped him to his rightful manliness. He saw that her worth survived" (317–18). The place where Robert almost has reached is thrice ennobled.

Mrs. Lovell, on the other hand, gets her interclass status from the way she deals with men. If classlessness weakens Robert, it empowers Mrs. Lovell. But that she is not "of" her class is recognized by those who feel her power. Edward worries about her class-jumping:

. . . if the man [Robert] saw Mrs. Lovell again, her instincts as a woman of her class were not to be trusted. As likely as not she would side with the ruffian; that is, she would think he had been wronged—perhaps think that he ought to have been met. There is the democratic virus secret in every woman; it was predominant in Mrs. Lovell, according to Edward's observation of the lady. The rights of individual manhood were, as he angrily perceived, likely to be recognized by her spirit, if only they were stoutly asserted; and that in defiance of station, of reason, of all the ideas inculcated by education and society. (229–30)

Mrs. Lovell is wonderfully subversive in regard to class differences: she not only has the "democratic virus" that worries Edward, but she also reminds readers of Catherine Walters and thus of the ease with which class barriers can be leaped—or straddled. More particularly she subverts the class rite of duelling: by embracing its values and worshipping bravery, she ensures that a trail of bloody corpses stretches behind her, all the way to India. But when it comes to sex, she turns out to be conventional. Her sisterhood cannot be with Dahlia when it is with "the conventional women of society" (207).

And so Dahlia's last words are not addressed to Mrs. Lovell or to her even more conventional sister Rhoda. The "deeper community" is only with Robert, who has, like Dahlia, suppressed his name and been humiliated at the hands of the "gentlemen" but, most importantly, has seen that her worth survived. These qualities go toward making Robert Dahlia's "sister" in a book that, unlike those of Dickens and Collins, posits equality as a defining feature of sisterhood.

9

Healthy Relations:
Nursing Sisters in Gaskell's
"Every-Day" Stories

RUTH (1853), NIGHTINGALE, AND THE HEROIC NURSING SISTER

FLORENCE NIGHTINGALE HAD A PROFOUND INFLUENCE upon Elizabeth Gaskell. Nightingale's presence and courage personally affected her, but the greatest impression was on Gaskell's work. She domesticates Nightingale's heroic public image, creating heroines whose nursing of others can recoup fallen reputations, so that they rescue themselves in rescuing others. In two of her books, she makes nursing the bond between sisters and makes individual sisterhoods the bonding force in a larger community of women. She thus asserts the heroic potential of sisterhood within "every-day" activities.

When the two women met, in October 1854, Nightingale had just been through an experience remarkably like one Gaskell had described the year before in *Ruth*, published in January 1853. *Ruth*'s concluding chapters detail the effects of a cholera epidemic on a hospital, the "Eccleston Infirmary," during the early autumn after an extraordinarily hot summer. The book's heroine offers herself "as matron to the fever-ward" after the sickness sweeps through the town, killing with especially quick savagery the prostitutes, the poor, and the homeless.[1] At the hospital itself, one doctor had died, and "the customary staff of

matrons and nurses had been swept off in two days" (421). Ruth, who is the unmarried mother of a small boy, is eventually blessed and thanked by the townspeople who had previously ostracized her, and her selflessness is publicly recognized by the hospital directors and doctors. One man, whose daughter died with her head on Ruth's breast, says "The blessing of them who were ready to perish is upon her" (425).

In October of 1854, Gaskell was staying at the Nightingales' home at Lea Hurst, near Matlock, where Florence Nightingale had just come from London's Middlesex Hospital.[2] In two letters she wrote during this visit, Gaskell records what Nightingale told her of the cholera epidemic she had just been through:

> . . . Miss Florence Nightingale, who went on the 31st of August to take superintendance of the Cholera patients in the Middlesex Hospital (where they were obliged to send out their usual patients to take in the patients brought every half hour from the Soho district, Broad St especially,) says that only two nurses had it, one of whom died, the other recovered; that none of the porters &c had it, she herself was up day & night from Friday [Sep 1] afternoon to Sunday afternoon, receiving the poor prostitutes, as they came in, (they had it the worst, & were brought in from their 'beat' along Oxford St—all through that Friday night,) undressing them—& awfully filthy they were, & putting on turpentine *stupes* &c all herself to as many as she could manage. . . .[3]

Speaking of the Cholera in the Middlesex Hospital, she said, 'The prostitutes come in perpetually—poor creatures staggering off their beat! It took worse hold of them than any. One poor girl, loathsomely filthy, came in, and was dead in four hours. I held her in my arms and I heard her saying something. I bent down to hear. "Pray God, that you may never be in the despair I am in at this time." I said, "Oh, my girl, are you not now more merciful than the God you think you are going to? Yet the real God is far more merciful than any human creature ever was, or can ever imagine."'[4]

Nightingale answers the dying prostitute out of the same sturdy faith held by her sister-Unitarian Elizabeth Gaskell. It is Nightingale's style, however, and not a response that Gaskell would have put in Ruth's mouth when she was in Nightingale's position, being blessed by a prostitute about to die. Gaskell lacks the grittiness Nightingale developed by experience in the "fever-ward." Gaskell had visited hospitals, but she did not even know, for example, until these talks with Nightingale, that cholera is not contagious—her misconception about this matter is evident in Ruth. But her passionate interest in the subject of Nightingale's work connects seamlessly with her tireless visiting at London homes for "fallen women" and hospitals.[5]

That the two women would eventually meet seems inevitable now. They met just before Nightingale went to Scutari and made her reputation there. One cannot help but wonder whether Gaskell's fiction would have been greatly different had they never met. As it is, Nightingale is very much behind important books of Gaskell; to be more precise, a popular image of Nightingale as heroine is behind them. Yet Gaskell seems to have begun using the image in Ruth even before it began to be created around Nightingale in the popular imagination.

Gaskell is selective about which elements she uses of Nightingale's image—that of a new female heroic ideal. She constructs female heroic figures who are not famous but part of "every-day stories," women for whom nursing others through dangerous illness is an act of self-definition, pursued at risk to their own lives and involving selflessness and sometimes loss. Like Nightingale and her "sisters," Gaskell's heroines often temporarily or permanently give up their own sexual prospects while performing their nursing functions. Moreover, the "sisterhood" of Nightingale's nurses is literalized in Cranford and Wives and Daughters, where blood sisters or half-sisters are the nurses. These sisters' heroic nursing actions do not bring the wide acclaim Nightingale found, but they do get the notice of

neighbors and townspeople, notice that has the effect of rehabilitating the nurse's reputation, which in some cases has been sullied by real or merely rumored sexual transgressions. Thus nursing becomes a means of moral as well as physical recuperation.

Sickness is an axis on which plots turn in Gaskell's books.[6] The heroine of Ruth nurses her seducer, Henry Bellingham, and others afflicted by a cholera epidemic. The courage and selflessness she shows in her nursing finally makes her a heroine even for the dour and usually unforgiving townspeople who have considered her a whore. In Wives and Daughters (1866), in a chapter called "Molly Gibson's Worth is Discovered," Molly's and Cynthia's nursing begins the resolution of the book's plot. Molly's reputation is somewhat tarnished by rumor when she confronts her stepsister's threatening suitor, Preston, and thus rescues Cynthia from a disastrous engagement. But Molly regains the esteem of the townspeople by her nursing of Aimée (a "sister-in-law" of sorts) at the risk of her own health. She so impresses the proud Squire Hamley, who considers a lord's daughters none too good for his sons at the book's beginning, that he begs his second son to marry Molly. When Cynthia returns from the pleasures of London to nurse Molly, she is redeemed in everyone's estimation from the selfishness, dishonesty, and unscrupulousness she has shown every time we have seen her previously. In Cranford (1853), nursing also occupies an understandably important place among the aging sisters of the town.

SISTERS' RESCUES AND SISTERS ACROSS THE CLASSES

Nursing a sister through dangerous illness is one form rescue takes in Cranford and Wives and Daughters, but it is not the only form of heroic rescue undertaken by one sister for another, as Molly Gibson shows when she rescues her stepsister Cynthia from a threatening suitor in Wives and Daughters. There are other sides to sisterly relations in Gaskell. One sister may perform heroic actions for another, as Molly does for Cynthia in Wives and Daughters, although the heroism is deromanticized within the context of an "Every-Day Story" (the subtitle of the book) and contained in a chapter whose title parodies the romance elements: "Molly Gibson to the Rescue." One sister's example may work to give courage or moral strength to another, as happens frequently in Cranford and the

later book, or one may demonstrate some kind of power that had been unknown to the other sister, as Cynthia shows Molly when every eligible male in the book proposes to her. These sisters search for a relation that is healthy and possible, and they have to be set against the idea of women in Victorian novels (or Victorian life) defined merely in their relation to men—"relative creatures" in Françoise Basch's phrase, or participants in "corrupt relations," the phrase of Barickman, MacDonald, and Stark to describe any family situation structured by patriarchy in Victorian novels.[7]

Gaskell looks for a sisterly relation that approaches equality and is extendable to all women. This search naturally leads her to some interrogation of the idea of *class*, which would seem to be an impediment to any real equality as epitomized in an ideal sisterhood. Gaskell is no revolutionary whose sisterhoods push for the abolition of class difference; she looks for a *healthy* relation among the classes in which the worth of all is recognized, and her plots enact the conviction—perhaps one should call it the gently satiric fiction—that the higher classes are educable toward this end. For Gaskell, sisterhood is a relation among women that can be idealized as *health*, considered in its broadest sense: in which one sister's endangered well-being is actively preserved, if possible, by her sister's intervention; in which healthy sexuality is promoted rather than stifled by a sister's presence; and in which class differences are reminders that equality is an ideal.

CRANFORD (1853): A SOCIETY OF SISTERS

Cranford, presented to us as a town of women, is a city of sisters, a sorority of the whole, a collection of individual sisterhoods, and a society that plays games with class distinctions, although such distinctions are lessened in the course of the book. "In the first place, Cranford is in possession of the Amazons," Gaskell's narrator, Mary Smith, begins; "all the holders of houses above a certain rent are women."[8] That qualification "above a certain rent" is important because the women of Cranford pique themselves on being what the narrator always refers to coyly, in quotes, as "aristocratic society." But the sole representative of anything above gentry in Cranford, a widow of a Scotch baron, gives up her title of Lady Glenmire

when she marries the local doctor and becomes plain Mrs. Hoggins.

The Cranford women taken all together form one sisterhood, the sorority of "the ladies of Cranford, in my drawing room assembled" (164), as Miss Pole puts it, and this sisterhood unites in common cause—to pledge an annual sum in secret support of Miss Matty Jenkyns, for example, when Miss Matty's bank fails and she loses her savings. Individual pairs of sisters within the group are Deborah and Matilda Jenkyns; the daughters of Captain Brown, Miss Jessie Brown and her older, dying sister; the Miss Barkers, former servants and now milliners to the élite of Cranford; and the contrasting sisters-in-law, stiff-necked, snobbish Mrs. Jamieson and amiable, egalitarian Lady Glenmire.

The Miss Barkers hardly figure in the story as sisters, since the elder Miss Barker is dead before the book opens. Miss Betty Barker we remember chiefly for having outfitted her cow in grey flannel, in response to Captain Brown's jesting but straight-faced suggestion for curing its ills. "Do you ever see cows dressed in grey flannel in London?" asks the narrator disingenuously, for the narrative fiction here is of a series of papers written by a Midlands correspondent to readers in London. Betty Barker also invites the Cranford ladies to tea, in a chapter called "Visiting," that entertainingly defines much about how class is perceived in Cranford. The invitations are tendered in careful sequence according to the invitee's standing, beginning with Betty's older sister's old mistress Mrs. Jamieson and excluding Mrs. Fitz-Adam ("I must draw a line somewhere" [75], says Betty). Mrs. Fitz-Adam is the widow of the local surgeon, and there is ironic foreshadowing here, since it is on account of Mrs. Jamieson and her class prejudices that Mrs. Fitz-Adam is excluded and the class-conscious Mrs. Jamieson's titled sister-in-law will marry the local doctor (who is Mrs. Fitz-Adams's brother). Moreover, it is Mrs. Fitz-Adams who later pledges more than any other woman (without letting the others know) in support of Miss Matty Jenkyns when Miss Matty is in need.

Of the other pairs of sisters, each story involves a romance. We do not read far into *Cranford* before we find problems with the opening fiction of an all-female society. "In short, whatever does become of the gentlemen, they are not at Cranford," says the narrator, "the ladies of Cranford are quite sufficient" (1). This is straightforward enough, but unless "Cran-

ford" and "Our Society" are read as the limited society of women *within* Cranford—"our" society as the consciousness and intercourse of these women—then the exclusions of that opening paragraph do not last beyond three and a half pages. As Nina Auerbach points out, the female society of Cranford has "an unsettling power to obliterate men" when they are not needed but also the "gift of producing them" when they are.[9]

The first sisters' story is that of the Browns: Miss Brown, about forty years old, and her sister Miss Jessie, less than thirty and "twenty shades prettier" than her sister with a "round and dimpled" face with "something childlike" in it, and "large blue wondering eyes" (7). Miss Brown is dying when we meet her, of a painful, lingering complaint that gives an unpleasant expression to her face that the narrator at first takes for "unmitigated crossness" (13). Miss Brown *is* cross at times, and her ill temper is aimed at her nurse-sister, Miss Jessie. Gaskell's psychological acuteness plays on the relations between these sisters: she observes without sentimentality that Miss Brown's generosity makes her more cross as a patient, for example:

Miss Jessie bore with her at these times, even more patiently than she did with the bitter self-upbraidings by which they were invariably succeeded. Miss Brown used to accuse herself, not merely of hasty and irritable temper, but also of being the cause why her father and sister were obliged to pinch, in order to allow her the small luxuries which were necessaries in her condition. She would so fain have made sacrifices for them, and have lightened their cares, that the original generosity of her disposition added acerbity to her temper. All this was borne by Miss Jessie and her father with more than placidity—with absolute tenderness. (13)

Captain Brown, who has been the lion of Cranford as the sole man around, is killed on the railway where he works. (*Cranford's* deceptive quietness is punctuated by deaths violent and otherwise, as well as a bank failure.) The women of Cranford rush to help the Misses Brown, especially Deborah Jenkyns, whose portrait as a stern, willful woman is considerably softened by her behavior in the aftermath of the Captain's death. Miss Brown dies only a few days later, and almost immediately Major Gordon, a former regimental comrade of the Captain and suitor of Miss Jessie's, shows up. Major Gordon had proposed some time before and been refused by Miss Jessie:

. . . he had discovered that the obstacle was the fell disease which was, even then, too surely threatening her sister. She had mentioned that the surgeons foretold intense

suffering; and there was no one but herself to nurse poor Mary, or cheer and comfort her father during the time of illness. (26)

The necessity for nursing has held the romance off only temporarily. Major Gordon and Miss Jessie marry, and at the end of *Cranford* they return with their two almost-grown children. And Deborah's alacrity to nurse both Misses Brown after the Captain's death rehabilitates her in our eyes from the dour spinster, disapproving of the Captain and his tastes, to whom we were first introduced. "Matilda, bring me my bonnet," she says the instant she hears of the accident, "I must go to those girls. God pardon me, if ever I have spoken contemptuously to the Captain!" (20). In the last glimpse the narrator has of Deborah, she is thinking fondly of the Captain while Jessie's young daughter, Flora, reads to her.

The romance in the Jenkyns sisters' story is resumed too late, and it has been interrupted for a far less worthy cause. Thomas Holbrook, a cousin of Miss Pole's and a yeoman (he rejects the title of Squire) living on his estate a few miles from Cranford, had many years before the novel begins proposed to Miss Matty, who had been dissuaded from accepting him by class considerations. Miss Pole tells the narrator that "Cousin Thomas would not have been enough of a gentleman for the rector and Miss Jenkyns. . . . they did not like Miss Matty to marry below her rank. You know she was the rector's daughter, and somehow they are related to Sir Peter Arley: Miss Jenkyns thought a deal of that" (35). Lady Glenmire scandalizes her sister-in-law Mrs. Jamieson by marrying Doctor Hoggins, but Matty cannot defy her sister by marrying yeoman Holbrook.

After Deborah's death Holbrook invites the ladies—Miss Matty, Miss Pole, and the narrator—to spend a day at his house, gives a book to Miss Matty at her departure, and gives every indication of wanting to revive their friendship. But he sickens and dies within a few weeks. Matty quietly has mourning caps made to observe his death, caps being the only item of dress that changes according to fashion in Cranford. And she also allows her maid to have male visitors, lifting a prohibition that had stood since Deborah's time and that had caused the dismissal of at least one maid who had to hide her young men in the kitchen.

The strength of Deborah's will and her example last even after her death. Matty, who "made no secret of being an arrant coward" (108), is inspired to courage

by the memory of her sister. During the "The Panic," when it is believed a band of foreigners is robbing Cranford houses, Matty intrepidly ventures forth and helps her neighbors. Matty is also naturally superstitious, "but a desire of proving herself a worthy sister to Miss Jenkyns" keeps her from indulging her superstition (101). We learn after Deborah's death that she nursed Matty through a long illness, as Matty tells Mary Smith, who conjectures that it followed "the dismissal of the suit of Mr. Holbrook" (47). The Misses Brown's situation is reversed: the nursing is *by* rather than *of* the sister not romantically involved, a recovery from disappointed romance rather than an abeyance of the romance.

In the relation of Mrs. Jamieson and her sister-in-law, Lady Glenmire, there is no sisterly nursing. However, the theme of health comes into their story, too. Lady Glenmire marries the Cranford doctor, a union very much *infra dig* as far as Mrs. Jamieson is concerned, though Hoggins, like Mrs. Gaskell's village doctor Gibson in *Wives and Daughters*, is a good and caring practitioner, eminently eligible. These doctors in Gaskell are at a cusp as far as class is concerned, and their wives and daughters move down from the aristocracy or up into the squirearchy. Class consciousness or pride of difference is sterile in these books, and one kind of potency comes from the doctor's powerful indifference to class, enabled by skill. He has, unlike anyone else, free movement among classes resulting from the demand for his services in a place where no titled practitioners are available. Both Hoggins (137) and Gibson frequently sup on bread and cheese and beer. But they also seem to have nearly as much money as anyone else in their respective books, as much or more practical sense and at least as many scruples—in *Wives and Daughters*, Gibson and his daughter, Molly, and Squire Hamley's second son, Roger, are the most scrupulous characters. Gaskell was early in her anticipation of the modern elevation of the doctor to a kind of brevet aristocracy by virtue of the premium put on his skills. Male healers, however, although they flourish and are important in Gaskell, are not at the center of her books. Hoggins rarely appears in *Cranford*, and Gibson has to struggle to have any good effect after he marries Hyacinth Clare in *Wives and Daughters*. The women are at the center, especially in *Cranford*. Healthy for the most part, Cranford's community works because it is given strength by its individual sisterhoods.

WIVES AND DAUGHTERS (1866): SISTERS AS HEROINES OF THEIR OWN STORIES

Gibson, Gaskell's most interesting male character in *Wives and Daughters*, is the pivot for some of the book's action because his daughter and stepdaughter are its main characters, and in his medical practice he treats all the county: earl and countess and lady, squire and plain Miss Browning and Mr. Craven Smith. Gibson, like others of Gaskell's doctors—Hoggins in *Cranford* and Davis, who adopts Ruth's bastard child (confessing himself illegitimate also) at the end of *Ruth*—is painted favorably, as one skilled in his profession and straightforward in his manner. He talks to Molly when she is a child exactly as he talks to adults. His conversation is always refreshing and usually funny: fetching her from a day at Lord and Lady Cumnor's, he tells Molly, "I expected to find you so polite and ceremonious, that I read a few chapters of *Sir Charles Grandison*, in order to bring myself up to concert pitch."[10]

Gibson's second marriage brings the main characters together in the action of *Wives and Daughters*, and the action leading up to his marriage begins with a declaration of love, but it is not that of Gibson to his wife to be but that of Gibson's apprentice, Coxe, to Molly. Gibson intercepts a letter from Coxe to the sixteen-year-old Molly, who knows nothing of Coxe's infatuation. Gibson chastises Coxe and, because Molly's governess is away on a visit, he sends Molly, who never learns of the letter's contents, off to nurse Squire Hamley's wife. When Molly asks simply "Why am I to go, papa?" (63), Gibson puts off her question with an odd little narration about the Fates:

"There are three old ladies sitting somewhere, and thinking about you just at this very minute; one has a distaff in her hands, and is spinning a thread; she has come to a knot in it, and is puzzled what to do with it. Her sister has a great pair of scissors in her hands, and wants—as she always does, when any difficulty arises in the smoothness of the thread—to cut it off short; but the third, who has the most head of the three, plans how to undo the knot; and she it is who has decided that you are to go to Hamley. The others are quite convinced by her arguments; so, as the Fates have decreed that this visit is to be paid, there is nothing left for you and me but to submit." (64)

As Reynolds had done in *The Ladies Waldegrave* (page 29), Gaskell domesticates the Fates in Gibson's story and makes them concerned about romance rather than death. Though Molly says this is all non-

sense, these particular sisters do have some control over events in the book. The governess, Miss Eyre (!) writes to say *she* has nursing duties for a sick relative and cannot return to Gibson's house. Gibson hesitates to bring Molly back to his unsupervised house, but does not feel it right to dismiss Coxe for his indiscretion. Then Gibson visits his daughter and finds himself thrown together frequently with the widow, Mrs. Kirkpatrick, *née* Hyacinth Clare. And so fate works in earnest, this time, but not in Gibson's version of the myth of the sister Fates in which he must imagine himself as the one with "the most head," but in the narrator's version: "fate is a cunning hussy, and builds up her plans as imperceptibly as a bird builds her nest; and with much the same kind of unconsidered trifles" (83). In this case all the imperceptible details conspire to put Gibson together with the attractive widow, Mrs. Kirkpatrick, and to suggest to him the many reasons why it would be nice to have a new wife in his house. He does not grasp until after their marriage his wife's moral obtuseness. Perhaps it is stupidity; Coral Lansbury says of Hyacinth, "no writer except Flaubert has made a stupid woman so interesting."[11]

Gibson and Mrs. Kirkpatrick marry, and very soon Hyacinth's daughter Cynthia comes to live with the Gibsons. Gibson's idea of getting Molly out of the way of romance by having her nurse Mrs. Hamley results in his own romance, in the beginnings of Molly and Roger Hamley's romance, and in the coming together of Molly and Cynthia.

Wives and Daughters is the story mainly of Molly Gibson and her stepsister Cynthia Kirkpatrick; A. W. Ward tells us in the introduction to the Knutsford edition that one of the titles considered for the book was simply *Molly and Cynthia* (xiv). But other women paired as sisters figure in the story. One such pair is Molly and Osborne Hamley's wife Aimée, who will become "sisters-in-law" when Roger Hamley and Molly eventually marry, as we know they must in the last chapter of the book left uncompleted at Gaskell's death. Molly and Aimée are already sisters-in-law in the sense that Molly has been adopted by the Hamleys. Mrs. Hamley even occasionally calls her Fanny (232), the name of her dead daughter. Molly, the only person besides Roger who knows of Osborne's secret marriage to Aimée until late in the book, feels herself acting in Aimée's interest even before she knows her, and once she does know her she is immediately nursing her in an illness crucial to both their lives.

A third sisterhood, that between Lady Harriet Cumnor and Molly, is not a literal relation but perhaps the healthiest sisterhood in the book. It involves no love rivalry, as Molly's and Cynthia's relation does. It crosses the classes in a way genuinely beneficial to both women. Molly straightens Lady Harriet out about certain of her haughty ways and she does it largely by being ignorant of the distinctions the earl's daughter makes. Lady Harriet has been talking about the Misses Browning: "Pecksy and Flapsy I used to call them. I like the Miss Brownings; one gets enough of respect from them at any rate; and I've always wanted to see the kind of *ménage* of such people" (184). Molly tires of this way of talking fairly quickly. She challenges Lady Harriet, being careful to ladyship her: "your ladyship keeps speaking of the sort of—the class of—people to which I belong, as if it was a kind of strange animal you were talking about; yet you talk so openly to me that—" and she stops. Lady Harriet at first blusters, realizing that she has been caught out making distinctions without differences *on her own terms.* "Don't you see, little one, I talk after my kind, just as you talk after your kind," she says (184). But Molly knows this is no explanation and perseveres in asking why Lady Harriet makes an exception of her. And so comes the admission: "You at least are simple and truthful, and that's why I separate you in my own mind from them and have talked unconsciously to you as I would—well! now here's another piece of impertinence—as I would my equal—in rank, I mean; for I don't set myself up in solid things as any better than my neighbours" (185). But Molly wants something far more substantial than Lady Harriet's concession that "solid things" have nothing to do with rank: she wants Lady Harriet to stay away from her friends if she is going to call them names. Lady Harriet, to her credit, accepts and remembers this chastisement, promising "to be respectful to them in word and in deed—and in very thought, if I can" (187)—a promise she is still honoring months later at the charity ball (340) and in fact several years later (619). Gaskell's narrator is not one who dearly loves a lord—talking irreverently about "the aristocratic ozone" being absent from the charity ball before the party from Cumnor Towers arrives (331) and picking out the lordly and ladylike failings of each of the party there. But Lady Harriet is favorably presented in the book and much of the reason is her temperamental resemblance to Molly.

Lady Harriet for her part confronts Cynthia's exfiancé Preston directly when there are rumors about

him and Molly. She gets him to deny any entanglement with Molly—and to admit his broken engagement with Cynthia. This behavior of Lady Harriet's gets her "a good many strictures on manners and proper dignity" (619) from her family at home, thus furthering her sisterhood with Molly, who is used to these lectures and whose example for bluntness and truth-telling works on Lady Harriet as it does not on Cynthia. Lady Harriet's "trotting" of Molly around Hollingford is an instance where difference in classes is used to good effect, consciously to attract attention and help rehabilitate Molly's reputation: "Hollingford is not the place I take it to be," says Lady Harriet to herself, after her tour with Molly, "if it doesn't veer round in Miss Gibson's favour" (620). Lady Harriet's last service is to write Cynthia to let her know how sick Molly is after her return from nursing Aimée Hamley. By that time the two stepsisters, Cynthia and Molly, have become very close, but their relation begins rockily.

The two grow into sisterhood as their intimacy develops. They are not blood sisters, as Molly reminds us: "Ever since she had heard of the probability of her having a sister—(she called her a sister, but whether it was a Scotch sister, or a sister à la mode de Brétagne, would have puzzled most people)—Molly had allowed her fancy to dwell much on the idea of Cynthia's coming" (261). Some other authors avoid the closest of sister relations (two shared parents) because of their squeamishness about sexual difference—Scott, for example. Ferrier takes twin sisters and separates them in appearance as their separate educations progress. Gaskell begins with two women who have the most attenuated sisterly relation possible and shows their affection and mutual influence growing until their appearance also signals the closeness and one cannot distinguish them from full blood sisters. Eventually little plain Molly is "as tall as Cynthia" (515) and shares her sister's "delicate fragrant beauty" (691). Cynthia, although she does not think at the beginning she "will ever be a good woman" (254), nevertheless comes to approach Molly in care and solicitude for her sister.

The first thing that happens is a rivalry, in two chapters titled "The Half-Sisters" and "Rivalry." Molly is jealous when she sees Roger's affections shifting to Cynthia. She does not like Roger's calling Cynthia her sister (362). She understands that she is jealous, labels these feelings as mean and selfish (313), and discovers that the recognition does not

lessen the feelings. She sees that Cynthia does not return Roger's affection, and because she really loves Roger, she now must desire Cynthia to love him. "She would have been willing to cut off her right hand, if need were, to forward his attachment to Cynthia" (401):

"I am his sister," she would say to herself. "That old bond is not done away with, though he is too much absorbed by Cynthia to speak about it just now. His mother called me 'Fanny' [the name of Mrs. Hamley's dead daughter]; it was almost like an adoption. I must wait and watch, and see if I can do anything for my brother." (411)

But a great difference separates this from the "brother-sister" relationships that impede couples in Dickens. With Cynthia out of the way, Molly would not hesitate to marry her "brother" in an instant; she would not have Walter Gay's scruples (in *Dombey and Son*) about such a union. But if she cannot be the successful rival (and Molly has not yet learned from Cynthia how a woman might compete in such an arena), she can only be spoiler or helper, and Gaskell invokes the comparison of "the real mother in King Solomon's judgment" (480), who wishes her beloved well even if she cannot have him. Her heroic act is in meeting Preston, at the risk, it turns out, of her own reputation, to force him to break off his engagement with Cynthia.

Molly and Cynthia give demonstrations of female power to each other. Molly forces the issue with Preston by honesty and fearful courage. When these are not enough, her resourcefulness leads her to threaten Preston with telling Lady Harriet, whose friendship she has won by just these qualities. Preston caves in because he knows the earl's family will recognize his conduct, in attempting to hold Cynthia, as dishonorable. During this encounter Preston sees "that Molly was as unconscious that he was a young man, and she was a young woman, as if she had been a pure angel from heaven" (561). The important point is not really Molly's purity but the fact that she deals with Preston without switching on sex or allowing it to be switched on by the circumstances. This empowers her. Cynthia is incapable of switching off sex, and that empowers *her*. It impels proposals from Preston, from Roger, from Coxe, and from Henderson, whom she eventually marries.

Each woman has something to show the other in coping with a sexual system loaded against them both. Molly has to be able to assert her sexuality, and this she learns from Cynthia. The book codes this new

knowledge in terms of "growth": Miss Browning remarks that "Molly is grown as tall as Cynthia since Christmas" (515), and the narrator talks about "her rapid growth during the last few months" (519). Its real nature becomes obvious when Roger remarks her "growth": "'Poor Osborne was right!' said he. 'She has grown into delicate fragrant beauty, just as he said she would; or is it the character which has formed her face?'" (691). Cynthia's position is more dangerous; she really needs more help than Molly does. A fiancé with proof of a woman's having engaged herself, unwilling to let her off the hook, not only has society behind him—he also has its values internalized in the woman's wish to do the "right" thing. Cynthia is not Laura Fairlie, willing to go through with a loveless marriage to Percival Glyde simply because she once gave a promise and he will not release her. Cynthia is willing to break but has no way to deal with a man except the mode of allurement. Significantly, almost her first words in the book, about the least eligible of men—her new stepfather, Mr. Gibson,—are "I like your father's looks," spoken to Molly (248). Molly gives Cynthia her demonstration of how to deal with Preston, he sends back her letters, and Cynthia then writes to break her engagement with Roger. Cynthia learns to say no, although even this lesson is handled with a comic disparagement: Roger does not quite get the message until Cynthia has acquiesced to yet another proposal, Henderson's.

The search for psychic health in these sisterly relationships goes on while bodily health is constantly at risk. The main locus of the risk is Hamley Hall, though characters also sicken in Hollingford (Molly, Mrs. Gibson briefly) and as far away as Newport (Miss Eyre's nephew) and Africa (Roger). Hamley's insistence on the status of his ancient family, his oppressive gentility, is sterile and unhealthy. The length of the family's pedigree is astonishing when we consider how unhealthy a place Hamley Hall is. Aimée Hamley and her son flourish as long as they are kept away, but they are brought there by news of Osborne's illness—and find that the news was meant to prepare for worse news of his death. As soon as Aimée arrives she is struck down, and when she recovers, her son sickens. Mrs. Hamley slowly sickened and died there, and Molly was unable to help her. Osborne suddenly died there. Things only begin to improve when the Squire starts to realize the worth of Aimée and to appreciate Molly at her proper rate. Until that point, Roger may have been safer among the hazards of Africa than at home in Hamley Hall.

Nursing one's sister in Gaskell is, aside from the immediate benefit to the sister, a particular form of self-sacrifice by which one's "worth is discovered," to quote part of a chapter heading about Molly. When Molly nurses Aimée she is to some extent doing what is expected of her by males—her father and the helpless grieving Squire Hamley, whose elder son has suddenly died of a burst aortic aneurysm. But she is also interested and needed. Her relation to these well-intentioned but sometimes bumbling and dangerous men is partly a chosen one. To Aimée, though, she is life. Molly exhausts herself in caring for Aimée and sinks into illness herself. And this incident completes the restitution of Molly's good name in the eyes of Hollingford: "All the Hollingford people forgot that they had ever thought of her except as the darling of the town" (683).

Cynthia, visiting in London, is kept ignorant of Molly's illness by her mother, but Lady Harriet writes—first contriving to get Mrs. Gibsons's blessing for the letter—and describes its seriousness. Cynthia arrives home the next day, to her mother's shock. Her return signals a change in Gibson's attitude toward his stepdaughter, whom he was inclined from the Preston and Coxe incidents to think "a flirt and a jilt" (632). She comes back to nurse Molly out of gratuitous affection; no one expects it of her, and, in fact, her mother would rather she stayed in London cultivating another proposal from the lawyer Henderson, since she has already turned down Preston, Roger Hamley, Coxe, and Henderson once. Her mother calls Cynthia's return very foolish. "'Very foolish,' said Mr. Gibson, echoing his wife's words, but smiling at Cynthia. 'But sometimes one likes foolish people for their folly, better than wise people for their wisdom'" (682).

Wives and Daughters is a book of confidences and confidantes among sisters (and one brother's confidences) with Molly Gibson at the center. Molly learns from Osborne the secret of his wife early in the book. She feels a kinship with Aimée from the beginning; she, as the only person in England who knows Aimée's address, brings her to Hamley; and at their first meeting she is immediately engaged in nursing that saves Aimée's life. From Cynthia, Molly learns the secret of her engagement to Preston, and she acts to release her.

The confidences of sisterhood here lead to curative action. Some comparisons with other sisters in novels show how notable is this salubriousness. In Jane Austen the heroine frequently hears, from *outside the*

family, confidences that affect her sisters. These may be passed on much later, but usually not at all. Thus Elinor Dashwood hears from Colonel Brandon and Willoughby matters affecting Marianne, some of which she communicates later. Elizabeth Bennet hears from Colonel Fitzwilliam and Darcy things of great moment to both Jane and Lydia, but she keeps them to herself. Dickens isolates Amy Dorrit and Florence Dombey from any confidences from their real or figurative sisters. In Collins, sisters unwittingly displace one another (Anne Catherick and Laura Glyde), are out of sympathy with one another's methods (Norah and Magdalen Vanstone), or are so unequal in nerve and strength (Marian Halcombe and Laura Glyde) that one cannot bear the truth and must be tenderly deceived. Meredith's Dahlia begins with half-confidences in letters to her sister, Rhoda Fleming, but later Dahlia's sexual fall and its consequences render her so "other" that confidences are at an end. Rhoda reverts to a coarse and class-bound Puritanism while Dahlia is refined by her suffering until nothing but the "overearthly" remains.

Molly does not wish for confidences from Cynthia and about Aimée, but she holds them and acts on them. Her father, who "hates to have her mixed-up in mysteries," counsels her never to be "the heroine of a mystery that you can avoid, if you can't help being an accessory" (604), but the heroine of both these mysteries, and the rescuer of both these "sisters," is precisely what she does become. Cynthia ends up a heroine as well—not to the surprise of Cynthia, but perhaps to that of some readers who do not think heroines should be "all things to all men" (250) or, by their own admission "not good." Cynthia understands very early her role in an every-day story that yet pushes in its way at the limitations that bind all women: "Perhaps I might be a heroine still, but I shall never be a good woman, I know" (254). She, like Molly, grows into her sisterhood. The heroism of these two is not Jeanie Deans's dramatic sort, but it is real nonetheless. Each of them helps the other change into something different, more nearly equal to her sister than she had begun and better for the link they have made together. Gaskell's last book ends with a rosy picture of what sisters can accomplish, one altogether too rosy for George Eliot, whose *Middlemarch* is in part a reply to *Wives and Daughters*.

10

Reform and Rescue in Middlemarch (1872)

Early in *MIDDLEMARCH*, after we have been hearing about Dorothea's ambitious but unformed schemes, comes this sentence: "Women were expected to have weak opinions; but the great safeguard of society and of domestic life was, that opinions were not acted on."[1] The comment bears on all the opinions—strong *and* weak, of women *and* of men—that are not acted upon in the book. Looking back in ironic condescension to a time when provincial England—midlands and marches—was benighted, the sentence implies that we are now in a utopian present of 1872 when society and domestic life have been reformed. In reality after the Second Reform Bill in 1867 the political landscape seemed to some—*Middlemarch*'s narrator among them—strewn with wrecked reforms, or at least "checked" ones.

Middlemarch itself may well have helped bring about some specific reforms in The Married Women's Property Act. This act, really a series of parliamentary decisions begun in 1870 and amended in 1874, 1882, and 1893, had its most significant provisions written in 1882, ten years after the publication of *Middlemarch*. One of the main concerns of the act—as of Dorothea and Ladislaw's dilemma—has to do with a married woman's separate property, distinct from her husband's, after marriage and in widowhood.[2] But the book itself is about false reform and failed reforms. George Eliot ends it with a contrast between then and now, "those times when reforms were begun with a young hopefulness of immediate good

which has been much checked in our days" (576), yet in fact the reforms are checked within the span of the novel. The genuinely attempted reforms (as opposed to the more questionable intellectual reforms of Casaubon and the still more dubious religious ones of Bulstrode) are medical and political; each of these reforms is also connected to reform in attitudes toward women. These different kinds of reform are linked at key points throughout the book. The "Prelude" asks where a modern woman is to find her epos when she cannot, like St. Theresa, find it "in the reform of a religious order" (xiii). The "Finale" juxtaposes the sentence about checked reforms quoted above with the unresolved question of exactly what it is Dorothea should have done: "Many who knew her, thought it a pity that so substantive and rare a creature should have been absorbed into the life of another, and be only known in a certain circle as a wife and mother. But no one stated exactly what else that was in her power she ought rather to have done" (576).

Middlemarch is a novel about a woman looking for a heroic role as reformer in the public arena, who finds herself instead attempting a series of private rescues.[3] Reform is the public or social manifestation of what at the private and personal level is the desire for rescue. Both reform and rescue are expressions of a liberal impulse toward freedom and equality, and so public reform connects thematically with the private rescue plots so integral to the depiction of sisters in nineteenth-century British novels. Neither the public

reforms undertaken around Dorothea nor the rescues she undertakes have unequivocally happy results. But all are connected by Dorothea and her sisterhoods.[4]

DOROTHEA'S SISTERS

Dorothea's sister Celia is near her throughout the novel. The images of two sisters, Casaubon's mother and Will Ladislaw's grandmother, watch over her in her blue-green boudoir. And figurative sisterhoods extend all around Dorothea. Sometimes these depend on a three-way dynamic. The sisterhood of Dorothea and Rosamond is constructed partly by their rivalries but also by resemblances between Rosamond and Dorothea's literal sister Celia, the fairer, vainer sister.[5] Rosamond and Celia, though profoundly different in their attitudes toward marriage and sexuality—Celia is not a coquette—are both cool women who despise impulse and emotional display; their similar voice qualities are made much of by the narrator. Rosamond and Dorothea are rivals for Lydgate and for Ladislaw, and they are linked briefly by the imagery of the book. Rosamond is compared frequently with a flower on a stem, while Dorothea is a haloed saint and a martyr. But in the last book Dorothea loses her halo, changes out of deep mourning, and acquires at least once—just before she and Ladislaw conquer the obstacles to their marriage—the flower-on-a-stem image that has distinguished Rosamond (557). A more surprising linkage is that between Mrs. Bulstrode and Dorothea: Mrs. Bulstrode's loyalty to her husband when he is in disgrace, when his bubble of religious reform is exposed for hypocrisy, sisters her with Dorothea, passionately loyal to Casaubon as he sinks under the weight of his illness and the futility of his studies.

But one of Dorothea's "sisters" is not even a woman. The character of Will Ladislaw shows what U. C. Knoepflmacher has called "a transference to the male of the deprivation and suffering [Eliot] finds in the lot of women."[6] Ladislaw is constructed as a sister to Dorothea through his experience of dependence, through his susceptibility to being formed by her idealizing conception of him, and finally by being the object of one of Dorothea's rescues. *Middlemarch* thus continues the extension of sisterhood to males that can be seen in Meredith's Robert Eccles and Gaskell's Osborne Hamley.[7] Ladislaw is simultaneously an assertion that gender differences are largely artificial and an illustration of the novel's suspicion that there

may be limits to reforming relations between men and women.

Dorothea is also "sistered" with other fictional heroines in overt allusions as well as inevitable echoings of other books. *Middlemarch* cannot help but allude to books that have treated the same society and classes it treats, as well as the same questions about marriage and money, sex and gender. Thus there are echoes of *Emma*, *Pride and Prejudice*, *Little Dorrit*, and *Wives and Daughters*, as well as an explicit reference to *The Woman in White*. Emma Woodhouse and Marian Halcombe, Elizabeth Bennet and Amy Dorrit, Molly Gibson and Cynthia Kirkpatrick are all sisters of Dorothea and mirrors held up to her at one time or another; the likenesses are brought to our attention so that we may more readily see the differences. Though none of these books asks *Middlemarch*'s question about how a woman is to satisfy her ambition for accomplishment outside "a certain circle as a wife and mother," they all ask other questions about women's relation to men and to other women. What is the correct proportion of money and romance in marriage? How much and what kind of dependence and independence should each marriage partner have? In Eliot as in Austen, the main character's most important society after marriage, as before it, consists of sisters, and so this last question is aptly discussed by the sisters, Celia and Dorothea (507–8), as it had been earlier by Elizabeth and Jane Bennet. Then there is a woman's difficulty in correctly assessing how a prospective husband feels about her and about women in general. After marriage, what changes? How does one live with an incompatible mate? Eliot treats this last question with a depth and seriousness not previously seen in the novel, though her treatment is indebted to Gaskell's examination of the Gibson marriage and Austen's glimpses into the marriages of the Bennets and the Collinses. When *Middlemarch* echoes some of the situations in *Wives and Daughters*, it does so for the purpose, it seems to me, of tempering the optimism of Gaskell's book. The smart provincial medico in *Middlemarch*, unlike Mr. Gibson in *Wives and Daughters*, is neither the anchor of his little society nor proof against the managing efforts of his none-too-scrupulous wife. Moreover the heroine here wants—at least initially—something more than to bask in her husband's glory. Alluding to the answers other books have found, *Middlemarch* constructs its own original turn on each of the questions.

How, for example, does one choose one's mate?

Does one pick in advance on the basis of money and family? Does one trust to impulse and intuition, after love at first sight? Does one vet the prospective bridegroom for a year or two? Dorothea thinks she knows Casaubon before she marries him. She decides after a few meetings (during which she spends much of her time dealing with the advances of Sir James Chettam) that he is the perfect spiritual match for her. The narrator asks us to put this leap to conclusions in a timeless context: "Dorothea's inferences may seem large; but really life could never have gone on at any period but for this liberal allowance of conclusions, which has facilitated marriage under the difficulties of civilisation. Has any one ever pinched into its pilulous smallness the cobweb of pre-matrimonial acquaintanceship?" (13). This remark recalls Charlotte Lucas's conviction, in *Pride and Prejudice*, that knowledge of one's prospective husband is either not possible or not desirable. After Jane Bennet and Charles Bingley have spent four evenings in company with each other, Charlotte says, "if she were married to him tomorrow, I should think she had as good a chance of happiness, as if she were to be studying his character for a twelvemonth. Happiness in marriage is entirely a matter of chance. . . . it is better to know as little as possible of the defects of the person with whom you are to pass your life" (23). Elizabeth Bennet condemns this opinion as "not sound," but it would hardly be accurate to say the book does. While Elizabeth and Darcy carefully maneuver to learn each other's faults and then either reform or explain them away, Jane and Bingley fall in love at first sight, are kept apart by others while they learn nothing further about each other, and then marry with every prospect of perfect happiness.

Where does *Middlemarch* come down on the question its narrator poses and Charlotte Lucas had answered in the earlier book? Certainly the Casaubons' marriage is no parallel of the Bingleys'. Dorothea jumps to conclusions about her first husband's real nature. She mistakes Casaubon in every respect important to her: she thinks him "a man who could understand the higher inward life, and with whom there could be some spiritual communion; nay, who could illuminate principle with the widest knowledge: a man whose learning almost amounted to a proof of whatever he believed!" (13). She is dismally wrong. But her romance with Will Ladislaw is not a confirmation of Elizabeth Bennet's approach. Dorothea and

Ladislaw have three years in which to study each other's character, but the happiness of their marriage is not guaranteed by the mutual knowledge they have gained, in the way we are invited to believe Elizabeth's and Darcy's is. Once again *Middlemarch* suggests a variation on the previous answers. Ladislaw's character has been not so much assessed as created by Dorothea. "That simplicity of hers, holding up an ideal for others in her believing conception of them, was one of the great powers of her womanhood" (532), and Ladislaw's susceptibility to it is part of their fit. Ladislaw is Dorothea's will/Will; she constructs him to match her idealism, and he allows himself to be so constructed.

DOROTHEA AND MIDDLEMARCH COURTSHIP

The younger male society of *Middlemarch* is largely composed of men who have been either declared or potential suitors of Dorothea; the female society, of women whom those men have married. The courtships are the narrator's initial method of showing us these people. We learn a great deal about the men—except Casaubon, about whose true nature the narrator is coy, letting us find it out as Dorothea does, after their marriage. We learn also about the women, and links begin to be formed among them. And Dorothea's character is presented for our scrutiny by a narrator sometimes ironic and sometimes not.

Three of the four men, Chettam, Casaubon, and Ladislaw, are suitors of Dorothea; the fourth, Lydgate, is a potential suitor who takes himself out of the action early because he thinks he knows what it would be like to be married to her: "To his taste, guided by a single conversation, here was the point on which Miss Brooke would be found wanting, notwithstanding her undeniable beauty. She did not look at things from the proper feminine angle. The society of such women was about as relaxing as going from your work to teach the second form, instead of reclining in a paradise with sweet laughs for bird-notes, and blue eyes for a heaven" (64). When Lydgate looks at Rosamond, on the other hand, he sees a woman "who was instructed to the true womanly limit and not a hair's-breadth beyond—docile, therefore, and ready to carry out behests which came from beyond that limit" (243). Later, when he discovers how unanswerably

Rosamond can turn blue eyes and the limits of her education into power, he tries to generalize his discomfort by the thought that "It is the way with all women." But he remembers Dorothea, and "this power of generalising which gives men so much the superiority in mistake over the dumb animals, was immediately thwarted by Lydgate's memory of wondering impressions from . . . Dorothea's looks and tones of emotion about her husband when Lydgate began to attend him—from her passionate cry to be taught what would best comfort that man for whose sake it seemed as if she must quell every impulse except the yearnings of faithfulness and compassion" (409). Lydgate wonders dreamily in his new state of awareness what it would really be like to be married to Dorothea. Later still, in the bleak part of the book's "Finale" that deals with Rosamond and Lydgate, the question why he did not marry Dorothea comes up again: Lydgate had called Rosamond "his basil plant; and when she asked for an explanation, said that basil was a plant which had flourished wonderfully on a murdered man's brains. Rosamond had a placid but strong answer to such speeches. Why then had he chosen her? It was a pity he had not had Mrs Ladislaw, whom he was always praising and placing above her" (575).

Lydgate is put off by Dorothea and attracted to women who are husband-killers. His first love was the Parisian actress Laure, who killed her husband onstage in what may have been merely an accident but certainly agreed with her intent: "*I meant to do it*," she says unequivocally, "I do not like husbands. I will never have another" (105). This declaration is offputting for Lydgate, who wants to be her husband. Laure's candid admissions link her with Rosamond. So frequently the flower in the early part of the book—in Lydgate's eyes "flowers and music, that sort of beauty which by its very nature was virtuous, being moulded only for pure and delicate joys" (113), Rosamond becomes the basil plant that flourishes on her dead husband's brains. Rosamond dislikes marriage. She does not herself locate the cause of her malaise, being deluded into imagining Will Ladislaw preferable to her own choice: "He would have made, she thought, a much more suitable husband for her than she had found in Lydgate." But the narrator continues, "No notion could have been falser than this, for Rosamond's discontent in her marriage was due to the conditions of marriage itself, to its demand for self-

suppression and tolerance, and not to the nature of her husband" (520).

Dorothea's husband-killing is a reader's fantasy. Dorothea's husband—like Laure's—actually dies, but she is innocent—unlike Laure and Rosamond—of killing either his physical body or the body of his ambitious intent. And yet within half an hour of the first time she speaks her mind to Casaubon, in Chapter Twenty-Nine, he is clinging to the library steps in his study, gasping for breath (196). The idea of wishing Casaubon dead would no doubt horrify Dorothea, however fervently readers may wish it. Lydgate remembers Dorothea's passionate entreaty during Casaubon's illness "to be taught what would best comfort" her husband. And even at the worst of times with Casaubon, Dorothea does not dislike the institution of marriage, nor being married. In a revealing conversation with Celia after Casaubon's death and just before the novel's resolution, she makes it obvious that she wants a husband—one in particular—even as she protests that she does not. "As if I wanted a husband!" says Dorothea. "I only want not to have my feelings checked at every turn" (508). She then immediately bursts into tears. Celia's reaction is to tell her how "shamefully" she submitted to Casaubon's unreasonable requests of her: "I think you would have given up ever coming to see me if he had asked you." Such attendance is a test for Celia in which sisterhood must stand out against wifeliness. The bigoted Sir James attempts later to prevent Celia from seeing her sister because Dorothea has married a man beneath her class, without a fortune, and a foreigner into the bargain. But Celia quashes the prohibition with little effort. Now she tells Dorothea that "of course men know best about everything, except what women know better," and gets her sister to laugh. "Well, I mean about babies and those things," explained Celia. "I should not give up to James when I knew he was wrong, as you used to do to Mr Casaubon" (508). As unlike as the two sisters may be, they are alike in being able to live within the conditions of marriage that chafe Rosamond. Laure and Rosamond do not like marriage. Celia and Dorothea do. And as trivial as Celia can sometimes be, she is honest with Dorothea and has things to teach her sister about self-knowledge early in the book and about sisters needing to avoid submerging themselves in wifehood later.

Each of the other three men is an active suitor for Dorothea. Sir James Chettam's unreconstructed

male-supremacist attitudes are those most witheringly dealt with in the book; though the narrator keeps assuring us earnestly of his good nature, we are not convinced. Chettam is not a reformer. Thus he is distinguished from practically every other male character in the book, because practically every other male is a hopeful reformer, an incompetent one, a venal one, or a hypocritical one. Infatuated with Dorothea, convinced that she must like him, he muses complacently about how he could be helped out of his fog by asking advice of this decisive woman:

In short, he felt himself to be in love in the right place, and was ready to endure a great deal of predominance, which, after all, a man could always put down when he liked. Sir James had no idea that he should ever like to put down the predominance of this handsome girl, in whose cleverness he delighted. Why not? A man's mind—what there is of it—has always the advantage of being masculine,—as the smallest birch-tree is of a higher kind than the most soaring palm,—and even his ignorance is of a sounder quality. Sir James might not have originated this estimate; but a kind Providence furnishes the limpest personality with a little gum or starch in the form of tradition. (12)

Limp men do not interest Dorothea, although she is fooled about Casaubon, but *there* she imagines an intellectual and spiritual stiffness. She considers Chettam silly (22) and the idea of his being a suitor of hers ridiculous (4). But the episode is not complimentary to Dorothea. That Chettam is paying court ought to be apparent to her. The narrator says coyly, "It is difficult to say whether there was or was not a little wilfulness in her continuing blind to the possibility" of his courting her (21).

In showing Dorothea's naivety about Sir James's intentions, *Middlemarch* invites a comparison between Dorothea and Austen's Emma Woodhouse. Dorothea and Emma both mistake their ardent suitors, imagining that their all-too-obvious devotion is meant for other women. Emma is convinced that the attentions of Mr. Elton are meant for Harriet Smith, whom she has adopted as a sisterly protégée. The results are nearly disastrous, since Emma talks Harriet into rejecting a good offer of marriage from someone Harriet cares about. Dorothea's mistake resolves itself somewhat more gracefully, since she imagines Sir James Chettam to be pursuing her sister, and he takes that hint just as soon as he is convinced Dorothea does not care for him. Emma is chagrined by her experience, but she does not have to live with the results of her matchmaking. Dorothea, on the other hand, has Sir

James for a brother-in-law, and when she is widowed she moves into his sphere of control, at least briefly, finding herself "only in another sort of pinfold than that from which she had been released" (341). But another way to look at Celia's graceful acquiescence to Dorothea's matchmaking is that it has rescued her sister from embarrassment or worse.

Dorothea is like Emma in being willful and intelligent. Both engage us. Both are introduced as lacking a certain amount of self-knowledge. Celia knows more of her sister than Dorothea knows herself when we first see the Brooke sisters. In Book One, for example, Celia says of Dorothea: "She likes giving up." Dorothea answers, "If that were true, Celia, my giving-up would be self-indulgence, not self-mortification" (10). But the narrator has already assured us of the truth of Celia's observation: "Riding was an indulgence which she allowed herself in spite of conscientious qualms; she felt that she enjoyed it in a pagan sensuous way, and always looked forward to renouncing it" (3). Dorothea is the object of a good deal of ironic playfulness in this first part:

She would perhaps be hardly characterised enough if it were omitted that she wore her brown hair flatly braided and coiled behind so as to expose the outline of her head in a daring manner at a time when public feeling required the meagreness of nature to be dissimulated by tall barricades of frizzed curls and bows, never surpassed by any great race except the Feejeean. This was a trait of Miss Brooke's asceticism. (16)

At this point Dorothea's "asceticism" could be thought the vanity of nonconformity, and Dorothea an interesting comic heroine, but still one very much like Emma Woodhouse at the beginning of *Emma*. But having introduced Dorothea with all her limitations, the narrator does something no book of Austen's does in taking us right out of the ironic mode in an apology for the heroine:

The intensity of her religious disposition, the coercion it exercised over her life, was but one aspect of a nature altogether ardent, theoretic, and intellectually consequent: and with such a nature, struggling in the bands of a narrow teaching, hemmed in by a social life which seemed nothing but a labyrinth of petty courses, a walled-in maze of small paths that led no whither, the outcome was sure to strike others as at once exaggeration and inconsistency. (17)

There is no irony in these careful distinctions and corrections nor in this instruction of our feelings toward Dorothea. If Eliot wants us to compare her heroine and Emma, she also wants us to see the differences.

The greatest difference is in Dorothea's romantic heroism: instead of a heroine constructed by the male romantic lead in his image—an Emma made by Mr. Knightley—Eliot gives us a heroine who constructs the hero, in the person of Will Ladislaw, in her image.

CASAUBON AND "CHECKED" REFORMS

Casaubon is *not* created in Dorothea's image of him, not constructed as Ladislaw is by "that simplicity of hers, holding up an ideal for others in her believing conception of them, . . . one of the great powers of her womanhood" (532). Casaubon's attitude toward women is not revealed by the same incidental glimpses into the mind of a possible suitor that we are given for both Chettam and Lydgate. We discover only slowly that Casaubon believes in a more profound subjection of women than the other men are capable of entertaining. He wants to be Dorothea's husband even after he is dead. She can resist him while he is alive: "While he lived, he could claim nothing that she would not still be free to remonstrate against, and even to refuse" (332). But the claim he makes upon her, that she thinks relates only to his work and continuing what would have been, had he completed it, "the doubtful illustration of principles still more doubtful" (331), is that she agree to obey him, after his death, in any and every wish. The night before his death he tells her solemnly that he has a request, and when she asks what it is he replies: "It is that you will let me know, deliberately, whether, in case of my death, you will carry out my wishes: whether you will avoid doing what I should deprecate, and apply yourself to do what I should desire" (331). She does not agree to Casaubon's absurdly open-ended wish, but only because his death prevents her browbeaten acquiescence. All that remains of his will to control her after his death is his literal last will.

Casaubon's provision that Dorothea will lose her inheritance from him if she marries Ladislaw is mean-spirited, suspicious, and perfectly on the mark in its suspicion. But its significance goes beyond the personally insulting. Casaubon's death is one of those places in *Middlemarch* where improvement is promised but does not come about. Dorothea appears at her husband's death to have personal freedom and the means to accomplish some of her ambitious schemes for gen-

eral betterment. In fact she is presented with a cruel dilemma that shows her she can have one only at the expense of the other. Finally she chooses the personal freedom, having realized that she has never exercised any wider freedom. When Celia pleads that if she does not marry she can go on doing what she likes, Dorothea replies: "On the contrary, dear . . . I never could do anything that I liked. I have never carried out any plan yet" (566). Her theater of action has to narrow to the personal when she takes action; if she is to have any freedom of action at all she must give up some of her larger plans to better the world. And she does choose—Dorothea's Will rather than Casaubon's will. But the very next sentence after her embrace with Ladislaw is "It was just after the Lords had thrown out the Reform Bill" (560), linking her decision with at least the temporary arrest of reform.

Casaubon's action in cutting off Dorothea's inheritance would not have been legally binding at the time he supposedly made it, in 1831. *Middlemarch* fudges the historical evidence slightly in pursuit of a larger historical truth. English common law had always recognized a dower right of widows, and in Dorothea's case, because there were no children to inherit, this would have amounted to half Casaubon's real property. But the power of testation over the dower right had been steadily increasing before the nineteenth century, and in 1833 the Dower Act provided that a husband "could expressly bar his wife's right of dower, without her consent," by means of a will.[8] In other words the reform-minded 1830s were moving backward in regard to reforming married women's property rights. The very circumstances that enable Casaubon's action in his will (or would within a year or two) show that there is no reform in the area—the rights, the place, and the freedom of women—that legal, political, and medical reforms metaphorically point toward throughout the book. Casaubon is enabled, in a slight rearrangement of legal chronology, to have a portion of his wish to be her husband after his death by controlling Dorothea's property after his death—not her separate property, but that to which English common law had historically considered a widow entitled by virtue of her having lived in sanctioned marriage with her husband.[9]

But what the episode says about the early seventies and "reform much checked in our days" is as significant as its slightly inaccurate historical reference to the thirties. *Middlemarch* has always that ironic double reference: it is about the thirties *and* about the

early seventies. As Eliot was writing the book, in 1869, the House of Commons passed a Married Women's Property Bill by a vote of 131 to 33. It was not a new idea, having been first introduced as a bill in 1857. But when it went up to the House of Lords in 1869 it was dropped. Considered again by the Lords in 1870, the bill was gutted; according to Lee Holcombe, "the Lords tore the Commons' bill to shreds, striking out fourteen of its seventeen substantive clauses and replacing them with new provisions, and amending the other three."[10] The Commons passed the bill, but by the time Eliot published the last number of *Middlemarch* in 1872 the parliamentary efforts to amend the Married Women's Property Act of 1870 were already under way, and they did not cease until amending acts had been passed in 1874 and 1882. Though there have been further amendments in the twentieth century, English law has never restored anything like the original common law dower right that would impel some settlement on a surviving spouse by countermanding a will.

Although the Victorians were probably as talented as we are when it comes to reconciling contradictory principles, it must nevertheless have disturbed some that a wife divorced for adultery under the 1857 Matrimonial Causes Act was entitled to maintenance—alimony—while her sister, the chaste widow, could not see a penny of her dead husband's property, whether or not she had any of her own, if he had so willed. Given this anomaly in the effects of the divorce and property laws, it might seem likely that the 1857 Matrimonial Causes Act would have been the more hotly contested issue. But it was not. Parliamentary debate about women's property reform began at the same time, in the middle fifties; but it was not until the end of the next decade that even an unsatisfactory first step was taken toward securing separate property rights for women. The 1870 Act's provisions, immediately seen as inadequate, were contested and amended for another dozen years. The inference to be drawn from this struggle is that women's property represented a far more threatening issue for reactionaries than did the divorce question. The Married Women's Property Act, however flawed in practice, aimed at effecting a material equality between men and women that its more perceptive opponents in Parliament recognized as genuinely revolutionary.[11] Eliot, too, recognized that pressure toward property reform was movement toward equality of rights and, more importantly, equality of ambition. But the 1870

Act itself was so feeble as to appear to Eliot, and probably many others, as reform that was being "checked" rather than carried through.

The identification of "reform" with Dorothea's novel ideas about what a woman might accomplish happens early in *Middlemarch*: Eliot writes that "all people, young or old (that is, all people in those ante-reform times), would have thought her an interesting object if they had referred the glow in her eyes and cheeks to . . . young love" (16). Dorothea's glow is ambition for something more: "But perhaps no persons then living—certainly none in the neighbourhood of Tipton—would have had a sympathetic understanding for the dreams of a girl whose notions about marriage took their colour entirely from an exalted enthusiasm about the ends of life, an enthusiasm which was lit chiefly by its own fire, and included neither the niceties of the *trousseau*, the pattern of plate, nor even the honours and sweet joys of the blooming matron" (17). That now—in 1872—there are persons with a "sympathetic understanding" of Dorothea's notions does not mean that the sympathy has extended to enthusiastic reform. Behind the narrator's comments is an acknowledgment that though Dorothea's ambition might not be such an anomaly in the present, an increase in the number of such women has not meant great changes—there may be something self-limiting about women's emancipation.

THE SISTERHOOD AND RESCUE OF WILL LADISLAW

If there is a single character who illustrates the novel's doubts about what might be achieved in bringing men and women together, that character is Will Ladislaw. Ladislaw, alone of the male characters who come within the sphere of Dorothea's charm, does not assess her from a male supremacist view. At their first meeting, when Dorothea professes to be ignorant about art and unable to judge his sketch, Ladislaw's assessment is unfavorable, mistaken (for reasons that already point to attraction), but not superior:

Ladislaw had made up his mind that she must be an unpleasant girl, since she was going to marry Casaubon, and what she said of her stupidity about pictures would have confirmed that opinion even if he had believed her. As it was, he took her words for a covert judgment, and was certain that she thought his sketch detestable. There was too much cleverness in her apology: she was laughing both at her uncle and himself. But what a voice! It was like the

voice of a soul that had once lived in an Æolian harp. This must be one of Nature's inconsistencies. There could be no sort of passion in a girl who would marry Casaubon. (53)

He thinks her insincere and without passion—two mistakes, but both deriving from an incipient jealousy about her approval, whether of art or of husbands. There is no sign here that he knows himself to be superior, even as a judge of art. And a moment later, as he thinks back about the comic aspects of the scene, he laughs with "no mixture of sneering and self-exaltation" (54). Later, in Rome, Will considers Dorothea's reverence for Casaubon a husband-worship that would be a weakness in any woman (144). He retracts his earlier doubts about her sincerity and lack of passion but conjectures that "she must have made some original romance for herself" (145) in the marriage to Casaubon. He longs to rescue her, but since Casaubon is neither dragon nor Minotaur (153), but "a benefactor with collective society at his back" (145), Will must forbear, and in the outcome it is Dorothea who rescues *him* rather than vice versa.

Though Casaubon is no Minotaur and Dorothea's blue-green boudoir is not quite a labyrinth, nevertheless her room, Casaubon's living will and testamentary will, and Sir James's suppression of her projects, are all restraints and enclosures. She lives in "the stifling oppression of that gentlewoman's world, where everything was done for her and none asked her aid"; she endures "the gentlewoman's oppressive liberty," and the narrator calls it "moral imprisonment" (189). True, also, in breaking for freedom from Casaubon's wealth and Casaubon's will, she falls first into another sort of "pinfold"—Sir James Chettam's—and afterwards is "absorbed into the life of another, and . . . only known in a certain circle as a wife and mother" (576). But Ladislaw seems to represent Dorothea's own choice over the constraint of Casaubon, and among the men Ladislaw is preferable because his sensibility has been trained by a universal feminine experience of dependency. Henry James correctly observes that Ladislaw is "a woman's man" (654)—correctly and perhaps ironically—while he mistakenly imagines Lydgate to be "the real hero of the story."[12] Ladislaw *is* a woman's man, though not a womanly one. The attraction he immediately feels for Dorothea is frankly sexual, while his reaction does not spin itself out as Chettam's and Lydgate's do with faintly masked visions of a sultan and his harem. And he recognizes that his desire to effect a rescue of Doro-

thea is futile and must give way to acceptance of being rescued.

Ladislaw has been schooled in dependency. *Middlemarch* explores all kinds of dependencies, and Ladislaw, who is led through many varieties, comes out looking fairly self-sufficient. He begins with Casaubon's help, a benefaction that seems pure charity until it is examined more closely. At its first mention, during Dorothea's visit to Casaubon's manor-house at Lowick, talk of Casaubon's support of Ladislaw is juxtaposed with Mr. Brooke's comment about the French king's wish for a fowl in all his subjects' pots. Dorothea's indignant opinion is that it is "a very cheap wish. . . . Are kings such monsters that a wish like that must be reckoned a royal virtue?" (51). A few moments later Casaubon explains, in his ponderous and circumlocutious way, his providing for Ladislaw: "putting his conduct in the light of mere rectitude" (54). After a few visits with Dorothea in Rome during which her formative influence—"that simplicity of hers, holding up an ideal for others in her believing conception of them" (532)—starts to work on him, Ladislaw declines any further help from Casaubon. Will and Dorothea begin to realize that Casaubon's benefactions are not charity but simple justice; Casaubon sees that they realize it, and he reacts with an emotion that is as near as he comes to rage. Casaubon forbids Ladislaw his house and begins to contemplate his testamentary exclusion of him from Dorothea's life. He reenacts his family's disinheriting of Ladislaw's grandmother.

The images of the two sisters, Casaubon's mother and Ladislaw's grandmother, are Dorothea's constant companions in her blue-green boudoir. The sisters are types of the two men most important in her life. Dorothea's room was once Casaubon's mother's room, where miniatures of the two sisters hang opposite each other. Dorothea, when about to enter her own socially correct but unfortunate marriage, heard about the sister's "unfortunate marriage" and looked at the close-set grey eyes and the "nose with a sort of ripple in it" (50) just a few minutes before she met Ladislaw with his grey eyes too near together and nose "with a little ripple in it" (52).

Ladislaw moves from dependence on Casaubon to dependence on Mr. Brooke, uneasily remains there for a while, and then finds himself more or less unwillingly a free agent. But during this time he rejects without hesitation a miserly offer of maintenance from Bulstrode, an offering Bulstrode construes as

charity but which is no more than partial restitution to the heir whom he cheated out of an inheritance. These plot developments enable Ladislaw frequently to assert his independence even though he is almost continuously economically dependent. Then at the book's climax, he moves into Dorothea's money. But Dorothea must break through his resistance to the idea; he keeps insisting "We can never be married":

> At last he turned, still resting against the chair, and stretching his hand automatically towards his hat, said with a sort of exasperation, "Good-bye."
> "Oh, I cannot bear it—my heart will break," said Dorothea, starting from her seat, the flood of her young passion bearing down all the obstructions which had kept her silent—the great tears rising and falling in an instant: "I don't mind about poverty—I hate my wealth."
> In an instant Will was close to her and had his arms round her, but she drew her head back and held his away gently that she might go on speaking, her large tear-filled eyes looking at his very simply, while she said in a sobbing childlike way, "We could live quite well on my own fortune—it is too much—seven hundred a-year—I want so little—no new clothes—and I will learn what everything costs." (560)

The scene recalls one in which Amy Dorrit tells Arthur Clennam that she has *no* money and therefore the obstacle to their marriage has been removed. Arthur is in the Marshalsea for debt, having lost all his money and that of his partner, but before his partner comes to tell him his debts are settled and his old life ready to be taken up, Amy Dorrit has been nursing him. He tells her that they "must learn to part again" (885). She has been urging him to accept her money (before she was informed that had all been lost in Merdle's fall), in terms like Dorothea's: "I have no use for money. I have no wish for it. It would be of no value at all to me but for your sake" (828).

Eliot, characteristically, alludes to the scene while reversing its import. In order to qualify for happiness by marrying Arthur Clennam, Little Dorrit has to lose not only this paternal inheritance but a later one she acquires through her uncle. Money for her would mean independence, so it must go. For Dorothea, *her own money* represents a measure of independence, but the use of Casaubon's money means subservience to Casaubon's continuing will, "The Dead Hand" of Book Five of the novel. But Dorothea's independence is Ladislaw's dependence; this rather fundamental compromise in the economics of marriage, when both parties are not equally rich, *can* go in the direction of

male dependence. Ladislaw's resistance has to be broken through, and it is done here very simply through an emotive equation of Will and Dorothea: "Her lips trembled, and so did his" (559). Her "young passion bear[s] down all the obstructions which had kept her silent" and they embrace. She holds him away for the wholly supererogatory, rational comments about how they can live well on her money. "I will learn what everything costs" (560), says Dorothea, when she has already learned this, and it is Will who has yet to learn.

The assertion of Will Ladislaw's "sisterhood" with the heroines of recent romantic fiction, with Amy Dorrit, with Dorothea herself, may be the boldest blow the book strikes for its causes. But it was risky. Henry James illustrates the risk when he reads Ladislaw as "a woman's man" and implies that he is "womanish" or "feminine." In the middle-class construction of gender, which included economic independence for the male and dependence for the female, Ladislaw *was* feminine.

Ladislaw has been deliberately constructed to raise the kind of objection James makes, and also—perhaps to discredit that very objection by suggesting that it is encoded ethnic bigotry—Ladislaw is made a "foreigner." Actually, he merely has some Polish blood, and in *Middlemarch* he is surrounded by the "tribes of Toller, Hackbutt, and the rest, . . . who sneered at his Polish blood, and were themselves of a breed very much in need of crossing" (417). Ladislaw's foreignness allows for another allusion, this time to Collins's *The Woman in White.* Shortly after Casaubon's death, Celia tells her sister about the will's provision against her marrying Ladislaw. Celia has no suspicion that Dorothea might be romantically interested in that direction: "Of course that is of no consequence in one way—you never *would* marry Mr Ladislaw; but that only makes it worse of Mr Casaubon." Then she repeats a judgment of the vicar's wife: "Mrs Cadwallader said you might as well marry an Italian with white mice!" (339). Equating Ladislaw with Count Fosco and his pet mice expresses succinctly the Middlemarch tribe's xenophobic meanness, but it also brings to mind the differences between the two men rather than their similarities: nothing could be more unlike Fosco's imposition of his will on all those around him than Ladislaw's malleability. "An Italian with white mice!—on the contrary," Dorothea thinks, "he was a creature who entered into every one's feelings, and could take the pressure of their

thought instead of urging his own with iron resistance" (344). Ladislaw's yielding quality is less universal, more specifically aligned to Dorothea's will than she knows at this point, but it is literally a "saving" feature in that it allows Dorothea's rescue of him.

Ladislaw's rescue is accomplished only after Dorothea goes through a period of intense sexual jealousy when she imagines he loves Rosamond.[13] After this crisis Dorothea sees the rescue of Ladislaw *and* of Lydgate and Rosamond "an obligation on her as if they had been suppliants bearing the sacred branch. . . . The objects of her rescue were not to be sought out by her fancy: they were chosen for her" (544). Dorothea temporarily rescues Lydgate by giving him money and her trust in his innocence. She rescues Rosamond from her infatuation with Ladislaw and thus saves Lydgate too, though this marriage's "hidden as well as evident troubles" (544) will not disappear because one catastrophe has been averted.

I have said that the personal rescue in all the forms we have looked at it in paintings and novels moves ideally toward equality and the erasure of difference. Dorothea's power to save, to rescue, comes from her ability to get on a level with another person. Ironically, this power unnerves Casaubon and perhaps even hastens his death. Dorothea's encounters late in the book as she takes on the rescue of Lydgate (Chapter Seventy-Six), of Rosamond (Chapter Eighty-One), and of Ladislaw (Chapter Eighty-Three) depict her first as an imposing or awe-inspiring figure: Lydgate thinks she has "a heart large enough for the Virgin Mary" (530), Rosamond feels "something like bashful timidity before a superior" (548), and even Ladislaw is put off by what he perceives as her "queenly way of receiving him" (in her agitation she forgets to put out her hand to him or to sit down—557). But these scenes move rapidly toward equality.

Lydgate perceives that Dorothea is a woman with whom a man can be friends—something he "never saw in any woman before" (530). Ladislaw and Dorothea are emotively equated in the reconciliation scene we have already looked at. Rosamond's meeting with Dorothea begins with Dorothea's apparent superiority and Rosamond's getting smaller and smaller (547), but soon both women are reduced to helpless childishness (549) and are clinging to each other like very young sisters in a shipwreck.

Middlemarch is such a wonderful book that we expect it to teach us how men can get past their stupid notions of supremacy and how women can join each other as sisters to help and ensure that passage. But it does not. If anything it warns that the road to reform is longer than some had thought and that the solutions of previous books no more provide an answer than does this book. In *Middlemarch* every reform is costly. The Featherstone almshouses and the Bulstrode cholera hospital are built on the wrongs of women. What is gained in breaking gender stereotypes so that the heroine can marry is lost again because marriage itself is a narrowing of Dorothea's scope of influence to "a certain circle as a wife and mother." How that could have been avoided the narrator does not address: "no one stated exactly what else that was in her power she ought rather to have done" (576). Dorothea is willing to submerge herself while her husband pursues reform; Rosamond is not willing to do the same. All this suggests an either/or, zero-sum view of reform—a forecast that women reformers will have to forfeit a great deal and that reform will not come about merely as a result of domestic compromise between pairs of reasonable people.

Notes

Chapter 1. Defining Sisters

1. The identification of the landscape as the East Bay of Mentone on the coast of France, as well as many other important details about the picture, may be found in the only monograph on Egg's work, Hilarie Faberman, "Augustus Leopold Egg, R.A. (1816–1863)" (Ph.D. diss., Yale University, 1983), 304–8.

2. Janet Todd calls sisterhood "the only relationship that is potentially equal within the rigidly hierarchical family," in *Women's Friendship in Literature* (New York: Columbia University Press, 1980), 33.

3. This dichotomy is suggested by Susan Casteras, who discusses the painting in *Images of Victorian Womanhood in English Art* (Rutherford, N.J.: Fairleigh Dickinson University Press, 1987), 38–40:

The mutual process of self-identification shared by women, blood sisters or not, could be expressed with . . . disquieting effects, as in Augustus Egg's *Travelling Companions* of about 1862, one of countless canvases that quite eerily twin the features, attire, and doppelgänger identity of the sitters. It is otherwise clear, however, that the two females are quite different in spirit, an impression communicated by both the differentness and the psychological distance between the two. Their lives and dresses may nearly overlap, but the sister at left has fallen asleep amid her voluminous skirts, while her counterpart reads. Superficially, they are embodiments of idleness and industry, their hats seemingly confronting each other more than the women themselves do. But what kind of book is being read—a French novel or the classics? And what is the meaning of the bouquet of roses, which in a courtship context would connote impending romance? Do their pert, feathered hats allude to the same accoutrement in John Everett Millais's *My First Sermon* and its sequel, explorations of feminine moral vigilance in girlhood? Egg has chosen to create a "problem picture" for his viewers, who must also interpret the meaning of the journey that the sisters have embarked upon. Are they tourists and is the scenery real or imagined by them? Neither sister bothers to look out at the magnificent Italian hillside and water glimpsed through the train window, and together the pair has managed to create quite a snug "portable parlor" to shield them from the dangers—and the beauty and the challenge—of the beckoning view.

4. At least twice more these same images show up in Fuseli's depictions of two sleeping women, possibly sisters: a painting of about 1793 and a drawing of 1810, both in Zurich. *An Incubus Leaving Two Sleeping Girls* (oil, ca. 1793, in the Muraltengut in Zurich), and *The Incubus Leaving Two Sleeping Women* (pencil and watercolor, 1810, in the Zurich Kunsthaus), are listed and illustrated in the catalogue of the Tate Fuseli exhibition in 1975.

5. Edgar Wind was the first to identify Reynolds's debt to the Romano fresco, in "'Borrowed Attitudes' in Reynolds and Hogarth," *JWCI* 2 (1938–39). Nicolas Powell writes at length about the iconography of the Reynolds and Fuseli pictures in his monograph, *Fuseli: The Nightmare* (New York: Viking, 1972).

The Psyche story, as James Hall points out in his *Dictionary of Subjects and Symbols in Art* (New York: Harper & Row, 1979), is not really a myth, but "a late antique fairy tale." In fact, it is a male allegory about art as well as domestic relations, constructing women as erotic objects, voyeurs of their own pleasure (Psyche's curiosity), and envious of their sisters' pleasure (the jealous sisters who urge Psyche to break trust with her lover). The sight of sleeping Psyche causes Cupid to fall in love and set up housekeeping; the female form as the legitimate object of the gaze leads to the domesticated relation. But the sight of the sleeping Cupid is forbidden and dangerous: when the transgression is committed and he is the object of the female gaze, Cupid and his domicile vanish.

6. And only a little later than Egg's painting is Wagner's Brunhilde, asleep surrounded by magic fire, whom Siegfried falls in love with. Examples of English paintings of sleeping women from literature are illustrated in Richard Altick's *Paintings from Books: Art and Literature in Britain, 1760–1900* (Columbus: Ohio State University Press, 1985). In the forties and fifties, a woman pictured asleep usually has to do with social consciousness and not sex. When a fruitseller (as in W. P. Frith's *The Sleepy Model*, 1853, Royal Academy) or a seamstress (as in numerous pictures by Cope, Redgrave, and others) sleeps in a mid-nineteenth-century picture, it just means she is tired. Venus's devotees, on the other hand, are leisure-class women like the goddess herself. Indolence rather than exhaustion causes the sleep. Late Victorian painters, some of them clearly influenced by Egg's picture, put their female subjects to sleep individually, in pairs, and in larger numbers. The painter may twin sleeping subjects, as Albert Moore does in *Dreamers*. Allen Staley comments that in Moore's later pictures "almost everybody has fallen asleep," in his "The Condition of Music," *Art News Annual* 33 (1967): 86. Other painters compose and color their sleepers like ripe fruit to be plucked and tasted, as in Frederic Leighton's *Flaming June*. They wrap their subjects with sexual symbols like snakes as in Leighton's *Garden of the Hesperides*, or they unwrap them and make the symbols unblushingly explicit, as in Lawrence Alma-Tadema's *In the Tepidarium*. No English artist paints a picture quite so explicit as the two intertwined nude sleeping women of Gustave Courbet's *Le sommeil* (page 88), completed four years after *The Travelling Companions* and illustrated below in Chapter 3.

7. On the relation between the reader and the gazer, consider the following passage from Susan Ferrier's *Marriage* (1818):

Lord Lindore turned his eyes with more animation than he had yet evinced towards his cousin, who sat reading, apparently paying no attention to what was going on. He regarded her for a considerable time with an expression of admiration; but Adelaide [one of the twin sisters who are the book's main characters] though she was conscious of his gaze, calmly pursued her studies. (277)

The hint of combining beautiful sleepers and readers is picked up from Egg by later painters who use the motif in comparatively uninteresting ways, as in Moore's *Reading Aloud* (1884, Glasgow Art Gallery) and Alma-Tadema's *The Favourite Poet* (1888, Lady Lever Art Gallery, Port Sunlight).

8. Casteras, *Images of Victorian Womanhood*, 39–40.

9. The hats are almost identical to the one used the next year by Millais for the stylish little girl in *My First Sermon* (Guildhall Art Gallery, London), and to the one Walter Crane had drawn in 1861 and labeled, "a 'pork pie' hat of the period," in an illustration reproduced by Isobel Spencer

in *Walter Crane* (New York: Macmillan, 1975), 19. If there is allusion in the hats, as Casteras suggests (see note 3 above), it is Millais alluding to Egg rather than vice versa.

Anne Buck discusses crinoline fashion and this painting in *Victorian Costume and Costume Accessories* (Carlton, Bedford: Ruth Bean, 1984), 45. Up to the early 1860s, huge crinolines like these distinguished upper-class women, who would have been prevented from working by the encumbrance of the fashion, had they had any work to do. Their lower-class counterparts had to wear more serviceable dresses. Then came the predictable democratization of the trend, according to Christopher Walkley, "'Nor Iron Bars a Cage:' The Victorian Crinoline and Its Caricaturists," *History Today* 25 (1975): 713. A *Punch* cartoon of 1862 (reproduced in Walkley) signals the shift: a lady with an enormous wire cage crinoline berates her maid (who wears a single hoop under her dress) by saying, "Mary! Go and take off that thing directly! Pray are you not aware what a ridiculous object you are?"

10. According to Stella Margetson, the first woman to travel on the first passenger railway from Liverpool to Manchester was Fanny Kemble, three weeks before the line's official opening on 15 September 1830. "When Rail Travel Was an Adventure," *Country Life* 166 (July, 1979): 170–71.

11. Casteras, *Images of Victorian Womanhood*, 14.

12. Susan Morgan, *Sisters in Time: Imagining Gender in Nineteenth-Century British Fiction* (New York: Oxford University Press, 1989), 1–20.

13. The phrase is Françoise Basch's, from the title of her 1974 book, *Relative Creatures: Victorian Women in Society and the Novel* (New York: Schocken Books, 1974).

14. *Woman and the Demon: The Life of a Victorian Myth* (Cambridge: Harvard University Press, 1982), 2.

Chapter 2. Demythologizing Reynolds

1. The accusation was pictorial rather than verbal: a reviewer from the *London Evening Post* of 9 May 1775 wrote that Hone's *The Conjuror*, exhibited at the Royal Academy that spring, "was meant to charge [Reynolds] with plagiarism." The Hone picture is reproduced and the review is quoted by John Newman in "Reynolds and Hone: 'The Conjuror' Unmasked," in Nicholas Penny, ed., *Reynolds* (New York: Abrams, 1986), 345.

2. Newman, 352.

3. E. H. Gombrich, "Reynolds's Theory and Practice of Imitation," in *Norm and Form: Studies in the Art of the Renaissance* (London: Phaidon, 1966), 131.

4. Walpole's correspondence on the subject, before and after the picture's completion, is quoted and commented on in David Mannings's catalogue entry in Penny, *Reynolds*, 292–93.

5. John Guille Millais, *The Life and Letters of Sir John Everett Millais* (New York: Frederick Stokes, 1899), 2:39. According to Walter Armstrong, who is quoted here, Millais, unlike Reynolds, did not employ anyone to finish the detailed background of the picture. He had himself designed the grey dresses trimmed in pink and yellow. While Lady Waldegrave lived, a copy of the Millais hung near Reynolds's portrait of the Waldegrave sisters at Strawberry Hill. Millais, 2:40.

6. Malcolm Warner discusses the sitters and the landscape in "John Everett Millais's *Autumn Leaves*: 'A Picture Full of Beauty and without Subject'," in Leslie Parris, ed., *Pre-Raphaelite Papers* (London: Tate Gallery/Allen Lane, 1984), 127. John Ruskin's comments on the picture are in E. T. Cook and Alexander Wedderburn, eds., *The Works of John Ruskin* (London and New York, 1903–12), 14:66–67.

7. Timothy Hilton, *The Pre-Raphaelites* (New York and Washington: Praeger, 1974), 78. Warner, 128.

8. Richard and Samuel Redgrave, *A Century of British Painters* (1866, 1890; reprint, Ithaca: Cornell University Press, 1981), 284.

9. Casteras quotes *Vanity Fair* and *Daniel Deronda* on "the connection between the fair toxophilites' arrows and the amorous darts of Eros," Casteras 155.

10. David Robertson, *Sir Charles Eastlake and the Victorian Art World* (Princeton: Princeton University Press, 1978), 45, 269–71.

11. *Book of Materials*, quoted in Penny, 205.

12. David Mannings, in Penny, 206.

13. *The Hero in Eclipse in Victorian Fiction*, trans. Angus Davidson

(London: Oxford University Press, 1956), 60. Of the Owen *Two Sisters*, Richard and Samuel Redgrave write, "In 1797, he exhibited a portrait of two sisters, by which he gained great credit, one of whom he soon afterwards married." *A Century of British Painters*, 240. In William Owen's *Two Sisters*—now in the New Orleans Public Library—the two ladies are pretty clearly in mourning. The Redgraves do not tell us whether Owen married the younger, darker sister who faces us squarely from the picture, or the older, shorter, fairer one who turns away.

14. The Romano/Reynolds pose is immediately borrowed again by Henry Fuseli to depict a sleeping, not a dying, woman in *The Nightmare* (page 17), completed in 1781, the same year Reynolds painted *The Death of Dido*, which Fuseli had seen in progress—Powell, 67. Reynolds himself painted the Boccaccio subject, in 1789, using a pose very similar to that of the *Dido*.

15. *Sex and Sensibility: Ideal and Erotic Love from Milton to Mozart* (Chicago: University of Chicago Press, 1980), 280–81.

16. Susan Casteras discusses pictures of nuns, accompanied by sisters of their order or of their blood, alone, or being "rescued" by romantic males, in "Virgin Vows: The Early Victorian Artists' Portrayal of Nuns and Novices," *Victorian Studies* 24 (Winter 1981): 157–84 and also in *Images of Victorian Womanhood in English Art*, 77–84.

17. The situation of the woman worker was frequently painted from the 1840s on in single-figure compositions that aimed at pathos. The *sisterhood* of women workers is a slightly different topic, and though the result sometimes evoked pathos, as in Frank Holl's *The Song of the Shirt*, at least one painting, Eyre Crowe's *The Dinner Hour, Wigan* (1874—Manchester City Art Gallery) treats the subject in an upbeat fashion, stressing solidarity rather than exploitation.

18. Graham Reynolds, *Victorian Painting* (New York: Harper & Row, 1987), 12.

19. Casteras, *Images of Victorian Womanhood*, 38.

20. Two of Tissot's commentators speculate on the meaning of these repetitions. Malcolm Warner says "it is an enchanting touch worthy of Buñuel, but what does it signify? Are they four pairs of twins? Or have four pairs of women arrived at the ball not too early this time but (the worst of all socialites' nightmares) wearing the same outfits, quite by chance? Is Tissot wryly likening fashion to a uniform?" Warner asks these questions in "Comic and Aesthetic: James Tissot in the Context of British Art and Taste," in Krystyna Matyjaskiewicz, ed., *James Tissot* (London: Phaidon Press and Barbican Art Gallery, 1984), 28. In her essay in this volume, Krystyna Matyjaszkiewicz suggests that the repetition of the figure in the pink dress in *The Ball on Shipboard*—right profile (left foreground), back view (center), left profile (behind the railing to the right), and front view (coming up the companionway ladder)—may be an attempt to convey movement, prompted by the figure studies of Eadweard Muybridge—Matyjaszkiewicz, "Costume in Tissot's Pictures," 76. And she extends the last suggestion offered by Warner by pointing out that "pairs of figures were used in contemporary fashion plates to show different costumes or variants, and also to show the same costume from two points of view. Throughout his career, Tissot adopted this compositional device in his modern life pictures," Matyjaskiewicz, 69. The device suggests that the fashion is more important than the face, and perhaps even that the wearer of fashionable clothes wishes to assert such a priority and be judged by the clothes.

Tissot has an eye for the sort of women who conform to a Victorian gender stereotype that discouraged individuality. He was working a few years after the midcentury "redundancy" scare. The 1851 census showed about seven and a half million males over the age of ten compared to well over eight million females of the same age. This meant that nearly 10 percent more women were reaching marriageable age than men. Social critics began to talk about the problem of "redundant" or "superfluous" women (W. R. Greg's 1868 article "Why Are Women Redundant" is the most frequently cited example). One image conjured up by this talk—women waiting in serried lines for scarce positions—is not within Tissot's preferred range of subjects, but another—clusters of stereotyped, identical women grouped around a few eligible males—can be found in more than one Tissot painting. None of his commentators, so far as I know, makes this sociological suggestion about his twinning.

21. Beaumont Newhall, *The History of Photography from 1839 to the Present Day* (New York: Museum of Modern Art, 1964), 49–60.

22. For discussions about the meaning of the prohibition to marry a deceased wife's sister, see Nancy Fix Anderson, "'The Marriage with a De-

ceased Wife's Sister Bill' Controversy: Incest Anxiety and the Defense of Family Purity in Victorian England," *Journal of British Studies* 21 (Spring 1982): 67–86; the section on Dinah Mulock Craik's novel *Hannah* in Sally Mitchell, *Dinah Mulock Craik* (Boston: Twayne, 1983); Margaret Morgan-roth Gullette, "The Puzzling Case of the Deceased Wife's Sister: Nineteenth-Century England Deals with a Second-Chance Plot," *Representations* 31 (Summer 1990): 142–66; and Helena Michie's *Sororophobia: Differences Among Women in Literature and Culture* (New York: Oxford University Press, 1992), 23–27. For general background to the issue of marriage restrictions see T. E. James, "The English Law of Marriage," in R. H. Graveson and F. R. Crane, eds., *A Century of Family Law: 1857–1957* (London: Sweet and Maxwell, 1957).

23. The explanation I offer here and in the next chapter concerning twinned women in Victorian paintings does not apply to the proliferation of identical women evident in classical-subject and related paintings. Behind Rossetti's *Astarte Syriaca* (1877—Manchester City Art Galleries) two women with identical faces and almost exactly symmetrical gestures look dreamily heavenward; two such women gaze outward from below the bar leaned on by *The Blessed Damozel* (1871–79—Lady Lever Art Gallery). Another pair play stringed instruments and sing to each other in the foreground of *The Bower Meadow* (1872—Manchester). In Edward Burne-Jones's work, the nearly identical women multiply until ten or twenty figures commune with their mirror images in conversation or in silence, staring into water or into space, in pictures such as *The Golden Stairs* (1880—Tate), *The Mirror of Venus* (1898—Gulbenkian Foundation, Lisbon), or *Laus Veneris* (1873–78—Laing Art Gallery). Albert Moore painted a trio or quartet of largely undistinguishable redheads, clothed in *Dreamers* (1882—Birmingham) and unclothed in *A Summer Night* (1890—Walker Art Gallery). Pairs and trios of nudes in classical settings but with the merest of narrative pretence were produced in quantity by Poynter, Alma-Tadema, and Waterhouse. In *Mythology and Misogyny: The Social Discourse of Nineteenth-Century British Classical-Subject Painting* (Madison: University of Wisconsin Press, 1989), Joseph A. Kestner reproduces more than two hundred paintings by Rossetti, Leighton, Poynter, Moore, Arthur Hacker, Burne-Jones, Alma-Tadema, Waterhouse, and others. About half of these paintings depict two or three or more women with little if any effort to differentiate among the faces. Kestner believes that these indolent women, as well as the vicious and dangerous women in many other classical-subject paintings, indicate misogyny in the painters and in the society that bought and admired such works.

Chapter 3. Painted Women and Unpainted Pictures

1. *The Art Bulletin* 58 (1978); reprinted in Norma Broude and Mary D. Garrard, eds., *Feminism and Art History: Questioning the Litany* (New York: Harper & Row, 1982), 222.

2. Nina Auerbach, *Woman and the Demon: The Life of a Victorian Myth* (Cambridge: Harvard University Press, 1978), 163; Helene E. Roberts, "Marriage, Redundancy, or Sin: The Painter's View of Women in the First Twenty-Five Years of Victoria's Reign," in Martha Vicinus, ed., *Suffer and Be Still: Women in the Victorian Age* (Bloomington: Indiana University Press, 1972), 75.

3. Roberts, "Marriage, Redundancy and Sin," 67; Nochlin, *"Lost and Found,"* 241; Auerbach, *Woman and the Demon,* 151.

4. Casteras, *Images of Victorian Womanhood,* 131.

5. Auerbach, *Woman and the Demon,* 159.

6. Paintings I have mentioned in the first two chapters show the Victorians' fondness for contrasting the material fortune of two women or their differences in temperament or coloring or vocation or morality. Abraham Solomon has a picture titled *A Contrast* (1855), of a working and robust family of fisherfolk on the seashore next to a middle-class, idle and sickly family group on holiday or in convalescence. A book of colored lithographs by C. Clarke published at midcentury is entirely devoted to such oppositions and is called simply *Contrasts.*

7. Lynda Nead describes the role of painting in the construction of social myth that helped Hood's poem become a "standard story;" she also talks about how the standard story was modified by other kinds of discourse—especially medical and sociological studies—in her book *Myths of*

Sexuality: Representations of Women in Victorian Britain (Oxford: Basil Blackwell, 1988).

8. Timothy Hilton, *The Pre-Raphaelites* (New York and Washington: Praeger, 1974), 140.

9. Anthony Blunt, *The Paintings of Nicolas Poussin: A Critical Catalogue* (London: Phaidon, 1966), 32.

10. Nochlin, "Lost and Found," 240.

11. *The Letters of Charles Dickens,* ed. Madeline House, Graham Storey, Kathleen Tillotson, and others (Oxford: Clarendon Press, 1965–1988), 5:698.

12. Elizabeth K. Helsinger, Robin Lauterbach Sheets, and William Veeder, *The Woman Question: Society and Literature in Britain and America, 1837–1883* (New York: Garland, 1983), 2.xi.

13. Nead, *Myths of Sexuality,* 6.

Chapter 4. Looking-Glass Arts

1. Olive Schreiner, *From Man to Man, or Perhaps Only,* with an introduction by S. C. Cronwright-Schreiner (New York: Grosset and Dunlap, 1927), 93. Subsequent page references in arabic and roman numerals are to this text.

2. Adrienne Auslander Munich, *Andromeda's Chains: Gender and Interpretation in Victorian Literature and Art* (New York: Columbia University Press, 1989), 33,35.

3. Munich, *Andromeda's Chains* 2,3.

4. Joseph Kestner, *Mythology and Misogyny: The Social Discourse of Nineteenth-Century British Classical-Subject Painting* (Madison: University of Wisconsin Press, 1989), 39–40.

5. The portrait of Effie Gray in *The Order of Release, 1746* brought to the mind of at least one critic the heroic sister-rescuer of *The Heart of Midlothian. The Order of Release, 1746* recalls Scott's novel doubly. The female rescuer was modeled by an Effie but reminds us of the other sister: Walter Armstrong says this figure is "a Jeanie Deans, in fact, with meekness ousted by a spice of pugnacity" (quoted in Millais, 1:183).

6. See Louis A. Montrose's fascinating discussion of the way Spenserian and Shakespearean reinscriptions of gender, in works where gender distinctions have seemingly been challenged, reflect an Elizabethan accommodation between the comfortable notions of male control and the fact of a woman monarch. "A Midsummer Night's Dream and the Shaping Fantasies of Elizabethan Culture: Gender, Power, Form," in Margaret W. Ferguson, Maureen Quilligan, and Nancy J. Vickers, eds., *Rewriting the Renaissance: The Discourse of Sexual Difference in Early Modern Europe* (Chicago: University of Chicago Press, 1986), 65–87.

7. Richard D. Altick, *Paintings from Books: Art and Literature in Britain, 1760–1900* (Columbus: Ohio State University Press, 1985), 425,464.

Chapter 5. First Sisters in Ferrier, Austen, and Scott

1. Patricia Meyer Spacks, "Sisters," in Mary Anne Schofield and Cecilia Machelski, eds., *Fetter'd or Free? British Women Novelists, 1670–1815* (Athens: Ohio University Press, 1986), 141.

2. Susan Morgan, *Sisters in Time: Imagining Gender in Nineteenth-Century British Fiction* (New York: Oxford University Press, 1989), 11–19,24.

3. Moira Ferguson, ed., *First Feminists: British Women Writers 1578–1799* (Bloomington: Indiana University Press, 1985), 27.

4. Morgan, *Sisters in Time,* 24.

5. *Letters for Literary Ladies* (London: J. Johnson, 1795), 3. Subsequent page references will be included in the text; note that each part of the *Letters* is paginated separately.

6. Margaret Kirkham, *Jane Austen, Feminism and Fiction* (Sussex: Harvester Press, 1983), xi–xiii.

7. Ferguson, *First Feminists,* 402.

8. Mary Wollstonecraft, *A Vindication of the Rights of Woman, with Strictures on Moral and Political Subjects* (1792; reprint ed. Charles W. Hagelman, Jr., New York: Norton, 1967), 214.

9. Fanny Burney, *Camilla, or A Picture of Youth,* ed. Edward A. and Lillian D. Bloom (London: Oxford University Press, 1972), 821. Subse-

quent page references will be included in the text.

10. Ferguson, *First Feminists*, 183.

11. Susan Ferrier, *Marriage*, ed. Herbert Foltinek (Oxford: Oxford University Press, 1986), 59–60. Subsequent page references will be included in the text.

12. Kirkham, *Jane Austen, Feminism and Fiction*, xi,48,43–44.

13. Kirkham, *Jane Austen, Feminism and Fiction*, 82.

14. In an essay called "*E Pluribus Unum:* Parts and Whole in *Pride and Prejudice*," in John Halperin, ed., *Jane Austen: Bicentenary Essays* (Cambridge: Cambridge University Press, 1975), Robert B. Heilman usefully applies Aristotle's tragic plot concepts of peripetia and anagnorisis to the comedy of *Pride and Prejudice*. These concepts of reversal and recognition can help describe a particular situation that recurs throughout the novels of the nineteenth century. The heroine does not realize that a man she does not love (Emma Woodhouse and Mr. Elton, Dorothea Brooke and Sir James Chettam) that a man she does love (Mary Douglas and Colonel Lennox in *Marriage*, Jane Eyre and Rochester) or that a man she does not *yet* love (Elizabeth Bennet and Darcy) is wooing *her* rather than a rival or a sister. The realization that *she* is the object is a reversal and frequently a means of self-recognition—sometimes the culmination and other times only the beginning of a long process of self-recognition. These situations always involve sisters or constructed sister and/or rival relationships such as those of Emma Woodhouse and Harriet Smith, Mary and Emily in *Marriage*, Jane Eyre and Miss Ingram, or Elizabeth Bennet and Miss Bingley. Heilman also discusses Austen's avoiding judgment without courting relativism in *Pride and Prejudice*, notes the way Lady Catherine and Mrs. Bennet are linked by the book's plot, and has new things to say about *Sense and Sensibility* as well.

15. *Pride and Prejudice* in *The Novels of Jane Austen*, ed. R. W. Chapman, 3rd edition with revisions (Oxford: Oxford University Press, 1965), 100. Subsequent page references in the text to this novel and to *Sense and Sensibility* refer to the Chapman edition.

16. Spacks, "Sisters," 146.

17. Sandra Gilbert and Susan Gubar's reading of Jane Austen seems to me to be very perceptive in many of its observations, such as its generalization that the Austen plot is "improving the father"—*The Madwoman in the Attic: The Woman Writer and the Nineteenth-Century Literary Imagination* (New Haven: Yale University Press, 1979), 154. That this plot is gratifying to male readers is certainly true, but it is also gratifying to female readers because it suggests a possibility for individual happiness short of social revolution. Gilbert and Gubar are also very good on the heroines' constructed sisters such as Mary Crawford for Fanny Price and Jane Fairfax for Emma Woodhouse, though very exclusionist judgments are made on the basis of these sisterings. That "each of the sisters seems incomplete because she lacks precisely the qualities so fully embodied by the other" (*Madwoman*, 165) seems to lead to the conclusion that both sisters are crippled by the lack. Finally this view is intolerant. Are none but strong and perfect sisters to enter the New Woman's New Jerusalem? Just as *Sense and Sensibility* demonstrates that opposing temperaments can go some way toward integration, the later novels insist that such integration cannot or should not always happen. The assertion of difference between sisters, without judgment, seems to me where the trope of sisterhood enables the most fundamental of feminist statements. That is precisely Austen's contribution to feminism.

18. Christine St. Peter describes, and I think correctly, the manner in which Austen heroines find or create for themselves confidantes for the period *after* their marriages. She calls the process "winning the sister," because in most of the books this woman is either a sister-in-law (Elizabeth Tilney in *Northanger Abbey*) or a blood sister (Marianne in *Sense and Sensibility*, Jane in *Pride and Prejudice*, and Susan, whom Fanny has rescued from the horrors of their Portsmouth house, in *Mansfield Park*):

This woman, whose virtues are complementary to the heroine's, bonds with the heroine, lives in close proximity to her in the heroine's married life, makes possible her removal into that other world to which her marriage destines her and, most important, provides a life-long source of emotional support without which the heroine's community would be considerably less stable and satisfying. In other words, I am talking about sisterhood as a socially authorized institution, parallel to and necessary for the institution of heterosexual marriage in Austen's novelistic world.

"Jane Austen's Creation of the Sister," *Philological Quarterly* 66 (1987):

475. St. Peter is arguing for a more conservative view of Austen than the Gilbert-Gubar reading that reveals "a proto-radical feminist consciousness" in the novels. Gilbert and Gubar describe the books as having a "cover story" in which Austen has to hide features of independent and strong women she finds admirable in characters who are condemned by the stories, women like Mary Crawford who are alter egos or shadow "sisters" of heroines like Fanny Price. St. Peter calls the Gilbert and Gubar reading "creative misprision of Austen's novels." At the same time, she is arguing for "a more diffused kind of emotional and sexual relationship than the marriage-as-climax school would generally allow": "To put it most simply: while an Austen heroine needs a husband, a man is not enough. She also needs a woman" ("Creation of the Sister," 473–75).

19. *The Heart of Midlothian* ties for second place (with *The Bride of Lammermoor*) in the contest for the Scott book providing subjects for the most paintings during the nineteenth century. Each book inspired eighty paintings, according to Richard Altick's research, while *Ivanhoe* inspired one hundred (Altick 433). Some pictures concentrate on one sister, such as Whistler's *Arrangement in Yellow and Gray: Effie Deans* (1876), or depict a scene not actually presented in the book, such as the meeting between George Staunton and Effie that Millais painted in 1879 (page 100). Most of the paintings, however, show one of the key scenes such as Jeanie and Effie with their father, Jeanie and Effie in prison, or, as in Charles Leslie's painting of 1859, *Jeanie Deans and Queen Caroline*.

20. Sir Walter Scott, *The Heart of Midlothian*, ed. Claire Lamont (New York: Oxford University Press, 1982), 98. Subsequent page references will be included in the text.

21. When Harry Shaw talks about Scott's ambiguous feelings about lynching and mob violence, he writes exclusively about the Porteous riot and seems to forget that there is more than one lynching in *The Heart of Midlothian*—*The Forms of Historical Fiction: Sir Walter Scott and His Successors* (Ithaca: Cornell University Press, 1983), 235–37.

22. Georg Lukács, *The Historical Novel*, trans. Hannah and Stanley Mitchell (London: Merlin Press, 1962), 52.

23. Michel Foucault, *Discipline and Punish: The Birth of the Prison*, trans. Alan Sheridan (New York: Pantheon, 1977), 59–60.

24. I see Jeanie's rescue as the beginning of a possibility where Susan Morgan describes it as a *fait accompli*:

[Jeanie] reminds the Queen of the Queen's own death, and that when that hour comes, the thoughts of what we have done for others can most sweeten our despair. That scene, a plea for a sister, pleads for a kind of sisterhood as well. It is one that can include queens as well as peasants, men as well as women, the good girls and the bad. Indeed, at the center of the plot is Jeanie's sense of her bond with, and her obligation to, her sister. And I point out the symbolic value of Scott's making Jeanie and Effie half sisters rather than full-blooded sisters. What unites them is the father, what they share is their lives under his dominance. And such dominance is felt even by a queen. The claims of sisterhood replace the masculine idea of brotherhood. As depicted in the novel, that is the vision that has posed so long as natural and universal, but which in historical practice has always been an artificial and exclusive principle, a matter of elitist codes and factions, of being the right sex and the right color and the right class.

Sisters in Time: Imagining Gender in Nineteenth-Century British Fiction (New York: Oxford University Press, 1989), 79.

25. In her eulogy for Catherine Macaulay in *A Vindication of the Rights of Woman*, Mary Wollstonecraft wants to praise her friend's strength of mind, but she also wants to avoid male-appropriated language: "I will not call hers a masculine understanding, because I admit not of such an arrogant assumption of reason" (Wollstonecraft, 164). The word shows up applied to female understanding in the male writers most tortuously contesting received ideas about gender. Dickens does not use it; he may be convinced there is nothing to recommend masculine understanding even if such a thing could be found. Scott uses it here, Meredith uses it to describe Rhoda Fleming standing up to Edward Blancove, and Collins uses it to describe his forceful and intelligent sisters Marian Halcombe and Magdalen Vanstone. Eliot puts it to rest as an adjective for describing minds, at least for any but the most obtuse novelist, when she says of Sir James Chettam, "A man's mind—what there is of it—has always the advantage of being masculine"—*Middlemarch*, ed. Bert G. Hornback (New York: W. W. Norton, 1977), 12.

26. Judith Wilt, *Secret Leaves: The Novels of Walter Scott* (Chicago and London: University of Chicago Press, 1985), 123.

27. Wilt, *Secret Leaves*, 220.
28. Morgan, *Sisters in Time*, 78–81.
29. Morgan, *Sisters in Time*, 82.

Chapter 6. Sisters in the Perturbed Families of Dickens

1. Although they do not treat sisters explicitly, such a view can be extrapolated from the discussion about Dickens's families in Richard Barickman, Susan MacDonald, and Myra Stark, *Corrupt Relations: Dickens, Thackeray, Trollope, Collins, and the Victorian Sexual System* (New York: Columbia University Press, 1982), 59–110.

2. *The Battle of Life* in *The Works of Charles Dickens*, The Gadshill Edition (London: Chapman and Hall, n.d.), 402. Subsequent page numbers in the text refer to this edition.

3. *Dombey and Son*, ed. Alan Horsman (Oxford: Clarendon Press, 1974), 550. Subsequent page numbers in the text refer to this edition.

4. *Little Dorrit*, ed. Harvey Peter Sucksmith (Oxford: Clarendon Press, 1979), 19. Subsequent page numbers in the text refer to this edition.

5. Avrom Fleishman argues that Amy Dorrit represents "a modern instance of the Christian ideal of humility. . . . Little Dorrit is the heroine of a novel of masters and servants because she reaches an absolute level of servitude itself: she is the perfect servant"—"Master and Servant in *Little Dorrit*," *Studies in English Literature* 14 (1974): 580–81. This is perhaps what Dickens would consciously argue, but the book seems to me to present a wholly darker view of servitude in the degradation or self-deception of Affery's situation or Mrs. Clennam's imagining herself the "servant and minister" of God as she persecutes Arthur, his father, and especially his birth-mother. Somehow Dickens can see the unhealthiness of Amy Dorrit's servant-status in relation to all the Dorrits, but that status suddenly becomes healthy at the end of the book when it is in relation to a husband.

6. William Myers writes, in "The Radicalism of *Little Dorrit*," that the Tattycoram "adoption" is the point where the novel is at its most radical: *because* Meagles is good and kind, "his failure with Tattycoram points to a complete breakdown, in terms of sympathy, understanding, and charity, between the classes. What the well-intentioned, warm-hearted Meagles family cannot admit to themselves is their inability to give Tattycoram equal human status with Pet"—*Literature and Politics in the Nineteenth Century*, ed. John Lucas (London: Methuen, 1971), 85.

7. Lionel Trilling may not be a typical reader, but he certainly speaks for many of us:

No reader of *Little Dorrit* can possibly conclude that the rage of envy which Tattycoram feels is not justified in some degree, or that Miss Wade is wholly wrong in pointing out to her the insupportable ambiguity of her position as the daughter-servant of Mr. and Mrs. Meagles and the sister-servant of Pet Meagles. Nor is it possible to read Miss Wade's account of her life . . . without an understanding that amounts to sympathy.

"*Little Dorrit*," in *The Opposing Self: Nine Essays in Criticism* (New York: The Viking Press, 1955); reprint in *Dickens: A Collection of Critical Essays*, ed. Martin Price (Englewood Cliffs, N.J.: Prentice-Hall, 1967), 153.

8. The Miss Wade/Harriet Beadle subplot may well have suggested to Wilkie Collins the only "sister" situation that occurs in *The Moonstone* (1868): Lucy Yolland, the crippled daughter of a fisherman from Cobb's Hole, loves Rosanna Spearman, the Verinder's second housemaid. Lucy imagines a cozy domestic arrangement with Rosanna in London, where they would live together "like sisters." But Rosanna has a futile obsession with Franklin Blake, one of her young mistress's suitors, and her love for him is complicated by the fact that she, a reformed thief, knows him for a thief, since she was watching him the night he stole the Moonstone. Rosanna kills herself. Collins's sensational elements, the diamond theft and the suicide, may perhaps obscure the elements of resemblance between the stories. In each case the women are represented as crippled in some physical or psychic way (Rosanna is hump-backed). The stronger woman imagines an idyllic life in which the two live together as sisters. But the other woman cannot escape an attachment that includes a dream of a place beyond her present, servile status.

Chapter 7. Looking-Glass Women

1. Barickman, MacDonald, and Stark, *Corrupt Relations*, 113.

2. *Corrupt Relations*, 114.

3. Knoepflmacher, U. C., "The Counterworld of Victorian Fiction and *The Woman in White*," in *The Worlds of Victorian Fiction*, ed. Jerome Buckley (Cambridge: Harvard University Press, 1975), 352.

4. Winifred Hughes, *The Maniac in the Cellar: Sensation Novels of the 1860s* (Princeton: Princeton University Press, 1980), 148.

5. *Myths of Sexuality: Representations of Women in Victorian Britain* (Oxford: Basil Blackwell, 1988), 9.

6. Nead, *Myths of Sexuality*, 80.

7. Charles Bernheimer describes similar public consternation about prostitution in France and the literary hay made of it by mid-century authors. In *Figures of Ill Repute: Representing Prostitution in Nineteenth-Century France*, he discusses "the police registration and carding of prostitutes" that corresponded to English enforcement of the Contagious Diseases Acts. "The prostitute is ubiquitous in the novels and the paintings of this period," Bernheimer writes, "not only because of her prominence as a social phenomenon but, more important, because of her function in stimulating artistic strategies to control and dispel her fantasmatic [sic] threat to male mastery"—*Figures of Ill Repute* (Cambridge, Mass.: Harvard University Press, 1989), 2.

8. William Acton, *Prostitution Considered in Its Moral, Social, and Sanitary Aspects in London and Other Large Cities; with Proposals for the Mitigation and Prevention of Its Attendant Evils* (London, 1857), 72.

9. Henry Mayhew, *London Labour and the London Poor*, 4 vols. (London, 1861–63), 4:219.

10. *Harriet Martineau on Women*, ed. Gayle Graham Yates (New Brunswick, N.J.: Rutgers University Press, 1985), 265.

11. Martineau, 266.

12. Ibid.

13. "How I Write My Books," *The Globe* (26 November 1887), reprint, *The Woman in White*, ed. Kathleen Tillotson and Anthea Todd (Boston: Houghton Mifflin, 1969), 511.

14. *The Woman in White* in *The Works of Wilkie Collins*, 30 vols. (New York: Peter Fenelon Collier, 1895; reprint, New York: AMS Press, 1970), 1:89. Subsequent page numbers in the text for this novel, *No Name*, and *The New Magdalen* all refer to this edition.

15. See Nead, *Myths of Sexuality*, 118–22.

16. Mrs. Oliphant combines praise of *The Woman in White* with moral condemnation of *No Name* in her unsigned *Blackwood's Magazine* review of the latter book in August, 1863; reprint, Norman Page, ed., *Wilkie Collins: The Critical Heritage* (London: Routledge and Kegan Paul, 1974), 143. The limited success of *No Name* is described by Virginia Blain in her introduction to the Oxford World's Classics edition (1986).

17. Jenny Bourne Taylor in her book on Collins and nineteenth-century psychology says "with Mercy [Merrick, in *The New Magdalen*], as with Magdalen Vanstone . . . the greatest form of imposture is duping respectability"—*In the Secret Theatre of Home: Wilkie Collins, Sensation Narrative, and Nineteenth-Century Psychology* (London: Routledge, 1988), 218.

18. Page, *Critical Heritage*, 143.

Chapter 8. Sisters, Sexual Difference, and the Underclass in Meredith's *Rhoda Fleming* (1865)

1. Helena Michie, "'There is No Friend Like a Sister': Sisterhood as Sexual Difference," *ELH* 56 (1989): 404.

2. Dorothy Mermin, "Heroic Sisterhood in *Goblin Market*," *Victorian Poetry* 21 (1983): 112.

3. Michie, "There is No Friend Like a Sister," 407.

4. *Rhoda Fleming* is volume 5 of *The Works of George Meredith*, Memorial Edition (New York: Charles Scribner's Sons, 1909–11), 4. Subsequent page numbers within the text refer to this edition.

5. When Benedick makes a similar declaration of love to Hero's

cousin/sister Beatrice in *Much Ado About Nothing*, she demands that he defend Hero's innocence by challenging Claudio (her command, more precisely, is "Kill Claudio"). The end of this scene in Farmer Fleming's cottage, with Robert pledged to do what he can to find and save Dahlia, also resembles a scene at Pemberley in *Pride and Prejudice*, when Elizabeth goes looking for her uncle after she has just heard of Lydia's flight with Wickham. Elizabeth encounters Darcy, confesses her sister's shame, but does *not* hear his pledge to find her sister and do what he can, since he leaves the pledge unspoken.

6. Cyril Pearl discusses Catherine Walters in *The Girl with the Swansdown Seat* (London: Frederick Muller, 1955), 92–105. Lynda Nead talks about the furor over the horsebreaker as classbreaker in *Myths of Sexuality*, 59–62.

7. Nead, *Myths of Sexuality*, 61–62.

8. *The Letters of George Meredith*, 3 vols., ed. C. L. Cline (Oxford: Clarendon Press, 1970), 1:79.

Chapter 9. Healthy Relations

1. *Ruth* in *The Works of Mrs. Gaskell*, The Knutsford Edition, 8 vols. (1906; reprint, New York: AMS Press, 1972), 421. Subsequent page numbers in the text refer to this edition of *Ruth*.

2. Cecil Woodham-Smith, *Florence Nightingale: 1820–1910* (New York: McGraw-Hill, 1951), 79; Winifred Gérin mistakenly says the two women met *before* the cholera epidemic, *Elizabeth Gaskell: A Biography* (Oxford: Clarendon Press, 1976), 242.

3. *The Letters of Mrs Gaskell*, ed. J. A. V. Chapple and Arthur Pollard (Cambridge: Harvard University Press, 1967), 305.

4. *Letters*, ed. Chapple and Pollard, 318.

5. Gérin, *Elizabeth Gaskell, A Biography*, 242.

6. Laurence Lerner, in an otherwise perceptive introduction to the Penguin *Wives and Daughters*, talks about Molly Gibson's illness, caught while nursing Aimée Hamley through *her* illness, as "one of those low-spirited declines into which Victorian heroines drop at low moments of the plot" (8). In fact, sicknesses tend to be plot-*movers* in Victorian novels, and nowhere are they more important than in Gaskell.

7. Françoise Basch, *Relative Creatures: Victorian Women in Society and the Novel* (New York: Schocken Books, 1974). Basch's book discusses, among many other novels, *Cranford, Ruth*, and *Wives and Daughters*; Barickman, MacDonald, and Stark deal only with Dickens, Thackeray, Trollope, and Collins in *Corrupt Relations: Dickens, Thackeray, Trollope, Collins, and the Victorian Sexual System* (New York: Columbia University Press, 1982).

8. *Cranford* in *The Works of Mrs. Gaskell*, 1. Subsequent page numbers in the text refer to this edition.

9. *Communities of Women: An Idea in Fiction* (Cambridge: Harvard University Press, 1978), 81. Is Cranford self-sufficient? All of Auerbach's communities of women are "simultaneously defective and transcendent" (5), although Cranford seems to be the one most nearly self-sufficient in her view. Coral Lansbury qualifies her positive answer to the question in only one respect: "Elizabeth Gaskell was always convinced that single women could lead lives that were as satisfying as those of married women, with one stipulation—those lives had to be led apart from their families"—*Elizabeth Gaskell: The Novel of Social Crisis* (New York: Harper & Row, 1975), 87.

10. *Wives and Daughters* in *The Works of Mrs. Gaskell*, 28. Subsequent page numbers in the text refer to this edition.

11. Lansbury, *Elizabeth Gaskell: The Novel of Social Crisis*, 200.

Chapter 10. Reform and Rescue in *Middlemarch* (1872)

1. *Middlemarch*, ed. Bert G. Hornback (New York: W.W. Norton, 1977), 3. Subsequent page numbers in the text refer to this edition.

2. We know of George Eliot's early interest in the cause of the Married Women's Property Act: she writes Sophia Hennell in January of 1856 that proposed changes to the laws concerning married women's property "would help to raise the position and character of women. It is one round

of a long ladder stretching far beyond our lives." *The George Eliot Letters*, ed. Gordon S. Haight, 7 vols. (New Haven: Yale University Press, 1954–55), 2:227.

3. My reading of *Middlemarch* is indebted to the work of many critics, especially those writing on political reform, on the idea of novels being in conversation with each other, on female heroism, rescue, and sisterhood, on the "feminization" of male characters, and on the complicated question of Eliot's feminism. Jerome Beaty sketched the political events of the years 1829–32 referred to by Eliot in "History by Indirection: The Era of Reform in *Middlemarch*," *Victorian Studies* 1 (1957–58); Patrick Brantlinger related the disillusionment at failed reforms in *Middlemarch* to a widespread rejection of reform idealism in the decades after the middle of the century, evident in other novels such as *The Warden* and *Pendennis—The Spirit of Reform: British Literature and Politics, 1832–1867* (Cambridge: Harvard University Press, 1977). Bert G. Hornback argued that the political is always turned back toward the personal in the book in *Middlemarch: A Novel of Reform* (Boston: Twayne, 1988). That novels might be in conversation with each other is a premise of Jerome Meckier's *Hidden Rivalries in Victorian Fiction: Dickens, Realism, and Revaluation* (Lexington: University Press of Kentucky, 1987) and is implicit in Susan Morgan's *Sisters in Time: Imagining Gender in Nineteenth-Century British Fiction* (New York: Oxford University Press, 1989). Morgan also writes about a nineteenth-century transformation of a masculine heroic tradition into a feminine one in the novel. I have been much influenced in my thinking about Will Ladislaw by U. C. Knoepflmacher's discussion of Eliot's androgynous narrators and the resolution of her own "internal gender divisions" through "a transference to the male of the deprivations and suffering she finds in the lot of women"—"Unveiling Men: Power and Masculinity in George Eliot's Fiction," *Men by Women*, ed. Janet Todd (New York: Holmes and Meier, 1982), 134, 139. Also relevant to what I call the "sistering" of Will Ladislaw is Carolyn Heilbrun's important book *Toward a Recognition of Androgyny: Aspects of Male and Female in Literature* (London: Gollancz, 1973) and Susan Morgan's discussion (in *Sisters in Time*) of the "feminization" of Chad and Strether in James's *The Ambassadors*.

Those who write about *Middlemarch* and its author disagree about Eliot's "feminist credentials," to use Jeanie Thomas's words in "An Inconvenient Indefiniteness: George Eliot, *Middlemarch*, and Feminism," *University of Toronto Quarterly* 56 (1987): 392. Feminists who restate the question Virginia Woolf asked (Why is Dorothea Brooke not allowed the fulfillment of accomplishment that Eliot herself achieved?) include Lee Edwards, "Women, Energy, and *Middlemarch*," *Woman: An Issue*, ed. Lee R. Edwards, Mary Heath, and Lisa Baskin (Boston: Little, Brown, 1972); Patricia Beer, *Reader, I Married Him: A Study of the Women Characters of Jane Austen, Charlotte Brontë, Elizabeth Gaskell, and George Eliot* (New York: Barnes and Noble, 1974); Marlene Springer, "Angels and Other Women in Victorian Literature," *What Manner of Woman: Essays on English and American Life and Literature*, ed. Marlene Springer (New York: New York University Press, 1977); and Ellen Moers, *Literary Women* (Garden City, N.Y.: Doubleday, 1976). Feminist critics also attack Eliot's wariness of female suffrage and her conviction that men and women have innate differences not culturally caused. But Eliot has strong feminist defenders, who argue that Dorothea shows women's social trammels in 1872 more realistically than Eliot's experience would indicate, and that the novel as a whole, as well as Dorothea's own life, shows that amelioration of social conditions is possible but gradual; see especially Kathleen Blake, *Love and the Woman Question in Victorian Literature: The Art of Self-Postponement* (Sussex: Harvester Press; Totowa, N.J.: Barnes and Noble, 1983); Patricia Meyer Spacks, *The Female Imagination* (New York: Knopf, 1972); Zelda Austen, "Why Feminist Critics Are Angry with George Eliot," *College English* 37 (1976): 549–61; Jeanie Thomas in the work cited above; and Dorothea Barrett, *Vocation and Desire: George Eliot's Heroines* (London and New York: Routledge, 1989). Two excellent reviews of feminist criticism of *Middlemarch* are Ellin Ringler, "*Middlemarch*: A Feminist Perspective," *Studies in the Novel* 15 (1983): 55–61 and Jeanie Thomas's article already cited. Anne E. Patrick (1987) also reviews the criticism while arguing that the book "contains a systematic critique of gender stereotyping, one that is integral to the action of the novel and central to its chief thematic concern"—"Rosamond Rescued: George Eliot's Critique of Sexism in *Middlemarch*," *The Journal of Religion* 67 (1987): 220–38. Patrick's title, "Rosamond Rescued," points to her own rescue of Rosamond from full

blame for the Lydgates' marriage problems, rather than to *Dorothea's* rescue of Rosamond. Finally, Barbara Hardy sees the book in a way that is almost a reversal of my own view—for her it is a psychologically flawed version of the male sexual rescue, rather than a psychologically astute depiction of Dorothea's rescue of Will (and others). Hardy argues that Ladislaw delivers Dorothea from the impotent Casaubon, even though Will himself self-disparagingly denies he is a rescuer at all (145, 153), Casaubon is dead before the rescue takes place, and Ladislaw seems intent on going away until Dorothea closes with him. *Particularities: Readings in George Eliot* (Athens: Ohio University Press, 1982).

4. George Eliot's opinions about reform are complex, but they tend to be simplified into a uniform conservatism by scholars such as Gordon Haight, in *George Eliot: A Biography* (New York: Oxford University Press, 1968). This comes about partly because of Eliot's reservations about extending the franchise—evident in *Felix Holt*, in her "Address to Working Men" in the January, 1868 *Blackwood's*, and in her letters, for example 4:403 and 4:496 in *The George Eliot Letters*. But she also believed Mill's argument for extending the franchise to women a good one (*Letters* 4:366), even though she saw clearly that working for women's suffrage was likely to be futile for a long time to come, and discouraged her friend Sara Sophia Hennell from doing so (4:390).

Another ground of her conservatism, more troubling to feminists, is her belief in a "difference of function" between the sexes, a difference clearly going beyond the biological to what she sees as a difference of moral influence. Writing to John Morley in May, 1867 about women's suffrage, for example, she says (in involuted diction and overqualified language such as she put into the mouth of Casaubon):

I would certainly not oppose any plan which held out any reasonable promise of tending to establish as far as possible an equivalence of advantage for two sexes, as to education and the possibilities of free development. . . . The one conviction on the matter which I hold with some tenacity is, that through all transitions the goal towards which we are proceeding is a more clearly discerned distinction of function (allowing always for exceptional cases of individual organization) with as near an approach to equivalence of good for woman and for man as can be secured by the effort of growing moral force to lighten the pressure of hard non-moral outward conditions. (4:364–65)

The "distinction" is called a "difference of function" between men and women in a letter to Emily Davies (8 August 1868) where she talks about "woman's peculiar constitution for a special moral influence," "that exquisite type of gentleness, tenderness, possible maternity suffusing a woman's being with affectionateness, which makes what we mean by the feminine character" (4:468).

But she is adamant on the necessity for giving men and women absolutely equal intellectual opportunities. In 1869 she writes to Mrs. Nassau John Senior:

There is no subject on which I am more inclined to hold my peace and learn, than on the "Women Question." Its seems to me to overhang abysses, of which even prostitution is not the worst. Conclusions seem easy so long as we keep large blinkers on and look in the direction of our own private path.

But on one point I have a strong conviction, and I feel bound to act on it, so far as my retired way of life allows of some public action. And that is, that women ought to have the same fund of truth placed within their reach as men have; that their lives (i.e. the lives of men and women) ought to be passed together under the hallowing influence of a common faith as to their duty and its basis. And this unity in their faith can only be produced by their having each the same store of fundamental knowledge. It is not likely that any perfect plan for educating women can soon be found, for we are very far from having found a perfect plan for educating men. But it will not do to wait for perfection. (5:58)

The letter which seems to me to bear most closely on the questions of reform in *Middlemarch* is an early one, written at the time of the revolutions of 1848. Eliot writes to John Sibree, Jr., to tell him she joins him in his happiness about the events in France. She makes clear that what she would like to see happen in her own country is not *political* reform, but a more profound *social* reform:

I should have no hope of good from any imitative movement at home. Our working classes are eminently inferior to the mass of the French people. In France, the *mind* of the people is highly electrified—they are full of ideas on social subjects—they really desire social *reform*. . . . Here there is so much larger a proportion of selfish radicalism and unsatisfied, brute sensuality (in the agricultural and mining districts especially) than of perception or desire of justice, that a revolutionary movement would be simply destructive—not constructive. Besides, it would be put down. Our military have no notion of "fraternizing." . . . Our little humbug of a queen is more endurable than the rest of her race because she calls forth a chivalrous feeling, and there is nothing in our constitution to obstruct the slow progress of *political* reform. This is all we are fit for at present. The social reform which may prepare us for great changes is more and more the object of effort both in Parliament and out of it. But we English are slow crawlers. (1:254)

Eliot's conviction that revolution would be put down probably comes from hearing accounts of the Peterloo massacre, which occurred three months before she was born. But the important distinction between social and political reform illuminates her later jaded attitudes about what can be accomplished through legislative processes, the limited value and the danger of the extended franchise, and the difference between Reform Bills and real reform.

5. Mary Garth, Rosamond Vincy, and Dorothea have other three-way sisterly links, though Mary is somewhat apart from the main actions in which Rosamond and Dorothea participate. The group of the Garths and Fred Vincy is in a kind of idyllic place off to the side of Middlemarch where reform actually *succeeds*. Caleb Garth is a practical reformer who does his bit to make things better for the people on the farms he tends. Fred is genuinely reformed by the efforts of Mary, who is a spiritual sister of Dorothea's and Rosamond's—she went to school with Rosamond—but differentiated from Rosamond in her contentment with her place and from Dorothea in her satisfaction with the way she can serve. The narrator identifies Dorothea with St. Theresa while observing of Mary that in relation to "the saints of the earth . . . Mary was not one of them" (218), linking the two women with the image of sainthood while asserting their difference.

6. "Unveiling Men: Power and Masculinity in George Eliot's Fiction," *Men by Women*, ed. Janet Todd (New York: Holmes and Meier, 1982), 139.

7. In 1883 Olive Schreiner puts together Gaskell's insights about healing sisterhood and Eliot's about removing gender differentiation by a man's having what is conventionally considered female gender-specific experiences. In *The Story of an African Farm* (1883; reprint, Boston: Little, Brown, 1927), Gregory Rose has a spiritual transformation when he assumes female disguise for weeks while nursing the dying Lyndall.

8. Lee Holcombe, *Wives and Property: Reform of the Married Women's Property Law in Nineteenth-Century England* (Toronto: University of Toronto Press, 1983), 22.

9. It could be argued that dower protection under the old common law system of marriage provision gave way to a *better* system of clearly defined settlements. But as Susan Staves points out, the loss of the dower right had "considerable ideological significance" (5). Staves presents the complexities of the issue in the second chapter of *Married Women's Separate Property in England, 1660–1833* (Cambridge, Mass.: Harvard University Press, 1990). Her discussion makes clear that although by technical rule of law a man in 1831 could not have prevented a wife's dower right by will, yet the Dower Act of 1833 only made explicit what had already been taking place for many years: the replacement of dower rights by contractual settlements.

10. Holcombe, *Wives and Property*, 177.

11. Holcombe, 164.

12. "George Eliot's *Middlemarch*," *Galaxy* (March 1873): 424–28; reprint, *Middlemarch*, ed. Hornback, 654–55.

13. During Dorothea's period of jealousy, which is a kind of sexual dark night of the soul, the narrator uses the most bizarre image of the book, putting Dorothea and Rosamond together as true and false mothers, and thus "sistering" them in a fashion:

There were two images—two living forms that tore her heart in two, as if it had been the heart of a mother who seems to see her child divided by the sword, and presses one bleeding half to her breast while her gaze goes forth in agony towards the half which is carried away by the lying woman that has never known the mother's pang.

Here, with the nearness of an answering smile, here within the vibrating bond of mutual speech, was the bright creature whom she had trusted—who had come to her like the spirit of morning visiting the dim vault where she sat as the bride of a worn-out life; and now, with a full consciousness that has

never awakened before, she stretched out her arms towards him and cried with bitter cries that their nearness was a parting vision: she discovered her passion to herself in the unshrinking utterance of despair.

And there, aloof, yet persistently with her, moving wherever she moved, was the Will Ladislaw who was a changed belief exhausted of hope, a detected illusion—no, a living man towards whom there could not yet struggle any wail of regretful pity, from the midst of scorn and indignation and jealous offended pride. (543)

Dorothea imagines Solomon's judgment carried through to its literal, bloody conclusion, with the divided child as her own heart and Ladislaw her true child/lover, and Ladislaw also divided into the true and false lover. Rosamond in this vision becomes false claimant to the child, "the lying woman who had never known the mother's pang." But she is also Dorothea's sister because Solomon's two suppliant women are sistered by their love of the child, as two women are made sisters by their rivalry for a child/man—and Ladislaw is described as being such a child/man, like Shelley and like Daphnis. *Wives and Daughters* also uses the image of Solomon and the two claimants, when Molly thinks about Roger and Cynthia. Paintings similarly assert the sisterhood of women who are rivals, from the Old Testament subject of *Moses Brought before Pharaoh's Daughter* by Hogarth, 1746, or Francis Hayman's version, *The Finding of the Infant Moses*, 1746 (both painted for the London Foundling Hospital); or "modern life" variations such as Frederick Barwell's, *Adopting a Child*, 1857, which also includes, as do the Moses pictures, both adoptive and birth mother. The sisterhood and near identity of *sexual* rivals is asserted comically by such pictures as James Tissot's *In the Conservatory* (page 49) and seriously by others such as Millais' *Retribution* (page 52). Many of these pictures assert with a startling likeness of the faces the figurative truth of sisterhood through mutual love and pain: the adoptive mother and the blood mother, the true and false claimant to the child, the rivals for the adult male—all are sisters under the skin, and the pictures sometimes make them skin-deep twins as well.

Bibliography

Acton, William. *Prostitution Considered in Its Moral, Social, and Sanitary Aspects in London and Other Large Cities; with Proposals for the Mitigation and Prevention of Its Attendant Evils.* London, 1857.

Altick, Richard D. *Paintings from Books: Art and Literature in Britain, 1760–1900.* Columbus: Ohio State University Press, 1985.

Anderson, Nancy Fix. "'The Marriage with a Deceased Wife's Sister Bill' Controversy: Incest Anxiety and the Defense of Family Purity in Victorian England." *Journal of British Studies* 21 (Spring 1982): 67–86.

Auerbach, Nina. *Communities of Women; An Idea in Fiction.* Cambridge: Harvard University Press, 1978.

———. *Woman and the Demon: The Life of a Victorian Myth.* Cambridge: Harvard University Press, 1982.

Austen, Jane. *Jane Austen's Letters to Her Sister Cassandra and Others.* Edited by R. W. Chapman. 2nd ed. London: Oxford University Press, 1952.

———. *The Novels of Jane Austen.* Edited by R. W. Chapman. 3rd ed. Oxford: Oxford University Press, 1965.

Austen, Zelda. "Why Feminist Critics Are Angry with George Eliot." *College English* 37 (1976): 549–61.

Barickman, Richard, Susan MacDonald, and Myra Stark. *Corrupt Relations: Dickens, Thackeray, Trollope, Collins, and the Victorian Sexual System.* New York: Columbia University Press, 1982.

Barrett, Dorothea. *Vocation and Desire: George Eliot's Heroines.* London and New York: Routledge, 1989.

Basch, Françoise. *Relative Creatures: Victorian Women in Society and the Novel.* New York: Schocken Books, 1974.

Beaty, Jerome. "History by Indirection: The Era of Reform in *Middlemarch.*" *Victorian Studies* 1 (1957–58): 173–79.

Beer, Patricia. *Reader, I Married Him: A Study of the Women Characters of Jane Austen, Charlotte Brontë, Elizabeth Gaskell, and George Eliot.* New York: Barnes and Noble, 1974.

Bendiner, Kenneth. *An Introduction to Victorian Painting.* New Haven: Yale University Press, 1985.

Bernheimer, Charles. *Figures of Ill Repute: Representing Prostitution in Nineteenth-Century France.* Cambridge: Harvard University Press, 1989.

Blake, Kathleen. *Love and the Woman Question in Victorian Literature: The Art of Self-Postponement.* Sussex: Harvester Press; Totowa, N.J.: Barnes and Noble, 1983.

Blunt, Anthony. *The Paintings of Nicolas Poussin: A Critical Catalogue.* London: Phaidon, 1966.

Brantlinger, Patrick. *The Spirit of Reform: British Literature and Politics, 1832–1867.* Cambridge: Harvard University Press, 1977.

Buck, Anne. *Victorian Costume and Costume Accessories.* 2nd ed. Carlton, Bedford: Ruth Bean, 1984.

Burney, Fanny. *Camilla, or A Picture of Youth.* Edited by Edward A. and Lillian D. Bloom. London: Oxford University Press, 1972.

Butler, Marilyn. *Jane Austen and the War of Ideas.* 1975. Reissue with a new Introduction. Oxford: Clarendon Press, 1987.

Casteras, Susan P. *Images of Victorian Womanhood in English Art.* Rutherford, N.J.: Fairleigh Dickinson University Press, 1987.

Collins, Wilkie. "How I Write My Books." *The Globe.* 26 November, 1887. Rpt. *The Woman in White.* Edited by Kathleen Tillotson and Anthea Todd. Boston: Houghton Mifflin, 1969. 511–14.

———. *The Works of Wilkie Collins.* 30 vols. New York: Peter Fenelon Collier, 1895. Rpt. New York: AMS Press, 1970.

Dickens, Charles. *David Copperfield*. Edited by Nina Burgis. Oxford: Clarendon Press, 1981.

———. *Dombey and Son*. Edited by Alan Horsman. Oxford: Clarendon Press, 1974.

———. *The Letters of Charles Dickens*. Edited by Madeline House, Graham Storey, Kathleen Tillotson, and others. 6 vols. Oxford: Clarendon Press, 1965–1988.

———. *Little Dorrit*. Edited by Harvey Peter Sucksmith. Oxford: Clarendon Press, 1979.

———. *The Works of Charles Dickens*. The Gadshill Edition. 34 vols. London: Chapman and Hall, n.d.

Dorment, Richard. *British Painting in the Philadelphia Museum of Art: From the Seventeenth through the Nineteenth Century*. Philadelphia: Philadelphia Museum of Art, 1986.

Eagleton, Terry. *The Rape of Clarissa: Writing, Sexuality and Class Struggle in Samuel Richardson*. Minneapolis: University of Minnesota Press, 1982.

Edelstein, T. J. "Augustus Egg's Triptych: A Narrative of Victorian Adultery." *The Burlington Magazine* 125 (1983): 202–10.

[Edgeworth, Maria.] *Letters for Literary Ladies. Includes Letter from a Gentleman to his Friend upon the Birth of a Daughter, with the Answer and Letters of Julia and Caroline*. London: J. Johnson, 1795.

Edwards, Lee R. "Women, Energy, and *Middlemarch*." *Woman: An Issue*. Edited by Lee R. Edwards, Mary Heath, and Lisa Baskin. Boston: Little, Brown, 1972. 223–38.

Eliot, George. *The George Eliot Letters*. Edited by Gordon S. Haight. 7 vols. New Haven: Yale University Press, 1954–55.

———. *Middlemarch*. Edited by Bert G. Hornback. A Norton Critical Edition. New York: W. W. Norton, 1977.

Faberman, Hilarie. *Augustus Leopold Egg, R.A. (1816–1863)*. Ph.D. Dissertation. Yale University, 1983.

Ferguson, Moira, ed. *First Feminists: British Women Writers 1578–1799*. Bloomington: Indiana University Press, 1985.

Ferrier, Susan. *Marriage*. Edited by Herbert Foltinek. Oxford: Oxford University Press, 1986.

Fleishman, Avrom. "Master and Servant in *Little Dorrit*." *Studies in English Literature* 14 (1974): 575–86.

Foucault, Michel. *Discipline and Punish: The Birth of the Prison*. Translated by Alan Sheridan. New York: Pantheon, 1977.

Fuseli, Henry. *Henry Fuseli; 1741–1825*. London: Tate Gallery, 1975.

Ganz, Margaret. *Elizabeth Gaskell: The Artist in Conflict*. New York: Twayne, 1969.

Gaskell, Elizabeth Cleghorn. *The Letters of Mrs Gaskell*. Edited by J. A. V. Chapple and Arthur Pollard. Cambridge: Harvard University Press, 1967.

———. *Wives and Daughters*. Edited by Frank Glover Smith. Introduction by Laurence Lerner. Harmondsworth: Penguin, 1969.

———. *The Works of Mrs. Gaskell*. The Knutsford Edition. 8 vols. 1906. Rpt. New York: AMS Press, 1972.

Gérin, Winifred. *Elizabeth Gaskell: A Biography*. Oxford: Clarendon Press, 1976.

Gilbert, Sandra M., and Susan Gubar. *The Madwoman in the Attic: The Woman Writer and the Nineteenth-Century Literary Imagination*. New Haven: Yale University Press, 1979.

Goldsmith, Oliver. *The Vicar of Wakefield*. London, 1766.

Gombrich, E. H. "Reynolds's Theory and Practice of Imitation." *Norm and Form: Studies in the Art of the Renaissance*. London: Phaidon, 1966.

Graves, Algernon. *Dictionary of Artists Who Have Exhibited Works in the Principal London Exhibitions. . . .* 1901. New York: Lenox Hill, 1970.

———. *The Royal Academy of Arts: A Complete Dictionary of Contributors.* 4 vols. 1905–6. New York: Lenox Hill, 1972.

Gullette, Margaret Morganroth. "The Puzzling Case of the Deceased Wife's Sister: Nineteenth-Century England Deals with a Second-Chance Plot," *Representations* 31 (Summer 1990): 142–66.

Hagstrum, Jean H. *Sex and Sensibility: Ideal and Erotic Love from Milton to Mozart*. Chicago: University of Chicago Press, 1980.

Haight, Gordon S. *George Eliot: A Biography*. New York: Oxford University Press, 1968.

Hall, James. *Dictionary of Subjects and Symbols in Art*. Revised Edition. New York: Harper & Row, 1979.

Hardy, Barbara. *Particularities: Readings in George Eliot*. Athens: Ohio University Press, 1982.

Heilbrun, Carolyn. *Toward a Recognition of Androgyny: Aspects of Male and Female in Literature*. London: Gollancz, 1973.

Heilman, Robert B. "E Pluribus Unum: Parts and Whole in *Pride and Prejudice*." *Jane Austen: Bicentenary Essays*. Edited

by John Halperin. Cambridge: Cambridge University Press, 1975.

Helsinger, Elizabeth K., Robin Lauterbach Sheets, and William Veeder. *The Woman Question: Society and Literature in Britain and America, 1837–1883.* Vol. 2: Literary Issues, 1837–1883. New York: Garland, 1983.

Hilton, Timothy. *The Pre-Raphaelites.* New York and Washington: Praeger, 1974.

Himmelfarb, Gertrude. *Marriage and Morals among the Victorians and Other Essays.* New York: Vintage, 1987.

Holcombe, Lee. *Wives and Property: Reform of the Married Women's Property Law in Nineteenth-Century England.* Toronto: University of Toronto Press, 1983.

Hornback, Bert G. *Middlemarch: A Novel of Reform.* Boston: Twayne, 1988.

Hughes, Winifred. *The Maniac in the Cellar: Sensation Novels of the 1860s.* Princeton: Princeton University Press, 1980.

James, Henry. "George Eliot's *Middlemarch.*" *Galaxy* (March 1873): 424–28. Rpt. in *Middlemarch,* ed. Hornback. 652–55.

James, T. E. "The English Law of Marriage." *A Century of Family Law: 1857–1957.* Edited by R. H. Graveson and F. R. Crane. London: Sweet and Maxwell, 1957.

Johnson, Claudia L. *Jane Austen: Women, Politics, and the Novel.* Chicago: University of Chicago Press, 1988.

Kestner, Joseph A. "The Force of the Past: The Perseus Legend and the Mythology of 'Rescue' in Nineteenth-Century British Art." *Victorians Institute Journal* 15 (1987): 55–70.

———. *Mythology and Misogyny: The Social Discourse of Nineteenth-Century British Classical-Subject Painting.* Madison: University of Wisconsin Press, 1989.

Kirkham, Margaret. *Jane Austen, Feminism and Fiction.* Sussex: Harvester Press, 1983.

Knoepflmacher, U. C. "The Counterworld of Victorian Fiction and *The Woman in White.*" *The Worlds of Victorian Fiction.* Edited by Jerome Buckley. Cambridge: Harvard University Press, 1975.

———. "Unveiling Men: Power and Masculinity in George Eliot's Fiction." *Men by Women.* Edited by Janet Todd. New York: Holmes and Meier, 1982. *Women & Literature* 2 (1982): 130–46.

Lansbury, Coral. *Elizabeth Gaskell: The Novel of Social Crisis.* New York: Harper & Row, 1975.

Lanser, Susan Sniader. "'No Connections Subsequent': Jane Austen's World of Sisterhood." In *The Sister Bond: a Feminist View of a Timeless Connection.* Edited by Toni A. H. McNaron. New York: Pergamon Press, 1985.

Lennox, Charlotte. *Sophia.* London, 1762.

Lister, Raymond. *Victorian Narrative Paintings.* New York: Clarkson Potter, 1966.

Lukács, Georg. *The Historical Novel* (1937). Translated by Hannah and Stanley Mitchell. London: Merlin Press, 1962.

Maas, Jeremy. *Victorian Painters.* New York: G. P. Putnam's Sons, 1969.

Margetson, Stella. "When Rail Travel Was an Adventure." *Country Life* 166 (July, 1979): 170–72.

Marshall, William H. *Wilkie Collins.* New York: Twayne, 1970.

Martineau, Harriet. *Harriet Martineau on Women.* Edited by Gayle Graham Yates. New Brunswick, N.J.: Rutgers University Press, 1985.

Matyjaskiewicz, Krystyna, ed. *James Tissot.* London: Phaidon Press and Barbican Art Gallery, 1984.

Mayhew, Henry. *London Labour and the London Poor.* 4 vols. London, 1861–63.

Meckier, Jerome. *Hidden Rivalries in Victorian Fiction: Dickens, Realism, and Revaluation.* Lexington: The University Press of Kentucky, 1987.

Meredith, George. *The Letters of George Meredith.* Edited by C. L. Cline. 3 vols. Oxford: Clarendon Press, 1970.

———. *The Works of George Meredith.* Memorial Edition. 27 vols. New York: Charles Scribner's Sons, 1909–11.

Mermin, Dorothy. "Heroic Sisterhood in *Goblin Market.*" *Victorian Poetry* 21 (1983): 107–18.

Michie, Helena. *Sororophobia: Differences Among Women in Literature and Culture.* New York: Oxford University Press, 1992.

———. "'There Is No Friend Like a Sister': Sisterhood as Sexual Difference." *ELH* 56 (1989): 401–21.

Millais, John Guille. *The Life and Letters of Sir John Everett Millais.* 2 vols. New York: Frederick Stokes, 1899.

Mitchell, Sally. *Dinah Mulock Craik.* Boston: Twayne, 1983.

Moers, Ellen. *Literary Women.* Garden City, N.Y.: Doubleday, 1976.

Montrose, Louis Adrian. "*A Midsummer Night's Dream* and the Shaping Fantasies of Elizabethan Culture: Gender, Power, Form." *Rewriting the Renaissance: The Discourses of Sexual Difference in Early Modern Europe.* Edited by Margaret W. Fer-

guson, Maureen Quilligan, and Nancy J. Vickers. Chicago: University of Chicago Press, 1986. 65–87.

Morgan, Susan. *Sisters in Time: Imagining Gender in Nineteenth-Century British Fiction.* New York: Oxford University Press, 1989.

Munich, Adrienne Auslander. *Andromeda's Chains: Gender and Interpretation in Victorian Literature and Art.* New York: Columbia University Press, 1989.

Myers, William. "The Radicalism of *Little Dorrit.*" *Literature and Politics in the Nineteenth Century.* Edited by John Lucas. London: Methuen, 1971. 77–104.

Nead, Lynda. *Myths of Sexuality: Representations of Women in Victorian Britain.* Oxford: Basil Blackwell, 1988.

———. "The Magdalen in Modern Times: The Mythology of the Fallen Woman in Pre-Raphaelite Painting." *Oxford Art Journal* 7 (1984): 26–37.

Newhall, Beaumont. *The History of Photography from 1839 to the Present Day.* New York: Museum of Modern Art, 1964.

Newman, John. "Reynolds and Hone: 'The Conjuror' Unmasked." In *Reynolds,* ed. Nicholas Penny. 344–54.

Nochlin, Linda. "Lost and *Found:* Once More the Fallen Woman." *The Art Bulletin* 58 (1978). 139–53. Rpt. *Feminism and Art History: Questioning the Litany.* Ed. Norma Broude and Mary D. Garrard. New York: Harper & Row, 1982. 220–45.

Northcote, John. *The Life of Sir Joshua Reynolds.* 2 vols. London, 1818.

Ormond, Richard. *Sir Edwin Landseer.* Philadelphia: Philadelphia Museum of Art, 1981.

Page, Norman, ed. *Wilkie Collins: The Critical Heritage.* London: Routledge and Kegan Paul, 1974.

Patrick, Anne E. "Rosamond Rescued: George Eliot's Critique of Sexism in *Middlemarch.*" *The Journal of Religion* 67 (1987): 220–38.

Paulson, Ronald. *Book and Painting; Shakespeare, Milton and the Bible: Literary Texts and the Emergence of English Painting.* Knoxville: University of Tennessee Press, 1982.

———. *Emblem and Expression: Meaning in English Art of the Eighteenth-Century.* Cambridge: Harvard University Press, 1975.

———. *Hogarth: His Life, Art, and Times.* New Haven and London: Yale University Press, 1971.

Pearl, Cyril. *The Girl with the Swansdown Seat.* London: Frederick Muller, 1955.

Penny, Nicholas, ed. *Reynolds.* With contributions by Diana Donald, David Mannings, John Newman, Nicholas Penny, Aileen Ribeiro, Robert Rosenblum, and M. Kirby Talley, Jr. New York: Abrams, 1986.

Powell, Nicolas. *Fuseli: The Nightmare.* New York: Viking, 1972.

Praz, Mario. *The Hero in Eclipse in Victorian Fiction.* Trans. Angus Davidson. London: Oxford University Press, 1956.

Redgrave, Richard and Samuel. *A Century of British Painters.* 1866, 1890. Rpt. ed. Ruthven Todd. Ithaca: Cornell University Press, 1981.

Reynolds, Graham. *Victorian Painting.* Rev. ed. New York: Harper & Row, 1987.

Ringler, Ellin. "*Middlemarch:* A Feminist Perspective." *Studies in the Novel* 15 (1983): 55–61.

Roberts, Helene E. "Marriage, Redundancy, or Sin: The Painter's View of Women in the First Twenty-Five Years of Victoria's Reign." In Vicinus, *Suffer and Be Still,* 45–76.

Robertson, David. *Sir Charles Eastlake and the Victorian Art World.* Princeton: Princeton University Press, 1978.

Rossetti, Christina. *The Complete Poems of Christina Rossetti: A Variorum Edition.* Edited by R. W. Crump. Baton Rouge: Louisiana State University Press, 1979.

Roston, Murray. *Renaissance Perspectives in Literature and the Visual Arts.* Princeton: Princeton University Press, 1987.

Ruskin, John. *The Works of John Ruskin.* 39 vols. Edited by E. T. Cook and Alexander Wedderburn. London and New York, 1903–12.

St. Peter, Christine. "Jane Austen's Creation of the Sister." *Philological Quarterly* 66 (1987): 473–92.

Schreiner, Olive. *From Man to Man, or Perhaps Only.* With an Introduction by S. C. Cronwright-Schreiner. New York: Grosset and Dunlap, 1927.

———. *The Story of an African Farm.* (1883) With an Introduction by S. C. Cronwright-Schreiner. Boston: Little, Brown, 1927.

Scott, Sir Walter. *The Heart of Midlothian.* Edited by Claire Lamont. New York: Oxford University Press, 1982.

Scott, William Bell. *Autobiographical Notes of the Life of William Bell Scott.* Edited by W. Minto. 2 vols. New York: Harper and Brothers, 1892.

Shanley, Mary Lyndon. *Feminism, Marriage, and the Law in Victorian England.* Princeton: Princeton University Press, 1989.

———. "Marriage Law." *Victorian Britain: An Encyclopedia.* Edited by Sally Mitchell. New York: Garland, 1988.

Shaw, Harry E. *The Forms of Historical Fiction: Sir Walter Scott and His Successors.* Ithaca: Cornell University Press, 1983.

Spacks, Patricia Meyer. *The Female Imagination.* New York: Knopf, 1975.

———. "Sisters." *Fetter'd or Free? British Women Novelists, 1670–1815.* Edited by Mary Anne Schofield and Cecilia Machelski. Athens: Ohio University Press, 1986.

Spencer, Isobel. *Walter Crane.* New York: Macmillan, 1975.

Springer, Marlene. "Angels and Other Women in Victorian Literature." *What Manner of Woman: Essays on English and American Life and Literature.* Edited by Marlene Springer. New York: New York University Press, 1977. 124–59.

Staley, Allen. "The Condition of Music." *Art News Annual* 33 (1967): 80–87.

Staves, Susan. *Married Women's Separate Property in England, 1660–1833.* Cambridge: Harvard University Press, 1990.

Taylor, Jenny Bourne. *In the Secret Theatre of Home: Wilkie Collins, Sensation Narrative, and Nineteenth-Century Psychology.* London: Routledge, 1988.

Thomas, Jeanie G. "An Inconvenient Indefiniteness: George Eliot, Middlemarch, and Feminism." *University of Toronto Quarterly* 56 (Spring, 1987): 392–415.

Todd, Janet. *Women's Friendship in Literature.* New York: Columbia University Press, 1980.

Trilling, Lionel. "*Little Dorrit.*" *The Opposing Self: Nine Essays in Criticism.* New York: The Viking Press, 1955. Rpt. in *Dickens: A Collection of Critical Essays.* Edited by Martin Price. Englewood Cliffs, N.J.: Prentice-Hall, 1967. 147–57.

Van Ghent, Dorothy. *The English Novel: Form and Function.* New York: Rinehart, 1953.

Vicinus, Martha. *Independent Women: Work and Community for Single Women, 1850–1920.* Chicago: University of Chicago Press, 1985.

———, ed. *Suffer and Be Still: Women in the Victorian Age.* Bloomington: Indiana University Press, 1972.

———, ed. *A Widening Sphere: Changing Roles of Victorian Women.* Bloomington: Indiana University Press, 1977.

Walkley, Christopher. "'Nor Iron Bars a Cage': The Victorian Crinoline and Its Caricaturists." *History Today* 25 (1975): 712–17.

Warner, Malcolm. "John Everett Millais's *Autumn Leaves*: 'A Picture Full of Beauty and without Subject'." *Pre-Raphaelite Papers.* Edited by Leslie Parris. London: Tate Gallery/Allen Lane, 1984.

Waterhouse, Ellis. *Reynolds.* Boston: Boston Book and Art Shop, 1955.

———. *Reynolds.* London: Phaidon, 1973.

West, Jane. *A Gossip's Story.* London, 1797.

Wilt, Judith. *Secret Leaves: The Novels of Walter Scott.* Chicago and London: University of Chicago Press, 1985.

Wind, Edgar. "'Borrowed Attitudes' in Reynolds and Hogarth." *JWCI* 2 (1938–39): 182–85.

Wollheim, Richard. *Painting as an Art.* Princeton: Princeton University Press, 1987.

Wollstonecraft, Mary. *A Vindication of the Rights of Woman, with Strictures on Moral and Political Subjects.* 1792. Edited by Charles W. Hagelman, Jr. New York: Norton, 1967.

Wood, Christopher. *The Dictionary of Victorian Painters,* 2nd ed. Woodbridge, Suffolk: Antique Collectors' Club, 1978.

———. *Victorian Panorama: Paintings of Victorian Life.* London: Faber, 1976.

Woodham-Smith, Cecil. *Florence Nightingale: 1820–1910.* New York: McGraw-Hill, 1951.

Woolf, Virginia. *A Room of One's Own.* New York: Harcourt, Brace, 1929.

Index

185